(Re)Constructing Maternal Performance in Twentieth-Century American Drama

WHAT IS THEATRE?
Edited by Ann C. Hall

Given the changing nature of audiences, entertainment, and media, the role of theatre in twenty-first century culture is changing. The **WHAT IS THEATRE?** series brings new and innovative work in literary, cultural, and dramatic criticism into conversation with established theatre texts and trends, in order to offer fresh interpretation and highlight new or undervalued artists, works, and trends.

ANN C. HALL has published widely in the area of theatre and film studies, is president of the Harold Pinter Society, and is an active member in the Modern Language Association. In addition to her book *A Kind of Alaska: Women in the Plays of O'Neill, Pinter, and Shepard*, she has edited a collection of essays, *Making the Stage: Essays on Theatre, Drama, and Performance* and a book on the various stage, film, print, and television versions of *Gaston Leroux's Phantom of the Opera*.

Published by Palgrave Macmillan:

Theatre, Communication, Critical Realism
 By Tobin Nellhaus

Staging Modern American Life: Popular Culture in the Experimental Theatre of Millay, Cummings, and Dos Passos
 By Thomas Fahy

Authoring Performance: The Director in Contemporary Theatre
 By Avra Sidiropoulou

Readings in Performance and Ecology
 Edited by Wendy Arons and Theresa J. May

Theatre and War: Theatrical Responses since 1991
 By Jeanne Colleran

(Re)Constructing Maternal Performance in Twentieth-Century American Drama
 By L. Bailey McDaniel

(Re)Constructing Maternal Performance in Twentieth-Century American Drama

L. Bailey McDaniel

palgrave
macmillan

(RE)CONSTRUCTING MATERNAL PERFORMANCE IN TWENTIETH-CENTURY AMERICAN DRAMA
Copyright © L. Bailey McDaniel, 2013.

All rights reserved.

First published in 2013 by
PALGRAVE MACMILLAN®
in the United States—a division of St. Martin's Press LLC,
175 Fifth Avenue, New York, NY 10010.

Where this book is distributed in the UK, Europe and the rest of the world, this is by Palgrave Macmillan, a division of Macmillan Publishers Limited, registered in England, company number 785998, of Houndmills, Basingstoke, Hampshire RG21 6XS.

Palgrave Macmillan is the global academic imprint of the above companies and has companies and representatives throughout the world.

Palgrave® and Macmillan® are registered trademarks in the United States, the United Kingdom, Europe and other countries.

ISBN: 978–1–137–29956–7

Library of Congress Cataloging-in-Publication Data

McDaniel, L. Bailey, 1968–
 (Re)constructing maternal performance in twentieth-century American drama / by L. Bailey McDaniel.
 pages cm—(What is theatre?).
 Includes bibliographical references and index.
 ISBN 978–1–137–29956–7 (alk. paper)
 1. American drama—20th century—History and criticism. 2. Motherhood in literature. 3. Sex role in literature. I. Title. II. Title: Reconstructing maternal performance in twentieth-century American drama.

PS338.M66M33 2013
812'.50935252—dc23 2013004977

A catalogue record of the book is available from the British Library.

Design by Newgen Knowledge Works (P) Ltd., Chennai, India.

First edition: September 2013

10 9 8 7 6 5 4 3 2 1

Transferred to Digital Printing in 2014

For AJ—for all that you gave, all that you taught, and all that you left behind.

Contents

Acknowledgments — ix

Introduction If It's Not One Thing, It's Your Mother? Race, Sex, Class, and *Essential* Maternity — 1

1. New Woman (Re)Production in Rachel Crothers' Alternative Maternities — 17

2. Ethnic Anxieties, Postwar Angst, and Maternal Bodies in Philip Kan Gotanda's *The Wash* — 53

3. Race and the *Domestic* Threat: Sexing the Mammy in Tony Kushner, Alfred Uhry, and Cheryl West — 93

4. Queering the Domestic Diaspora, *Enduring* Borderlands: Cherríe Moraga's Familia de la Frontera — 121

Conclusion Nurturing Performance, Raising Questions — 153

Notes — 169

Bibliography — 209

Index — 221

Acknowledgments

THE MENTAL LABOR, CHUTZPAH (DENIAL), AND MOST IMPORTANTLY, external support that is required to write a book can't be measured with any preexisting rubric. If I could dare to come up with a unit of measurement to quantify the intellectual, psychological, and material sustenance I've received from the earliest stages to the completion of this book, the number would be superlative. The editorial and support staff at Palgrave Macmillan, and in particular Robyn Curtis, have been a source of support and kindness from the very beginning. And in truth, I don't know how I'd even begin to thank Ann C. Hall for all that she has done for me. From my initial (and lucky) contact with her to the present, Professor Hall was and has continued to be an encouraging, kind, astute reader. For being in my corner and for her early championing, I owe her so much. Thank you, Ann.

Many of the ideas that initially spawned this project began with my doctoral dissertation at Indiana University. Stephen Watt, Purnima Bose, Ellen MacKay, and Shane Vogel began as a dissertation committee and morphed into unofficial career counselors and the most generous of colleagues. With invariable patience and shrewd guidance, they helped me compose and refine what were initially only general, not always, coherent ideas, and I am deeply grateful. I also thank them for consistently modeling what a deeply humane but still prodigious scholar looks like. Role models, indeed. Although for most of my life I've liked to think of myself as politically aware and active, it was not until I was privileged (and lucky) enough to work with Purnima Bose that my critical lens began to crystallize in ways that changed me (and hopefully, as a consequence, my own students) profoundly. For showing me what it really means to walk the walk and not merely talk the talk (in both personal and professional landscapes), I thank you, my dear friend. The catalogue of what Stephen Watt has done for me is almost embarrassing. Whatever might be of value in the pages that follow is a result of his deep knowledge and sharp critical eye, and his unlimited generosity in sharing both. Were academic scholarship organized more like show business, I would certainly have to provide Steve with a personal manager's 10 percent of all my earnings. His largesse leaves me humbled.

At my professional home in the English department of Oakland University, the list of individuals to whom I owe much is long. For initially hiring me to do a job that I love and for their friendship and support, my colleagues in the English department are a gift that I don't take for granted. Rarely a day goes by that I don't benefit in some way from their individual and cumulative expertise and humor. To single out only two of the many, I'd be remiss if I didn't take a moment to thank Kathy Pfeiffer for not only being my cherished comrade-in-arms, but also the (deeply appreciated) colleague who helped me find "the last big idea" required to finish this book. As an internationally respected artist as well as scholar and educator, Andrea Eis shared her work for this book's cover, but also her friendship. And I couldn't begin to count how many of my undergraduate and graduate students have brought me new perspectives on this research and continue to inspire me with every semester. They have taught me much and I know it.

One of the first "big things" I learned in graduate school was the way that in everything we do and perceive "the personal is political." If I might tweak that truism, at the end of this project I believe as well that "the personal is published." This book and all that was required in its completion occurred because of the abundance of sincere guidance and compassion and—dare I not very academically say—love that I have very personally received from many. At the top of the list would surely be Kiki Shaffer and Ellen Epstein, two life rafts that helped and (even in their physical absence from my life) continue to help me in powerful ways. The lessons they taught me have a very long shelf life, and I'm in their debt deeply. Susan Batson shared of herself, her (quite literal) genius, and her bottomless well of life's wisdom. But perhaps more importantly, she taught me what a truly inspired teacher looks like. Susan's almost inhuman compassion, intellect, and work ethic manifested a personal and professional model to which I will always aspire, but will surely never match.

Despite hectic schedules, dramatic life events, and sometimes many miles between us, Molly Smith and Ann Marie Dunbar have provided more intellectual and psychological nourishment than they'll ever know. The bounty of their friendship is cherished. I am also in their debt for consistently reminding me of what a strong, brilliant, gracious woman looks like.

With their invariable understanding for all of the missed get-togethers, sparse phone contact, and an overall absence that was often required while writing this book, I owe an embarrassing magnitude of thanks to John and Bonnie McDaniel. Their generosity and love have been a powerful source of strength in ways that words can't express. I cherish and appreciate them so. Kathy, Charlie, and the other two John McDaniels helped me ride out

difficult times with humor, kindness, and impromptu musical interludes that reminded me of what was really (*really*) important. For approximately forty years, John McDaniel has been more than a brother; he has been an infinite wellspring of encouragement, love, laughter, and true inspiration. No matter what, he has been there without exception. For his unerring, precious friendship and for (always) making me believe that I could do anything, I owe him more than I'll ever be able to repay.

And, finally, this project would absolutely not exist if not for Stephen Blair's unflappability, gigantic brain, wit, and love—all of which I never cease to benefit from. As a scholar and a teacher, he continues to show me that achieving professional greatness and being an exceedingly kind person are not mutually exclusive. His herculean patience and emotional generosity leave me speechless in gratitude. In addition to consistently providing shrewd feedback and powerful encouragement, as a true best friend, his authentic goodness continues to make the good things better and the bad things less bad. Lucky me.

INTRODUCTION

IF IT'S NOT ONE THING, IT'S YOUR MOTHER? RACE, SEX, CLASS, AND *ESSENTIAL* MATERNITY

> Some of the most heated social and political debates taking place in late-twentieth-century America turn out to revolve around disputed meanings of mothering and motherhood in contemporary society... Because mothering is often romanticized as a labor of love, issues of power are often deemed irrelevant or made invisible... [On the contrary], mothering takes place in social contexts that include unequal power relations between men and women, between dominant and subordinate racial groups, between colonized and colonizer. Thus mothering cannot escape being an arena of political struggle.
>
> —Evelyn Nakano Glenn, Mothering: Ideology, Experience, and Agency

ON MARCH 27, 2005, THE *NEW YORK TIMES'* "MODERN LOVE" COLUMN published a piece entitled "Truly, Madly, Guiltily" by Ayelet Waldman.[1] A regular contributor to *Salon.com*, Waldman is also a novelist (including seven "Mommy-Track" mysteries), a Harvard Law graduate, a former public defender, and stay-at-home mother to the four small children that she raises with her husband, Pulitzer Prize–winning novelist Michael Chabon. About halfway through Waldman's 1,648-word piece she offers what will be read by many as a startling revelation, that she loves her husband substantially more than she loves their four children. Readers learn that after their twelve years of marriage, Chabon still inspires in Waldman "obsession," "exhilarating conversations," "paroxysms of infatuated devotion," and lots (and lots) of satisfying marital sex.[2] The usually positively charged notion of an

"all-consuming maternal desire" that displaces libido for all the best mothers is, according to Waldman, *not so good*. For Waldman this maternally driven libido quash is not an issue. As her first-person yarn ponders, among other questions, why she is the only woman at Mommy and Me class who "has not made the erotic transition a good mother is supposed to make," she reveals matter of factly that she is "incapable of placing her children at the center of her passionate universe." Make no mistake, she writes, she was in fact "in love" in the days following her daughter's birth—"just not with my baby." Invoking, perhaps, the foremost taboo of the piece, her disclosure continues: "If a good mother is one who loves her child more than anyone else in the world, I am not a good mother. I am in fact a bad mother. I love my husband more than I love my children."[3] Waldman's statements certainly deserve attention for their provocative implications regarding marriage, motherhood, and the nature of filial affection. But what happened after Waldman's piece appeared is particularly relevant for anyone interested in the always culturally contrived, never politically neutral notions of maternity in twentieth- and twenty-first-century American culture.[4]

Shortly after "Truly, Madly, Guiltily" was published, a not unexpected backlash emerged from a livid (mostly female) public that was as uncomfortable as it was furious with a woman who, without the requisite shame, described explicitly in print how she *could* survive the death of her children, but absolutely could *not* picture "a future beyond her husband's death."[5] Fueling the fire of controversy was the attention the statements and their backlash garnered from Oprah Winfrey and her audience, when the host-mogul devoted an entire show to Waldman. Although Winfrey defended Waldman during the show's taping, a panel and audience of enraged mothers revealed their disgust with the writer and mother who, according to *Publishers Weekly*, "made women boil."[6] And reactions were not limited to daytime television; among the "vitriol" inspired by Waldman's confession was a searing near viral Internet spoof, as well as hordes of angry responses from bloggers and readers.

Why does the admitted "maternal ambivalence"[7] of a confessional writer who also describes equally provocative positions on her own bi-polar disorder and suicidal thoughts (to name just a few of Waldman's revelatory blog topics) inspire such wrath? Was it Waldman's filially organized emotional agenda in and of itself that instigated such rage, or was it her audacity to state them publicly and unapologetically? Waldman's readers and Winfrey's audience clearly expected a "performance" of maternity that placed an altruistic concern for offspring first and foremost, particularly before the emotional and sexual needs of the mother. That a claim diverging from a paradigm of selfless maternity earned public rancor is hardly surprising. What deserves a second look is what if any presuppositions are enabled

by virtue of Waldman's status as a white, upper-middle-class white-collar woman. Waldman's race and class, not to mention her identity as a Jewish woman and wife of the same man for eighteen years, unavoidably shape the artificially defined norms with which her culture assigns her maternal role, her function, and value. Would public reaction to Waldman's statements have been equally critical if they originated from Chabon, the parent who Waldman writes *does* love his children more than his spouse? And how might the same "confession" be received if Waldman's less-than-altruistic attitude toward motherhood were uttered by a working-class woman of color? What if a lesbian mother had publicly stated that she loved her same sex partner more than her children? Would these declarations earn more, less, or qualified antipathy compared to Waldman's experience? The four chapters that follow explore these questions in their broadest sense—how exactly do race, class, gender, and sexuality inform the cultural rubrics of maternity that exist, falsely, as naturalized codes of identity? And how do these socially constructed subjectivities, particularly as they are expressed in American drama and performance, support (or alternatively resist or dismantle) hegemonic social organizations based in categories such as class, race, gender, and sexuality?

In theatrical texts and performance, metanarratives of maternity emerge as ubiquitously as plot, character, and dialogue. Indeed, even among the less linear/plot-driven examples, such as playtexts or performances considered absurdist or experimental, metanarratives of maternity sometimes exist when plot, character, or dialogue do not. While deconstructive and identity-based theoreticians have successfully revealed the falsely naturalized notions of identity based in categories such as race and gender, to name just a few, the identity of the mother remains subtly ingrained and stubbornly unnoticed. For example, referencing a subject as "(un)motherly" or "warmly maternal" might easily produce a consensual, if artificially based concept of what that particular construct entails, with accompanying linguistic and conceptual paradigms to complete the portrait. Often, automatically, a mother-subject's sexuality, political ideologies, professional ambition, child-rearing philosophies, location in a private/public dichotomy, and even race/ethnicity are safely, if reductively, assumed strictly as a result of her/his maternal coding.

In contemporary theatre, an exploration of maternal representation is especially timely. While cinema studies and studies of poetry and the novel have made significant excursions into analyses of agency and the maternal, interrogations into maternal constructs and staged motherhood remain largely absent. Among only a handful of book-length studies, Jozefina Komporaly's *Staging Motherhood: British Women Playwrights, 1956 to the Present* (2007) considers a wide-ranging collection of plays and performance histories, but restricts its focus to British drama of the second half of the

twentieth century. In terms of American drama specifically, the maternal territory is unexplored. Susanna Bösch's 1996 *Sturdy Black Bridges* is one exception, but Bösch investigates only African American motherhood and specifically restricts her focus to African American women playwrights. No recent research explicitly considers the ethnic- and class-based constructions of motherhood across the broad landscape of modern American drama. Representations of lesbian motherhood, working-class mothers, stand-in mothers who assume caretaking roles for wages, the ethnic mother, and even the more commonly "naturalized" white middle-class mother have also yet to be considered in any significant theoretical work with American-produced texts as its source material. Consequently, while considering a range of canonical and peripheral texts, this manuscript investigates the dissimilar constructions of mothering found in twentieth- and twenty-first-century American drama as those plays articulate the historical and social variations and hierarchies within mothering, a relationship and institution, I argue, that is always socially constructed and not necessarily biologically determined.

Although each chapter advances the following in varying ways, I argue that a tradition of alternative maternity can be located in the near century-long body of work categorized as modern American drama, and further, this fluid and always politically informed rubric often dialectically clusters around (frequently racially) marginalized identities. I contend that modern American drama turns, often effectively, to a kind of countermaternity in order to push against sociopolitical oppression and constraints of identity. Moreover, the "solution" to a subject's marginalized status often positions the maternal in conflict with reproductive paradigms invested in essentialized biological gender. Finally, while in these plays we can often locate a gender-neutral deployment of maternal performance, constructs that offer progressive alternatives to a restrictive politics and/or binaried concepts of self, any analysis is incomplete, I argue, without further consideration of what if any investment these countermaternities have in very American race-based anxieties.

Among other concerns, social apprehensions concerning miscegenation, cultural meditations on eugenics, ethnically based anxieties surrounding assimilation, and the fluid performances of race that the aforementioned generate all contribute to and reflect the ways that a mother subject's values and functions operate. In any analysis of culture and text, a methodology that does not take into account the interreliant nature of identity-based social hierarchies within broader political marginalization risks oversimplification, if not negligence. Or, as Henry Bial and Scott Magelssen keenly articulate, "Approaching particular historical moments as sites of convergence of class-based and sex-based anxieties reveals much more about their complexities

than past approaches that have privileged a single axis of identity over all others."[8] Particularly when finding focus in what I term the countermaternal, the interrelated nature of these multiple identity constructs and their attendant hierarchies deems theatrical performance—a practice already preoccupied with a multiplicity and performance of self—an especially valuable medium of analysis. In the chapters that follow, I explore how quite literal performances of the mother prompt unique and useful revelations regarding the often mutually supporting, frequently restrictive ideologies of self.

The methodologies involved in and available to the study of theatre, drama, and performance are certainly numerous, often complimentary, and at times contradictory. Assuming one's initial, basic terms of analysis connote the same meaning to multiple readers/disciplines can have radical implications, both rhetorically and politically. Among the most obvious examples that require explication here are "drama," "theatre," and "performance," designations that deserve and have received scholarly attention from entire manuscripts attempting to explore and define the parameters of various critical positions. Assuming consensus or failing to explore conceptual variations among connotations of "theatre" versus "performance," for example, risks oversimplifying complex and occasionally contradictory academic discourses; more significantly, however, epistemological discrepancies regarding and within the studies of theatre versus performance might also imply material (as well as academic) displacement for the elided subject or discipline at the hands of a supposed elitist frontrunner.

In what follows, I elaborate on Stephen Bottom's argument in which he contends that the dichotomy of Performance Studies/Theatre Studies should exist not as a binary to support uniformly or deny but, more usefully, to unpack and resist. In his analysis of the oppositional, usually hierarchal, relationship between that which is known by scholars as "theatre" (mere entertainment) versus the more "efficacious" nature of "performance," Bottoms extrapolates the "braid of efficacy and entertainment"[9] that increasingly places "'theatre' only as the acting out of dramatic literature in a purpose built building, whereas performance is taken to encompass pretty much anything else."[10] This dichotomous paradigm surfaces as a kind of braid in which, going as far back as Plato, the "theatrical" is linguistically and conceptually demoted to a kind of "ontological malaise"; "performance," on the other hand, emerges as the more esteemed partner and "carries with it connotations of having real effects in the real world [and] seems authentically efficacious rather than emptily ostentations."[11]

While critics such as Bial and Magelssen point to an increasing relaxation within the theoretical discord, as "these once-rival schools of thought mov[e] toward reconciliation,"[12] a potential for a hierarchizing of Performance Studies over Theatre History remains and deserves continued attention. As

Bottoms explains, a conception of "theatre" as a phenomenon unable to produce the results of its more powerful rival "performance" would surely result in Theatre Studies being further subjugated and consisting of only the most traditional examples, occupying an increasingly smaller place of importance in scholarly or politically based agendas of research.[13] More dangerous is the devaluation of Theatre Studies based specifically on a perceived lack of political effectuality. As Bottoms points out, in response to the expanding field of Performance Studies over the past few decades, and as a result of the "curiously limited and limiting definition of that which constitutes 'theatre,'"[14] Theatre Studies finds itself in the ineffectual, markedly *non*revolutionary landscape of entertainment, while its more powerful, often understood as more important opposite Performance Studies is relegated to virile rebellion and subversive potency. This divide has resulted in a situation that has become "highly problematic, and even potentially crippling" for both disciplines. As Bottoms clarifies, the tendency to relegate the "performative" and the "theatrical" to opposing boxes of (either) potently subversive or (merely) entertainment inadvertently accomplishes two dangerous things: first, modalities of performance that are not necessarily subversive (e.g., the US Military Industrial Complex) but that *do* deserve to be performatively critiqued are not; second, any subversive material relegated to what is understood as merely theatrical is ignored.[15]

This book then echoes Bottoms' argument that the "near-puritanical opposition of efficacy and entertainment"[16]—an opposition that places theatre scholars into precipitate judgment regarding the/any potential of theatre to question or resist cultural norms—is a binary that needs to be picked apart, a "braid" that needs further unraveling, but a binary that would surely benefit from resistance as well. While this book interrogates this theatre-performance continuum itself, especially as that continuum often feminizes the so-called ineffectually theatrical in relation to the "potency" of the performative, overall I rely more consistently on what scholars and theoreticians understand as theatre. In other words, I propose an understanding of methodologies based in Performance Studies and Theatre Studies not as two bifurcated and oppositional formations, but rather as what Bottoms describes as "two fields [existing] as dance partners, capable of learning from and supporting each other, provided of course that the dance is between mutually respectful equals."[17]

I also employ the concept of "the play" and "drama" in specific ways. As Stephen Watt explains, "Drama" is not necessarily "a synonym for *play* and [the former] can mean any number of things."[18] For the most part the following chapters explore "dramatic" texts in the strict sense, understood as an interactive social experience between playwright and reader, between producers of theatre and spectators. A play is thus a historical artifact that,

although still existing today for our consideration, has also occurred and reoccurred in real historical time, with the creation and the production of a text embodying the material world of the actors, directors, writers, set designers, and spectators. Thus, in addressing "the theatrical," I deal with what is situated both (uniquely) at the moment it occurs, as well as later, sometimes modified, in the form of the written text, or future productions; critical documents; reviews; and historical detail. Further, the varied implications that result from the commercial and institutional, not to mention sociopolitical conditions surrounding the existence of a particular play or individual performance(s) also illuminate my analysis. In any attempt to read the signs of drama, it would seem crucial to consider whether or not a play or production is considered, for example, (1) a mainstream Broadway "social comedy" that earned profitable attendance revenue despite the economic depression of its audiences; (2) a more expressionistic, or even grassroots performance that emerged from fringe production conditions and appealed to small, if inordinately politically aware, spectators; or even (3) a canonical mainstay of international stages and classrooms, designated with a so-called universal status in relevance and subject matter. The legislative, cultural, and economic realities defining the moment(s) any performance/text is originally and subsequently engaged is also unavoidably relevant to how we "read a play."

My methodology, then, aims to place itself within a historical context of specific productions, (individual) textual production, spectator response, and critical reception, relying throughout on feminist materialist paradigms of analysis. In *Reading the Material Theatre*, Ric Knowles investigates the ways that critics might engage a productively "politicized analysis of the ways in which specific aspects of theatrical production, and specific contexts of reception, shape the audience's understanding of what they experience in the theatre."[19] In addition to the staged and scripted "raw event," what we construct as production and performance also includes the cultural politics of the external realities surrounding the play, not to mention, as Marvin Carlson points out, the ways in which the memories of the spectator inform her/his reception. While that memory can be based on the performer's or director's celebrity construct, a venue's politics, or merely previously viewed (different) productions, these real and (re)imagined phenomena unavoidably engender meaning in a performance/text, both while it is occurring and afterward, in isolated reading. Analogous to Knowles' position on a materialist semiotics and Carlson's suggestion of theatre are caretaker of cultural memory, Catherine Schuler eloquently submits: "Fundamental to a materialist historiography is the assumption that social institutions are marked by the laws, ideologies, social practices, and culturally sanctioned traditions peculiar to the historical moment... theatres must be understood as social institutions, the material practices of which are marked by a particular legal,

ideological and cultural context."[20] In other words, in expanding "text" and its meaning beyond more conservatively understood components such as dialogue, characterization, stage directions, or even playwright biography, theatre, and performance as a meaning-making apparatus succeeds as multilensed, productively complex discourse.

In addition to "theatre," "performance," and "drama," the use of "American" as a descriptive term presents an array of muddied, misleading, even dangerous elisions. Unpacking the challenges (if not polemics) associated with describing cultural products from the United States as "American" requires unraveling a complex weave of rhetorical assumptions and political over simplifications. In addition to the imperial history and rhetorical incongruities portended by a casual employment of the word, the use of "American" can also be read as a political abatement of nations other than the United States that comprise the Americas. Indeed, the use of "American" also need not imply texts written in English. Some recent critical treatments of American drama, for example, have expanded their parameters to include in their understanding of "American theatre and performance" texts beyond those written in English exclusively or at all. Employing a more transnational understanding of American drama, Felicia Londrés's and Daniel Wattermeier's *The History of North American Theatre* (Continuum International, 1998) considers pre-Columbian Native American performance traditions and includes source material from colonial theatre amid North America, including theatre in Spanish and French as well as English.[21]

Perhaps the most obvious, portentous slippage inherent to a loose usage of "American" involves the rhetorical and political equivocations regarding original American subjectivities, namely native populations, an important issue to address in this book, in particular, given the omission of any individual chapter exploring Native American constructs of maternity and maternal performance. As S. E. Wilmer points out, the increased inclusion of Native American theatre in anthologies, research, and syllabi addressing "American theatre and drama" can be traced to a broader visibility and significance to area studies, as well as anthropologists' and ethnologists' exploration of autochthonous song and dance traditions.[22] This inclusionary shift is crucial to a more expanded and egalitarian canon, to be sure. The scope of my analysis here, however, contains itself to a historiography that considers text, production, cultural conditions, but stops short of ethnoanthropological considerations and ritual, which would seem requisite to any serious consideration of native performance and its traditions.

Following the research of feminist sociologists such as Evelyn Nakano Glenn, I use "mothering" to name the material and ideological practices associated with motherhood, maternity, maternal behavior, reproduction, and even fertility. In this sense, accordingly, mothering occurs within and

is shaped by market forces and state policy, can exist outside biological filiation, and often surfaces amid discourses and representations that pretend to speak universally. E. Ann Kaplan's work with maternal representation in film traces the reductive constructs of the "good mother" to Rousseau's *Emile, or on Education* (1762) and its "angelic" mother ideology.[23] While Kaplan's suggestion of an imposed maternal binary of selfless angel versus evil witch provides insight when considering, for example, the work of Ibsen's overtly revolutionary Nora in *A Doll's House* (1879), or the masochistic portrait Miller offers with *Death of a Salesman's* (1949) Linda Loman, I am interested in complicating this binary and in what follows, move toward an exploration of the interreliant nature of social hierarchies. Said another way, this analysis affords insight into deeply entrenched, surreptitiously codependent nature of essentialized maternal subjectivities but at the same time hopes to bypass what my undergraduate students and I have come to fondly describe as "the Frankenstein School."

In my undergraduate classes, I encourage my students (burgeoning critics who are enthusiastic to assess a character's potential political value) to resist employing the Frankenstein School, a mode of inquiry that encompasses an understandable if not very useful method of evaluation that, in terms of analytical sophistication, mimics Shelley's Modern Prometheus. Similar to the nameless large one's appraisal of "fire" and "friend," we might be tempted to assess "Linda Loman *baaaad*... Wasserstein's Heidi *gooood*." Rather than engage in a critical finger-pointing exercise, one in which particular maternal performances are lauded while others faulted, my book explores the ways that the material forms of production, including the playtext itself, proffer discourses of maternal identities and the ways in which these subjectivities contribute to and resist complimentary sociopolitical oppressions. For example, while it is common to recognize that the labor market is segmented by race and gender or even that domestic labor, including mothering or caring work, is "woman's work," less acknowledged is the reality that mothering work is not just gendered, but often racialized, class-based, and codependent among groups of women, as those groups are also constructed across shifting race and class identities. Consequently, the following chapters rely on the work of scholars such as Shari L. Thurer and Nakano Glenn, who investigate the ways in which the construction of mothering as universally women's work obscures and erases additional, often equally constructed, subdivisions such as race and class. This critical stance also places first and foremost the reality that mothering ideologies do not exist in isolation, but rather within complex ideologies imbricated by patriarchy, capitalism, and imperialist geopolitics. In other words, then, while restricting my scope of analysis to American-staged representations and the fertile discourses of race, class, and gender that emerged in the past century, the following chapters consider the

dialectic of shifting sociopolitical forces and their constructs as they find residency in the often interdependent oppressions from within and around notions of motherhood.

While the reality of contemporary theatre's commodification is undeniable in terms of the capitalist cultural market place, it does not necessarily follow that the potential for subversiveness or resistance within theatre (or even other forms of entertainment) remains ineffective or trivial.[24] And while critics such as David Savran have deliberated on theatre's arguable "marginal position," both economically and culturally, I am hesitant to agree completely with what some critics describe as the "dominated position"[25] of the contemporary American theatre.[26] Savran and others contend that the "cultural producer is [unavoidably] placed in an irreducibly contradictory position," a position that sees the theatre practitioner usually "critqu[ing] hegemonic values insofar as it is the best way of the accruing cultural capital [while] on the other hand, his or her class allegiance blunt[s] this critique."[27] This volume picks up from Savran's analysis, adding that crucial occasions *do* indeed exist in which class (or other power-invested) allegiance does not merely abstain from "blunting critique," but can successfully challenge or explicitly resist what Jill Dolan warns of as a potential "elite, highbrow, universal function of the arts in culture." I rely on a critique of theatre that, as Dolan rightly points out, does not necessarily allow for or subsume these assumptions about the arts' universal function; we might instead "proactively argue for theater as a local practice, one that serves the communities in which it flourishes differentially," insisting upon the "value of theater history, theory, criticism, and practice, not just as part of a Western civilization redemption narrative (in which art brings salvation and civilization) but as part of identity practices inflected with postmodern understandings of the productive instability of subjects and communities."[28] Accordingly, I understand a play to be a cultural product of the most telling kind: in live public performance and in individual private reading, it engages a conversation within and among the material realities and agendas of those who experience it and produce it. And when we examine these cultural products and their spectators with an eye toward the racial, economic, and gendered hierarchies within what is understood as "mothering," we might also locate reproductive schemas that exist as alternative paradigms of agency—paradigms that challenge the status quo in valuable, and at times, effectual ways.

In his Preface to *Communists, Cowboys, and Queers*, Savran states his intention to effect a "felicitous disequilibrium of the discourses of Marxism, feminism, and gay and lesbian studies."[29] If, while adding race to the mix, I might borrow his concise articulation of methodology, this book explores the frequently universalizing, politicized constructions of maternity within modern American drama, employing and complicating these identity

discourses with an eye toward how maternal constructs support, resist, and complicate hegemonic ideologies. In terms of specific chronology, I cast my analysis on material ranging from Rachel Crothers' 1911 *He and She* to Tony Kushner's 2004 *Caroline, or Change*. This near century-long body of material emerges from a kaleidoscopic landscape of race, sex, class, and gender-based paradigms that arise from and react to one of the most consequential periods in world history. However, while specific moments in history consistently inform this book in respective chapters—for example, the Depression, World War II, the African American civil rights movement—this volume neither relies on nor evolves from a strictly teleological analysis. The reality that theatre itself, but especially that originating from the United States, sometimes occupies a less-than-valorized position in a so-called literary canon would only seem to underscore the importance of further research and analysis. In other words, American drama, assuming the still arguable "marginal position" and "critical disregard" it inhabits within American literature,[30] provides a ripe and valuable terrain for exploration of the presumptions, values, and myths that surface within what can be understood as a "national literature" broadly, and maternal discourses specifically.

The lens of materialist feminism informs my analysis consistently throughout this book. Following second-wave feminism and the liberal and radical shifts in philosophies and activism that followed, since the early 1980s feminist materialist criticism has explored, among other things, issues of assumed spectatorship, the role Aristotelian catharsis plays in sustaining social hierarchies, reductive constructions of gender and sexuality, and, of course, continued the important work of research and recovery of women practitioners in theatre. Among others, theorists such as Sue-Ellen Case, Teresa De Lauretis, Jill Dolan, and Janelle Reinelt have successfully brought to the forefront issues surrounding social hierarchies, symbolic code, and hegemonic praxes as they infiltrate text, performance, and spectatorship. This text uses the important theoretical framework of these feminist materialist critics, but I add to the equation issues that concern the often surreptitiously ingrained discourses and representations of mother subjects and broader maternal constructs.

The following chapters explore the ways in which the last approximately one hundred years of live theatre and dramatic texts, both within and outside the canon of American drama, suggest rubrics of maternity that engage, sometimes directly, the subjugation of marginalized peoples, whether marginality is experienced by the maternal subject him/herself, or an Other whose subjugation *is facilitated by that notion of motherhood*. Often, I argue, while these performance and literary texts offer narratives (often self-consciously) that critique social hierarchies vis-à-vis plot, character, and even performance style, they also posit a construct of motherhood deeply invested in race-based subjectivities, whether supportive of or productively

resistant to essentialized notions of identity. Indeed, I submit that at times these ethnically informed engagements with maternal identity go one step further and suggest a more gender-neutral understanding of the mother role itself. In other words, in the plays that follow, a simultaneous connection between biology and maternity is often posited as less-than-requisite to a politically productive performance of motherhood. The following explores how this (dis)investment in biologically invested notions of gender contributes to and/or refuses essentialized notions of race- and even class-based subjectivities as those notions are focused specifically in the role of the mother.

My first chapter, "New Woman (Re)Production in Rachel Crothers' Alternative Maternities" considers the "feminist mother" of the progressive era, looking particularly at the New Woman identity as it both buttresses and dismantles the previous, often domestically invested models of fin-de-siècle maternity. Investigating several turn-of-the-century, so-called politically overt "discussion plays" of Rachel Crothers, a canonical playwright who receives only mixed reviews in her role as a feminist, I contend that the trope of the white, upper-middle-class, unmarried, artist-activist New Woman—via her nongynocentric expression of mothering labor (a maternal identity not reliant on biological childbirth)—projects usefully alternative models of motherhood vis-à-vis a gender-neutral understanding of reproduction and nurturance. Regrettably, this trope also loses political ground because of its requisite and unchallenged privilege, a privilege that occasionally nods to 1920s eugenics discourses and permeates Crothers' broader ontology of "maternal feminism."

Despite arguable commercial success as both a playwright and screenwriter, Philip Kan Gotanda typically receives less critical attention, if not praise, when compared to his peer and fellow post–Yellow Power playwright David Henry Hwang. In "Ethnic Anxieties, Postwar Angst, and Maternal Bodies in Philip Kan Gotanda's *The Wash*," I pay particular attention to Gotanda's family drama that exists, I contend, as a kind of staged meditation on sexually and politically vulnerable patriarchs enduring (what they experience as) spousal and offspring withdrawal, betrayal, and rejection. With a revealing frequency, these vulnerabilities and the emotional and political angst they engender center on (and exist as a reaction to) the mother.

Strategically blending dramatic realism with occasional use of expressionistic devices, *The Wash* (1987) presents characters forced to negotiate the ethnic shame of a "marked American-ness" alongside assimilationist-fed ethnic guilt. Considering Gotanda's investment in fractured and fluid subjectivity (a multiplicity buttressed by deviations from realism), I examine how conflated, and often conflicting, gender and race constructs find focus in maternal performance. Regardless of a character's biological gender, in fact, the "mother role" for Gotanda absorbs and rearticulates the

conundrums—as well as posits the solutions—for a people haunted by, among other things, memories of home-country internment and displacement, concepts of "failed" and racially informed masculinity, and myriad fears regarding the cultural and literal existence of future generations. For Gotanda, in other words, maternity (and the sexual, gender, and even class-based political economies it sustains) hosts a near pathological response to individual and group anxieties invested in postinternment-camp trauma, ethnic hybridity, and conflicting concepts of American-ness. Understood another way, as the figure cast as ultimately responsible for the ideological shaping of future generations—not to mention the potential "dangers" posed by her choice of sexual/reproductive partner—s/he is understood as an ethnic gatekeeper of racial identity and cultural continuity and emerges as the centrally contentious, portentous site of a postmodern race-based angst.

"Race and the *Domestic* Threat: Sexing the Mammy in Tony Kushner, Alfred Uhry, and Cheryl West" examines the asexual, overtly nurturing subject-of-color who puts her/his own mothering on hold while caring for a white employer's family—a subject also known as The Mammy. Alfred Uhry's 1987 *Driving Miss Daisy,* Cheryl West's 2002 *Jar the Floor,* and Tony Kushner's 2004 *Caroline, or Change* present caretakers of color who provide nurturance to white, southern, Jewish recipients, subjects who themselves surface in the texts as simultaneously marginalized and privileged. After my initial reading of these texts that in and of themselves self-consciously attempt to reorder the marginalized-Mammy/privileged-dependent dyad, I argue that when read against expectations, these "feel good" race plays also reveal very American, culturally determined miscegenation anxieties.

With "Queering the Domestic Diaspora, *Enduring* Borderlands: Cherríe Moraga's Familia de la Frontera" I look at lesbian playwright/activist Cherríe Moraga's 1990 drama *Shadow of a Man* and the maternal hysteric body as it sustains/dismantles the hegemonic architecture producing it. What I describe as a "queered maternal hysteric" emerges in Moraga's failed patriarch Manuel, a self-hating gay man and cuckold who occupies a nonnormative position via economic, ethnicized, and gender "failures." Not limited to corporeal delineations typically defining maternity, this queered hysteric offers a maternal construct disengaged from gender-specific notions of motherhood and enables a queered/nonnormative understanding of maternal performance in what Moraga formulates as a race- and sexuality-based borderland or *Frontera*. As a body hemorrhaging meaning, this figure speaks to the external laws controlling it; as a specifically *Chicano/a* figure whose body reveals a contested, nondefinable *Frontera,* s/he emerges as a beacon of dissidence contradicting what Anzaldúa describes as the "masculine order casting its dual shadow." If hysteria is a kind of psychic-corporeal resistance to oppressive ideologies, we might consider it residing not merely in the "female," but

rather feminized/Otherized body. Distinguishing the feminized body as an "occupied," sometimes physical, site of hegemonic rule, we can usefully consider a queer maternal presence whose pathology (hysteria) belies a body speaking, or rather an occupied body refusing to be silenced. Using a contextualized analysis allowed by three distinctive discourses of hysteria, I argue that this subject illuminates a uniquely "mismatched"/queered construct of nurturance, sexuality, and race. Although persecuted by the very oppressions that facilitate the hysteria, this queered maternal hysteric also offers radical, perhaps bodiless, alternatives to existing codes of identity.

In "Nurturing Performance, Raising Questions," I further advance the claim that in performances of motherhood we can locate a sometimes productive negotiation of the fluid, often contradictory narratives of self that are defined, *nurtured*, by binaried notions of race-, gender-, sex-, and class-based subjectivity. I surmise here that these conflicted and conflated constructs comment on the equally conflicting and conflated agendas that preoccupy the cultures for which the texts purportedly speak. In particular, my Conclusion considers the racially informed maternal ideologies that act in congress with *national* subjectivities. In moving past the discussion of essentialized identity as it is mapped onto, deconstructed in, and occasionally (re)deployed from theatrical maternal performance, this final section raises the tangential question of how these performances of a national/maternal self sometimes occur in texts beyond the stage and page.

As this volume resides within and beyond the parameters of theatre and literary scholarship, I nudge the inquiry outside of modern American drama and consider how we might explore culturally coded concepts of being vis-à-vis motherhood beyond the unique potentials afforded by a discipline already preoccupied with "acting out identity." If analysis exceeds the scope of literal enactment, for example, what remains to be discovered with regard to the naturalized paradigms of family, gender, and professional ambition in the politics of labor? How are nation-based maternal constructs embedded in the ways that a historically influenced geopolitical identity is performed? How might advancements in reproduction technologies (and the changing political landscape from which they unavoidably emerge) negotiate broader issues of American feminism, autonomy, and class privilege? In moving beyond summary and review, in other words, this final section probes the opportunities afforded by unpacking the relationship between social hierarchies and maternal performance when we consider broader cultural phenomena.

* * *

The mother-domain of family is often the primary site in which children become socialized; consequently, this usually private sphere of female power

might emerge as a central focus for resistance to oppression. If the dominant ideology's attempts to nullify resistance become directed toward the site of the family, then, as Minna Caulfield points out, the mere "everyday activities of mothers" (in every way that subjectivity can be understood) can in the best case be coded as revolutionary.[31] The final question this book attempts to answer might then be, to what extent can maternal ideologies contrary to or critical of current repressive models succeed as materially productive realities to those subjects under its control? In exploring representations of mothering as those constructs dialectically engage "realities" on the stage and off, the following reveals the various ways that maternity is coded by and conflated with race, sexuality, politics, and working life in ways that become significant to us all. In other words, this book exposes maternal ideologies existing not as remote phenomena, but as contiguous and interdependent to multiple hegemonies. Occasionally, tellingly, these hegemonies rely on specific codes of maternity for their very existence.

CHAPTER 1

NEW WOMAN (RE)PRODUCTION IN RACHEL CROTHERS' ALTERNATIVE MATERNITIES

> It seems to have been reserved for this generation to work out new standards of social justice and develop a new basis for our industrial civilization. Freedom, maternity, education and morality—all the blessed and abiding interests of... home are at issue in this supreme struggle.
> —Margaret Dreier Robins, 1911

IN 1911, THE YEAR THAT SOCIAL REFORMER AND WOMEN'S TRADE UNION League President Margaret Dreier Robins made the above statement, Rachel Crothers was in the most overtly political stage of her multidecade career. Both within and outside the American theatre, the opportunities available to women (and attitudes toward gender reform) during the decades of and preceding Crothers' prodigious work reveal a great deal about her professional accomplishments. As described in my Introduction, I contend that a contextualized, materialist consideration of a play text and its reception is requisite to any analysis of what Ric Knowles describes as the "cultural work" a performance accomplishes. In other words, this chapter interrogates the maternal construct as it is performed, in every sense, on the early twentieth-century American stage, but fundamental to that study is an investigation of the play text alongside a more "politicized analysis of the ways in which specific aspects of theatrical production, and specific contexts of reception, shape the audience's understanding of what they experience in the theatre." [1]

As Sharon Friedman points out, prior to the twentieth century, "Unless a woman had friends or family in the theatre, or connections to secure financial backing, she had little hope of having her play produced."[2] That Rachel Crothers had none of these and still achieved a nearly four-decade run of success, mostly with herself at the creative helm, is a substantial feat. Arguably, Crothers' regular commercial success in the first three decades of the twentieth century and her insistence on creative control throughout would be enough to place her in broader categories of feminist theatre. As a practitioner who placed gender hierarchies as a central issue to be explored in performance, it would also be fair to assess her work as politically progressive. Situating Crothers in a feminist canon is a task not free of complications, however. At the textual level, an ambivalence toward feminism found in most of her plays; her frequent commercial success, occurring even less "radically" on mainstream Broadway stages; and several of her own public comments often seem to dilute the political potency of her oeuvre.

Many of Crothers' more provocative texts, especially those produced early in her career, engage varying incarnations of the New Woman construct. With roots dating back to post-Victorian responses to the restrictive domesticity of the "Angel in the House" and the equally reductive alternative, the Whore and "Fallen Woman," the New Woman figure surfaced in England and later in the United States bent on securing increased personal freedoms.[3] Included in these freedoms were smoking, drinking, and working outside the home—often motivated by personal fulfillment—and enjoying sex in a dangerously masculine way. While conservative voices at the end of the nineteenth century were still trying to counsel against the fundamental evils linked to higher numbers of women seeking professional lives or worse, rejecting their so-called intrinsic maternal-domestic identities, scores of women attempted to place themselves within new social and economic conditions that promised to be a proactive response to previous exclusions. The varying success these women enjoyed, many of them artists and writers, can be seen in the work and lives of Kate Chopin, Charlotte Perkins Gilman, Frances Ellens Watkins Harper, Susan Glaspell, and Angelina Weld Grimké. With so many real-life New Women surfacing in the roles of writer and artist, it's not coincidental that Crothers, herself a writer, offers up two feminist protagonists in *A Man's World* (1915) and *He and She* (1920), New Women who earn their respective incomes as a writer and a sculptor. New Women writers and their treatises (sometimes fictional or dramatic, sometimes not) provide an especially revealing testing ground for an analysis of cultural shifts taking place at and around the turn of the century. As Lois Rudnick writes, "American women's literary production and their impact on public policy were arguably greater during the Progressive Era than at any other time in U.S. history until recent times."[4]

The pattern of divergent voices trying to be heard in what was not one congruous sociopolitical movement is particularly significant when we examine Rachel Crothers, a playwright, actor, director, producer, activist, and "New Woman" who has received and still receives only mixed reviews for her achievements as a feminist. As is typical within many New Woman texts, Crothers' earlier and more political plays focus on issues of motherhood. Along with an exploration of the shifting gender politics that characterized the new century's first three decades, Crothers work frequently digs into the sediment of public/private binaries—the problematic either/or social paradigms still attempting to assign women any "professional status" invested exclusively in domesticity and motherhood. That Crothers' complication of this gender binary often goes so far as to articulate a feminist subjectivity that explicitly touts (as positive) public/professional employment is noteworthy, to be sure. But a less-obvious and worthwhile exploration of maternity itself also functions productively, particularly when these texts and their histories are read against expectations.

Although Crothers often leaves essentialized notions of gender unquestioned, this pattern is not uncommon during the period or even within, specifically, feminist discourse of the period; indeed, the latter often relied on "women's moral superiority" as evidence for more deserved freedoms.[5] Theatre and gender scholars alike have explored the catch-22 dilemma that exists from gained social freedoms for women emerging out of an essentialist rhetoric of moral superiority. In her analysis of Progressive Era dramas, Judith L. Stephens explains that these plays regularly interrogated "issues that grew out of contemporary social movements dedicated to changing women's position in society"; but as "a site of struggle over the meaning of gender" they also "characteristically adhered to the conventional belief in the moral superiority of females while simultaneously addressing issues arising from women's changing position in society." Stephens continues: "The feminist tradition inherited by leaders of the Progressive era was a tradition marked by ties to religion, family, and a sense of moral duty," and it made *strategic* sense that "female reformers of the Progressive Era openly embraced the moral hegemony nineteenth-century ideology bestowed on middle-class women."[6]

Essentialist-based discourses of this time also used and then productively extended public/private binaries. Although essentializing, rhetoric supporting much of the Progressive Era's feminist accomplishments promised a reorganization of the gender-based restrictions regulating work and family life. As a response to the inflexible Victorian public/private binary that placed women literally inside, within her domestic role (and men outside, free to inhabit a professional, public, but often morally suspect subjectivity), the New Woman's insistence on and celebration of a professional identity outside the home usefully addresses (1) increased professional freedoms,

but also (2) complicates pre-existing public/private binaries of domesticity. Stephens makes this association clear:

> Nineteenth-century middle-class ideology constructed an image of Woman as a *morally superior* being especially suited for protecting her (female) domestic sphere from the corruption of society or the (male) work place. Accepting this conventional belief which, on the one hand, relegated women and men to separate spheres but, on the other, gave females special sanctifying powers, women reformers of the Progressive era successfully argued for a logical extension of those powers from the private sphere of the home into the wider public sphere of society.[7]

In other words, Crothers' varying participation in a rhetoric of gender and moral subjectivity that places women's "nature" as essential/inevitable if also superior does not deviate dramatically from the offstage work of active, often influential reformers. Because these very conflations typically orbit (and occasionally deconstruct) performances of maternity, Crothers' work provides an especially rich body of material for the work of this book.[8]

In addition to the admittedly less potent, occasionally essentializing lexicon in which Crothers' plays might participate, however, a paradigm of *non-biological* maternity surfaces in her work that creates radical alternatives to existing models of motherhood (models that rely on essentialized, biological paradigms of gender and maternity). In their interrogation of the New Woman identity and that identity's complicated relationship with the role of the mother, two of Crothers' earlier and most explicitly feminist plays, *He and She* and *A Man's World*, suggest a maternal labor that is neither figuratively nor literally gynocentric and freed from typical conflations of biology and the female body. This chapter, however, does not attempt to provide a conclusive response regarding Crothers' work or its ultimate value to feminism. Rather, in looking closely at Crothers' professional life and the commentary it provides to an investigation into what Elaine Showalter describes as "the ways in which the self-awareness of the woman writer has translated itself into a literary form in a specific place and time span,"[9] this chapter examines how that "awareness" (within the plays themselves, and the discourse surrounding them) has developed and where it might lead in our understanding of gender, performance, and maternal constructs on and off the American stage.

Here I argue that in her exploration of the turn-of-the-century New Woman, two of Crothers' most "political" plays invoke that identity in ways that productively reimagine the paradigms of motherhood. Because this redefinition at times bypasses gynocentric-biological understandings of maternity, the spectator/reader is offered a rubric of gender and reproduction whereby "feminism" and "motherhood" are not necessarily mutually exclusive concepts. Although this reimagining offers positive alternatives vis-à-vis

the nonbiological framework in which the mother role is placed (endowing maternal status/representing the performance of motherhood to subjects *not* responsible for the biological reproduction of their dependents), Crothers occasionally relies on essentialized gender constructs in the process. In keeping with the materialist semiotics of performance outlined earlier, I further suggest that any final analysis is incomplete without also considering the contextual realities of the playwright, the productions, and the sociopolitical moment from which they emerged. In addition to a brief outline of the American New Woman identity and my analysis of the playtexts themselves, I explore the historical context of both American feminism and American theatre from which Rachel Crothers emerged.

With regard to *A Man's World*, I also investigate what if any relationship transpires between what Jill Bergman posits as the strategic use of "the discourse of evolution and progress" and the New Woman activists who invoked (if not relied) such rhetoric.[10] As critics and historians such as Bergman, Angelique Richardson, Martha Patterson, and Anna Stubblefield point out, within the politically active culture of women's clubs and activists that *defines* the New Woman, there also exists a eugenics-inspired directive that disputes the value of desegregation and undeniably "participat[es] in a widespread national discourse that linked American progress and white supremacy."[11] If, as Stubblefield writes, "the eugenics movement thrived in the United States during the first three decades of the twentieth century,"[12] and (as biologist Charles Davenport reported in 1904), many American scientists "now recognize[d] that characters are inherited as units,"[13] how did the race- and class-based rhetoric of essentialized identity and evolution coexist with a political agendas bent on endowing women with more reproductive agency? I explore how *A Man's World* and New Woman texts like it disclose sites of maternal agency as they negotiate the radical social changes occurring at the turn of the century; I pay particular attention to how these negotiations function in collusion with what Bergman terms an "American dominance and imperialism on a world stage."[14] How, in other words, does this rhetorical positioning take place "against the broader national context [arguing] implicitly [for] the classifications of 'civilization' and 'barbarism' in order to define a specifically white identity for the New Woman"?[15] As an icon of progress and feminism, what relationship does the New Woman—and her drama—maintain with essentializing narratives of identity that are based explicitly in class and race?[16]

NEW FEMINISMS, NEW WOMEN

First emerging in the United States in 1894 when it appeared in a published debate on the pages of the *North American Review*, the term "New Woman"

connoted everything from vulgar and physically unappealing challengers to traditional gender roles and family sanctity to more positive images of independent, educated devotees of progressive social reforms such as sexual freedom and suffrage.[17] In the United States, the broader historical context for the New Woman is most closely associated with the suffrage movement in and around the 1890s. Martha Patterson notes, while the popular press and everyday discourse tossed the term around more and more frequently as an indictment rather than an accolade, "Its capaciousness allowed a diverse range of writers to deploy it strategically, playing on its ability to evoke a host of cultural anxieties and modern desires." Indeed, the profuse and variable nature of the term's potential meanings during the first fifteen years of the twentieth century allowed many of her more visible champions, as well as detractors, to draft her more broadly than the "settlement worker" or "suffragette"; "New Woman" could signify everything from "position[s] on evolutionary advancement, progressive reform, ethnic assimilation, sexual mores, socioeconomic development, consumer culture, racial 'uplift,' and imperialist conquest."[18]

Diverse reactions to the growing impetus toward progressive change in gender ideologies increasingly altered the sociopolitical landscape, eventually winning women the vote in 1919. The inconsistent reception of feminist agendas by women who *identified* as progressive or feminist, however, reveals telling blind spots within individual platforms. More than just one group's rejection of another's case for "free love," or one faction finding fault with class oppression, or, alternatively, racial inequality being considered anything short of enemy number one, this diversity of platforms exposes the interdependent nature of multiple oppressors and the variable responses they garnered. For example, what Rudnick describes as "first generation" New Women—individuals such as Jane Addams an Charlotte Perkins Gilman—understood new roles and freedoms for women as contingent upon higher numbers of women in professional fields, consumer and juvenile protections, industrial health, and general civic welfare (including day care, branch libraries, and public baths).[19] Another group, what Rudnick characterizes as "second generation" New Women, took great issue with existing paradigms of (hetero)sexuality; these women, for example, Mabel Dodge and Neith Boyce, understood sexual freedom as central to "a world in which both women and men could have love and meaningful work while helping to shape a more humane social and economic system."[20] While this latter group "embedded their critique of gender hierarchy in a critique of the social system," still another, albeit smaller, group argued that the overthrow of racial oppression was key to women's general emancipation.[21] While divergent voices may have disagreed on what was *most* obstructive to women's social, political, sexual, and economic emancipation,[22] their presence

reveals a battle fought with occasional moments of triumph, including the nineteenth amendment, easier access to (legal and non) birth control, and increased numbers of women pursuing higher education.[23] Although the Great War and later the Depression temporarily derailed feminist agendas—as momentum toward patriotism and then survival usurped attention from progressive social reforms—the fifteen odd years of the new century witnessed very public (if conflicting) discussions regarding the role of and rewards forecasted by the New Woman. Amid these discussions, the role of the mother and the contradictory articulations of maternal subjectivity within larger reform projects reveal telling anxieties about where the New Woman might reside in a public/private dichotomy.

As the new century promised, the potential for amplified freedoms for women, feminists, and reformers increasingly organized their efforts. In addition to the more radical and sometimes louder voices for change within Greenwich Village, women's clubs appeared with more frequency and in larger numbers than ever before.[24] Particularly among white, middle-class women, membership in clubs espousing "progressive" changes to women's roles in the public and private sectors continued to rise, reaching an all-time high in the early 1920s as approximately 2 million clubwomen organized along class, religious, racial, and political lines.[25] With visual depictions provided largely by Charles Dana Gibson and his "Gibson Girl" character, and authorial representations provided by writers such as Margaret Murray Washington, Pauline Hopkins, Edith Wharton, and Winnifred Harper Cooley, the New Woman appeared in word and image promising (or threatening) sociopolitical change, often through her provocative roles as consumer, harbinger of modern technology, instigator of evolutionary and economic development, and, finally, "icon of successful assimilation into dominant Anglo American culture."[26]

Among the bourgeois hostilities and anxieties surrounding the New Woman, vices that were *not* associated with sexuality were usually absent from the list of concerns.[27] An increased focus on sexual activity and sexual topics was common. This amplified attention on the New Woman's sex life regularly manifested in a tendentious commentary on maternal behavior. To be sure, changing trends in the (depiction of the) makeup of family structure can be identified as fodder for both the malignment or approbation of the New Woman. By 1900, for example, the rate of divorce had risen to 1 out of 12 married couples, and the national birth rate fell to 3.5 children per mother.[28] The trend for New Woman characters of this period and the majority of the women authors creating them is childlessness, a trend that makes Crothers' deployment of nonbiological maternity especially noteworthy. Despite the frequent accusation of childlessness, however, writers preoccupied with this construct almost universally place *maternal status* as central

to the "vision of the New Woman," even when their female protagonists are childless.[29] And in this sense, *A Man's World*'s Frank is no exception.

Chief among the only occasionally logic-based concerns surrounding the New Woman and her (non)involvement with motherhood was the belief, to some degree validated by official data, that a woman's level of education negatively correlated with her number of offspring. Far from the materialist historicist arguments we later understand in the work of Foucault and others, evolutionary theorist Herbert Spencer reasoned in 1898 that a "deficiency of reproductive power" among women attaining higher education could be "reasonably attributed to the overtaxing of their brains."[30] Providing a contrast to the "True Woman"—a subject defined by maternal devotion and selflessness—some writers such as novelist Ellen Glasgow offered the "self-assured dynamics of the childless New Woman." Further, when a New Woman protagonist does have children, she is often defined in some way by the subjugation she endures in her role as homemaker, as is the case with *He and She*'s Ann Herford. While this oppression and a sympathetically coded pathos are typically conflated with "the exigency for providing for her children," dire circumstances also become for the mother "a source of motivation toward economic and emotional independence."[31] In other words, motherhood for the New Woman functions as a device that, to *some* degree, motivates, facilitates, or at a minimum, underscores the importance of her political agency.

Amid the ambivalence (if not contradictions) found in the New Woman construct, one of the more consistent attributes is her interest and presence in the paid workforce. This also is not surprising given the real-world reality taking place at the same time. And as with *A Man's World*'s New Woman protagonist Frank, this interest in the work force often finds specific focus in *issues concerning working women*. By 1900 approximately 5 million women worked in a variety of mostly low-paying fields, principally in the areas of textile manufacturing, sales, clerical labor, domestic service, primary education, nursing, and agriculture.[32] Thus the predominance of financially comfortable New Woman characters offered repeatedly by Crothers does mirror the rising numbers of working women in control of their own incomes; at the same time, however, Crothers' less radical depictions do *not* reflect the trends in actual wage brackets. Thanks to a remarkably consistent stream of success, the financial privilege enjoyed by Crothers' New Woman protagonists was also experienced by the playwright who created them.

New Woman Playwright

To make a case for Rachel Crothers as the poster-woman of American feminist drama would be difficult. Dating back to her initial success at the turn of the century, she typically received mixed responses from feminist

critics, although she also garnered her share of overtly positive reactions. Perennial successes as a playwright in a persistently male-dominated field, often aided by her work as director and producer, are achievements hard to overlook. That much of her success was achieved by productions that only *sometimes* interrogated gender ideologies in overtly critical tones has resulted in the mixed reactions she receives from feminist critics then and now. To both second-wave writers intent on the recovery of forgotten women artists and more recent scholars focused on deconstructive methodologies or materialist-oriented theses, Crothers' plays are sometimes read as less significant or worse, problematic. Cynthia Sutherland's 1978 examination of Crothers and (the peer to whom she is most commonly compared) Susan Glaspell and Sharon Friedman's 1984 consideration of Crothers, Glaspell, and Lillian Hellman are among the few endeavors to consider Crothers' work in relation to broader feminist issues. And while Lois Gottlieb's and Colette and James Lindroth's sourcebooks of Crothers' career are impressive in their scope, neither text considers the playwright's work in terms of, for example, contemporary theoretical feminist issues and psychoanalysis, Marxism, or identity politics.

As I argue in subsequent chapters, a broader understanding of the historical and political contexts surrounding the play text and its performance is crucial to any analysis of the playwright or her/his work. The relationship between the New Woman identity and the state of American drama Rachel Crothers encountered is a telling one. Historically, a positive correlation exists between the rise and fall of organized American feminism at the turn of the century and the rise and fall of the New Woman in American drama.[33] This relationship becomes important when we look at the rise and decline of feminism within Crothers' plays. While some point to the broad, decade-long intervals in Crothers' career as a pattern marked by a decreasing feminist presence, we can also find larger historical realities, both onstage and off, influencing her work's political tone. Friedman contends, "[Feminist] themes clearly evolved during the years of suffrage activity...and against the background of World War I, the entry of women into the work force, [and] the disintegration of traditional roles"; the "disillusionment" with feminism that many see in Crothers' later plays, however, actually "reflects a larger decline of feminist activity." Furthermore, any perceived "feminist decline," a retreat not unique to Crothers' work, could also be explained as something more than simple political backsliding. As Friedman points out, this "'disillusionment' may actually represent responses to a new set of conflicts that were facilitated by feminist gains (for example, career opportunity, economic independence, sexual freedom)."[34] In other words, what some critics label political kowtowing might instead be a (new) negotiation of liabilities and conflicts arising from recently won freedoms.

A good deal of ambivalence surrounding Crothers' feminist achievements (or even hesitancy to laud her as a playwright of substance) arguably stems from her almost habitual commercial success, the majority of which occurred in mainstream Broadway runs. From her first one-act in 1899, Crothers could boast an average of nearly one produced play a year. With the most of these production appearing in large houses, and still many of those (even during the low ticket sales of the Depression) breaking even or better, a certain critical cachet potentially escapes a playwright who might otherwise emerge as politically progressive.[35] The political climate of Crothers' early work is also significant when we consider her reluctance to engage more experimental or avant-garde forms. These less commercial, often less realist-based forms were more aligned with leftist politics and often embraced by her more critically respected peers out of Provincetown. For example, although Judith Barlow includes Crothers in her 2000 anthology, describing her as "the most successful American woman playwright in the early part of [the twentieth century]," she also notes what she sees as a "justified" dismissal of Crothers "as a writer of conventional comedy and problem plays," performance texts that are "rarely technically innovative" and disappointing in the playwright's "approach to her subject matter."[36] That is to say, Crothers' reputation as a commercial, always realist-based playwright potentially diminishes her status as a "radical," feminist, or otherwise.

Among the politically themed theatre during the century's first two decades, the Provincetown Players were not alone. Amid the early impetus of the Little Theatre movement, in Greenwich Village Henrietta Rodman's Little Theatre and the Washington Square Players, not to mention the endeavors outside of New York such as Chicago's Little Theatre and Boston's Toy Theatre, had been performing since 1912. Moreover, Crothers' chronological proximity to the more confrontational, often more class-savvy feminism of playwrights such as Susan Glaspell, Zona Gale, and Zoe Akins might make her agenda (and its achievements) seem less effectual.[37] And while American Feminism/feminist theatre predating Crothers was based primarily on issues surrounding suffrage and race-based policy issues, as Cynthia Sutherland points out, the "mostly 'abolitionist' women who had originated the battle for suffrage in the 1840s and 1850s were either dead or retired" by the time of Crothers' arrival.[38]

It bears mention that among the more overt or "unapologetic" feminist writers and texts, several of Crothers' contemporaries also frequently faced pressures to include conciliatory overtones. In other words, before discounting Crothers' achievements (or even failures) as politically accommodating, we need to qualify her more "respected" feminist peers' excursions into "lighter fare" as well as their similarly enjoyed commercial successes. For example, after the success of her novel of the same title, Gale's *Miss Lulu Bett* opened

at the Belmont Theatre in 1920 and earned not just the Pulitzer, but also significant commercial success.[39] Yet as the playwright and feminist who had previously supported the Woman's Peace Party, the Woman's Peace Union, Jane Addams, and the Hull-House workers (and who would soon after help write the Wisconsin Equal Rights Law), Gale allowed public opinion (and its inability to accept more explicit articulations of feminist resistance) to manifest a change in her play's final act. Acceding to the expectations of her less-than-radical audience, Gale revised her original Ibsenesque ending, which saw Lulu walk "out of the house in which she has been a virtual servant to become an independent woman," and created a nonthreatening final act in which "Lulu [is] comfortably established as a respectable wife."[40] The offstage conciliations surrounding a playwright and public figure as politically active as Gale—an artist who weakened her text's political punch to avoid offending conservative spectators—can also be seen in fictitious worlds onstage. For example, several women-authored productions of the period interrogate the more muted political rhetoric of a spinster or "old maid" character whose single status conveniently bypasses any threats of gender role conflicts.[41] In that respect, Mary Herford in *He and She* and Francis "Frank" Ware in *A Man's World*, both a far cry from spinsterhood, deserve attention at minimum for their inquiry into gender and maternal ideologies while also remaining involved in romantic dyads with their respective leading men.

Of the (off stage) feminists and activists who worked during the years of Crothers' early success, many women, among them Jane Addams and Carrie Chapman Catt, also maintained a more palatable, if not downright, placatory tone in their rhetoric, keeping their feminism couched in domesticity, motherhood, and the power and moral obligations of a "feminized conscience"; among the more well-known, less radical feminist voices such as Addams and Chapman Catt, anything more controversial assumed a secondary role.[42] Sutherland explains, the "conciliatory" strategy espoused by feminist leaders such as Adams and Chapman Catt often "disregarded the arguments of radical feminists who insisted that only basic alterations in the organization of the family and sexual relationships could effect substantive changes in women's lives."[43] Of the more radical feminist voices, Emma Goldman's was one of the loudest. While Goldman's more explicit petitions for a major reorganization (if not eradication) of monogamous, patriarchal family structure and an overthrow of capitalism was not enthusiastically affirmed in the mainstream "feminist" productions of Akins and Crothers, it was also typically absent in the more "progressive," less commercial titles produced by Glaspell and the Provincetown Players. In other words, the ambiguity of Crothers' achievements in arguing a doctrine-specific "feminist platform" in her work needs to be taken with a grain of political salt. Although her frequent failure to specifically incorporate issues of class or to offer real alternatives to existing

models of domesticity might be criticized as contrary to more "respected" feminist agendas of her time, her only varyingly conciliatory feminism is heard alongside several equally accommodating peers.[44]

Other critics fault Crothers for repeatedly offering up comedies (especially later in her career) or for peppering her "discussion plays" with lighter fare. Some of her more respected feminist peers were also no stranger to satire and comedy, however. In the summer of 1915 the Provincetown Players presented Susan Glaspell's *Suppressed Desires* at the Wharf Theatre, a satire featuring a woman protagonist who almost destroys her own marriage as she experiments with psychoanalytic theories using her sister and brother-in-law as test subjects. A few years later at the Playwright's Theatre Glaspell continued to satirize feminist issues in her comedies *Close the Book* (1917) and *Woman's Honor* (1918).[45] For her part, Crothers advanced a broader (almost genial) understanding of what was suitable subject matter for the feminist playwright and the comic artist. In 1914 she told the *New York City Sun*:

> Why on earth shouldn't the same person write a comedy satire on advanced feminism and a serious play which is based on the plea for a [questioning of a] double standard... Surely the most militant feminist can't fail to see that if some of her radical ideas were at once adopted and acted upon they'd be very funny and would produce chaotic results.[46]

Whether or not "chaotic" or even humorous results followed, Crothers' comedies and her plays with comic moments did offer palpably controversial subject matter. In a *New York Times* review of the 1920 production, Alexander Wollcott lamented that *"He and She* seems peopled less with folks than with embodied points of view, and the play seems [like] a symposium."[47] The staged "symposium" about which Wollcott laments considered in no uncertain terms what comprises a profeminist marriage and further, how the feminist artist can, through her creative labor, stage a feminist event that advances a progressive agenda.

To be sure, feminist critics of performance and theatre have long faced the question of what actually constitutes a "feminist event." Charlotte Canning's description in her discussion of the overtly political groups of the 1960s and 1970s, groups such as 1973's New York Feminist Theater, are typical of second-wave understandings: "[NYFT] worked as consciousness raising, crammed into a few hours"; founder Lucy Winer believed that to do its job well NYFT's audiences would go "back to their lives with a kind of anger and energy-saying they will try to change their lives." As was the case with most American feminist theatre of the second wave, "the point of performance" was clear: the "shared political cause" of changing women's lives."[48] Might we assess any similarity in the goals of the overtly, if often essentializing,

liberal feminism of this period to earlier, pre- nineteenth-amendment, turn-of-the-century works such as Crothers? Said another way, could a Rachel Crothers' discussion play facilitate "a kind of anger" or garner momentum toward a "shared political cause" among it spectators that would eventually manifest social change? As did so many of her feminist contemporaries, Crothers chronicled and interrogated topics such as the double standard regarding women's sexuality, the private and public obstacles to women's professional ambition and accomplishments, changing understandings of motherhood and divorce. But from the playwright's very own description, characterizing Crothers as an overt political force for women (based on the play texts alone, certainly) is a complicated enterprise.

In 1931, after nearly three decades of commercial success on Broadway—and perhaps not coincidentally, after three decades of productions with increasingly weak political motifs[49]—Crothers describes her work as "a sort of Comédie Humaine de la Femme."[50] Far from what we might label today as a more nuanced or complex materialist feminism or even an essentialist-bent second wave, Crothers' universalizing feminism conjures often contradicting, if not politically waning, ideologies. In 1916 she tells the *New York City Sun*'s Henry Albert Phillips: "I [do not] go out stalking the footsteps of women's progress. It is something that comes to me subconsciously. I may say that I sense the trend even before I have hearsay or direct knowledge of it."[51] According to the playwright herself then, Crothers work aims in general to comment on universal/universalizing issues rather than the gender-specific ones. When issues central to women are addressed, it is "subconsciously" and, perhaps, "unintentionally." Nevertheless, with a multidecade body of work that invariably interrogates women's lives—even if those explorations only *sometimes* worked from a more progressive lens—both Crothers' performance texts and her place in what was a male-dominated universe of mainstream theatre is noteworthy, to say the least.

FEMINISM AND THE NEW WOMAN *OFF* STAGE

While self-conscious, often organized resistance to male-dominated institutions such as mainstream theatre was an increasing reality by the late 1960s and 1970s, Crothers' usually successful productions predate this trend by more than half a century.[52] In her discussion of feminist cultural politics and the relevance of textual "alternatives," Canning maintains, "While a dramatic work could be strategically envisioned as a feminist text, *the circumstances surrounding the theatrical production of the dramatic* text could work to undermine or diffuse those feminist meanings."[53] Canning's broader discussion focuses on the theatre of second-wave feminism, but her contention is telling with regard to Crothers' early career and subsequent successes.

Rosaline Brunt and Caroline Rowan contend that a "major form of feminist cultural politics is the construction of alternatives [which] involve not only changes in the cultural 'product,' like books, films, and theatre, but more importantly in the establishment of different ways of working."[54] Before determining if Crothers establishes a "different way of working" from the patterns created by her usually male predecessors, consider the landscape of a still developing American theatre, to the degree such a thing existed, during her emergence in New York.

In her study of Crothers, Lois Gottlieb explores how the idea of an "American theatre" and whatever that tradition might connote was in its infancy in 1896,[55] the year that Rachel Crothers arrived in New York at age eighteen and shortly thereafter began staging her one-acts with the Stanhope-Wheatcroft School.[56] Continuing her trend of directing her own work, Crothers' resolve to supervise the staging of her plays meant that nearly every level of decision making required her approval. This insistence on creative control (not the least of which included frequent stabs at producing, set design, and even acting in a play's lead role), occurring at a time in American theatre when the genre itself was still in its infancy, demonstrates an early awareness of the crucial part a marginalized subject's voice plays in telling that same subject's story. It is tempting to reason that Crothers' "alternative" way of working could be explained by the increasing control she was allowed because of her commercial successes. It is important to remember, however, that Crothers began assuming directorial control, power that she never relinquished, at the earliest points in her career, long before her work was considered professional or successful. In other words, while some critics might lean toward minimizing the "revolutionary" flavor of Crothers' ability to redefine "feminist ways of working" (since a positive box office would make otherwise uncomfortable changes easier to slip under the radar), these changes occurred from the start and when the playwright had no professional or commercial reputation to back up her demands. Further, her invariable insistence on creative control as director and producer is one that is not echoed in her more canonical feminist colleagues such as Glaspell, Treadwell, and Hellman. Indeed, this level of professional autonomy would have been impressive even for a *male* playwright. Engle explains: "Most of the considerable number of women and men who grew rich from writing for Progressive Era theatre did so by playing a subservient role within the production process, tailoring dramatic work to fit star performers or making changes to appease theatre managers, who in turn sought to satisfy the paying public."[57]

In her discussion of second-wave endeavors to reorganize patriarchally arranged institutions, Canning writes: "The valorization of counter institutions, indeed, of a counter-culture, opened new opportunities for feminists because both dramatics texts and theatrical event had to be transformed."[58]

Here Canning is describing the malleable counterculture of the 1970s. But this growing tolerance, if not outright enthusiasm, for a cultural "transformation" at the level of both text and event is *not* present at the time Crothers is carving her path into creative control. Although the Provincetown Players would have been offering a more limited degree of countercultural "credibility" elsewhere, the world of mainstream New York theatre, Crothers' world, was less tolerant to the reorganization of the male-dominated patterns of production that Crothers achieved. Thus although a Rachel Crothers play would not ever signify the "communal" flavor of resistance to gendered (and often other) oppressions that marked the undertakings of second-wave endeavors such as the New York Feminist Theater or San Francisco's Lilith Theater, the politically motivated "consciousness raising" stipulated within the second wave fairly describes Crothers' earlier plays in their ability to provoke political discussion, if not consciousness, among new ways of working.[59]

From the turn of the century to the 1930s, the three decades Crothers' experienced the most consistent success, many of her contemporaries—playwrights identified as more "peripheral," "political," or "avant-garde"—were being produced geographically and ideologically elsewhere. Crothers' initial competition for political cachet emerged by way of Glaspell and the Provincetown Players; as the Depression worsened and the 1920s and 1930s saw more productions from politically explicit groups such as the Group Theater and the Theater Guild, Crothers seemed a less radical alternative. Her plays frequently dramatized the highs and lows of upper-middle-class socialites and continued to ignore class-specific issues facing the nation.[60] Among her later plays, predominantly those staged during the more dire years of the Depression, most did not fall within the same socially and politically overt tenor of the Theater Guild, the Theater Union, or the Group Theater. Malcolm Goldstein notes, during the Depression "the casual mention of the scarcity of money was...a part of most plays," and further, this was the case "no matter what economic class an author or producer intended to reach."[61] As the leading woman playwright of the 1920s and early 1930s, Crothers was unique in mostly ignoring these references in her commercially successful comedies.[62] A hesitancy to include topics such as economic survival alongside peers who did so regularly certainly plays a part in the varying dismissals within political assessment of her work.

The unique state of a still burgeoning American theatre and its practices also affords insight: in the first fifteen odd years of the new millennium, the role of theatrical directors and the responsibilities included in stage direction in American theatre were in transition. Cheryl Black writes:

> At the turn of the century, directorial functions (script interpretation, casting, staging) were typically assumed by leading actors, producers, or even

playwrights who performed those duties in combination with other major responsibilities. The term "director" was rarely employed; "producer" generally served to mean anyone who assumed producing or direction responsibilities.[63]

Among theatre critics, particular contributions made by directors or specific directorial functions were rarely praised or even acknowledged. It was not until the 1920s that American theatre recognized "the importance of the stage director and [an] increased reliance on the specialist."[64] On the one hand, then, Crothers' achievement as "woman director" might be tempered by the fact that the playwright-director role was one that was sometimes merely assumed because "director" per se was not yet a viable profession. Nevertheless, since her insistence on directorship—on creative control in all areas—initially transpired when (1) she had no commercial clout to support her demands; and (2) a recognized post of "director" did not yet exist for her to request or point to as example, these early accomplishments seem groundbreaking.

As a presumably unintentional but compelling example of the critical circumvention that often occurs within discussions of Crothers alongside her more politically "credible" contemporaries from Provincetown, Black describes the latter's forward-thinking practices for stage direction and women, but does not include Crothers, the most successful woman director of her time, in the account of feminists and American innovators:

> In their early recognition of the director as specialists, the Provincetown Players once more placed themselves in the forefront of modern theatre practice... It is hardly surprising that a company offering so many plays by and about women should also offer unusual opportunities to women directors.[65]

Although Black briefly mentions Crothers earlier (tellingly lumping her in with George M. Cohan and David Belasco), she is mentioned along with her two male colleagues merely to evince the practice of commercially successful producers of the era who also assumed directorial roles. The fact that Crothers' identity as a successful *woman* is not highlighted or even footnoted by Black – not to mention that she is mentioned alongside two male peers, Cohan and Belasco – is a revealing if typical example of the critical eluding that occurs in discussions of Crothers as a feminist pioneer of American theatre.

Perhaps because Crothers, like Cohan and Belasco, is associated with mainstream commercial success as much as she is "guilty" of consistently realist-based form, the radicalism ascribed to her contemporaries rarely describes her own work. Complicating if not contradicting any negative

criticism toward Crothers and her penchant for realism, we might also consider that while avant-garde experimentation was taking place in Provincetown and elsewhere, major strains of New York theatre were also very much tied to an Ibsenesque realism, not to mention the innumerable productions still "heavily indebted to the nineteenth-century legacies of domestic melodrama and historical romance, written in the diction and rhythms of pseudo-Shakespearean blank verse and acted in a highly stylized manner."[66]

And as Black herself notes, in a study charting patterns among women directors throughout the twentieth century, taking into account chronological patterns of women working as (1) actress/director; (2) the playwright/director; and eventually (3) the specialist (director), the actress/directors (Minnie Maddern Fiske, Mary Shaw, Olga Nethersole) began directing in productions they also starred in around the turn of the century; "the woman director as specialist," however, "was a rarity until the 1930s."[67] If we look to the production histories laid out by Gottlieb and Lindroth, by 1901 Crothers was already directing her self-penned productions with the Stanhope-Wheatcroft school and then professionally directing, with her four-act social problem drama *Myself Bettina*, by 1908—two decades before women directors (as specialists) surfaced with any regularity.[68] From 1900 to approximately 1915, women directed less than 5 percent of the plays on Broadway.[69] With so few women peers to look to as professional examples or for support, and further, equally few stand-alone professional "directors" to validate still novel professional goals or demands, Crothers' place as an early, regularly successful women American director is considerable.

Crothers' four decades of creative production also nod to a woman-centered "creation" pattern that lends itself to "birth." As an offstage personification of the New Woman she frequently created onstage, Rachel Crothers the woman engages metaphorical associations with "conceived" ideas, gestation, and eventual delivery of one's progeny/creation. Indeed, this New Woman artist-as-mother whose "offspring" manifests in the art object is fictionalized with *He and She*'s protagonist. (But as with so many of her protagonists, Crothers' own position as New Woman artist-as-mother is also based in a certain class privilege.) When juxtaposed against the True Woman motherhood that directly preceded it, this more fluid New Woman artist-creator-mother circumvents essentialist alternatives: the working artist mother whose created sculpture signifies offspring; the childless, politically reforming maternal figure whose "dependents" include individuals benefitting from her activism; and even (childless) Crothers herself, whose plays might be read as "textual progeny."

This liberatory construct of reproduction, qualified in neither biology or even, necessarily, gender, was not an option for all women. In addition to

a class privilege required for the pursuit of an avocation that, particularly in the arts, might not ever be financially viable, sociopolitical costs were involved for real-world artists-as-mother. Brenda R. Weber notes: "For professional women, motherhood was often not an option sought or desired, and their very resistance to 'maternal instinct' unsexed them. The sort of semiotic power afforded to women through the trope of the mother was, consequently, not equally available to all women."[70] Those who did engage this trope, writers like Crothers emerged as a threat in that they exacerbated anxieties over what Weber describes as the increasing "cultural ambiguity": "The increasing number of women who claimed identities as professional (and public) authors at century's end, combined with the double-coding of the New Woman herself, increased the sense of potential threat."[71] Yet the results were not always negative, particularly for those artists who enjoyed success. Weber posits that by century's end, the "Text-as child-trope" often worked to "discursively reorganize governing ideologies," and the result for these professional women writers and their "progeny" was that "the cultural mandate that good women be good mothers underwent multiple displacements and relocations" and, occasionally, those same writers enjoyed greater agency as a consequence.[72]

Finally, beyond the theatrical and political contexts that inform assessment of Crothers-as-feminist, her public/professional identity outside theatre also informs the meaning of her work. In addition to the twenty-three full-length plays, a completed screenplay, and numerous one-acts between 1899 and 1937, Crothers' achievements also include offstage but very public accomplishments. She responded to shortages and hardships resulting from the Great War by organizing and leading the Stage Women's War Relief in 1917,[73] and later did the same with the Stage Relief Fund in 1932, the latter one of only a handful of charitable organizations aimed at helping actors find food and housing during the Depression (this was three years before any real relief came in the form of the Federal Theater Project.[74] As the Depression neared its end, her efforts at organized relief did not; in 1940, she founded and led (while still writing) the American Theater Wing Allied Relief Fund, an organization aimed at relief for soldiers and their families, assistance to refugees, and the staging of war bond drives.[75] And as a critical presence in American letters, she authored numerous articles and interviews. (She also occasionally performed as lead actor in her own productions, for example, performing the role of Ann when *He and She* moved to Broadway in 1920.[76]

Regardless of such accomplishments, however, Crothers' status as a feminist functions, certainly, according to the political discourses and identity constructs employed in the plays themselves. While issues of class and race rarely (if ever) enter Crothers' broader contentions of progressive maternity,

her suggestion of a reproductive rubric divorced from biology proposes a worthwhile alternative for the feminist spectator.

THE NEW WOMAN ON STAGE: *HE AND SHE* AND *A MAN'S WORLD*

The three-act drama *He and She* was originally staged as *The Herfords* in 1911 in Albany and in Boston a year later under the same title.[77] By 1917, the play was given the title *He and She* and toured briefly, only to be revived in 1919. By 1920, in a revival at the Little Theatre, the play finally met with some commercial success and only mixed critical reception, with Crothers playing the lead role of Ann. *He and She* appeared in a Broadway season still very much affected by the Great War. While many productions at the time featured blatantly political themes and patriotically inspired plot lines, both on and off the main thoroughfare of Broadway, New York theatre also had a number of escapist productions that, though sometimes political in nature, left issues of foreign policy and patriotism off the stage and out of the plot. Among these productions, dramas like Crothers', often referred to as "discussion plays," gave audiences more than escapist musicals or salon comedies; instead, these plays featured relevant, topical themes that were central to popular social issues or cultural conflicts with which the audiences would be familiar. As was the case with *He and She*, women's changing role in private versus public spheres was chief among these concerns.

While the play and its subject matter—relationship difficulties experienced by an upper-middle-class married couple who both work as sculptors—might initially seem odd in its avoidance of more topically political material, *He and She* was nevertheless described by Crothers, her critics, and its contemporary audiences as a discussion play: a genre with the potential/ambition of presenting controversial, sometimes politically based issues within an environment of mostly serious drama. Interrogating women's changing sex roles, the consideration of marriage as an option rather than requirement for women, and the promise for women to find satisfaction in a professional life in addition to or instead of motherhood makes *He and She* a strong example of what one critic describes as "a new style of mediation used by playwrights who continued to dramatize aspects of the 'woman problem.'"[78]

Represented in dramatic realism, the play engages an implied insistence on/avowal of truth. To be sure, "the goal of verisimilitude" and "desire to get closer to fact" was a prevailing theme in much of the American drama of the time, and as Friedman points out, women playwrights were quick to present issues central to the "facts" of their own lives.[79] Regarding this enthusiasm for "verisimilitude" on the stage, Crothers was no exception. As the protagonist of *A Man's World,* Frank Ware is an obvious example of this commitment to

"truth" in both character name and her actions throughout the play. And many of the personal-biographical undercurrents in *He and She* also point toward an affinity for "factual" staged representations. For example, the dignified sixty-five-year-old physician, Ann Herford's father Dr. Remington is, like Crothers' own, a family practitioner who garners significant respect from the community; he also shares a described "portliness"[80] with Crothers' real-life father. Much more than her autobiographical insertion of the patriarchal Dr. Remington, however, Crothers' own unresolved feelings toward her professional, often physically absent, progressive-minded mother inform the play's plot. Dr. Marie Depew Crothers, a General Practitioner who worked and earned her MD in Pennsylvania and Chicago while her daughter Rachel resided in the small town of Bloomington, Illinois, emerges throughout *He and She* in sometimes unflattering ways.[81] Crothers' documented ambiguous feelings toward her own mother's frequent absence can be seen in Ann's and daughter Millicent's strained relationship—a strain that ultimately surfaces as the play's major conflict when Ann must choose between her own professional satisfaction or Millicent's psychological welfare.

The first act of *He and She* opens with a less-than-subtle introduction of the play's topic of changing gender roles when sculptor, husband, and father Tom Herford discusses with his conservative assistant Keith McKenzie both the progress of his latest piece and his purportedly supportive attitudes toward his wife's own work. Conveniently, McKenzie is also engaged to Ann Herford's best friend, the professionally ambitious Ruth Creel; *unlike* her fiancé Keith, Ruth seems convinced that a loving and healthy marriage and her own professional success are not mutually exclusive. Complicating matters are the Herford's sixteen-year-old daughter Millicent, who is home from boarding school for most of the play, and Tom Herford's unmarried sister Daisy, a lonely twenty-something who lives with and works for Tom as a secretary.

In a politically overt subplot, Ruth and Keith try unsuccessfully to deal with the conflict over her insistence on pursuing her emotionally rewarding career versus his persistent assertion that once married, her "profession" becomes that of wife. Adding to the crisis over whether or not the future McKenzies will ever make it to the altar, Tom's sister Daisy—a character coded as traditional, if not overtly submissive, pines for the misogynist McKenzie from a distance. Unfortunately for Daisy, the only person who sees her true feelings, not to mention the compatibility they promise as a couple, is Ann's father Dr. Remington, a patriarch coded as wise and all-knowing amid the chaos and confusion faced by the rest of the characters.

Against the dramatic foil of the Keith-Ruth-Daisy triangle and the issues of domesticity and women's professional ambitions that that triangle interrogates, Tom and Ann must deal with their increasingly troubled teenager

Millicent as well as the increasingly obvious fact that Tom's own sculpture is inferior to Ann's. In fact, Ann's piece is suggested as the family's only chance to win a lucrative and career-making award. Not accidentally, the two family conflicts have everything to do with each other: while Tom and Ann juggle fluctuating gender ideologies and try to determine if it really does *not* matter whose sculpture is best (and who brings home the prize money), it is also suggested that Ann's maternal absence, an absence that exists because of the time and devotion allotted to her profession, facilitates Millicent's emotional crises.

By the play's conclusion, the feminist spectator is left with no easy answers, given the overt suggestions of Ann's genius, Tom's open-mindedness, and the calamitous future that awaits Millicent if she lives without her mother's full-time attention. (In his role as Millicent's father, Tom's own absence as a hard working sculptor is never addressed as a possible reason for his daughter's troubles.) All three family members are coded as meaning well and seem trapped in a predetermined, limiting filial structure; their well-meaningness, however, does not enable any final reconciliation. The text's refusal to provide any revolutionary final ending is not unique to Crothers, however. Mediating rather than solving social and ideological conflicts—conflicts that were fashioned in and by these "discussion plays"—was often a hallmark of the genre. Sutherland explains: "Dramatic discourse tended to mediate conflicting views of women's 'legitimate' place in society more often than it intensified dispute."[82] We might even afford Crothers credit here for her refusal to provide easy answers by the play's conclusion. Specifically, beyond Crothers' rejection of an easy final conclusion, the play offers a resistant and alternative maternal paradigm in its suggestion of "production" and "reproduction" outside the female body. By creating "life," endowing a subject with vitality and presence (to an entity that exists away from and outside of her body), Ann performs a maternal function. Because the creation of that "offspring" takes place via the mother subject's mind, imagination, and perhaps her eyes and hands, a strictly gynocentric model of reproduction is bypassed.

Nevertheless, a cursory glance of the play and its critical reception suggests a less-than-convincing argument for categorizing *He and She* as profeminist. Indeed, the play is an especially telling example of the mixed and inconsistent response Crothers' work as a whole garners from feminist critics. In her analysis of *He and She* Gottlieb argues that an almost antifeminist "idealization of motherhood, and its dominant place in woman's identity are, finally, the most powerful arguments in the play"—arguments, she contends, that are "unassailable weapons" in an "antifeminist arsenal." Yet other critics (Gottlieb also among them) also suggest that *He and She* can exist as an (albeit antiquated) feminist text, largely because of the play's

argument of "woman as unique and crucial mechanism of child-rearing," one that deserves particular credit and respect in its own right as labor.[83] This articulation of maternity-as-paramount ultimately emerges as a double-edged sword of (potentially essentialist) subjectivity. Not unlike the play's front matter, which in the character descriptions lists Tom Herford as "a sculptor" and Ann Herford only as "his wife," couching an otherwise forward-thinking and behaving woman character's role as either domestic success or failure undercuts her radical potential. While questioning Ann's dedication to and participation in her professional life is a positive in and of itself, the fact that the discussion occurs within the broader context of good-versus-bad mothering, a context that is absent in the play's examination of gender roles for Tom and Keith, unavoidably diminishes some of the progressive work Crothers' "discussion play" performs.

For the New Woman, the problematic positioning of mothering within private/public landscapes was a paramount concern; the ambivalent maternity in *He and She* does not provide any facile replies to the complicated questions surrounding women's roles in and outside the family. Ann and Ruth productively refute earlier antifeminist characterizations of an emotionally based, domestically centered "talented woman" figure; yet the suggestion in the play's conclusion of Ann's "ultimate duty" (one invested in the caretaking of a troubled adolescent daughter) insinuates a less forgiving paradigm of gender and maternity. As an artist, wife, friend, professional, daughter, and mother, the latter is presented as the most important in Ann's identity. And while Ruth's eventual separation from Keith and his strongly implied connection with Daisy is debatably positive in the unspoken suggestion that a character such as Ruth ultimately *cannot* have both a rewarding career and a healthy marriage also leaves questions as to the play's feminist work. More than its ambiguous/debatable feminist conclusions, however, *He and She*'s suggestion of motherhood as a nonbiological enterprise and its relocation of reproduction outside the body generate politically useful, indeed feminist alternatives.

Crothers takes reproduction out of the womb; for this sculptor, gestation, creation, and nurturing occur in the creative mind and often even outside corporeality. As an artist relying on creative prowess and talent, as the "creator" of her piece, Ann produces shape and form and eventually, as she herself describes, "life" in her creation, a sculpture that not coincidentally represents the human form. *He and She* (as well as *A Man's World*) is not alone in featuring the artist front and center of the New Woman construct. Sutherland notes that several plays of this period feature articulate, likable female artist characters incarnating the dilemma of "people torn by the conflicting demands of sex role and career."[84] Not unlike Crothers herself, the New Woman as creative and creating subject achieves more than just the

suggestion of a professional existence for women outside domestic boundaries. The artist—as opposed to the nurse, the teacher, or the secretary—creates life from a location in which life did not previously exist. And while within his role as medical doctor Dr. Remington might be construed as generating life where it did not exist beforehand, he does not create a "living" form from nothingness. In line with most Western belief systems, the doctor, who *facilitates* the animation of the life form, is a bystander to the mother subject who biologically, perhaps alongside the work of a spiritual Creator, (re)produces life. This unique ability to "create," an agency invested in (re)production, becomes transferred from the mother to the feminist artist throughout the play.

As opposed to Ruth's profession—the corporate side of publishing, a position in which she does not create anything in its own right, but acts merely as liaison to other writers/artists who do—Ann's job entails taking lifeless matter and, by virtue of her hands, mind, imagination, and talent, generating what is often referred to as "living energy" from her work. Described by Crothers' as "intensely feminine," Ann's maternally coded character is also described as having a "strong vibrating personality which radiates warmth and vitality." Dressed in her "artist's working smock" with "sleeves rolled up," the "intensely feminine" Ann is immediately understood as a conflation of (1) reductive femininity and a (2) "vital"/"warm" earth mother artist-creator.[85]

In Ann's brutally honest but never mean-spirited critique of her husband's work in the play's first scene, audiences discover what is most important in a sculpture, and what is missing in Tom's. Sections of the huge piece the latter is working on, a piece featuring horses in motion, need to be more "life-like"; the spectator, Ann suggests, needs to "*feel* the running."[86] Further evidence of the sculpture-as-life-form trope, a few lines later Tom provides rationale for his piece's limitations to Ann, a response suggesting birth: "Well-it's the best that's in me." (13).[87] Invoking a metaphor that will be repeated throughout the play, Tom emphasizes the "internal" status of his creativity, and its corresponding potential to be released and delivered outside of the self. Continuing this metaphor within the same conversation, Ann replies that, not unlike what happens in biological childbirth, Tom's sculpture should aim for a "feeling of" what might be understood as a "rushing," something that is "too big, too free to be held in and confined."[88] Although the early and brief instances endowing Tom's work with reproductive phenomena are telling, the play makes its strongest suggestion of artist-as-mother-creator in the language and imagery describing Ann's more successful piece. As "the very best thing [she has] ever done"[89]—language that itself echoes sentiments of a proud mother boasting her child's worth—Ann's superior (to Tom's) creation is "alive" and "new."[90]

Crothers also depicts Ann's creative work as more organically, "naturally" executed than Tom's. For example, Tom requires (1) copious secretarial assistance from his sister Daisy (to, among other things, requisition marble, solicit and respond to mail, complete entry forms), and (2) requires Keith's and Ann's moral support, almost constantly; Ann, on the other hand, performs her creative labor offstage, alone, and without any help from outsiders. Her creation is the result of her "labor" alone. In the first act the spectator actually sees Ann's much-discussed, literal creation; unlike Tom's huge model that features horses in mid-gallop, Ann's nude woman is about "a foot high" and is presented not standing on its own only to be dramatically undraped, but carried in by Ann's cradling arms. Similar in size and presentation to a newborn, Ann tells the crowd of family and friends in the basement studio that she couldn't "come out until [she] finished her lady"; included in the others' anthropomorphizing remarks, Dr. Remington states, "She looks a little chilly to me," and Tom observes, "She looks pretty." If we did not recognize the sculpture as offspring before that, in the same scene and a moment later, Ann turns to Millicent and presents her daughter to Dr. Remington (mimicking the same gesture in which she presented her sculpture moments before), boasting "Look at her—Dad. Hasn't she grown?"[91] Later in the play Ann will passionately explain that men just can't "realize how deeply and fiercely creative women love their work,"[92] again using language that, if admittedly essentialist, also conflates sculpting with mother-child sentimentality along the lines of "one just has to be a mother to really get it." Equating her daughter Millicent and her sculpture as two examples of produced offspring, Ann's remarks highlight (perhaps reductively) both the maternal and reproductive basis nature of her own character's worth. But at the same time, she is also pointing to the *optional* nature of biology in the act of reproduction. Indeed, by the play's conclusion, Ann is forced to choose between her two "children," as, sadly for the feminist spectator, both options are presented as not simultaneously viable.

During a fight with his wife, Tom's apparently erroneous contention that women can't "change the laws of creation"[93] also unintentionally invokes imagery of the home rather than the womb as a site of reproduction. The home is indeed a place of gestation for Ann's creation; in the bowels of the domestic site (the basement studio), Ann privately, intimately gives form to what she will, by the play's conclusion, "give" to her husband. Ann urges her husband to accept her sculpture, the "ultimate gift" a wife might bestow: "It's grown and grown night and day... I want you to take it... It's there—something vital and *alive*... And I offer it to you, dear—if you want it."[94] While the sculpture's creation, gestation, and public delivery occur in the basement, Ann's "offering" performs a vertical assent and resides finally upstairs and outside the home, far away from the hidden, cavernous (womb-like)

studio space that witnessed its initial stages. Although the home-based trajectory of the "offspring" is from bottom to top and reverses the imagined descent of gynecological birth, the basement existing as the dark and hollow site of conception/gestation/growth—not to mention Ann's "painful" vertically aligned delivery—alludes to a biological birth process, but one removed from the literal maternal body.

Along with *He and She,* 1915's *A Man's World* is arguably Crothers' most provocative and forward-thinking gender treatise staged during the more politicized "first stage" of her career was.[95] Recently, Keith Newlin described *A Man's World* as a successful "critqu[e of] male expectations of women, morality, and marriage while offering a still trenchant exposé of the double standard."[96] In 1936, Arthur Hobson Quinn described it as "one of the most significant dramas of [its] decade."[97] Writing in 1936, the "decade" Quinn references occurred twenty years earlier. This lapse in time between the production and Quinn's remarks underscores one of the more persistent themes of the play. The conflicts experienced by the play's protagonist are defined in many ways by fissures in time: the time in which she lives versus the "times" she strongly desires to influence and inhabit. With a name suggesting her androgyny as well as her moral attributes, Frank Ware is significant for, among other reasons, her romantic status as a New Woman protagonist. Frank avoids the spinster tag many of her staged contemporaries carry, but also evades the tidy ending that would position Frank and her lover reconciled in romantic, not to mention political, harmony. In addition to enjoying a thriving and emotionally rewarding career as a writer and social reformer, Frank is an unapologetically (although perhaps not overtly sexual) romantically active single woman. Unlike some of her New Woman peers, then, Frank proposes a model of unmarried feminist subjectivity that is not relegated to loneliness or spinsterhood, but one that *also* does not traverse into the taboo sexuality of the Fallen Woman. Contrary to the example provided by Ann Herford, Frank bypasses the matrimonial option. But she also, perhaps more importantly, does not retreat into compromised domesticity *after* the discussion play's "climax" presents the New Woman's political either/or dilemma. (*He and She*'s Ann does not escape this more conservative resolution.) Of course, while Crothers' presentation of unmarried feminine sexuality is not *bypassed* vis-à-vis Frank's tryst with her leading man, it is also a more tempered, perhaps "safer" version than those provided by the Fallen Woman of the same period.

With early exposition the audience learns that long before the play's action begins, Frank has led (and continues to lead) a life dedicated to fighting on behalf of and ministering to women of lower economic classes who have fallen on hard times. (This specific target of her benevolence is significant in the broader context of New Woman motherhood and the escalating

eugenics movement, which I address later.) Living in what is essentially an artist's boarding house in Greenwich Village, Frank acts as a kind of housemother to more than just her seven-year-old adopted son Kiddie; she also consistently proffers advice and comfort to the house's artist residents and their plethora of emotional and professional crises.

The major conflict of the play places reproduction and women's sexuality as the central theme, in particular in its exploration of the double standards regarding premarital sex, reproductive responsibility, and the "mystery" of Kiddie's biological parentage. While many in the house believe, falsely, that Frank is secretly Kiddie's biological mother, they also believe, accurately, that Frank's love interest, Malcolm Gaskell, fathered the precocious seven-year-old who bears a striking resemblance to the cad Gaskell. Significant to my argument here, while Frank is not Kiddie's biological mother, she knew and played nurse mother to the woman who eventually gave birth to him during Frank's tenure of aid work to London prostitutes and unwed mothers.

The play's brief final two acts present the most lucid examples of what is arguably Crothers' gender-related "message" in this discussion play: after revealing his hypocrisy by way of his relief in learning Frank did *not* conceive Kiddie out of wedlock (a growing suspicion shared by Gaskell and most of Frank's housemates), and upon Frank's discovery that Gaskell is indeed Kiddie's (still indifferent) biological father, the two split up with Gaskell departing relatively unpunished (except for his loss of Frank), and Frank (who initiates their final and permanent break up) maintaining the higher moral ground. The play's ending—which successfully avoids the more typical facile reconciliations of similar productions—is telling insofar as Frank voluntarily and independently selects a nonromantic, morally superior option. Critics such as Stephens note that "Frank's decision to reject Malcolm Gaskell was seen as a daring reversal of the usual pattern in which 'erring men easily won forgiveness from their mates.'"[98] Of course, as a white, financially secure New Woman character, Frank is also represented as wealthy enough to explore this option. As with the majority of women protagonists in Crothers' canon, issues of class and economic hardship for women engaged in political confrontation is bypassed with the device of an upper-middle-class protagonist who never experiences financial obstacles. Beyond a potential whitewashing of class- or ethnically based conflicts that would otherwise emerge for a more socially marginalized New Woman, however, this assumed privilege also potentially nods to a latent reliance on a eugenics discourse within Progressive Era platforms.

In 1865 when Charles Darwin's cousin and British naturalist Francis Galton first popularized the term "eugenics," he argued that intelligence and other "human mental qualities" could be cultivated similar to processes

employed by breeders of animals.[99] The social privilege enjoyed by the New Woman (on- and offstage) typically kept her reproduction patterns safe from eugenics' purview. By the late 1800s, the concept of encouraging reproduction of middle-class "pure whites" alongside the restriction of reproduction of (typically poor) "tainted whites" gained traction among those nervous about nonwhite immigration patterns and an increase in "degeneracy," the latter typically associated with "tainted whites" and the poor.[100] In the United States, social reformers, women's advocates, and feminist writers such as Margaret Sanger and Charlotte Perkins Gilman were varyingly conspicuous sources of (pro)eugenics discourse; in England, New Woman writers such as Sarah Grand and George Egerton posited corrective reproductive patterns to combat perceived social pathologies that threatened national and moral objectives.[101] For the typically middle-class New Woman working toward purportedly progressive reproductive agendas, class and ethnic identity and its relationship to "worthy breedability" made disturbing bedfellows—and occurred with some frequency.[102] Exploring the rhetorical assembly of the New Woman and social Darwinism, Richardson points out that as the nineteenth century came to an end, and in particular in England, eugenics discourse focused on the urban poor. In cities such as London (Kiddie's birthplace and the location that Frank initially meets his sexually unacceptable birth mother—a woman who would have been targeted by the policies Richardson outlines), this emphasis on class and untoward breeding patterns even superseded concerns over race. The concluding years of the century, in other words, the time period of Kiddie's biological conception and birth, witnessed New Woman and social reformer positions that were concerned with labor, health, and national efficiency issues, but also colored by what Richardson calls a "eugenic subtext."[103]

In a 1910 review of *A Man's World*, the *Nation* concluded that Crothers should be praised for "facing the consequences of the premises without hesitation or faltering";[104] the "premises" that generate the "consequences" include abolition of the sexual double standard, holding men equally responsible for unwanted pregnancy, and I argue here, the less-obvious contention of (a productive notion of) nonbiological maternity. With the exception of the last, these "premises" that Crothers interrogates fall under the rubric of New Woman concerns. As a woman who, not unlike Ann Herford, initially "refuses to accept the injustice of the traditional [double] standard," a standard that concerns "the unfairness" of two separate codes of morality for men and women,[105] Frank does not in the end choose a romanticized notion of domesticity. Instead, she opts for a single life, but one that, crucially, includes a performance of motherhood to her "adopted" son—not to mention the myriad "needy" bohemians who share her Greenwich Village rooming house. Also, like her New Woman counterpart in *He and She*,

Frank performs a maternity organized outside the human body, often associated with her work.

The most obvious of the nongynocentric articulations of motherhood, Frank's unofficial adoption of Kiddie constitutes a literal mother-son dyad that circumvents a sanguilineal bond. With his birth mother dead and a certain future of doom promised in an East End orphanage, Kiddie's future is markedly brighter as a result of Frank's decision to mother someone not biologically her own.[106] The "poor little nameless fellow" becomes what Frank describes as "the greatest comfort in the world,"[107] and situates her the text's newly imagined New Woman matriarch.

Even in terms of spatial organization, the composition of Frank's rooming house rearticulates concepts of "family" that offer a new, less-than-traditional understanding of domesticity; while more typical realist dramas of the Progressive Era theatre (including Gale's *Miss Lulu Bett*) would be set primarily if not exclusively in the male-dominated living space—the drawing room of the home, which is owned by the family patriarch—*A Man's World* occupies the *communal* drawing room of the Bohemian rooming house and occasionally, other tenants' apartments within the same building.[108] Admittedly, Crothers again automatically assumes a level of material comfort on the part of her protagonist, a financial security less than realistic for many single women living in New York City at the turn of the century.[109] Nevertheless, the nearly utopian tone of Frank and Kiddie's mother-son relationship valorizes a maternity not based on biological ties, but rather socially constructed mother-dependent relations; by the play's conclusion, with a resolution that sees Gaskell gone and a Frank/Kiddie/rooming house filial structure touted as superior, Frank and Kiddie's nonbiological connection is unequivocally celebrated. Their bond is suggested as the affiliation surpassing Frank's other emotional connections, including what she shared with Gaskell or rooming house tenants who assume dependent status to her care.

While the Frank-Kiddie dyad is the most obvious, Frank also performs a nurturing domesticity vis-à-vis the unofficial "bohemian orphans" inhabiting her rooming house. Among them, shy, spinster Clara Oakes will more fully realize her potential and approach a more self-actualized existence and professional acumen courtesy of Frank's fostering; the jealous actress Leonie Brune will lose some of her unattractive and covetous personality traits under Frank's *invariably* patient and nonjudgmental direction (even after a number of Leonie's jibes and machinations are directed at Frank specifically); and the love-struck, bumbling musician Fritz Bahn, another struggling artist, who we are meant to understand has amorous feelings toward Frank, meets with gentle, nearly maternal guidance in Frank's platonic, often motherly support—support that is occasionally delivered in a saccharine tone of maternal wisdom.

In Patricia Schroeder's discussion of Frank as signifying a specifically *patriarchal* alternative, she also mentions that in many ways, Frank models the act of motherhood as "her career."[110] Schroeder's comment invoking *both* a patriarchal subjectivity as well as a maternal identity seems no accident. With Frank, Crothers complicates—rather than merely reverses—a public/private binary organized according to gender. While a good deal of Frank's nurturing takes place within the walls of the boarding house, much also transpires in the province of public/professional labor; this is crucial for the fluidity it assigns the either/or division of "labor" that characterized the True Woman paradigm that she rallies against. Similar to Ann Herford, Frank performs a professional subjectivity that places her "work" firmly in the public domain, even if some of it is unpaid. Unlike her True Woman predecessor, the New Woman publicly occupies a world not restricted to/by home and hearth. As Brenda R. Weber notes, a late nineteenth-century "rigid polarization between female and male presumed that biology ordered social arrangements," and further, this "deterministic logic" was made explicit "in particular, through the cult of motherhood." In Weber's expansion of Bram Dijkstra's study of end-of-century gender culture, she continues:

> The mother, already a figure of some mythic proportion, became the critical signifier of sex/gender appropriateness, a sign that read as domestic, nurturing, and other-oriented. These markings were critical, for at century's end... the Victorian male establishment had become 'obsessed' with women's degeneration, which it attributed to excessive stimulation, both sexual and intellectual. The corrective was clear: "Only complete absorption in the practice of motherhood was considered a fit activity for women."[111]

Although Weber is specifically referencing England, her description of a "cultural ambiguity" hovering over the New Woman also fits the United States, particularly given the New Woman's mobility between the two countries:

> The professional woman (also associated with the New Woman) operated as a double-coded signifier that underscored this [cultural] ambiguity: she symbolized an image of sexual freedom and assertions of female independence, promising a bright democratic future; but at the same time she threatened an apocalyptic warning of the dangers of sexual degeneracy, the abandonment of motherhood, and consequent risk to the racial future of England.[112]

Because her public/professional ambitions and achievements are more typically coded as masculine, New Woman subjectivity exceeds True Woman domesticity in ways that affect a gendered workplace as much as the home. Beyond this public/private reorganization, however, Crothers' New Woman successfully reconfigures maternal and professional subjectivity.

For example, Frank's nurturance of Kiddie and the various Bohemian housemates can also be understood as a repeat performance of her care of and concern for the London prostitutes and unwed mothers she looked after while compiling her treatise on women's rights—a (telling) topic and a population that assumes a large part of Frank's professional life and care. Early exposition also reveals that Frank's writing is geared toward increasing assistance and compassion to this particular population. Although not in her physical custody, the women targeted by (and presumably benefiting from) Frank's anonymously penned (and thus altruistically motivated) treatise—a text that coincidentally even her forward-thinking cotenants believe is beyond the caliber of what a woman might write—might be regarded as "dependents" to Frank's protective auspices. In other words, as Kiddie's unofficial but functioning mother and as de facto rooming house "mother hen," Frank extends her guardianship and concern to imagined wards who might read and/or benefit from labor not invested in domesticity. Even within the section of life most likely to be void of maternal overtones for a feminist protagonist – the New Woman's professional, public self—Frank's existence is coded with a philanthropic, custodial nurturance.

But Frank's charges are struggling-to-indigent alongside what audiences understand as her own relative economic freedom, investing Crothers' New Woman mother with class privilege that makes her altruism easier to perform. This qualifying factor of class-based privilege contextualizing Frank's sociopolitical benevolence also harkens to eugenics discourses that themselves are invested in class hierarchies—essentialist arguments that relied on the so-called science of eugenics to garner increased freedoms for women.[113] For early twentieth-century New York audiences, Frank as progressive New Woman and activist no doubt emerges as a free-thinking Bohemian whose politics veer left. Kiddie's birth mother and the other women receiving Frank's attentions complicates this image. We might ask, then, what if any connection exists between Frank's class-enabled philanthropy and a eugenics-informed judgment/desire to oversee reproduction of women like Kiddie's (poor) mother?[114] Bender notes, for example, that "1913 was the year of the baby" and like the countless baby contests captivating America in the century's first two decades, social reformers and women activists were also motivated from a position of "improving the future of the race" vis-à-vis their focus on "the gospel of safe milk, scientific upbringing, and moral living to the *urban...working class.*"[115] Among the "host of reformers at the end of the nineteenth century and the first two decades of the twentieth century who sought to apply the logic of philanthropy to the questions of heredity," women activists typically focused on social "degenerates"; chief among the latter were "the tramp and pauper" – sometimes considered "beyond hope and their extinction encouraged."[116] Nevertheless, Crothers presents

a feminist landscape in which Frank's patronage is extended to sometimes politically marginalized dependents who are *not* her genetic offspring; her maternity is not organized according to binaried, biological reproduction schema, as she offers ministrations to recipients relegated as outsiders by dominant culture.

But with London prostitutes and unwed mothers comprising the majority of Frank's previous beneficiaries, a revealing detail emerges alongside another major component in some New Woman platforms: the eugenics movement and its involvement in purportedly progressive agendas regarding women's reproduction. Unlike *He and She*, *A Man's World* engages this dilemma regarding public interventions into women's reproduction (and certain kind of women at that) specifically by way of Frank's former vocation and targets of her philanthropy in London. When Frank is not custodial den mother to Clara, Fritz, or even Leonie, she is preoccupied with women like Kiddie's biological mother—a poor creature, we learn from Frank, who was likely "one of the hundreds" in urban London[117] whose out-of-wedlock status placed her outside the parameters of acceptability. While Crothers never mentions the eugenics movement explicitly, the play alludes to the poor and/or unwed mothers rousing (and chief among the subjects targeted by) a public policy that, according to its proponents, functioned as a positive social control aimed at improving the physical and mental aptitudes of future generations.[118] The race- and class-based implications for otherwise progressive political projects that invoking eugenics rhetoric (including feminist) are compelling. Stubblefield explains that the unambiguous "aim of the eugenics movement in the United States during the first half of the twentieth century was to prevent the degeneration of the white race."[119] In the first three decades of the century, a eugenics-supported logic articulating whites as "civilization builders" also posited nonwhites as "races [who] supposedly lacked the ability to produce civilization." This paradigm eventually morphs into a white/nonwhite binary whereby nonwhites assume the broader soubriquet of "tainted whites" (the latter including Eastern Europeans, Mediterraneans, Irish, the poor, the sexually promiscuous, and, of course, prostitutes).[120] It is not difficult to locate a woman like Kiddie's birth mother, mired by poverty and unacceptable sexual behavior, among the dregs of "tainted whiteness."[121]

Galton initially argued the interdependent relationship shared by the social fabric of society, evolution, and selective reproduction in a two-part article appearing in *Macmillan's Magazine* in 1865.[122] Galton's eugenics argued that "the new duty which is supposed to be exercised...is an endeavor to further evolution, especially that of the human race."[123] The employment of "duty" seems no accident, given the term's connotations with a *maternal* responsibility that peppers the broader discourse. Requisite

to furthering evolution, to an ambiguous "furthering of the race," was the curbed reproduction of society's undesirables as well as the encouraged reproduction of their social opposites. What emerges in discourses of eugenics, then, is a public, potentially state-regulated intervention into women's reproductive habits and rights directly, the role of mothering and its social construct indirectly.

When in the play's first act Frank argues with fellow-writer Gaskell about the latter's reductive portrayal of his latest female protagonist, specifically "the poverty and the wrongs of the woman," she harkens as well to the reductive representations of the women targeted by her own political and professional work—women like Kiddie's biological mother. During the play's final, passionate debate between Frank and Gaskell, we learn, however, in a very antieugenics tone, that Frank will indeed "throw [Gaskell] over," not merely because he impregnated and deserted Kiddie's mother, and also not simply because of his continued dereliction of fatherly duties toward his seven-year-old son. Frank, the spectator discovers with presumed admiration, can never accept Gaskell because of his sexist, classist dismissal of women like Kiddie's biological mother, his former lover:

> *Gaskell*: It's the biggest thing. We've found each other. Look at me. You know it's the one perfect thing on earth-a perfect love and we've found it.
> *Frank*: It never could be perfect while you believe what you do.[124]

Reading this exchange with a lens focused on eugenics objectives, Frank contests more than the double standard for premarital sex, although that is undoubtedly a major part of what she alludes to regarding Gaskell's "beliefs." Frank also seems to challenge ideologies that bespeak Gaskell's facile disgust and disposal of the poor girl who "suffer[ed] the tortures of hell."[125] Nodding to a distaste toward the sexuality/reproduction of social undesirables, Gaskell's position represents a growing sentiment among middle-class white Americans preoccupied with what Bergman describes as "the use of domestic ideology in the 'civilizing' project of Americanness."[126] In her confrontation (indeed, contestation) of Gaskell's contempt for women like Kiddie's birth mother and their value/cost to society, Frank approaches another kind of progressive maternity. In her passionate condemnation of Gaskell's "beliefs"—his presumed revulsion toward/dismissal of women like Kiddie's birth mother—a triumphantly coded Frank might also signify a positively coded antipathy toward eugenics.

Frank's maternal attention to Kiddie's birthmother is complicated, however. The latter's character would come as no surprise to turn-of-the-century audiences: a typical arc of a Fallen Woman narrative was outlined by seduction, prostitution, and then suicide. That the woman giving birth to Kiddie

starts out as Frank's philanthropic ward and ends up deceased can be read as more than the plot device facilitating Kiddie's adoption. Pamela Fletcher explains that in casting the prostitute or harlot as a "victim of individual temptation and moral failure" rather than a subject who struggles in earnest toward economic survival, the "seduction-outcast-suicide narrative both sustained the ideal of bourgeois femininity by imaging the consequences of its lapse as fatal, and controlled the anxieties raised by the prostitute as a figure of *social chaos and disease*."[127] With so many fallen women of this period represented as working class or poor, a eugenics-friendly strategy functions seamlessly with an ideology that "contains vice within the lower classes" while also reminding women that sexual purity ensures social position.[128] In this way the care Frank offer's Kiddie's birthmother becomes even more relevant. While her destitution echoes conventional patterns of the poverty-stricken Fallen Woman, it also invests the New Woman's identity with "the rescue"—both social and financial—of the former. Thus part of what constitutes Frank as a New Woman mother figure is her nurturance of, indeed, her comothering with a *fin de siècle* Fallen Woman, one that also provides momentum to eugenics platforms. Frank's own maternal agency emerges in large part from the "motherwork" she performs with and for Kiddie's birthmother and other women like those who "Gaskell ruined,"[129] and her disenfranchised status ascribes a progressive tenor to Frank's character and agenda. At the same time, though, and perhaps tempering this narrative of presumed maternal political achievement, Frank's empowerment seems to *rely* on it.

With regard to progressive feminists and antifeminists alike, "There was common ground between medical authorities...and many of [their] feminist opponents. Both camps were prepared to turn to biology as the key to—and panacea for—social issues, as the sex debates that heralded the dawn of the New Woman unfurled."[130] A conflation of women's emancipation, material and biological enterprises undergone (or not) by the female body, and even issues of "national efficiency" were commonplace, and this relationship frequently traveled into the vicinity of eugenics-based logic. This refusal of biology, then, positions Frank's (and Ann's) nonbiological maternity in a unique, arguably progressive category (even if the latter's dramatic action surreptitiously nods to a eugenics-informed hierarchy vis-à-vis Kiddie's birth mother).

Furthermore, Frank's almost melodramatic moral superiority to Gaskell's dastardly past and unrepentant attitude also nods to a model of essentializing sexual difference ubiquitous to the purportedly progressive discourses surrounding the New Woman. As Richardson notes, the "social purity" movement that provided steam to earlier progressive rhetoric (rhetoric that attempted to endow women with agency in matters of reproduction) eventually became "transformed by the very idea it had sought to transform, having set out to challenge the sexual double standard, and oppose the justification

of social and sexual inequality through biological means."[131] Even this relied, in part, on eugenics-friendly rational. Richardson explains: "It now began to endorse fundamental sexual difference, feeding off of discourses of degeneration, and biologizing male sexuality as brutish if left unchecked."[132] This essentializing architecture that in problematic ways buttressed progressive agendas also involved caveats that relied on negative portrayals of poor, "tainted white," immigrant, or sexually promiscuous women—women like Kiddie's birth mother.[133] As Richardson surmises, this gender-specific movement for "social purity developed along increasingly eugenic lines."[134] And turn-of-the-century antifeminist rhetoric was also clear in its explanation (and motivation) surrounding *decreasing* women's enfranchisement, alluding to motherhood as the core reason to exist: "The *raison d'être* of a woman is her maternity. For this and this alone nature has differentiated her from man, and built her up cell by cell and organ by organ."[135] Both feminist and antifeminist agree, by her very "nature" motherhood—even New Woman motherhood—held the future of the country, the race, perhaps even civilization in her reproductive choices.

* * *

By invoking reproductive paradigms independent of biological procreation, Crothers' New Woman maternity qualitatively resists more typical reductive models based solely in the female body. In their performance of a nonbiological motherhood, one that is only sometimes invested in essentialized gender constructs such as moral superiority or emotional prowess, Frank Ware and Ann Herford, as professionals and mothers in varying forms, suggest a new organization of family and gender altogether.

Beyond any achievements of the performance texts themselves, however, Crothers' production strategies and their context also shape the meaning of her work and what it does/not accomplish. While feminists and (sometimes more critically respected) peers of her era are regularly described as among "the most distinguished" of woman dramatists and political figures, it also bears mention that avant-garde offerings like those produced by the Provincetown Players reached fewer audiences overall than those reached by Crothers.[136] As the playwright of the first half of the century who wrote the largest number of plays for the conventional theatre, plays in which the role of women was the major theme, Crothers' decades of work reached more spectators and perhaps induced more discussion than that of many of her more "radical" peers.

In *He and She*'s first scene, throughout a detailed process of exposition meant to tell spectators exactly who in the play is sexually and socially progressive and to what degree, Keith asks Tom: "Have you ever been sorry that Mrs. Herford is a sculptor-instead of just your wife?"[137] More important

than Tom's answer is the early, prominent position of the question. Right away Keith articulates an either-or binary of domestic wife/mother versus nondomestic professional and creative agent. Invoking a maternal and gender construct that exposes the ambivalence and contradictions within this reductive binary, Crothers' earlier, more obviously political work offers nonbiological, positive alternatives. In *He and She*'s concluding moments, when Tom urgently tells his wife, "I'm not going to let you sacrifice yourself," she replies with the subtext-laden "It's my job. She is what I've given to life. If I fail her now-my whole life's a failure."[138] Because of the scene's context, there is no doubt that the referent of "she" is adolescent Millicent, *not* the award-winning nude form Ann gave "life" to in her basement. The optimistic spectator might see the dramatic device of Tom's eventual submission of Ann's sculpture as his own as a gender-neutral opportunity to complete the birthing process of Ann's artistic offspring. A more pessimistic, perhaps more realistic, appreciation suggests a binaried construct of family and gender in which professional and personal fulfillment are mutually exclusive options for a working mother, even a New Woman mother like Ann Herford.

Rachel Crothers holds a unique position in the history of American theatre, not to mention the specific annals of women playwrights. No other American woman dramatist garners such a diverse, sometimes disputed, critical response from scholars who see her as (at worst) a commercially successful political capitulator to (at best) a feminist maverick who authentically lived the life of professional and political freedom her plays espoused. Looking particularly at Crothers' early, more politically overt, work provides valuable insight into the sometimes chimerical nature of the mother construct at the turn of the century. In the first two decades of the "new millennium," American culture and the feminists who inhabited it were negotiating suffragists' demands for the vote; social reformers' insistence on increased rights for women based on "intrinsic" essentialized moral superiority; radicals' espousals of free love and a complete overthrow of patriarchal understandings of family; and Marxist feminists' suggestions of class and gender oppression as interdependent, inseparable evils (with race-based oppression included only occasionally). Interrogating the varied discourses that surrounded Crothers' work at this point in American history—a moment that recognized motherhood as a still contested role, to be sure—tenders a revealing snapshot into the sociopolitical pressures at work in how American culture defined maternity and gender. In exploring the texts along with the material contexts of criticism and performance, we can identify a suggestion of maternity that, in bypassing essential biological understandings of gender and procreation, evokes a productive construct of motherhood and maternal labor, one that nods to nurturance, reproduction, and feminism as (occasionally) compatible objectives.

CHAPTER 2

ETHNIC ANXIETIES, POSTWAR ANGST, AND MATERNAL BODIES IN PHILIP KAN GOTANDA'S *THE WASH*

> The word "assimilation" has two meanings—interbreeding and comprehension of political and social conditions. In the latter sense, the young Japanese are more readily assimilated than [immigrants of] European races; in the former, fortunately, scarcely at all, for a certain pride of ancestry makes Japanese, as a whole, averse to mixed marriages.
> —David Starr Jordan, Statement to the Congressional Committee on Immigration, March 1924

WHEN FOUNDING STANFORD UNIVERSITY PRESIDENT AND AMERICAN Breeders Association member David Starr Jordan made the above statements to the US Senate in March 1924, he alluded to two significant, potentially conflicting trajectories inherent to the phenomenon of assimilation.[1] The more positive trajectory involves the minimization of conflict-generating differences; more negative (and typical) outcomes manifest as the erasure and/or discrediting of minority cultures and identities, as well as the consequent shame experienced by those whose culture is censured. These erasures can and historically do underwrite nationalist-oriented policies and military actions that often function alongside hierarchies based in race.[2] Jordan's comments allude to another crucial aspect of assimilation discourses, both pro and con, an aspect that is particularly relevant to performances of maternity. Notions of "interbreeding," to use his term—or miscegenation, reproduction between individuals of different ethnicities—are often in

congress with discourses of assimilation, whether touted as positive or negative. The potential power/danger to recast the ethnicity of future generations places the role of the mother in a precarious political position. As Eiichiro Azuma and others have pointed out, for populations who have experienced direct threats to cultural and literal survival, the (reproductive) activities of mere individuals can indeed represent whether or not one's people and culture endure. Azuma writes: "Like white Americans, Japanese immigrants stressed the value of child rearing and the need to protect the chastity of their daughters from 'inferior' races,'" but after the trauma of interment, "they also linked these conditions to the survival of their race in the United States."[3] Locating objectives such as the "survival of [the] race" in the landscape of the domestic, then, places the roles of (latently "breeding") mothers and daughters in the foreground of a high stakes sociopolitical stage.

In the broadest sense, this chapter explores how the constructed subjectivity of motherhood in Gotanda's *The Wash* (1987) supports and resists the dialectic of cultural forces and everyday practices as they find residency in the interdependent oppression of race, gender, and class. Considering Gotanda's interrogations into normalized paradigms of patriarchal Japanese American filiation, I examine the ways in which the play conflates and complicates particular gender and race constructs that themselves are invested in a personal-political quicksand of (1) assimilationist-fed shame versus (2) monoracial/panethnic pride. From an already marked Asian American[4] subjectivity, this push-pull of ethnically informed anxieties is uniquely experienced by a Nisei generation who saw its very existence threatened by a "homeland" they desired to identify with, but that existed instead as threat.[5]

When Gotanda told interviewer Robert Ito that his "parents' camp experience continues to inform [his] work and life both on a conscious and on an unconscious level," he added that in his work he aims to productively "exploi[t] themes of its psychic scar [and] the subsequent internalized racism being passed on from generation to generation."[6] The "psychic scar" of internment figures heavily in *The Wash*, to be sure, but of particular importance to my argument here is the reproduction of that trauma in intergenerational terms, and the consequent role/responsibility/culpability that gets mapped on to the maternal body as a result. In examining how Japanese American motherhood emerges from what Teresa Williams-León and Cynthia Nakashima describe as "the social processes by which multiracial/multiethnic people with Asian ancestry construct, negotiate, and sustain identity,"[7] we might also determine how that very maternal construct reconfigures identity. For Gotanda, I argue, the mother role absorbs and rearticulates the conundrums of—and posits potential solutions for—a people haunted by memories of home-country internment and displacement, varying concepts of failed masculinity, and myriad fears regarding the cultural and literal existence of future generations.

In the years following the war, at both the policy level and in popular discourse, essentializing sentiments of domesticity frequently conflated motherhood, Whiteness, and patriotism. One of the more powerful examples of this relationship is the Hiroshima Maidens Project (HMP). Established in 1955, the HMP involved American mothers performing a public, political "benevolence" in hosting and funding the transport and medical/cosmetic surgery of 25 Japanese women who had endured serious medical trauma with the US bombing of Hiroshima. The hopes were that "such an act would, quite literally, help to heal the wounds of war."[8] The HMP offered a narrative in which "the white American mother and the idealized American home she produced were portrayed as the solutions both to the problem of damaged femininity and to the lingering ethical doubts about American democracy caused by the devastating effect of the atomic bombs."[9] With programs such as the HMP, motherhood, and in particular *white* motherhood, emerged as a beacon of healing, national consciousness, and forward-thinking progress. Caroline Chung Simpson writes: "The project succeeded in affirming the idea of American dominance through the celebration of the white American homemaker, who represented a way of life that distinguished America as a land of privilege and progress, safe from the pressures and problems of the outside world."[10] Not unlike the race- and gender-based economy articulated in *The Wash*, then, postwar sentiments of race and gender suggest a conflation of Whiteness and "progressive" domesticity that places Japanese American women/mothers in what Homi Bhabha explores as the "ambivalence of mimicry."[11] But while the "progressive" nature of that ethnogender (Anglicized) construct might offer relief from patriarchy, it also suggests a latent denunciation of Asian American identity. With regard to the HMP, for example, eventually "the public narrative of the healing of the bomb victims from Japan began to merge with the story of the healing effects of white American mothers."[12] Similarly, the relationship between racialized/Anglicized motherhood and the politics of gender identity is further complicated for Gotanda's mother characters because of the consistently racialized components within "progressive" ideologies—ideologies that contradict patriarchal Asian filiation and often approach more Western codes of identity and behavior.

After nearly four decades of marriage, protagonists Nobu and Masi are travailing the newly carved terrain of their separation in different ways. Both Nisei, Masi and Nobu, have been living apart for thirteen months, although Masi is still a consistent presence in the family home, performing regular visits in which she brings groceries, picks up Nobu's soiled laundry, and drops off the cleaned wash. Although she is close with their two adult daughters, thirty-three-year-old Marsha and twenty-nine-year-old Judy, Masi has performed the bold move of securing her own apartment and recently has begun seeing Sadao, a widower who is also Nisei and, like Masi and Nobu, an internment

camp survivor. Moreover, Sadao deviates consistently from traditional Nisei masculinity and in his dealings with Masi in particular, performs an overt feminism that seems maternal at times. While older daughter Marsha is still unmarried and a frequent presence in both her parents' daily lives, Judy is on the outs with her father as a result of her marriage to James, a "kurochan," or African American. In addition to refusing to speak to Judy, Nobu also has yet to see Judy's and James' newborn (biracial) son Timothy, the baby who would otherwise be Nobu's prized firstborn grandson. Despite efforts to forge a reconnection between Nobu and Judy from (1) Marsha; (2) Masi; and even (3) Kiyoko, the Japanese restaurant owner and widow that Nobu has been seeing, Gotanda's patriarch remains steadfast in his refusal to accept his daughter's decision to marry and then reproduce with a non-Japanese American man—in his eyes made all the worse for being a kurochan.

Judy's reproductive choices and Masi's resistance to traditional and patriarchal Nisei gender norms leave Nobu angry and confused, to be sure. But the rage and frustration at his own impotence to regulate the behavior of the women/mothers in his life emerges as well amid a shame and powerlessness borne out of internment camp trauma. As Nobu negotiates the "dishonor" and indignities facilitated by his own marked Americanness alongside assimilationist-fed ethnic guilt, the nontraditional behaviors of his wife and daughter/new mother Judy serve as painful reminders that times are changing. Gotanda presents these changes as deeply imbricated in a new domesticity that conflicts with traditional Nisei ideologies, but that also suggests a surreptitiously Anglicized notion of maternal performance.

With regard to what she terms "reproductive labor," Evelyn Nakano Glenn writes: "Japanese American women...maintained the family as a bastion of resistance to race and class oppression, while at the same time [the family] was the vehicle for their oppression."[13] Traise Yamamoto goes further, suggesting that "while the family may delineate the boundaries of maternal influence it may also be seen as a 'culture of resistance' in which women play a vital role."[14] In this way, *The Wash* constructs a maternal landscape that is a latent source of gender-based subordination as well as a source of resistance to social hierarchies. As a marked American who is displaced and imprisoned by his own country, Nobu endures a course of (ethnic- and gender-based) political subjugation and personal defeats, but those injuries are frequently cultivated alongside and from within performed resistance to Nisei domesticity.

HER MOTHER'S DAUGHTER, A FATHER'S ANXIETY

Nobu's discomfort surrounding what he perceives as Judy's and Masi's deviant maternity is one of the stronger indications of motherhood as a host of ethnic- and gender-based anxieties. At times this discomfort approaches a

kind of rage. On the surface, Gotanda's isolated, angry male protagonist seems merely a curmudgeonly Nisei who is increasingly uncomfortable with end-of-life disappointments. But Nobu's self-assessed "failures" assume politically telling incarnations when contextualized with his youngest daughter's trajectory, and in particular, her reproductive choices. Like her mother, Judy's often sexually oriented misdeeds represent more than just a refusal of Nobu's wishes or a culturally unacceptable engagement with independence. From Nobu's perspective, Judy's reproductive actions (like Masi's own acts of personal-political resistance) employ a sociocultural paradigm that is frightening and foreign, but also implicitly Anglicized. As one of only two mother characters in the play, Judy performs an ethnic and gender subjectivity that is couched in a maternity that threatens Nobu's already tenuous grasp on cultural survival and generational continuity.

Early exposition in the first scene alludes to Gotanda's conflation of Judy's reproductive narrative and Nobu's ethnic- and gender-based anxieties. When Masi asks him why he doesn't consider altering the design of a kite whose construction he has been unsuccessfully struggling with for months, Nobu angrily retorts: "My old man did it this way."[15] Immediately following his implication here of kite flying/construction as activities invested in ethnic, multigenerational tradition, Masi changes the subject and asks if he has seen Judy's baby yet, to which he angrily grunts in the negative. In these early moments Nobu's refusal to see Judy's biracial baby is couched in his kite-making stage business, a "stunted effort" that bespeaks the father's/husband's/grandfather's impotence in a metaphorical attempt to "create a viable structure," one based on traditions/patterns he inherited from previous generations. In addition to speaking to issues of lineage, and a passing down cultural practices, kite-making speaks to Nobu's *past*—his own role as son and the consequent purpose of tradition preservation. As keeper of the kite/flame, Nobu would otherwise be entrusted to pass down the kite-making knowledge to Timothy, a grandson who is, maddeningly, not a product of a Japanese American or Sansei father, but who is also half African American—a source of betrayal for a Nisei grandfather who (in addition to his overt racism) sees Whites and African Americans as a major reason for, in the case of the former, political and economic dispossession, in the case of the latter, his formerly all Japanese American neighborhood's financial and cultural deterioration. From his perspective, both groups are responsible for the increasingly limited "space" he/Japanese American culture occupies.

Gotanda repeatedly invokes this rhetorical move of placing the tradition- and lineage-oriented activity of kite flying as a positive (if not palliative) activity for Nobu against a feminized and maternally coded (perceived) failure from one of the play's two mother characters. Most obviously, Judy's maternal/ethnic failure emerges in her shameful, perhaps assimilationist

choice to reproduce with a kurochan who will eventually produce the cherished first born, but biracial, grandchild. For Nobu, in the patriarchal schema of Nisei filiation, a firstborn grand*son* who is not ethnically pure Japanese (as he would have been if Judy had married another Sansei) is unforgivable. Nobu's shame, anger, and betrayal from what he deems Judy's assimilationist sexual and maternal behavior, is typically presented in context with anxieties surrounding (at risk) Nisei tradition and his own honor. Analogous to a proverbial "death by hanging," Nobu experiences an "ethnic betrayal by reproduction." For Nobu, this betrayal portends an irreversible outcome to be feared. With a telling narrative proximity, Nobu's nonacceptance of and anxieties surrounding Judy's motherhood are juxtaposed with his (stunted) kite-flying endeavors. But while Nobu's cultural and generational "impotence" in kiting becomes associated with Judy's motherhood, it convenes as well around a deviant maternity performed by his wife.

A memory sequence in the first act provides one of the many moments that contrast Nobu as traditional, cold Nisei patriarch against Sadao as feminist nurturer. A past argument between an explicitly cruel Nobu and a submissive Masi is intercut with a Sadao love fest, as Masi receives multiple forms of domestic service and attention from her sensitive new partner. The almost surreal warmth and mutual support Sadao and Masi share in their breakfast scene is juxtaposed against the memory/fight sequence that also takes place on stage in the same scene; the action ends with Masi and Sadao romantic and content while, just a few feet away, a silent Nobu is revealed with his kite, standing in a spotlight, alone. Gotanda's stage directions indicate that "[h]e lifts the kite above his head and begins to move it as if it were flying. For a moment Nobu seems to be a child making believe that his kite is soaring high above in the clouds. (*End of scene*)."[16] In addition to the disgrace generated by Judy's motherhood, then, Masi's own questionable actions as wife/mother are presented as unacceptable and shameful for an isolated and angry patriarch left to regress into (memories of) kite flying, a boyhood activity steeped in tradition and father-son/gender-specific cultural continuity.

During a visit with Timothy at Masi's apartment, Judy hears Masi describe a surprising anecdote that casts the presently misanthropic Nobu as, instead, a Nisei father who exceeded narrow paradigms of fatherhood and almost reveled in a warm and nurturing role with his infant daughters. Masi tells Judy, for example, that Nobu regularly got up in the middle of the night with his daughters, changed their diapers, and sang them lullabies. In the scene directly preceding this conversation, during a rare, powerful moment in which Nob risks vulnerability and embarrassment, he actually sings this Japanese lullaby in the presence of Chiyo, Kiyoko, and Curley. Gotanda's footnote translates the Japanese as "Sleep, sleep, hushabye, / Little

boy, good boy, go to sleep now. / Little boy, where has your ball gone? / Way over the mountains to the distant fields."[17] This lullaby, significantly sung in Japanese and alluding to the (absent) multigenerational male-male connection, suggests a filial wound that hovers around an ethnically informed anxiety.

The lullaby activity speaks to Nobu's mourning of an (ethnically, even politically) uncorrupted childhood, even his own. Although as a child he would have certainly been defined by a marked Americanness, as the young Nisei who had yet to endure internment, that version of Nobu was not yet defined by the dispossession and violation of the camps; the lullaby, childhood, and filially invested notions of tradition have yet to be corrupted in the past of the lullaby memory. Furthermore, this past is also a period *not yet marred* by the (maternally coded) misdeeds of his wife and daughter. After he finishes the lullaby, Nobu tells Kiyoko, as well as Curley and Chiyo, who are laughing at him, "My pap used to sing it to me (*Dim to darkness*)."[18] The dramatically uncharacteristic engagement with sentiment and public display of emotion is invested in (1) a longing for a preinternment innocence and (2) a precamp promise of "possibilities." That both are also informed by Nobu's investment in multigenerational, child-oriented Japanese tradition further underscores the degree of betrayal Nobu perceives from Judy's sexual and reproductive actions.

Judy's resistant maternal and Sansei gender performance function most obviously in her choice of husband and the birth of Timothy. But her engagement with a more progressive, perhaps more Western gendered/maternal agenda goes beyond literal reproduction of the next generation. For example, when Nobu breaks down crying in the second act, literally begging Masi to return, it is Judy who pulls Masi away. Far from the obliging Japanese American mother figure Nobu needs his daughter to be, Judy's own "deviant" behavior is complimented in this scene—and throughout the play—by her support/facilitation of Masi's more resistant maternity. Indeed, Judy's charge for a Masi-Nobu divorce in the first act emerges as one of what will be several important contrasts between Judy and Marsha; these differences become particularly relevant for the markedly different engagement each sister has with motherhood.

As one of only two mother characters in the play, Judy's frequent contrast to the single and childless Marsha comments on the less acceptable nature of Judy's choices and personal ideologies, and the ways that both are often defined in context with her maternal identity. It is not Marsha but Judy who gets her mother to go to a ceramics class to develop outside interests and meet new people. It is not Marsha but Judy who "kept harping on [Masi] to move out on [Nobu] all those years."[19] Of the four women in Nobu's life—Masi, Kiyoko, Marsha, and Judy—the latter is the only one who does

not give Nobu a massage, cook for him, or perform some form of explicit domestic labor (including cleaning, cooking for and feeding, grocery shopping, emotional facilitation, and, of course, doing the wash). While Marsha, like her mother, performs multiple forms of emotional caretaking for a solitary and depressed Nobu ("bad" new mother) Judy does not. What's more, Judy's invariable refusal to engage his ill humor not only contradicts a submissive position that puts patriarchal needs first, but at times approaches a coldness itself. Even Marsha's knowledge of "homyu" (Curley's "stinky Asian fish" dish) juxtaposed against Judy's stated ignorance of the culturally specific dish suggests a difference in the two sisters' relationship with Japanese heritage and cultural knowledge. And, of course, as the lone voice of encouragement to Masi with regard to any future romantic/sex life (or any life) beyond Nobu, Judy stands in stark contrast to her more traditional and childless sister.

Far from encouraging her mother's divorce, Marsha's endeavors to reunite her parents occur more than once. These attempts to reconcile them are most powerfully demonstrated in the nearly violent coffee-serving incident at the "reconciliation dinner" hosted by Marsha (a dinner Judy would not attend). Coded as the "good," submissive, *ethnically nonthreatening* daughter, it is particularly telling that unlike her sister, Marsha is not a mother. Not even dating at present, she poses no (sexual) threat to Nobu's honor or the racial/cultural continuity issues Judy raises. Even better, as Nobu explicitly tells Judy in the second act, Marsha undoubtedly *will* marry a Sansei. While Judy's feminism and digression from (a lost, mourned for) tradition repeatedly contrasts Marsha, it is not coincidental that Judy is a mother and Marsha is not. Innocuous Marsha poses no threat to Nobu's honor as a result of her single/childless identity, but also in the promise that no (ethnically and maternally coded) misdeeds will transpire, since she *will* marry a Japanese American man and produce the longed for Yonsei (fourth generation).

Aside from Nobu's experience of Judy as a Sansei who betrays/threatens cultural (or even literal) continuity, Judy's reproductive choices also speak to the female Asian body, and more specifically the maternal body, as a discursive text that can engage in a unique form of ethnically coded meaning making. To begin with, as a Sansei Judy is born of parents who are themselves US-born; but she is also perceived by dominant culture as an immigrant body in the ways that race functions as signifier for an otherized Asian subject. While Nobu's miscegenation anxieties might be particular to his own camp-based trauma, perceived threats to "racial purity" are certainly not unique to the play's patriarch and, in terms of US culture, predate Japanese American internment by decades, if not centuries. Wendy Ho notes the *legislated* disdain toward behaviors of (and the potential results from) miscegenation, pointing out that in the 1880 amended version of California's Civil

Code, "The issuance of a marriage licence to a white person and any 'Negro, Mulatto, or Mongolian'" was explicitly prohibited according to state law."[20] Centuries-old Western miscegenation anxieties can be traced to pseudo-scientific discourses, political, and economic policy as well. Azuma writes: "Based on bourgeois liberalism and the fictive racial hierarchy of eighteenth-century Europe, Anglo-American racial ideology defined miscegenation as causing the degeneration of race, nation, and class in scientific terms."[21] And as recently as the 1960s, several US states still explicitly prohibited marriage between Whites and Asians (in particular, Asian men, like African American males, were considered "threats to white racial purity").[22]

As Nobu himself demonstrates, opposition to interracial marriage/reproduction was not unique to racist white Americans; and the rationale/warnings from each side often employed similar "cautionary" logic. In addition to pressures from the United States and state legal codes, Nisei received clear messages from their Issei parents and the broader Japanese American community to stay within their own ethnic boundaries. Beyond (strong) filial pressures, widely read Japanese language newspapers enthusiastically touted "racial solidarity" in interpersonal/romantic relationships. Yoo points out that these influential periodicals suggested in no uncertain terms that "in matters of the heart, Japanese Americans would be best off with one another." Moreover, "marriage announcements frequently appeared in the papers and acted as a positive reinforcement," and as Nisei eventually found out, particularly in the years before and during internment, "interpersonal relationships uncovered values and expectations within families and the ethnic community" that resulted in formidable "pressure from all sides [that] pushed Nisei toward other Japanese Americans."[23] Decades after internment, potential romantic and reproductive activities of Japanese Americans with those outside ethnic boundaries continued to be a source of concern and a target for control. As Nisei eventually had their own children, and those Sansei approached an age whereby these behaviors could pose a problem, second generation Japanese Americans found a new filial dilemma on their hands. Spickard notes: "Interracial romance and marriage was a steady theme of community debate from the 1960s on. Much of the concern centered around the gender differential in interracial romance: far more Sansei women than men dated and married non-Japanese."[24] Crucially, these decade- if not century-, long pressures (coming from both racist white attitudes and legislation *and* exclusionary Japanese ideologies) assign the maternal body an idiosyncratic agency in its ability to confuse and complicate race-based borders. Included in this potential to complicate and confuse is the compulsive revelation of those engagements from the maternal body as a corporeal text.

While the mother subject offers productive complications to essentialist discourses of identity, as a corporeal text it also affords meaning-making

opportunities in its ability to act as metaphor to the national body. This is particularly true with regard to the Asian American maternal form, as Judy demonstrates most obviously in her choice of partner and her biracial son. In Karen Shimakawa's discussion of the immigrant/ethnically otherized body as that which presents a "unique threat" to both "the literal and symbolic 'American' body," she notes David Palumbo-Liu's contention that, with regularity, "exclusionist and antimiscegenation psychologists, sociologists, and jurists found a particularly effective synthesis in the 'science' of eugenics/ethnology and the rhetorical politics of racial exclusion in the early twentieth century."[25] Significantly, in their "conceptualiz[ations of] the body of the nation as one in dire need of protection from infection," discourses of the 1920s and 1930s allowed for

> a particular discursive formation that blended science with politics, economics with sociology, national and international interests, within which the nation was imagined as a body that must, through fastidious hygienic measures, guard against what passes from the exterior...and prevent any reproductive act that would compromise the regeneration of its species in an increasingly massified and mobile world.[26]

Consequently, the connotations of (and a conflation between) maternal and national bodies as vulnerable agents requiring "protection" against "what passes from the exterior" unavoidably assign the mother role with simultaneous responsibility and a need for regulation. The maternal body as symbol and mechanism constituting a national body is robbed of power by virtue of what is at stake and its (always latent) culpability. But it also incorporates the power to *interrupt*—by virtue of its reproducing abilities, and its compulsive (physical) revelation of such—a race-based invisibilizing that otherwise relegates the Asian American body to an ethnonational no-man's land. This "invisibilizing" of the Asian American body, as Traise Yamamoto adroitly explains, is deeply implicated in a black/white dyad organizing US race hierarchies:

> The racial economy of the United States...is structured by several related binaries that powerfully position racially marked others along axes of difference that both assert and maintain white dominant ideology. The most significant structural binary, one that has shaped and continues to shape the national consciousness, is based on a black-white paradigm in which Blackness is coded as difference and is determined in relation to normative Whiteness. The implicit reliance on alienated difference-in which what one is and is not simultaneously define each other-subtends the logic of binary oppositions, and the belief in the objective veracity of sight naturalizes the metaphor of color as a fact of the body.[27]

What can be understood as a "master schematic for racialized identity in American culture" essentially positions the Asian body along White borders.[28] Yamamoto suggests that "the slippage between ideological structures and what is assumed to be observable difference is...nowhere clearer than in the positioning of Asian Americans within the racial structure of the United States." Asian American identity, assigned to an "intermediary space," exists outside the black/white signifying paradigm and becomes involved in a "conflation of ontological/moral status and seemingly observable color difference"; as a result "the black-white dyad renders Asian Americans invisible as subjects." But, she continues, "the logic of visuality, coupled with the ideology of East-West difference results in the status of Asian American as highly *visible racially marked subject.*"[29] This always already "marked" status as Other American, however, does not go so far as to render the Asian body as the binary to Whiteness, but rather a function of and contributing factor to its own invisibilizing. In other words, as an ethnically marginalized subjectivity, *Asianness* incorporates a simultaneous markedness that deems the Asian body Other while at the same time becomes invisibilized by a black/white binary. If "what characterizes Asian Americanness as it comes into visibility...is its constantly shifting relation to Americanness, a movement between visibility and invisibility, foreignness and domestication/assimilation," then it is that very "*movement between* enacted by and on Asian Americans...that marks the boundaries of Asian American cultural (and sometimes legal) citizenship."[30] In its best case, the maternal body underscores but also potentially obscures those boundaries. The maternal form can mark these boundaries instead as fluid and subject to (gendered) agency and choice. Said another way, beyond the more immediate performances of political resistance Judy engages with each of her parents, the sheer fact of her marriage to Jimmy and the birth of biracial Timothy alludes to her literal ability to (re)produce Japanese American subjectivity, an ability that places her body (and its representation) in a unique position, one that does not automatically involve restricting and restrictive constructs.

For the Yonsei/Timothy's generation, might a multiracial identity point to a (celebrated rather than Nisei-feared) diversity that bespeaks an eventual minimization of oppression as experienced by Issei and Nisei? Or does it instead speak to the dangers of exogamy, the imagined but also at times real ethnic and cultural threats felt by Issei and Nisei parents who were once quite literally facing annihilation? This semiotic flux, if not political dilemma, of the ethnically mixed body *as text* nods to the unavoidable quandary of the subject whose "visibility as multiracial Japanese American" has also "rendered them racially unreadable at the surface of their skin."[31] Using in her analysis literal bodies, imagined bodies, and even literary

bodies, Creef points out that "signifying power of [the] multiracial body," bespeaks the "dramatic lack of national imagination to envision not just a non-white, but a complex multiethnic and multicultural reconfiguration of America."[32] Expounding on Yamamoto's discussion of what she describes as the "powerful ideology of pigmentocracy" that organizes US culture and politics, Creef points out that "literary representations of the Japanese American body are almost always shaped by a visual politics of representation." In her analysis of playwright and poet Velina Hasu Houston, for example, Creef contends that the Japanese American body functions as a kind of "battleground," one that hosts a "battle fought over [Japanese Americans'] claim to American identity"—an identity that is "threatened by a visual politics of representation intent on casting them out of the protective membership of the nation and into exile."[33] As the agent responsible for Timothy's own (re)production of a newly configured/biracial Japanese American body, then, Judy proffers an additional/alternate text for the "battleground" of a "pigmentocracy" that relegates the Japanese American body as invisible other.[34]

When Nobu's youngest daughter extolls the value of a divorce to a still undecided Masi in the second act, the audience learns of an additional (and ethnically coded) component to the shame and betrayal Judy's reproductive actions engender. As Masi consoles Judy over her father's emotional withdrawal and refusal to see her baby, the latter bemoans: "All he can talk about is how he can't show his face at Tak's barbershop because I married a kurochan."[35] Judy's complaint indicates that deeply embedded in Nobu's rage/disappointment in the ethnic make-up of his daughter's new family is the added violation from the *public* shame it generates. For a traditional Nisei such as Nobu, the catastrophic mood inflecting his failure to control Judy's behavior is informed by the Issei parenting style with which he was likely raised, one preoccupied with issues of honor, shame, and gossip. Spickard explains:

> The child-rearing practices of Issei parents reinforced family solidarity. Children were prized, but they were expected to be assets to their families... [B]eginning at around age four or five, the child was made to feel the weight of duty. Formerly lavish affection was withdrawn, and responsibilities took its place. The child must now behave well, because her behavior reflected on the entire family... The emphasis was on shame and dependency, on obligation and responsibility. Most especially, the youngster could never do anything to sully the family name, cause the neighbors to gossip, or bring Japanese people under criticism from non-Japanese Americans.[36]

Particularly vexing to a Nisei patriarch still deeply invested in the high value placed in honor and a near pathological avoidance of (public) shame,

nonacceptance of Judy's motherhood is shadowed by the ethnic betrayal in providing a "not quite Japanese enough" grandson; but the "sin" is compounded by the shame Judy brings to Nobu at the very male, ethnically specific landscape of Tak's barbershop. In other words, Nobu's trauma is based in Judy's actions, but also, as she seems to know, based in the displayed nature of Judy's maternal, ethnically coded failures—a public betrayal that the maternal body and its offspring cannot avoid revealing.

A conversation between Nobu and Judy in which he finally engages in some/any dialogue with his youngest daughter since the birth of the "ainoko" (a derogatory term for biracial) grandson underscores the fact that Judy, unlike her mother and sister, is alone in her refusal to engage in traditional/conservative gender paradigms, but also the only person who has Nobu's number in terms of his ethnically invested anxieties and their conflation with the reproductive actions of his daughter:

> *Nobu*: Damn kurochan...
> *Judy*: He's black, not kurochan. It's "African American." (*Pause*) Everybody marries out, okay? Sanseis don't like Sanseis.
> *Nobu*: Tak's son married a Nihonjin, Shig's daughter did, your cousin Pasty......
> *Nobu*: Marsha's going to. (*Pause. Looks back to Timothy.*)
> *Judy*: But is that any reason not to see my baby? He's a part of you, too.
> *Nobu*: No, no. Japanese marry other Japanese, their kids are Yonsei—not these damn ainoko.
> *Judy*: You're gonna die out, you know that. You're gonna be extinct and nobody's gonna give a goddamn.[37]

Anxieties surrounding extinction and dying out, of course, harken on the surface to the feared dilution and eradication of Japanese American culture and bloodlines resulting from generations of Sansei "marrying out"; equally telling, however, Judy's reference to "dying out" speaks to the legitimate fears generated by a camp experience that, while not completely equivalent to the extermination occurring in European camps at the same time, certainly would have felt similar in terms of a genocidal threat to the lives and culture of those imprisoned and displaced by their own country, and occasionally their own neighbors.

Finally, Judy complicates marginalizing maternal paradigms (perhaps less directly but no less significantly) in her digression from the model often suggested by Masi as matriarch. These complications transpire by virtue of the *contrasting* example Judy offers to a previously submissive Masi. But they occur as well in the politically progressive *similarities* mother and daughter share, as a latter-day Masi finds support from and achieves resistance-by-example with her offspring—a daughter/new mother who

(according to more standard rubrics) would/should instead be on the receiving end of parental support/indoctrination.

Indeed, the behavioral, intergenerational modeling that transpires between mother and daughter assumes powerful cultural overtones that at times approach genetically informed articulations. In "Beyond Manzanar" Jeanne Wakatsuki Houston explains that her identity as a Japanese American woman is an identity "naturally" inseparable from that of her mother; she concludes: "My natural inclination [is]to do as she did."[38] A "natural" tendency, maternal influence over a daughter's identity is coded as a nearly genetic phenomenon. Within discourses of family and gender, too, the top-down mother-daughter enculturation can surpass mere ideologies of family and engage a nation-based subjectivity. Yamamoto surmises: "To reject the mother is to reject one's own gendered and racial identity; to be 'as *American as Doris Day*' implicitly is as to be *as American as her mother is not*, to disavow the subjectivity represented by the mother."[39] A Sansei daughter, Judy's identity is inextricably linked to a maternally (Masi) influenced but always ethnically defined rubric of expectations. But in Gotanda's landscape of mother-daughter (non)enculturation, the similarities occur alongside differences. In a discussion of Hisaye Yamamoto's short fiction, Yamamoto describes the "importance of the mother as a model of enculturation [as well as] resistance to the structures of patriarchy" within Japanese American maternal paradigms. Both enculturation and resistance are "fundamental to the necessity of the daughter's identification with [the mother]." She writes: "In an environment structured by racism and sexism, one of the most crucial aspects of 'motherwork' is the enculturation of children in modes of survival and resistance [even if] that process of modeling and enculturation is not always overt."[40] If, as Yamamoto writes, "Japanese American women must both differentiate from and identify with the mother in order to construct a viable subjectivity in which gender and race are mutually constitutive,"[41] consider the *two-way* transmission of cultural signification and even models of resistance that occur between Masi as mother and Judy as daughter-new-mother. Certainly, Judy's politically resistant ideologies contrast the earlier (submissive) ethnogender constructs that Masi typically embraced. Much of Judy's character can be understood as a Sansei daughter who defines herself in *non*-Masi terms. Perhaps less obvious, however, is that according to a more typical assimilation/one-direction-intergenerational "progress" narrative, Judy's performance of gendered and maternal resistance (in defying Nobu, in marrying an African American man, in encouraging Masi's departure, even in naming her son the Anglicized "Timothy") is not the sole example of maternal defiance in Gotanda's text. In the latter half of the play, much of Judy's resistance occurs *alongside* (rather than contradictory to) Masi's own increasingly "deviant" domesticity.

NISEI TRADITION, NISEI TRAUMA, AND MATERNAL (DIS)HONOR

In addition to Judy, Masi's functions as the play's most obvious allusion to motherhood as a concourse of race-based trauma. And as one of the play's three older Japanese American women, the differences between Masi as mother on the one hand and childless Kiyoko and Chiyo on the other are marked. These differences suggest broader implications for Japanese American female subjectivity as a function of ethnic (American versus Japanese) ideologies, but also suggest a gender construct that imbricates, specifically, camp-based trauma and motherhood.

Amid Masi's qualified independence after leaving Nobu, her "professional identity" involves cleaning for others and is thus invested in the caretaking of others. Her romance with Sadao, while resistant to a more conservative Nisei gender construct, is plagued with inconsistency, if not also a lingering sense of guilt. Chiyo and Kiyoko, on the other hand, are also two Japanese American women of a certain age but who were, perhaps significantly, born in Japan and did not endure the trauma of internment. Unlike Masi's explicitly domestic professional identity, Chiyo and Kiyoko are entrepreneurs who run the small businesses they also own. (Kiyoko's profession as restauranteur does not quite merit the kind of domesticity performed by Masi; even though her clients are fed in her restaurant, Curley prepares all of the food. Kiyoko is "management" and in no uncertain terms, the boss.) But beyond their professional differences, Masi's tentative, sometimes confused participation with Sadao contrasts strongly the romantic ideologies of Chiyo and Kiyoko, the former acting as an outspoken, consistent finger-wagging friend to the latter, as she warns Kiyoko to *not* accept subpar treatment from Nobu. The hesitancy and guilt that Masi regularly performs in her relationship (and as a *result of her happiness*) with Sadao is completely absent in Kiyoko, whose own *brief* tentativeness is instead (to the degree it exists) motivated in an uncertainty over Nobu's emotional availability. These behavioral, professional, and ideological differences between Masi and the play's two other older Japanese American women seem relevant given the latter's immigration and (lack of) internment status. Less confused, less inclined to feel the need to prove their "Japaneseness" (indeed, both women were married to white Americans and indicate no unease about the intermarriage throughout the play), the very different shadows cast by childless (Issei) Chiyo and childless (Issei) Kiyoko suggest in Masi a Nisei femininity informed by ethnically hyphenated motherhood and conservative domesticity, a domesticity that itself becomes imbricated in ethnically based trauma.

As the play's action begins, however, Masi's participation in a marginalizing Nisei domesticity comes into question. For their entire marriage, the

audience learns, Nobu's emotionally withdrawn, nearly abusive behavior has been the de rigueur his wife has come to accept. Gotanda writes in the first scene, during an exchange in which Nobu's aggressive tone and coldness go unchallenged: "She is not upset by his actions [and] she has no expectations... Business as usual."[42] Before the first act concludes, however, this formerly acquiescent Nisei wife/mother has also begun to chart a journey of resistance that will mark her as *occasionally* culturally deviant, *at times* politically progressive. To be sure, Masi's deviations from conservative maternal constructs vary in degree and consistency. Certainly the act of a Nisei wife/mother leaving her husband of four decades is remarkable when contextualized with the patriarchy of typical postwar Japanese American filiation. Furthermore, her repeated attempts at and eventual defiance of Nobu is significant for its qualified disregard for public censure; she is undoubtedly cognizant of the potential shame awaiting a wife/mother/daughter whose actions exceed what family and community deem acceptable.[43] But Masi's deviations from traditional Nisei domesticity are also noteworthy for their departure from the earlier, more typical submission she herself performed in the camp as an obedient Nisei governed first by paternal and eventually spousal control.

Dialogue between Masi and her daughters reveals that while in the camp she was likely in the position to make a marital match. For Issei parents in the years before and during internment, the future marriage and eventual offspring of an eligible child was especially consequential. What new in-laws would mean in terms of public acceptability or stature was a concern, to be sure; but a family's economic status could also be influenced—a legitimate concern for Issei parents who now found themselves dispossessed of their homes, family farms, or livelihoods. The majority of the Nisei generation came of age during the internment period; as a result, weighty decisions surrounding marriage (two families legally joined, but also indirectly joined through new associations with another family's reputation) often occurred under challenging, complicated circumstances.[44] When Masi tells Sadao, "I don't think I ever really cared for Nobu. Not the way he cared for me," Gotanda suggests strongly that Nobu was not Masi's first (or general choice), despite her eventual decision to marry him. Removing any doubt as to her romantic preferences, moments later she tells Sadao: "There was someone else who liked me in camp. I liked him, too [but] I married Nobu."[45] Masi's public choice of Nobu contextualized with what Gotanda suggests as a strong interest in Chester, alongside her private *dis*interest in Nobu, indicate a more conservative decision-making process for an eligible Nisei woman who enjoyed male attention from two different men. (It is fair to assume that Nobu and Masi were already a couple before internment, as suggested by among other things his comment in act two, in which he complains that before internment-

generated financial losses, her father had "promised he could set [him] up in business;[46] we also learn that before camp, while working on her father's farm, Nobu essentially stalked Masi from the field.) Romantically seeing Chester (explicitly or surreptitiously) while attached to Nobu would certainly count as behavior unbecoming a good Nisei daughter. Less appealing Nobu was the man to whom Masi was, for all intents and purposes, betrothed. Because the potential shame any Chester-oriented contact would generate affects her family as well as Masi individually, her attraction to and connection with Nobu's competition deserves attention for its qualified disregard of filial honor.

In the decades preceding internment, parental/Issei influence was formidable. And while this generation did see a diminished influence during internment due to, among other reasons, increasing tensions between Issei and Nisei,[47] the former still enjoyed a generational authority, particularly in weighty decisions such as a daughter's marriage.[48] Parental concern over Masi's dating life would have been strict, then, but equally significant is a likely conflation of nonacceptable sexual behavior with Western/American subjectivity. Azuma explains that "many Issei parents dreaded the 'sexual laxness' and 'uncontrollability' of young Nisei, which they usually attributed to negative 'American' influences." Echoing the vigilance that Nobu will employ in his own concerns over Judy's (racially specific) reproductive choices, a 1930 article from *Shin Sekai,* one of California's major Japanese language newspapers, warned: "It is our responsibility—parents, social leaders, and community at large—to make sure to raise our children properly [so as] to avoid interracial marriage."[49] The culture in which Nisei such as the one Nobu and Masi came of age, in other words, defined social/sexual comportment not only as a paramount interest and a primary responsibility of the parent, but (even before the racial/reproductive anxieties Judy facilitates), choices informed by concerns with racial purity.[50] For Issei parents before the war, as for Nobu today, then, anxieties over the sexual/reproductive choices of wanton Nisei women linger.

Issei influence was complicated (if not checked) during internment, and this *reduced* authority becomes significant on two fronts: First, with regard to Masi's behavior in camp, her submission to a parental agenda indicates a more traditional and conservative gender performance; but the reality that Issei influence was diminishing underscores a willingness to acquiesce. Second, this *former* submissive behavior becomes relevant for its contradiction to the construct she performs later in life. The Masi who chooses Sadao as a new partner differs considerably from the Nisei wife/mother her Issei parents raised her to be—the woman who chose Nobu over Chester, even amid the period of decreasing Issei control. Disregarding what is expected of her, this "new" feminist subject contradicts her past as she employs a level of political resistance she could not manage in the camps.

Masi's decision forty years ago to marry Nobu and forego Chester (not to mention staying with him for four decades) speaks to her placing community needs/group approval over her own. At the same time, the *new*, evolving feminist subjectivity audiences see—particularly when juxtaposed against the daughter/wife who historically acquiesced to family/patriarch needs—alludes to digressions from Japanese American gender and filial ideologies invested in public acceptance. Masi's earlier submission contrasts her present behavior in ways that indicate an Americanized prioritization of individual-versus-community needs, individual-versus-community identity. Social paradigms in which the needs/values of the group matter more than individual are non-Western and certainly in line with kinship networks in many immigrant communities (Japanese Americans being no exception).[51] With the very real threat to survival that rampant racism and internment presented, attention to group needs, communal cooperation, and adherence to community axiom would be particularly important; Masi's decision to acquiesce/marry Nobu and forego Chester coalesces with this model, particularly in the gossip-laden culture of the camp. Indeed, strong social networks in which families and neighborhoods would have access to others' private and public affairs thrived in the years preceding internment and, due to close quarters of camp culture, continued during internment. As the adult children who experienced (formerly powerful, but still present) Issei pressures, Masi's generation would have been subject to what Spickard describes as the "[i]interconnecting gossip networks [that] linked all the West Coast Japanese American communities"; as such, "the Nisei could never be free from scrutiny... Most Nisei understood all this to be just the way things were." Before and during the war, and in a tellingly group-oriented/non-Western mentality, the potential family-wide threat of damaging information about a lone family member was a legitimate concern. Spickard writes: "Every town and rural district had a well-oiled Japanese American gossip machine, ready to pounce on tidbits and put them to use encouraging conformity."[52] Masi's recent behavior, then, nods to an increasing engagement with a Western-oriented perspective on the (primary) interests of the individual and disregard for conformity. Her Nora-like departure from the family home, her choice of uber-nurturer/quasi-feminist Sadao, and her decision to officially divorce Nobu contrast the daughter/wife/mother figure who, in the past, chose a romantic partner and eventually spouse based on interests other than her own and endured for decades an emotionally abusive marriage. It stands to reason these previous choices would be influenced by duty and a fear of shaming one's family. Yet much of her *recent* behavior could and perhaps does generate filial shame or at minimum, public judgment. As a result, the more progressive domesticity Masi engages now (including most obviously, her eventual decision to divorce) indicates a move toward a more

Western/Americanized paradigm in which the interests/rights of the (independent, self-reliant) individual trump those of the group.

By the second act the audience learns that the price Masi has paid to stay with Nobu over the years involves more than just verbal hostility and isolating coldness. His bullying and emotional withdrawal are complimented by a complete absence of sexual contact and physical intimacy. In a conversation between Masi and her daughters, she informs them: "There are things you kids don't know. I didn't want to talk about them to you but...Daddy and I, we didn't sleep... (*Continues.*) together."[53] Dramatically different from the demonstrative and healthy connection she enjoys with Sadao, Masi reveals a longstanding habit of consenting to a painful, lonely marriage, a habit that contradicts her *present* refusal to accept this kind of connection, even if it generates personal or filial/group embarrassment. This refusal indicates a move away from a submissive (if not masochistic) gender paradigm that prioritizes communal needs/values at the expense of individual, and embraces instead a Western gender construct whereby her needs prevail and her own happiness assumes a higher importance.

Sadao's (remarkable) account of his group therapy session also indicates a positioning of individual interests over (public) concerns regarding shame. His tear-filled sharing during the therapy session itself, his naked vulnerability as he describes it to Masi, and an overall absence of self-consciousness parallel Masi's own individualist agenda in her decision to allow Sadao to spend the night. As Sadao matter-of-factly confesses, "How strange. I am crying in front of all these people that I don't know. And yet I feel no shame,"[54] he reveals a highly sensitive, *un*-Nisei-like masculinity, to be sure. But his openness, the freedom with which he engages it, and his disregard for (and nonparticipation) in any shame reveals *two* people who seem to care less and less what image they portray to others. Attending first to their own individual agendas, how their actions might generate public censure, family shame, or community disapproval seems to matter not at all.

The specific means by which Gotanda reveals Masi's earlier, qualified moments of resistance during internment comment on Nobu's present as much as it does Masi's past. Her alleged, mitigated rejection of conservative Nisei gender rubrics (involving perhaps a momentary connection with Chester) is rooted specifically in *sexual* deviancy. And this deviancy informs—indeed, *engenders*—Nobu's chronic ethnically based crises. In particular, her possible indiscretion with Chester during internment becomes associated with Nobu's camp-oriented trauma that further supports anxieties invested in race and gender. During a conversation about Masi's new pottery class, with a non-sequitur that is obviously motivated by suspicion, Nobu brings up Masi's unknown whereabouts forty years ago when, at a camp dance they were to attend, he waited while neither she nor Chester showed up. Masi's reply that

she cannot possibly remember does not satisfy Nobu's suspicion.[55] Working on the assumption that Masi engaged in romantic activity with Chester, regardless of whether actual sex took place or merely under-the-radar courting activities, any Masi-Chester connection would be a source of humiliation and emasculation to Nobu. Despite several decades old, however, Masi's actions and their relationship to Nobu's sense of self are still paramount. Said another way, the abusive/scared/withdrawn Nisei that audiences see in Nobu is, purportedly, a man broken by the racism, imprisonment, and dispossession that he endured as a marked American. But the proximal rhetorical positioning of (1) Masi's unsanctioned sexual choices and (2) Nobu's ethnic- and gender-based identity crises suggest a relationship between Masi's (bad) maternal subjectivity and Nobu's ethnically informed trauma.

While uncertainties about Masi's sexual past (not to mention her Sadao-related present) haunt Nobu in a more typical malaise of doubt and insecurity, Nobu also occupies an uncomfortable psychic space whereby doubts (whether about himself, Masi's virtue, the state of his marriage, or whether she ever loved him in the first place) get absorbed and rearticulated in insecurities that are conflated with his own ethnic, gendered, and national identity. A powerful example occurs during the Marsha-orchestrated and -hosted dinner for Nobu and Masi, an evening clearly meant to facilitate a Nobu-Masi reconciliation (not to mention a scene that reveals Marsha's growing tendency to perform the role of Nobu's caretaker following Masi's increasing refusal). Nobu and Masi engage in a disagreement that reveals him to be abusive and a bully, but also confused and frightened. Just before verbally assaulting Masi for putting milk and sugar in his coffee when she *should* know that he likes to do it himself, he surreptitiously brings up the troubling fact that she's often not at her new apartment when he calls. While her absence is explained by the announcement of her new pottery class, his suspicion is undeterred. These suspicions over Masi's present romantic/sexual behavior bleed into longstanding anxieties over her past:

> *Nobu*: I call in the evening. I guess [pottery class is] where you must be. (*Pause*) Remember those dances they used to have in the camps? You were a good dancer... Best in the camps... Remember that fellow Chester Yoshikawa? That friend of yours?
> *Masi*: He could dance so good.
> *Nobu*: Remember that dance you were supposed to meet me out front of the canteen?... I waited and waited...

When Masi replies that it was "over forty years ago," and she couldn't possibly be expected to "remember something like that," an undeterred Nobu charges:

Nobu: You didn't show up. Chester didn't show up either (*Masi puts cream and sugar into Nobu's coffee.*) . . .
Masi: Probably something came up and I had to help Mama and Papa.
Nobu: Where were you, huh?
Masi: How am I supposed to remember that far back? Chester died in Italy with the rest of the 442 boys.
Nobu: Where the hell were you?[56]

Nobu's progression toward the milk-coffee-spilling tirade that follows *ostensibly* stems from Masi not remembering how he likes his coffee (during his explosion, among other hostilities, he knocks the coffee over and aggressively orders Masi to clean it up—which she refuses to do, only to have Marsha oblige). In this scene Masi resists the submissive position she has historically assumed. But more telling than Masi's budding refusal of submissive domesticity, the audience sees (1) Nobu's rage (and "damage") and (2) Masi's failings/resistance both contextualized with a suggested sexual indiscretion on her part. The fact that this transgression (may have) happened in "the camps" and further, occurred with one of the infamous "442 boys," implies first that Nobu is still haunted by camp-inspired gender and ethnic failures (as a man, a husband, a father, a marked American, a provider). But it also implies that he finds a workable scapegoat for those anxieties in Masi-the-bad wife/mother for all of it.

The association of Masi's domestic shortcomings and Nobu's trauma is also important for what the audience is told about the alleged "other man," one Masi may have cheated with and worse, done so with others' awareness. In addition to his good looks and his skills on the dance floor, the most prominent feature we learn about Chester is his status as one of the esteemed "442 boys."[57] As the most recognized battalion in US military for its size, length of service, and losses endured, this all Asian American combat unit comprised mostly Nisei volunteers. Suffering egregious offenses, not the least of which being the continued internment of their family members while they fought abroad, these American soldiers eventually earned a public apology by President Truman. As a member of the 442nd, and one who died in battle no less, Chester, unlike Nobu, exists as a former-but-still-haunting sexual threat and possible source of public shame to Nobu in terms of a relationship he may have had with Masi; but in specifically eth-nonational terms, Chester's potent (Nisei, male, patriotic, heroic) silhouette exacerbates Nobu's perceived failures: (1) the failure to safeguard his family; (2) the failure to secure what was at one point a promising economic future with Masi's (then economically secure) father; and (3) a failure/shaming as an "American," a US-born citizen deemed foreign and an enemy by the racist and xenophobic actions of his own country—a not-quite-American

status that feels more acute against the painful relief of Chester's (Japanese) American heroism.

Furthermore, the hero narrative that casts Chester as "the Nisei who fought back" comments on Nobu's wartime (in)actions as something that perhaps exceeds passivity and approaches compliance. Shimakawa explains that in direct contradiction to a separatist (panethnic, community-avowing, politically empowered) ethnic subjectivity that understood assimilation as *contrary* to political agency, many Nisei before and even during the war considered cooperative and even assimilationist ideologies as less than negative—even patriotic.[58] Because of the so-called threat they knew they were thought to pose, many Japanese Americans were eager (before, during, and after internment) to *diminish* perceived "differences" from Whites; from this perspective, cooperation and assimilation might work to "facilitate safety" from racist white aggression. Positively spun engagements with assimilation and cooperation occurred with regard to interment specifically, and in this sense Nobu's self-assessed passivity would seem especially problematic against the example of a "heroic" (more aggressive) Chester, a Nisei whose actions took him out of the camp and, after enlisting, died as a Japanese American war hero, one whose (American) loyalty and masculinity could never be questioned.

Contextualized with the "action" performed by Masi's lover (a kind of ethnogendered heroism), Nobu's own wartime situation seems more passive "reaction." This arguably unfair assessment of passivity, of course, came with strategic rationale behind it. As Spickard notes, although they often "met little success in [their] endeavors," many Nisei actually "urged their people to cooperate with government plans for mass imprisonment" in attempt to appear as innocuous, "good Americans." Indeed, as documented in internees' firsthand accounts, published decisions of the Japanese American Citizens League, and letters to (Japanese and English language) newspapers, a number of Japanese Americans desperate to prove their loyalty and Americanness "advocated compliance" to their own government and consented to removal.[59] Paradoxically these "exhortations to 'patriotism' complicated the exclusionary impulse of the relocation, claiming the 'insider' status of Americanness by embracing the position of the.. 'outsider.'"[60] In other words, one might prove her/his "Americanness" by (the patriotic sacrifice of) submitting to racist aggression. This perverse dynamic becomes further complicated—as with Gotanda's fictional Chester—by the fact that Nisei increasingly volunteered to serve in the US military, often, while en route to or already removed to their respective camps.

In other words, as a kind of anti-Chester, Nobu experiences ethnogendered crises that begin with war- and camp-oriented emasculations, but also extend a list of failures that encapsulate his (flawed) role as provider, father,

husband, and Masi's (inferior) lover. From this context Masi's performance of "bad wife/mother" works on two levels. In putting her needs before her family's she resists an oppressive paradigm of domesticity informed by Nisei cultural norms. But her potential sexual indiscretion occurs, significantly, with Nobu's opposite: a Nisei who *did* fight back against the country determined to rob Japanese American citizens of freedom, pride, assets, and habeas corpus. Nobu's shame-spiral originates in Masi's suspected, very specific sexual misdeeds of the past, and once again deviations from the "good Nisei mother" facilitate the psychic and sociopolitical fault lines that threaten to swallow Nobu up.

The relationship between Nobu's emasculation, sociopolitical trauma, and Masi's (non)adherence to Nisei gender ideologies also transpires in explicitly intimate terms. Although he clearly has an interest in sex with women, as both his attraction to Kiyoko and his hidden pornography collection in the closet suggest, it has been fifteen years since Nobu has initiated or participated in any sexual activity with his wife. Not unlike a veteran struggling with PTSD-generated impotence, Nobu's psychological and political "wounds" facilitate a disinterest (or inability to engage in) sex with his partner; the feelings of shame and powerlessness that emasculate him manifest sexually. It is important to unpack *where* these anxieties originate, and the ways that Nobu's "wounds" involve ethnogender crises. Moreover, the crises themselves become psychologically (and rhetorically) buttressed by their contextualization with the maternal, whether Masi's unacceptable domesticity is merely suspected (as it was in camp) or literal (as with her decision to leave Nobu and see Sadao).

For example, when Masi reveals supremely intimate information about her sexless marriage to her daughters (a highly private confession that, itself, digresses from conservative Nisei paradigms), her language reveals much about the underpinnings of Nobu's sexual withdrawal. She confesses: "Every time I wanted to, he would push me away. Ten, fifteen years he didn't want me." As she continues unpacking the details of his detachment, she explains that during arguments, "just like always," Nobu was

> going on and on about how it was my fault this and my fault that. And I was trying to explain my side of it, when he turned on me, "Shut up, Mama. You don't know anything. You're stupid." ... He didn't even need me to make him be right anymore. *He just needed me to be stupid.*[61]

Although she employs the concept of "stupid" (rather than "promiscuous," "deviant," or "bad mother") here, Masi alludes to the broader dynamic of Nobu's psychosexual trauma tied up in Masi's (required) shortcomings. Whether stupidity or more general digressions from (traditional) Nisei

domesticity, Masi's/"Mama's" shortcomings "need" to exist for Nobu as a support, explanation, or even distraction from his own trauma, the real source of which is too difficult to face.

The scene in which, after fifteen years, Nobu does initiate sex with Masi (or anyone, for that matter) further suggests a Masi-/maternally oriented function to Nobu's identity-based quandaries. Nobu's previously Japanese American neighborhood is feeling the effects of ethnic flight and the new population, primarily African American and Mexican, leave him feeling ethnically threatened. He complains to Masi that "all the Nihonjins [Japanese] moving out...This place is a dump, Mama. Neighborhood's no good. Full of Colored people"[62] and continues to wax on about the different ways he has been emasculated, shamed, or disenfranchised. Included in his litany to Mama is the humiliation of being bossed around by Shig, his boss and a fellow camp member who is his intellectual inferior and never listens to him—one of many indignities he must endure because of the war. With regard to the neighborhood woes he mentions here (but among his general complaints, as well), Nobu communicates concern over the "disappearance," what he is experiencing as "removal," of Japanese Americans from his home base. But significantly, there is also a suggestion that the/any remedy for this ethnogendered angst lies in Masi's identity.

This conflation occurs consistently in Nobu's indirect scapegoating, of course; suspicions about Masi's past and present behavior are frequently mentioned alongside gripes (his changing neighborhood, spilled coffee) that in actuality have nothing to do with her. But this association also works in the ways that Masi as mother can purportedly *assuage* Nobu's ills. In other words, Nobu's shame (as a Japanese American unable to [1] protect his family from the camps, [2] obtain a loan from the bank, or [3] secure the economic future promised to him from Masi's father vis-à-vis a defaulted dowry) typically manifests in cruelty, but also as attacks on Masi's gendered status. For example, while Masi/Mama moves further into a maternal role in terms of the nurturing she offers Nobu in this scene, she also eventually comforts him in less maternal ways. After several lines in which she reminisces about/reminds his faltering confidence of the vital (and optimistic) man he used to be while working on her father's farm, she also reminds his ego that before internment he was indeed strong, spirited: "You and Papa. Proud."[63] Directly following their bolstering exchange, one in which the play's maternal subject has (temporarily) "made it all better," Nobu's interest in marital sex suddenly ends its fifteen-year hiatus. Masi responds to Nobu's economic- and neighborhood-centered anxieties, by reminding him of his precamp (gendered and ethnic) vitality and power. Immediately after she performs this emotional labor he asks for and she provides a massage. Tellingly, it is in this scene that Masi takes a momentary gendered/political step back to the two or three

forward she recently performed, and gives in to Nobu's requests that involve her submission and/or servicing his needs—*a Masi-performed submission* that *facilitates* his sexual performance. The conversation in which a now elevated Nobu requests a massage occurs alongside his request that she spend the night, make him her "hot rice and raw egg," and in no uncertain terms, have sex with him.[64] In other words, anxieties over (1) his father-in-law's failure to set him up in business; (2) Nobu's own failure to overcome that setback; and (3) his racially/racist-based fears about the demographic shifts of his formerly Japanese American neighborhood find solace in Masi/Mama's emotional and physical labor. Not coincidentally, this break in what has been Masi's own steady withdrawal—a break in which she provides an ethnic- and gender-based ego boost and quiets his fears—is an exercise that facilitates Nobu's first sexual initiation in fifteen years.

In addition to a Nobu plagued by his daughter's reproductive betrayals, the play's final scenes reveal a Nisei patriarch about to lose a wife who perhaps never loved him, a wife who also may have shamed him in sexual and even political terms (i.e., a possible dalliance with a Nisei war hero forty years ago, but also with her new, demonstratively emotional boyfriend who adheres to egalitarian gender ideologies). While the perceived miscarriages that inform Nobu's ("failed") subjectivities convene around resistant sexual/domestic ideologies of the play's two mother characters, it is important to note that maternal subjectivity is offered both as the *reason behind* but also the purported *remedy* for ethnogender trauma.

In what is the play's most sentimental scene, a desperate Nobu has finally swallowed considerable pride and attempts in earnest to negotiate a reconciliation with Masi—an unsuccessful attempt that culminates when he literally begs her return. During this climactic exchange, Nobu (for the first time) occupies a transparent, indeed childlike state, of vulnerability, and his language explicitly constructs Masi and the value/salve she potentially offers as maternal subject. He has been privately plagued by the unreachable, falsely promised prosperity, like so many postwar Nisei, but he has also been publicly shamed by a daughter whose sexual and domestic ideologies appear to him as, at best, disrespectful, at worst, assimilationist and sexually deviant.[65] He is broken by the racism and marked Americanness that has continued beyond internment, but also from a wife of four decades who has left him and will likely not return. Yet Masi and new mother Judy may also hold the key to a psychosocial recovery. Unlike childless Kiyoko or Marsha (who both attempt tirelessly but unsuccessfully to serve or heal Nobu), Judy as mother and Masi as mother exist not just as a source of anguish but offer potential panacea. Comments such as Masi's earlier entreaty of "Judy...he needs you"[66] point to the latter's purported ability to heal an aching Nobu. When the two finally meet face to face in the second act, Gotanda offers

an even stronger suggestion of Judy's power/responsibility in her role as mother. In a father-daughter-grandson scene that essentially launches the Nobu "transformation" that will crest in the play's final climax, Judy (and only Judy) gives it to her father straight when she tells him that "everybody marries out," and that "Sanseis don't like Sanseis." When Nobu tries to contradict or shut her argument down, she tells him (almost cruelly), "You're gonna die out." Her continued admonition that he'll be "extinct" and "nobody's gonna give a goddamn" work in some way as a kind of tough love that breaks a formerly xenophobic and racist armor.[67] With candor and without apology (only) Judy speaks to his greatest fears: a dread regarding the public shame generated by gender-specific misdeeds, but also his own (cultural and literal) continuity, the responsibility for both resting with the play's maternal/reproductive characters. It is following this exchange with Judy that Nobu will "awkwardly hold his grandson for the first time" and, while the rest of the stage darkens, "remains lit holding Timothy [and] begins to hum the traditional Japanese lullaby 'Donguri,'"[68] the same lullaby his father sang to him. It is Judy, in other words, who gently "delivers" her father to a modicum of personal/political equanimity, one in which he can redefine heritage and his own ethnogender subjectivity. Said another way, operating as both an "If it's not one thing it's your mother," as well as a "Mommy make it better" transaction, Gotanda presents a male protagonist whose identity-based conflicts and trauma emerge often directly from Nisei and Sansei maternal subjectivities.

But it is Masi who most powerfully emerges as Nobu's maternally coded crux *and* potential (but unfulfilled) remedy, particularly in the play's final scenes. For example, as she tries once again to alleviate Nobu's bitterness regarding her father's inability to set him up in business, Nobu hails her as Mama quite literally. Riling himself up despite Masi's attempts to calm him, he complains:

> I told Shig you can't keep stocking all that Japanese things when the Nihonjins are moving out of the neighborhood. You gotta sell to the Mexicans... Think Shig listen to me? He's the big store owner. The big man. If I was running the store it woulda been different. Different. (*Pause*) And your old man said he'd get me that store... He promised he could set me... up in business or anything else I wanted to do.[69]

The content and placement of Nobu's angry musings on Shig's disrespect, a vanishing neighborhood, and the lost income (and power) manifested by the war arguably stem from (or at least begin with) his father-in-law's reneging on promises for start-up capital. In this way, Nobu's complaints posit a relationship between who he is, who he *could have been*, and Masi's gender-specific

culpability. As a kind of "I coulda been a contender" moment, this scene implies that his dismal state of affairs (forty years of losses and humiliations) are (perhaps illogically) conflated with Masi's father's failure to deliver an unofficial dowry—he was supposed to "set [him] up."[70]

Further, any class-specific anxieties plaguing the retired produce man at this time might also be reinforced by the employment status of his wife and daughters. While as a housekeeper Masi does not boast the more professional occupations of Marsha and Judy, she is nevertheless employed. And as a dental hygienist and teacher, respectively, Marsha and Judy achieved some degree of higher education, an accomplishment that escaped the man who could not even assume a modest management position in Shig's store. This staged gender differential with regard to employment reflects offstage realities. Using the term "APA" to designate Asian Pacific Americans, Gordon Chang explains: "Because APA immigrant women often are initially more 'employable' than their husbands, the traditional power relationships between husband and wives and between parents and daughters" often experience disruption. While "the disruption of traditional patriarchal dominance may ultimately be a worthy goal," he continues, "family disruption caused by gender differences in employability has resulted in family stress and even increases in domestic violence directed at APA women." In other words, the increased opportunities that "may enhance the roles and opportunities of mothers and daughters" also bring with them legitimate, family-centered "social costs."[71]

Any discomfort Nobu experiences over class-based failures nod as well to latent anxieties regarding his *own* assimilation. Admittedly, Judy's and Masi's romantic and maternal choices suggest most obviously (for Nobu) unsettling moves toward Western codes of behavior and away from Japanese American ideologies. Nobu's *own* latent assimilation can be understood in the context of class-based aspirations. Despite their failure to manifest, his aspirations exist and can further be understood as a uniquely Nisei, postwar assimilation of American middle-class identity. In a description of his assimilating matriarch in *Fish Head Soup* (1991), for example, Gotanda told interviewer Robert Ito that she is both "proud of being Japanese and Japanese American and at the same time she also buys into the idea of being a second-class citizen." The character of Dorothy, he suggests, "believes something is happening...in white culture that is perhaps...better and that any kind of alignment with it gives you a certain stamp of credibility. It's a very complicated psychological mind-set...where there's a strong love-hate relationship with the dominant white culture."[72] A kind of double-consciousness, this ambivalence is certainly not new (or unique) to multiple ethnic-American communities. Indeed, the anxieties Nobu feels regarding a threatened Asian identity in his offspring contradict the (arguably assimilationist) actions of a man who

names his daughters "Judy" and "Marsha" (a typical phenomenon in immigrant parents who want their children to "be more American," but "*not too much*"). Unlike *Fish Head Soup*'s Dorothy, however, Nobu's own assimilation-fed shame is rendered predominantly from a class-based subjectivity. When taken together (1) the emotional torture of the bank scene; (2) his shame over failed promises and absent achievements that result from Masi's father's economic crises; and (3) a life spent working as a "produce man" rather than an independent farmer (or even store manager, such as Shig) generate decades of class-based shame, a shame arising from the failure to achieve what is constructed as an American narrative of class mobility and middle-class status.[73] While Nobu's end-of-life anguish is undoubtedly a function of racist and xenophobic frustrations (over his lost neighborhood, the "lost" Yonsei grandson Judy deprived him of), his troubles are also undoubtedly class-based and sourced to some degree in the employment status of his wife and daughters, not to mention the failure of Masi's dowry promise.

In this scene as in many throughout the play, the key that unlocks Nobu's psychosexual and sociopolitical prison rests most powerfully with Masi performing a particular kind of maternity, one that was "promised" to him literally (vis-à-vis his father-in-law) or unofficially, through a cultural appreciation for tradition and patriarchy. To feel better about (1) himself; (2) the world at large; (3) racist Whites; or merely (3) his (limited) financial/professional options, Masi and Judy would need occupy a more traditional gender role that aligns with conservative domesticity, but also avoid a maternity invested in Western/Americanized paradigms. Consider, for example, Nobu's choice of words after describing to Masi the heart-wrenching scene in the bank from which he hoped to secure a loan, an excruciating episode in which he sat silent and ignored for five humiliating hours:

> How come nobody sees me?... I get so pissed off... I'm shaking I'm so pissed off. And then, and then... I'm filled with shame. Shame. After what they did to me, "*I'm*" ashamed, me. How come I feel like this? How come I feel like this? I'm scared, Masi. I'm scared. Please. I need—.[74]

Relief for the humiliation and subjugation (both of which he voluntarily accepts for five long hours, a fact that surely intensifies his self-hatred) requires nurturing and compassion not from his wife, but from Mama. Nobu continues:

> I tried, I tried, Masi. After the war, after we got out of camp? After... (*Continues.*)... we got out I went to the bank like you told me. So your papa can't give me money, that's all right... I'll do it on my own. I got there and ask the man how do I sign up to get money. He says, "Sit there and wait." I

wait, I wait, I wait five whole goddamn hours. I go up, "How come nobody sees me?"...Everyone is looking...I'm shaking I'm so pissed off. And then, and then...I'm filled with shame. Shame...After what they did to me, *I'm* ashamed, me, *me.*[75]

Nobu's repeated invocation of "shame" is significant here. To begin with, it is worth noting that unlike Nobu, Sadao maintains *no camp associations with Masi*; Sadao has also forgone (or at minimum, resisted) the emotional reserve and patriarchy that Nobu has until now embodied. While Sadao performs an overt (indeed, delights in an) absence of shame, particularly when it comes to public emotions or vulnerability, Nobu—who experienced camp- and race-based traumas of the past forty years *alongside and in front of Masi*—is defined by defensive aggression and sublimated shame. But as is the case with the culpability Nobu places with Masi-as-scapegoat, Nobu also places Masi's "recuperative powers" firmly in the maternal.

Masi's role as Mama (a moniker he often uses in stressful moments) is what purportedly offers remedy to the trauma and humiliation that constitutes the bank scene, if not the past forty-two years. With an acute (and new) vulnerability, he continues:

When I got home I feel something getting so tight inside of me. My guts, tighter and tighter, getting all balled up. How come I feel like this? Huh? How come I feel like this? I'm scared, Masi. I'm scared. Please. I need...you...I need you. You. You know. You understand how it is now. Please, please, you come home, you come... (*Continues. Nobu begins to pull Masi)* home...home now, Mama. Just like always. You come home...just like always.[76]

Needing Mama to make it better, Masi's presence is the salve for his existential, gendered, ethnic failures. Even his use of the word "always" speaks to her perceived ability to provide consistency, stability, security to an uncertain world for an American male who saw his own country betray him. As Nobu concludes his long-awaited, if heartbreaking emotional thaw, he literally can no longer stand up to the previously sublimated shame and anger. Gotanda writes that "Nobu begins to break down, letting go of Masi. Begins to plead." Rather than Marsha or Masi, it is Judy who breaks the emotional turmoil and takes physical action, moving not to support Nobu, but rather to influence Masi. Nobu's breakdown continues and, as Gotanda writes, it is Judy, the Americanized/assimilated daughter who "pulls Masi away [while] Nobu crumbles."[77]

The psychological, political, existential anguish that he finally communicates here—engaging a public vulnerability that he has most likely never indulged in his sixty-eight years—concludes with a tone and words more

akin to a terrified child searching for its mother. Nearly infantilized, and supremely vulnerable, Nobu's entreaties suggest a childlike supplicant who needs Masi as Mama to make it better. The break from his previous adherence to a stoic, cold, patriarchal, at times abusive Nisei masculinity emerges alongside what turns out to be a last-straw slap in the face to his class-, filial-, and ethnogendered anxieties. Nobu's pain can be alleviated only by a comfort that is afforded by Masi, by Mama—gestures that Masi is no longer willing to engage.

Noncorporeal Maternity: Unfamiliar Motherhood from an Unfamiliar Place

With the death of his wife two years earlier, Sadao, like Nobu, is a camp survivor in his mid-sixties who finds himself living alone. The differences between the two men are striking not merely in terms of the former's marked deviation from traditional Nisei masculinity, but more specifically, in the ways that Sadao's overtly sensitive, nurturing demeanor and actions emerge as a kind of maternal performance. For the majority of the play, even Masi finds Sadao's explicit caretaking and implicitly feminized behavior difficult to get comfortable with. Gotanda's and Ott's casting of Sadao also informs a less traditional construct of Nisei masculinity. Coproduced in 1991 by the Manhattan Theatre Club and the Mark Taper Forum, in the latter productions Sadao was performed by George Takei, an actor who is as public about his queer identity as he is about being Nisei survivor of both the Rohwer and Tule Lake camps. Although he did not officially come out until 2005, Takei is known widely as a gay man (his sexual identity was known by most Star Trek fans since the 1970s; and in addition to public membership in several LGBT organizations, at the time he came out he had been in a committed and public relationship with his partner of eighteen years). Not exactly a politically neutral (or professionally safe) endeavor, coming out as a Nisei man—in 2005 and today—marks Takei's deviation from a conservative Nisei masculinity construct as it informs Sadao's own.

Included among the myriad domestic and quasi-maternal duties he performs in front of and for Masi (1) early in the first act, and in obvious contrast to the violent coffee-serving scene between Masi and Nobu just two scenes later, Sadao serves coffee *to Masi* (he waits on her often); (2) while doting on her from the kitchen he prattles about the values of different nutritional options, with almost motherly advice on how she might stay healthy; and (3) repeatedly throughout the entire play, he asks Masi about her state of mind, attempts to get her to reflect on and share her feelings, and shares his own emotional temperature in a manner that sometimes resembles group therapy. The morning following his first sleepover at Masi's

apartment (a platonic couch arrangement following their first fishing trip), the audience sees him gleefully preparing for her an elaborate waffle breakfast (homemade, of course; and in place unnecessary MSG and its dangerous chemicals, we learn, he adds his secret, a dash of prune juice "because it really does add a nice hint of flavor to the waffles if you don't overdo it."[78] A kind of Nisei Martha Stewart determined to feed and serve the play's maternal protagonist, unapologetically domesticated Sadao outmothers Masi as he delivers emotional and culinary succor to Nobu's wife and eventually, Nobu's daughter Marsha, who drops by and is shocked by the presence of her mother's morning guest, his engagements with domestic labor, and the feminist utopian "teamwork"[79] that Masi and Sadao enjoyed on their fishing expedition the day before.[80]

In Masi's experience, fishing is an activity reserved for Nobu alone and, as is also explored in *Fish Head Soup*, one strongly associated with masculinity in Japanese culture. Sadao's gift to Masi of an expensive fishing pole suggests a divergence from traditional Nisei masculinity while simultaneously a maternal/nurturing move—one that contradicts Nobu directly. When Masi interjects, "But this is so expensive. I know how much these things cost 'cause of Nobu. I don't know anything about fishing. He's the fisherman. I just pack the lunch and off he goes," Sadao quickly quells her doubts about cost or difficulty, informing her not just that he will teach her, but "We'll pack a good lunch-I'll make it."[81] With a level of equanimity and nurturance that rivals June Cleaver, Sadao's encouragement and patient tutelage in reel casting that follows is, tellingly, interrupted with an audible recorded phone message from Nobu, in which he attempts to bully Masi to come over, bring more eggplant, and pick up the next batch dirty wash because "I went fishing so I got a lot of dirty clothes."[82] In the context of her Nisei husband, fishing for Masi is an enterprise that merely extends a subordinate domesticity; with her new Nisei boyfriend, it's a gender neutral if not feminist endeavor that provides her an opportunity to receive attention and tutelage from a warm and care-giving presence—one determined to figure out and then meet her needs while also demonstratively communicating his feelings about how wonderful it all is.

Juxtaposed against Sadao's overt domesticity and sensitivity in the waffle scene, a memory sequence between Masi and Nobu interrupts the action. Nobu is lit in a pool of light and in dialogue with Masi lashes out at her for buying (according to him) the wrong fishing hooks. While he remains steadfastly deaf to her apologies and supplicating explanations, his frustration and anger only increase:

Nobu: I get home from the store I expect you to.. Jesus Christ... (*Starting to pace*)
[*She tries to explain, apologize*]

> *Nobu* (*interrupts*): I said size eight. I said size eight hooks! (*Pause*) This is my house. Masi? After I come home from the damn store—here... This is *my* house. (*Silence*)
> *Masi*: (*quietly*): I'm sorry. I'm wrong. You said size eight hooks.
> (*Nobu withdraws. Lights up. End of memory*).
> *Sadao gets up from behind the cabinet with the MSG.*
> *Sadao*: You don't mind, do you? Masi?... Is it okay with you?[83]

In addition to the dramatic contrast in tone and content of Nobu's versus Sadao's engagement with the gendered- and ethnically coded activity of fishing, Nobu's articulation, repeated twice, of "*my* house," suggests anxieties regarding his (precarious) place in the world, his (limited) personal and political power, and how both comment on a failed notion of Nisei masculinity that date back to internment. "*My* house" implies more than a reach for a "king of the castle" patriarchy, but also speaks to Nobu's need to be seen (and self-assessed) as the boss/decider/man-of-the-house who should have been (but wasn't) paid his due respect. The repeated "*my* house" alludes as well to an invocation of homeland, of domestic and entitled space and residency that was obviously denied/stolen in the camp experience. Indeed, it is in this scene that from Masi the audience learns that before internment Nobu was proud, strong, and promised to be an ample provider. Following internment, and following decades of racism and failed attempts at class mobility, Nobu's "domain," like his ethnic pride, is disappearing, nearly nonexistent. Home, "his house" over which he no longer has any control, represents a locus of homeland and (dis)empowered identity that eclipse his grasp; responsibility, blame, and mechanisms for coping all land squarely in the (bad) mothering function of the maternal subject. Of course, it is also no accident that in this same scene, the convivial, egalitarian dialogue and activity between Masi and *Sadao* takes place in *her* house, the tiny apartment that, from Sadao's perspective, generates no anxieties or discomfort and does not prevent him from flourishing in his enthusiastic performance of domesticity.

The feminized, nurturing figure Sadao casts also takes shape from his almost shocking comfort with risking shame/losing honor—a hypothetical that would otherwise paralyze a Nisei man of his generation. His remarkable vulnerability, both during his widow/widower support group and in his account of the group sessions to Masi after the fact, contradicts Nisei masculinity in its emotional verbosity, but is equally remarkable for Sadao's complete indifference to any potential with or concern for public shame.[84] As he recounts to Masi, when in the support group members ask him why he still wears his wedding ring, he tells Masi: " I began to cry. Like a little boy. I remember thinking, 'How strange. I am crying in front of all these people that I don't know.' And yet *I feel no shame*. The room was so still.

All you could hear was my crying."[85] This absence of shame in and of itself marks a dramatic departure from Nisei gender roles, vis-à-vis Sadao as an emotional (and hypercommunicative) figure in the scene, but also in his unapologetic revelation of the moment to Masi, the play's mother character. As Spickard notes, "the Nisei endured a lingering shame that it took decades to overcome";[86] as such, shame as a concept—whether borne specifically from a not-quite-*American* American identity or merely from the general (arguably extreme) focus on honor—is central to Nisei ideology. In his discussion of Nisei shame as a function of postinternment disempowerment and humiliations, David Mura explores what might be understood as a kind of survivor's self-loathing. As Mura points out, while Nisei found themselves imprisoned "not for any particular act," this group of marked Americans found themselves persecuted "simply by the fact of their race," and as such, many simply accepted an "equation...between being Japanese and being bad." Certainly a far cry from the empowered verbal freedom and emotional nakedness of Sadao, Michi Weglyn's description of Nisei "psychic damage" suggests a "'castration': a deep consciousness of personal inferiority, a proclivity to non-communication and inarticulateness." And Edison Uno summarizes Nisei postcamp psychology this way: "We were like the victims of rape. We felt shamed."[87] Sadao's extreme emotionalism and resistance to patriarchal/Nisei masculinity is also an example here of how he nearly trades places with Masi as the play's maternal figure. As the new nurturer on the block, it is his flexibility with traditional Nisei gender roles that help facilitate Masi's political expansion; Sadao's presence buttresses Masi's "rebirth" into a different kind of Nisei mother figure altogether.

Especially crucial to these psychosocial metamorphoses is the fact that Sadao, while a camp survivor, did not endure internment trauma *with* Masi. Nobu did. The humiliation and personal/political (not to mention sexual) impotence Nobu endures from internment trauma, classism, racism, and (what he perceives as) threats to Japanese American cultural survival feed his fear-based inflexibility and fuel his aggression and fault finding with Masi (and Judy) as maternal subjects. The shame that continues to haunt Nobu (as failed Nisei, marked/marginalized American, flawed provider, potential cuckold) is absent in Sadao, not merely from Sadao's ability to engage fluid Nisei gender constructs, but in psychological terms, may be because his own camp-oriented trauma did *not* take place in front of Masi.

As two Nisei men within three years of each other, Nobu and Sadao are both members of a self-consciously identified, ideological consistent community. As such, both would logically be expected to adhere to similar paradigms of ethnogender identity. David Yoo writes: "Because of their temporal affinity, [Nisei] experienced much of life together and clearly

had a sense of *generational consciousness* despite variation based on factors such as gender, class, and region"; even after internment and the immediate trauma of the postwar years, "subcultural and institutional structures that were instrumental in setting patterns for coming into one's own" remained. For Nisei, in other words, "generational identity was significant, steeped in common experiences and historical circumstances that *infused self-identity and group identity* with an immigrant-centered and racially circumscribed environment."[88] For Sadao, a "racially circumscribed" and "immigrant-centered" environment, however, does not seem to dictate a self-identity that conforms to a preexisting (inflexible) group identity. It is useful to remember, however, that Sadao did not experience the humiliating/emasculating phenomenon of internment in front of/with Masi. Perhaps consequently, the more typical Nisei male emotional reserve and preoccupation with shame avoidance (as performed by Nobu) is not requisite to the more Westernized, at times feminist, construct Gotanda offers in Sadao—a Nisei male who does not need to scapegoat Nisei motherhood. In his discussion of Nisei group-oriented behavioral influence over the individual—and in particular, a very anti-Sadao emotional detachment consistent in Nisei masculinity— Henry Yu writes: "[T]he attitude of the marginal Nisei" included being "integrally connected to [one's] Japanese background," alongside "feelings of self-consciousness and personal detachment."[89] Quoting Nisei sociologist Frank Miyamoto, Yu notes that these "characteristic traits of the second generation Nisei" suggest that while

> the Nisei might be "thoroughly American" in culture, their "psychology" differed from that of most Americans. There were varying degrees of 'reservation, inhibition about saying things directly to others, and self-consciousness that distinguish us from other Americans of our class.[90]

What to make, then, of Sadao's enthusiastic divergence from an oppressive Nisei patriarchy, one constitutive of Nisei masculinity and one that Nobu retains as if his life (or ethnic survival) depended on it? In diametric opposition to Masi's husband, her boyfriend (who is also a male postwar, postinternment Nisei survivor) performs acts of nurturing and a very *un-- *Nisei embrace of demonstrative emotions (not to mention his break from an obsession with shame avoidance); these departures suggest a Nisei masculinity not invested in *group-dictated* gender paradigms. This departure, in other words, nods to a newer and more flexible maternal construct since (1) Sadao's performance itself mimics maternal labor in his caretaking of Masi and in (2) the dissenting political position of a Nisei mother who dramatically *chooses* this maverick (more Western) Nisei as the man to replace old guard Nobu.

While Nobu's aggression toward Masi's (not to mention Judy's) maternal "failures" contrasts Sadao's quasi-maternal dotage, an additional reason explaining the disparities between the two men nods to a personal-political flexibility in Sadao that emerges specifically from class identity. As the play's front matter indicates, Masi's new beau is a retired pharmacist, a professional vocation that arguably allows more psychological security in terms of his own gender and racial subjectivity and in his role as provider. In contrast, the cruel/aggressive example Nobu performs (a retired produce man with crushed dreams of entrepreneurship) suggests an anxiety surrounding the place he occupies in a world that has displaced him, robbed him of a financial future, and continues to invisibilize him. While the race- and gender-based traumas that continue to plague Nobu facilitate his aggressive scapegoating of the play's mother figures, Masi and Judy, the absence of these same race- and gender-based anxieties in Sadao can be explained in a camp experience that did not involve Masi, but also involves a postcamp class privilege that eluded Nobu. As a US–born Japanese American male, in his achievement of a promised "American dream," Sadao's class-based success enables a flexibility (if not growth) in gender ideologies, with the result being a Nisei man who is emotionally vulnerable, but also feels no need to scapegoat Masi-as-bad-mother for a plethora of class-, race-, or gender-based anxieties.

Finally, while Sadao's quasi-"maternal performance" is relevant for its reinscription of Nisei male identity, it also hints at a construction of a maternal subjectivity not reliant on biological gender. Indeed, this move toward a biology-free construct of maternity is one that Gotanda employs as well in *Fish Head Soup*. Papa Iwasaki, in his various states of dementia, receives consistent care from his eldest son Victor. Unlike his younger brother, the son who attempts to racially pass (as both Italian and Latino) and is represented as being ashamed of his ethnic identity), Victor is constructed as an ethnically innocuous son from Papa's perspective. Tellingly, it is also safe and dependable Victor who assumes *all* caretaking responsibilities for his infantilized father while the play's "flawed Nisei mother" Dorothy deviates from Japanese American gender ideologies on several fronts, and embraces unapologetic assimilation on multiple levels. Like *Fish Head Soup*'s Victor, a biological male who performs for his father nearly every maternal function save for reproduction, Sadao suggests a noncorporeal maternity that resides in the fluid interstices of gender and ethnicity. In articulating a supportive, protective affection for Masi, Sadao's maternally inflected counterexample to Nobu—directed as it is toward Masi as the purportedly "bad mother" figure—suggests a less essentialist understanding of motherhood that resists patriarchy, gender binaries, and even biologically informed rubrics of identity.

REAL BODIES ONSTAGE

To a certain extent, the bodiless maternal construct that Sadao conjures also recalls the paradigms of noncorporeal reproduction offered by Rachel Crothers' adoption narrative at the turn of the century in *A Man's World*. Indeed, the utopian mutual-mothering enterprise suggested by Cheryl West's Madear and Raisa, not to mention Uhry's Hoke as quasi-mammy, also nod to notions of mothering that exceed rubrics based in essentialist discourses of race, gender, and biology. As a text that compulsively testifies, the maternal body can function as a powerful, resistant counternarrative in its ability to complicate often mutually constitutive hierarchies of identity. Removing the physical form from a semiotics of motherhood, nurturance and reproduction generates discursive opportunities for more progressive subjectivities as they are represented/performed. This is a good thing. But the moves away from biological motherhood engaged by these playwrights—not to mention the more directly transgressive motherhood offered by Gotanda's Masi and Judy—are represented from a broader context of dramatic realism and in this way, may lose political efficacy.

Realism makes available a potential intellectual lulling, specifically from the standpoint of Aristotelian catharsis, that theoretically leaves the spectator moved, satiated, and without the motivation (or thought) to critically engage the narrative at hand. Liberal-Humanist-inspired notions of (stable) reality, linearity, and unified subjectivity work in tandem to generate ideology through representation. Even in otherwise powerful or "moving" narratives that speak for and rearticulate possibilities on behalf of marginalized peoples, dramatic realism can retard or worse, prevent a critical engagement that, for example, Brechtian epic or more expressionistic modes encourage.

Is a semiotics of gender, race, and reproduction that relies on dramatic realism to tell its maternal story less effectual? For Gotanda, the maternal hosts a near pathological response to individual and group anxieties invested in postinternment-camp trauma, ethnic hybridity, and conflicting concepts of American-ness. And as the figure responsible for the ideological shaping of future generations—not to mention potential "dangers" posed by her choice of sexual/reproductive partner—the mother is understood as an ethnic gatekeeper of racial identity and cultural continuity; maternal subjectivity, in its broadest sense, emerges in *The Wash* as the centrally contentious, portentous site of race-based angst. Employing dramatic realism in the discursive strategies that problematize this arrangement, however, might also involve, to some degree, a compromise in efficacy. If the mother-domain of family is one of the primary sites in which children become socialized, this usually private sphere of female

power might emerge as a central focus for resistance to oppression. The manner in which the resistant subject is represented, however, deserves attention in addition to the content of her/his dramatic action. Scholars such as Elaine Kim and Josephine Lee have explored the complex ways that representation in Asian American theatre can reconstruct (and can also be defined by) the sociohistorical contexts that themselves participate in essentialized notions of race.[91] A linear, unified, stable subjectivity, as is generated most typically in dramatic realism, makes this representational hazard more likely. Stereotypes based in race often serve powerful purposes in the colonial project and its discourses, and as such it is no accident that so many postmodern and postcolonial texts articulate in varying ways a multiple or fluid subjectivity. Bhabha writes: "An important feature of colonial discourse is its dependence on the concept of 'fixity' in the ideological construction of Otherness. Fixity, as the sign of cultural/historical/racial difference in the discourse of colonialism, is a paradoxical mode of representation: it connotes rigidity and an unchanging order as well as disorder, degeneracy and daemonic repetition." As something that "needs no proof, can never really...be proved," the "stereotype," as a unified subject, exists for the oppressor as a "form of knowledge and identification that vacillates between what is always 'in place'...and something that must be anxiously repeated."[92]

By relying on a coherent and unified subject in its rearticulation of even politically resistant subjectivity, as a performance mode, realism might sacrifice, among other things, the discursive reminders of the marginalized subject's fluidity, multiplicity, and productive complications to external and unified definition. Indeed, one of the latent dangers portended by dramatic realism and its reliance on a unified subject is a surreptitious universalizing of individual experience and identity. For example, as an unavoidably marked American displaced and imprisoned by his own country, Nobu's trajectory of ethnic- and gender-based subjugation is frequently cultivated alongside Judy's resistance to Nisei domesticity. In placing a large part of Nobu's maternally organized conflicts in a more typical parent-child landscape, and from the broader context of dramatic realism, the spectator is offered an Asian American character's crisis invested heavily in parent-child conflict. As Lowe points out, "Interpreting Asian American culture exclusively in terms of the master narratives of generational conflict and filial relation essentializes Asian American culture, obscuring the *particularities* and *incommensurabilities* of class, gender, and national diversities among Asians; the reduction of ethnic cultural politics to struggles between...generations displaces (and privatizes) inter-community differences into a familial opposition.[93]

Yet we might also consider broader questions (and the political implications) of audience reception within a critique of dramatic realism. Dorinne Kondo argues:

> Seeing theater and performance of, by, and about Asian Americans—whether the narrative strategy is realist, non-realist, avant-garde, or some combination of strategies – has among its potential effects the empowering of other Asian Americans. The question of realist representation, then, must take into account not only narrative strategy, but also effect on actual audience members, mindful of an historical context in which there is a general subversiveness in simply being able to see progressive plays by and about people of color.[94]

In Kondo's exploration of "what counts as an effective intervention in our regimes of truth and, more specifically, how we disrupt an Orientalist hegemony," she usefully points out that "the complex politics of pleasure and of 'resistance' when nothing is beyond commodification or beyond the dominant" can have powerful effects on the way spectators "theorize, live, and contest race, nation, and other collective identities."[95] To be sure, one of the most influential and organizing collective identities to influence the daily lives of individuals is certainly that of the mother. And with vast potential for dramaturgical intervention vis-à-vis performers' bodies, casting decisions, and costuming (to name just a few), theatrical performance is an especially ripe field for representational interruption into linear, unified notions of being. Una Chadhuri maintains that within the medium of drama/performance itself there exists a "hidden poetics of alterity"; this particular "consciousness of others" she suggests is in fact "tightly woven into the fabric of the dramatic medium," a medium that (productively) "always also projected into the future, into other times and places of its potential reincarnation."[96]

Despite any limitation on the political worth of a realistic performance text, then, Gotanda's meditations on maternal subjectivity, and its productive engagement with an architecture of identity that relies on essentialisms, functions as a transgressive performance of domestic and political subjectivities. While important plays written by Asian Americans have certainly been in existence long before Gotanda's success with *The Wash*, the majority of the current body of Asian American theatre has emerged only more recently, dating roughly to the early 1970s.[97] In addition to Gotanda and the peer to whom he is most frequently compared, David Henry Hwang, Asian American playwrights such as Diana Son, Edward Sakamoto, Han Ong, Valina Hasu Houston, Frank Chin, Ping Chong, Jessica Hagedorn, Nobuko Miyamoto, Brenda Wong Aoiki, Sunil Kuruvilla, and Victoria Nalani Kneubuhl have seen their works published, staged, and/or recognized with

awards at a rate that is still painfully slow. With the still relatively sparse pool of offerings in the larger canvas of contemporary American theatre, it might be argued that any representation of Asian American drama that gets produced and published achieves some degree of political worth. But to relegate Gotanda's value (or the work achieved by *The Wash*) as merely a function of "visibility" is shortsighted and inaccurate.

While unpacking Omi's and Winant's theory of race, Kondo describes the productive possibilities offered by texts that "historicize and politicize identity formation." In this she refers specifically to (the value in) theatrical representations involving fractured, unstable subjectivities: "Processes of subject formation" that transpires from a "theoretical frame [whereby] identities such as 'race' are unmoored from their seemingly biological foundations," evolve quite usefully into an "unstable and 'decentered' complex of social meanings constantly being transformed."[98] I would suggest that Kondo's positive appraisal of these "deessentializing moves" also works for Gotanda's submission of motherwork and maternal performance. Indeed, whether occurring from biological mothers (such as Masi and Judy) who perform private and public interruptions into the race- and gender-based hierarchies that otherwise organize Japanese American domesticity, or through maternal subjects removed from biology, as with Sadao, Gotanda's maternity expands a maternal landscape that otherwise relies on typically essentialist, frequently patriarchal ideologies and, in the end, advances politically useful alternatives.

Chapter 3

Race and the *Domestic* Threat: Sexing the Mammy in Tony Kushner, Alfred Uhry, and Cheryl West

The figure of the Black Mammy is a uniquely telling construct that reveals much about the culture that produces and celebrates her. In addition to what this performance of African American maternity has to say about essentialized subjectivities based in race and gender, however, this construct also engages deeply embedded sexual ideologies, rubrics that inform and sustain social hierarchies that go well beyond domesticity. In her exploration of staged African American motherhood in plays by contemporary African American women playwrights, Susanna Bösch points out that the figure of the Black Mammy functions as a maternally coded "intermediary" and "interpreter" between black and white culture while also maintaining a presumed innocuousness—an innocuousness that definitively enables her proximity to white employers/owners. She writes,

> The Black Mammy is one of the best-known stereotypes of Black motherhood, whether [she] ha[s] children or not. She is the perfect image of the happy slave who enjoys working for white society... Since women have always been considered weaker and less threatening than men, the Black woman could work much closer to white people than her husband.[1]

Bösch's statement is important on two fronts. In addition to the recurring, reductive articulation of a specifically defined, naturalized paradigm of

ethnic maternity, the essentializing mammy icon also offers worthwhile, albeit less obvious, insight into the discourses of racially essentialized sexuality, most notably as those discourses emerge in support of and reaction to miscegenation anxieties. As scholars of race and American history agree, racist, often animal-like depictions of blacks as they commingle sexually with whites often positively correlate to public debates about black political rights. In other words, racist representations of blacks in narratives featuring blacks and whites as sexual partners appear more frequently and more offensively as the "threat" of black political agency increases.[2] The results of these miscegenation anxieties reach farther than a troubling and offensive discourse to be found in film, literature, cartoons, and theatre. Until the US Supreme Court ruled otherwise in 1967,[3] many American states still explicitly prohibited interracial sexual contact or marriage on moral, religious, and sometimes biological grounds.[4] The unsurprising essentialization of race and more specifically the racialization of sexual desire (what Elisa Lemire calls "the invention of 'race' as a set of traits that are more or less sexually desirable") follows.[5] What usually saves the Black Mammy/White dependent relationship from posing any threat to discourses of racial purity is the literal or figurative infantilization of one or both of its subjects. But what happens when this threat, whether explicitly or covertly, is not bypassed?

As a touchstone of African American motherhood in the American cultural imagination, What Patricia Hill Collins calls an "image [that] represents the normative yardstick used to evaluate all Black women's behavior,"[6] the Mammy is especially relevant to studies of stage and performance; among other reasons, as a/an (original) product of minstrelsy, the construct emerged specifically from (and was solidified on) the American stage. Judith Williams suggests, for example, that this portrait of black nurturance and "favorite of sentimental literature"—typically represented as "fat, black, and kerchiefed"—is, along with the Jim Crow construct, indelibly "linked to the minstrel stage."[7] Alfred Uhry's 1987 drama *Driving Miss Daisy,* Cheryl West's 1999 comedy *Jar the Floor,* and Tony Kushner's 2002 musical *Caroline, or Change* all incorporate analogous patterns of the nurturing person of color caring for a White Jewish subject as the latter is constructed as a qualified companion-in-oppression. These three texts attempt to resituate the performance of black nurturance while specifically reworking that maternal construct pervasive to Western drama: the Mammy. After briefly unpacking the ways that recent scholarship understands this construct, this chapter looks at these three performance texts and explores the ways that they interrogate both the construct itself and the Mammy-white charge dyad that it negotiates. With this analysis I suggest that even those attempts to progressively complicate models of black mothering—some quite self-consciously, as in

the case of Kushner—often rely on existing paradigms of oppression. Rather than redefining the power imbalances they critique, they often merely reorder them or worse, rely on articulations of essentialized, race-based sexuality that unavoidably inform the maternal performance they signify.[8]

NURTURING BLACK MATERNITY: HISTORICAL CONTEXTS, POLITICIZED INTENTIONS

A ubiquitous caricature of black nurturance, the Mammy deserves attention as a persistent deployment of essentialized motherhood. Chief among the characteristics constituting this construct are a biologically determined altruism and an "earthiness" that endows the caregiving subject with an inevitable "gift" of knowing how to serve a usually privileged charge, all while keeping her own needs and/or those of her family at a distance. Jacqueline Foertsch points out that this "dedicated, capable, and vital" character, an archetype she terms a "servant-savior-savant," has a "talent and wisdom" that supports the white characters' lives, success (particularly in the face of trauma), and demonstrates "terrific skills" and a "rare knowledge." This array of "talents and wisdom" has historically enabled the survival/vitality of the Mammy's white counterparts, but also historically performed a service that "emphatically downplayed or, worse, denied" the mammy's individuality or needs "through authorially enforced self-sacrifice."[9] Couched in what is commonly represented as a heartwarming, voluntary, presumably mutually beneficial exchange between nurturer-of-color and dependent white recipient, the result of this heartwarming relationship then typically produces the education of or gained insight by the privileged charge receiving care.

While analyses of the mammy-dependent dyad are important in their own right, it is crucial to consider what if any sexual tensions exist within texts representing this relationship. Frequently (positively) correlative to cultural anxieties surrounding miscegenation, as the one person of color who works so closely with whites this maternal construct is supposed to be anything but a sexual threat. The Mammy's asexual persona has motives (and ramifications) for black gender ideologies as well as white. For example, Collins points out that "[t]he mammy image buttresses the ideology of the cult of true womanhood"; for this Victorian-inspired, rigidly defined gender ideology organizing the sanctioned behavior and values of white women, "sexuality and fertility are severed." While "'[g]ood' white mothers are expected to *deny* their female sexuality," Collins suggests, "in contrast, the mammy image is one of an *asexual* woman, a surrogate mother in blackface [with] historical devotion to her White family."[10] In other words, the cult of true womanhood's gender binary supports the neutered status of the "safe" Mammy; and as a race-based, reductive sexual rubric it also sponsors

(equally essentializing) gender ideologies specific to black women and white women.

Historian Catherine Clinton, who contends that actual antebellum "mammies" were far from common, explores both the semiotic and material relationship between the emergence of the Mammy and the existence of interracial sexual contact between blacks and whites—in particular between African American women and white men. Clinton suggests the mammy "was created by white Southerners to redeem the relationship between black women and white men within slave society in response to the anti-slavery attack from the North during the antebellum period."[11] In other words, as criticism over and tensions surrounding sexual contact between blacks and whites increase, so does the existence and repetition of the Mammy.

Retrograde portraits of the Mammy might seem a model of a bygone era, but recent examples of African American mothering-for-hire suggest otherwise. While artists such as Betye Saar and Michael Ray Charles have used the visual arts to counter this obliging and sexually innocuous portraiture of black maternity,[12] twentieth-century American drama is still largely defined by nurturers such as those found in *Uncle Tom's Cabin's* Aunt Chloe and *The Little Foxes'* Addie.[13] From George Aiken in the former and Lillian Hellman in the latter, theatre audiences are treated to a nonthreatening person of color who is allowed to work closely with her white superiors in a trusted and quasi-filial role. Importantly, unlike the Jezebel and Tragic Mulatta, this equally reductive confluence of race and sexuality never approaches a performance of eroticized subjectivity; it is *because* she is a sexually neutered subject that she is allowed to become a pseudo-family member and occupy the most important role in a white child's life: a trusted source of maternal labor delivered with a palatable tenderness.

The degree of consistency with which depictions of the Mammy occur—but also the changes the construct undergoes—reveal much about the politics behind her existence. In addition to incorporating speech patterns marked by ignorance and malapropisms, early representations were defined, like today, by a temperament characterized as invariably cheerful and a large physical shape (although at times, as Lisa Anderson writes, in her earliest form she was also represented as animalistically sexual, differing from the neutered subject that characterizes the construct today).[14] Exploring specifically the corporeal form assumed by this icon of black maternity reveals much about the culture(s) that produce(d) her.

In her Introduction to a special issue of MELUS devoted to the black body, Carole E. Henderson explains the significance of applying a "critical optic to the flesh, for it is through this medium [this flesh] that the soul is tortured, distorted, maimed, and likewise healed." While Henderson does not reference the Mammy specifically, we might consider her adroit contention

regarding the black body as a politicized text: "For as long as there has been an America, the bodies of black folk have been co-opted by language and images meant to distinguish their presence as American citizens—indeed human beings—within the context of global body politics." By virtue of her ability to literally, physically move freely between two worlds (the restrictive world of the whites who employ/own her as well as her own), not to mention her neutered sexual status (particularly when juxtaposed against the eroticized Tragic Mulatta or Jezebel), reading the Mammy as a black body functions as a revealing testing ground for what Henderson describes as "the syntactical structures of race, class, gender, and sexuality, and the signs and symbols that support these systems."[15]

Kimberly Wallace-Sanders considers the ways that the Mammy has entered the cultural memory and changed over time and, further, how that ethnicized figure of "ultimate maternal devotion" suggests the ways that "myth, biography, fiction, history, and material culture merge in a dispute about race [and] motherhood...in American culture."[16] Investigating what she contends are the "earliest fictional characters displaying characteristics consistent with the mammy type," she looks at George Tucker's 1824 text *The Valley of Shenandoah*.[17] The novel's Mammy character Granny Mott is described as mulatto and possessing an attractive "yellowish complexion with delicate and raised features"; as Wallace-Sanders suggests, although this Mammy construct is eighty-four, and to look back when readers initially encounter her, the text implies that in her younger years (when she worked for several generations of the owner's family as Mammy) she was physically "quite attractive."[18] A far cry from the darker skinned, often physically large, sexually innocuous Mammy that will follow Granny Mott over the narrative course of the next 190 years, Tucker's Mammy construct deviates from the neutered versions that would quickly constitute the norm.

The timing of Tucker's (nonneutered) Mammy figure is particularly relevant: In the first two decades of the nineteenth century, the threat in the (white) cultural imagination of unregulated (black-driven) interracial sexual contact is significantly less than the perceived threat that will be felt by whites in subsequent decades—an increased anxiety that will parallel similar increases in military/federal interventions into the "peculiar institution" (not to mention increases in abolitionist activity). With more European features such as her lighter skin color and "delicate" features, Tucker's Mammy character is obviously the *product* of miscegenation; but further, as a major character (she is the narrator) who digresses from the sexually nonthreatening black mother figure, one who works so closely in the white home with whites (in part, *because* of her neutered status), the younger Granny Mott is an anomaly. In other words, it is the proximity of her work with whites (as Mammy) alongside the explicit physical attributes that code

her as potential sexual object to the white males who employ/own her—deviating significantly from the Mammies who will follow. Wallace-Sanders writes that this lighter-skinned and attractive construct "virtually disappears after 1854."[19] Tellingly, however, in 1824 the perceived "threat" of black political agency (or threat to the institution of slavery) is observably different (and less) than what it will progress to with the approaching US Civil War.[20] With a less (racially) threatening political landscape, the Mammy is tolerated/allowed to be represented as a sexual subject who is also free to work closely with (and as having reproduced with) whites. As the political landscape proves more "threatening," her sexual subjectivity decreases/disappears, making her proximity "safer" toward the miscegenation anxieties that surround her—anxieties that correlate positively to increases in black agency.

Into the next century, dyads constituted by black maternity and white charges also generate a heightened sensitivity (if not paranoia) directed toward interracial relationships: culturally determined taboos increased in waves of intolerance that paralleled (qualified) increases in African Americans' enfranchisement.

In her exploration of the Mammy and its employment in and contribution to racist ideologies (and legislation) through the civil rights movement, Micki McElya discusses the 1916 case of Marjorie Delbridge. This Chicago "tabloid media event" involved Delbridge, a fourteen-year-old white girl, who was forcibly separated from her adoptive mother Camilla Jackson, an African American woman who had raised her since birth. As McElya explains, the sole reason for Delbridge's removal from her mother's custody, as explained by the juvenile court judge deciding the case, was "racial difference" between the child and Jackson, a woman he referred to as Delbridge's "mammy." Significantly, mother and daughter resided in an overwhelmingly Black neighborhood. McElya writes: "[The case] illuminated graphically the racial constraints on the ideas of sexuality, domesticity, and motherhood that lay at the heart of early-twentieth-century mammy narratives."[21] In this massively sensationalized case that took place over several months, white Delbridge and her African American mother Jackson

> were confronted with the fiction of faithful slavery and *the limits of white tolerance of interracial maternal intimacy*. Coming in the midst of the Great Migration of black southerners to northern cities both the case itself and the publicity it generated were motivated by increasing popular and institutional concerns about...Chicago's supposed 'Negro problem.' *These concerns coalesced in Progressive anti-vice crusades, which focused on the city's expanding "Black Belt" as the source of prostitution, crime, and interracial entertainments.*[22]

The white public's conflation of African Americans with vice, in particular promiscuous or illegal sexual practices, is not new, certainly. But the positive correlation between (1) concerns over interracial contact and (2) rapidly increasing numbers of African Americans leaving the American south for Chicago (Chicago's "Negro Problem"), all against a backdrop of an assigned "lasciviousness" to a black population, seems especially crucial here.

In particular, we might note Chicago's unease with interracial contact between Blacks and Whites buttressing (and buttressed by) essentialists narratives of black sexuality and the way that relationship is drafted into maternal ideologies. Arguably "the zeal with which local members of the Southern Women's club rushed to claim responsibility" for Delbridge[23] speaks to a rescue narrative, one in which an adolescent white girl is forcibly removed from the only mother she has ever known in order to protect her from an increasingly present, lascivious, "threatening" black population (in this case, vis-à-vis the Great Migration). As Chicago's black population (and presumably, visibility) increased, the social anxieties generated by their presence, anxieties deeply embedded in narratives of so-called dangerous black sexuality, find focus in maternal subjectivity/the Mammy. Jackson's mothering is not under the microscope; her skin color, her neighborhood, and what both would mean, ostensibly, to an innocent and vulnerable white girl are. This relationship/tension is repeated throughout the century, most famously in *Loving v. Virginia*, the 1967 US Supreme Court case that would deliberate the relationship of black-white sexual contact and American constitutionality.[24]

Nevertheless, on American stages, any earlier incarnations of the Mammy construct that incorporated varying degrees of overt sexuality were ultimately replaced by typically neutered subjects audiences expect today. The consistency of these "sexually safe" icons, however, is also met with occasional attempts to subvert the caricature, particularly with the progress made by artists emerging from the Black Arts Movement in the late 1960s and early 1970s. But while playwrights such as Tony Kushner, Cheryl West, and even Alfred Uhry attempt to complicate the construct, the majority of American theatre in the twentieth and early twenty-first century offers performances of black maternity that are deeply invested in the Mammy—a construct whose sexuality rarely deviates from the jovial, eternally maternal, and asexual subject that audiences would eventually perceive as the norm.[25]

SEXUAL SUBJECT(S): PERFORMING THE (ANTI)MAMMY

Contrary to the critically coded "heartwarming," nearly universal appeal of Uhry's commercially successful *Driving Miss Daisy*, for example, Kushner's *Caroline, or Change* promises no palatable tenderness in its discussion of

race. In part because of the very public nature of its creators' (leftist) politics, and in part as a result of the nonrealist, at times Brechtian forms Kushner and director George Wolfe invoke, *Caroline* begs to be read, sometimes self-consciously, as a more politically combative, "ideologically effective" work. Wolfe's creative association unavoidably influences if not raises expectations of *Caroline* as a politically progressive text vis-à-vis his role as *Angel in America*'s original director, but even more so as the creator of 1986's Dramatists Guild Award–winning *The Colored Museum*; but the specific dramatic form Kushner and Wolfe engage in *Caroline* also shapes the play and the political "work" it sets out to accomplish.[26]

With only a few exceptions, as an art form the musical has been frequently relegated to anything from an oversimplified narrative that exists only to showcase musical and dance performance, or, "the most trivial of theatrical forms."[27] But as recent scholarship increasingly points out, this was not and is not the case for these performance texts that have been typically categorized as less politically astute than their nonmusical counterparts. Indeed, since the genre's earliest phases the politics of race *in particular* have found focus in American musicals. The most obvious form to which the musical's evolvement can be traced is American minstrelsy, the most explicit and long-lasting example of a performance tradition (that continues) informing the race and gender ideologies of American culture. In other words, despite frequent dismissal as "a type of popular entertainment hardly worth study"[28] the American musical has from its earliest inception offered texts that explicitly explore race- and sex-based hierarchies.[29] In this sense, then, Kushner's foray into what is undoubtedly "serious" drama that also happens to include music and song works from a tradition that speaks to provocative sociocultural issues.

Perhaps more compelling, however, Kushner's consistent use of epic theatrical devices and Brechtian performance tropes marks *Caroline* as an inarguably political text, and often self-consciously so. Breaking the fourth wall with direct address to the audience, characters who are not human but rather speaking appliances and a moon, and the spontaneous performance of song itself are all devices that obviously digress from dramatic realism. The Brechtian alienation effect that Caroline repeatedly invokes, a *Verfrumdungseffekt* that interrupts Aristotelian catharsis, prevents spectators' critical torpor, but in that same vein also prevents any suggestion of unified subjectivity—a notion that supports the linearity and teleological ideologies undergirding (an often politically conservative) liberal humanism. Scott McMillin posits that the "instances of [a] multiplied self" at work in epic theatre "put power off balance"; this is one way that "Brecht's theory of estrangement in the Epic Theatre" prevents autocratic catharsis. In song and the repetition within song, McMillin writes: "the actor seeks to become

a reporter of his character's actions even as he plays the character. Brecht sought political explicitness in the estrangement effect." With spontaneous eruption of (nonrealism based) song, what McMillin describes as the "demon" of the political status quo is "released... in outbreaks of doubleness valued for their resistance to linear plot, and the resistance subvert established norms."[30] For Kushner, the text's Brechtian, non-Aristotelian moves enable what McMillin astutely describes as "invasions of subtext [that] turn hidden motives into song and dance [and] the performance of a number resists definition."[31] When those "definitions" incorporate (essentialized) narratives of identity and the marginalizing ideologies that define them, the work of the "mere musical" functions in politically powerful ways.

Set in the winter of 1963, the same year that Birmingham, Alabama's "Bull" Connor, would unleash the violence of police dogs and fire hoses on peaceful demonstrators against segregation, *Caroline* chronicles the lives of the Gellmans and their maid Caroline. Despite eight-year-old Noah's recent motherless status, and as the play hints, perhaps *because of* the recent appearance of his father's second wife Rose, the young Gellman has remained passionately attached to the family maid Caroline, despite her gruff and even cruel objections. Indeed, Caroline's sporadic cruelty toward motherless Noah marks for audiences some of the most obvious departures from the mammy archetype. For example, early exposition informs reader and spectator that an almost violent cancer left young Noah without a mother; contrary to her textual predecessors, Caroline not only bypasses more typical Mammy-inspired and Christian-oriented narratives of "bearing God's will," or suffering life's tribulations with a martyred humility and a turned cheek, she almost sadistically tells Noah that actually, his scientist atheist father is not correct, God does indeed exist and he is vengeful and dangerous. Also motherless as a result of cancer, Caroline angrily sings to Noah that "God make cancer... When cancer eat people, it God eating them; God sometimes eat people like a wolf."[32] Beyond the abrasively cold, frightening nature of her sentiments in and of themselves, her departure from the mammy archetype here stands out for its passionate deviation from Christian-martyr-inspired passivity in the face of suffering. Against God, no less, a force she perceives as malignant and one that takes her destiny out of her control, Caroline's rage is unchecked and equally significant, expressed.

True to her Mammy-predecessors Caroline emerges as the eight-year-old's caretaker and world-wise conscience; also predictable to the Mammy construct, any political awakenings that transpire for Noah result from his dealings with his economically disadvantaged African American maid and mother substitute. Caroline's stalwart resistance to this mode of black maternity deserves our attention insomuch as Kushner attempts to complicate the Mammy paradigm, to be sure. Despite ardent attempts by Noah to designate

Caroline as his emotional sensei and as a source of succor, his family's angry domestic refuses. But the Caroline-Noah relationship also deserves consideration in the ways that it participates in a less obvious, potentially reductive (if ominous) engagement with interracial erotic tensions.

Neither the warm and selfless Berenice of Carson McCullers' *Member of the Wedding* (1950) nor the martyred Lena Younger of Lorraine Hansberry's *Raisin in the Sun* (1959), Caroline (sometimes aggressively) refuses to perform the role of the happy servant and mother stand-in.[33] Noah's near worship of the usually angry maid who is "always on" and "stronger than my dad" easily places Kushner's work within the politically progressive framework most critics and audiences received it.[34] Kushner's portrait of black maternity is represented as a three-dimensional agent who, if mostly unsuccessful, attempts to change or at least express what is wrong with her life and her culture. She is constructed as palpably unhappy and, atypical to the Mammy, she is painfully aware of the ideological and material realities that keep her down.

It is particularly relevant that unlike many Mammy-dependent narratives that precede Kushner, including Uhry's or West's texts, that present infantilized but nevertheless adult white counterparts, *Caroline*'s Mammy-dependent dyad presents an adult caretaker paired with a *literal* child. Since any potential moments of sexual conflict—significant in their existence at all—are shared by an eight-year-old boy and a thirty-nine-year-old woman, audiences see more than an anti-Mammy who refuses to know her place, as Caroline's political resistance approaches a kind of pedophilia.

Kushner sets the first act in the basement, a location that conjures an underground, secretive tenor. The play's initial lyrics of an "underground" recur throughout the play, alluding, of course, to politically subversive activities such as the underground railroad, but also the literal underground where much of the maid's labor takes place, as well as a hidden landscape for illicit activities. Kushner's protagonist clarifies that usually nothing happens underground in St. Charles because there is no underground, geographically speaking. But in *this* house, she tells the spectator, something does happen underground.[35] From George Wolfe's expressionistic choices in lighting as well as lyrics in the opening song, audiences learn that what happens in this basement makes the house "different" and not always pleasant.[36] While the basement's subversive activities take a political shape (Caroline's musical rants often take place here, not to mention her decision to "legally" abscond Noah's one-hundred-dollar Chanukah gift to feed her own children), the potential of unacceptable sexuality is also foreshadowed in language that evokes the taboo.

When eight-year-old Noah first enters, played originally by ten-year-old Harrison Chad, an actor who easily conveyed the character's chronological

youth and by no means suggested any physical or sexual maturity beyond Noah's eight years, important exposition is introduced. In these revealing interchanges between young, white Noah and his adult black caretaker, some of the most sexually latent moments in the play occur. Noah sings of a Caroline who, like the washing machine, are "on" when he gets home.[37] In addition to the objectification of his equating Caroline with an appliance, the longing, slow rhythm of Jeanine Tesori's music potentially insinuates a less-than-childlike subtext. Here Noah also assumes the role of the narrating speaker; he is the subject who explains his own journey for the audience and, therefore, assumes a degree of power. Describing with enthusiasm his own "descent" to the basement, he sheds a perverse light on the highpoint of his day: the sexually suggestive act of lighting Caroline's cigarette.[38] While the act itself is adult in nature, the cigarette further stands in as a sexual, oral substitute. Significantly, Noah does not light the cigarette while it is in Caroline's mouth, but more erotically places it in his own mouth, lights it, and then transfers it to Caroline's lips—an activity that, as with the "secrets" shared by pedophiles and their prey, parents must never discover, Caroline warns.[39] And while the lyrics of the conscience-like, if also Brechtian, Dryer and Washing Machine mention the basement's "groans," "moans," "shivering rumbling," and "cooking the meat right off your bones," Caroline's retort to them both—that at thirty-nine years old, she "should be somewhere being kiss by Nat King Cole"—mark her as a sexual agent, in and of itself atypical to her markedly neutered antecedent forerunners.[40] Caroline, an attractive and slender still youngish African American woman, has a libido; its unfulfilled needs are a frustration she feels free to address with the audience.

In her paper discussing Nina Simone's employment of the Mammy narrative in the singer's 1966 "Four Women," Debra Powell-Wright explains that as "the most well-known and enduring racial caricature of African American women" the Jim Crow–era Mammy icon was created intentionally to "suggest ugliness";[41] with this objective in mind, the construct was typically represented as "dark-skinned, often pitch black, in a society that regarded black skin as ugly" and even "tainted." Powell-Wright continues, explaining that "unlike the black domestic worker or house servant" the Jim Crow Mammy was constructed as "black, fat with huge breasts, and head covered with a kerchief to hide her nappy hair, strong, kind, loyal, asexual, religious and superstitious."[42] While Caroline's deviation from the Mammy's prototypical loyalty and kindness critiques the reductive black maternal construct, equally relevant is her (or the actor who created the role, Tanya Pinkins') physical form, the black female body on stage—one that does not conform to an ugly, neutered, or physically unappealing/safe construct.[43]

As scholars of race, gender, and performance studies have pointed out, the literal act of staging the black female body presents myriad potentials/

dangers for reductive/recuperative narratives of identity—narratives that both rely on and advance ideologies governing the distribution of power.[44] Caroline's corporeal sexuality, existing at all, functions in positive ways that go beyond a mere digression from the neutered subject who cares for whites. Summarizing Audre Lorde's argument about the "fearless and open acceptance of [black women's] own bodies and sexuality" as requisite to overcoming oppression, Wallace-Sanders underscores Lorde's suggestion that this self-awareness (what Lorde terms the "erotic" in *Sister Outsider*) confronts and disallows the "debilitating states of being, such as resignation, despair, self-effacement, depression, and self-denial."[45] In this way, Kushner's protagonist employs a specifically *sexually informed* physically based resistance; in addition to her self-referenced and, at times, performed sexuality, her (often frustrated) sexual state manifests in a black mother character who, although angry, passionate, and frustrated, never approaches passivity, self-effacement, or self-denial.

Particularly as it emerges from a physically attractive female performer, Caroline's explicit frustrations rearticulate black maternity that makes no effort to hide sexual impulses; but also, tellingly, these frustrations are verbally shared with her young charge. As she bemoans her desire for someone "waitin to warm the dark," "wantin to spark my spark," and "needin to share my bed," Noah is directly and repeatedly made privy to Caroline's desire—for her husband's "hot hands" and her wish to have her "soul stroked."[46] This surreptitious, potentially inappropriate emotional/sexual intimacy between the two typically goes unmentioned in what are usually positive critical assessments of Kushner's "maternal alternative." Aaron Thomas argues that as a Mammy figure, Kushner's protagonist is a positive engagement with the construct, "revitalize[ing] and reclaim]ing the stereotype as a real historical force for political change." Accordingly, Kushner resituates the Mammy *from* a reductive caricature based in political passivity/innocuousness, asexual subjectivity, and invariable white alliance to a more empowered agent who refuses to exist as a "cultural symbol" laboring as "a tool of subjugation."[47] Beyond an asexuality facilitating her ability (permission) to work closely with whites, however, as Thomas astutely writes, the Mammy as an icon also historically "performs ideological work by creating an allegedly sexless black female subject...who ostensibly effaces the possibility of white male desire for black female bodies and therefore obfuscates the undeniable histories—and modern realities—of interracial rape."[48] For Thomas, Caroline resists reductive tropes vis-à-vis her chronic unhappiness and frequent anger, a nonalliance to her White employers and her young White charge, but also and most importantly, because of the existence of her sexual past.[49] While sound and compelling, Thomas' read of Caroline as anti-Mammy stops short, however, of considering what if any sexual presence exists

between Kushner's eponymous protagonist and her charge. In addition to a small number of lesser components within her character that at times do nod to more two-dimensional Mammys of the past, the (acutely untoward) ambiguities and tensions surrounding adult Caroline's and young Noah's intimate connection speak to the possibility of reactionary anxieties toward interracial sexual connection.

Perhaps the strongest suggestion of sexual tension between Caroline and Noah occurs after the latter's stepmother Rose decides that in order to teach Noah a lesson in responsibility with regard to money, Caroline is to keep the change found in Noah's unlaundered pockets as she does the family's laundry. While Caroline continues to refuse Rose's half-hearted "charity" (it is supposed to serve as unofficial, inconsistent "raise" as well as a lesson for Noah), Noah essentially and with intense satisfaction toys with Caroline, intentionally planting increasing sums in his pockets before they find their way to the laundry. In a courtship-like pattern, he exercises more than class-based privilege over Caroline, for the first time brazenly asking if he can light her cigarette after he leaves an entire dollar. Like the proverbial wad of cash left on the nightstand, Noah's bequest becomes the price Caroline must pay for her self-respect. When she is finally unable to ignore her own children's needs and a litany of unpaid bills any longer (and finally takes Noah's planted change), his relief and jubilation read more like a lover's euphoria. While Noah's own responses to his gifts of small change continue to be marked by the thrill of his control over Caroline, the latter's discomfort is coded with an almost prostitute-client anxiety.

Consistently departing from the prototypical and acceptable "sass" white audiences and readers typically witness in the Mammy, Caroline's deviation from jovial Aunt Jemima-hood are angry, real, and never safe. It might be tempting to construe any aggressive behavior performed by Kushner's protagonist—or even *Jar the Floor*'s various matriarchs—as a reductive sass endemic to Mammy archetypes of the past. *Member of the Wedding*'s Berenice and *Gone with the Wind*'s Mammy are easy examples of this. In his exploration of the Mammy as that construct differs from the "Aunt Jemima" figure, Bogle notes that while the latter typically emerges as "sweet, jolly, and good-tempered," she is also typically more polite and "certainly never as headstrong" as the former, a sometimes forceful, sassy, presence in her white family's life.[50] But *Jar*'s black mothers and Kushner's Caroline move beyond a cartoonish Mammy-esque feistiness. Most obviously, their sporadic hostility often (or in Caroline's case, always) goes beyond the humorous or palatable. Perhaps most significantly, moments of "headstrong" anger are consistently informed by an explicit awareness of unacceptable living conditions, whether those limiting conditions derive from socioeconomic circumstances, repressive race-based ideologies, advanced age, or the psychoemotional limitations produced by them all.

Tellingly, when Caroline's anger is performed toward Noah, her own children, her confidante and fellow domestic Dotty, and even for the spectator/reader who watches it all transpire, her postsass anger targets economic immobility and inhumane working conditions, but also, occasionally, explores an inadequate sexual existence. For example, Dottie, who is Caroline's confidant and a frequent recipient of Caroline's hostility, is also a peer who is going to night school and enjoying the company of a male companion. As she acutely points out to Kushner's protagonist, the latter is now "hateful," and "sick and shame"; as Dottie describes her dreams for her future and her own active social life, Caroline, she points out, is "drinking misery tea." Throughout this exchange between the two, as Dolly scolds her friend, "[You] lost your old shine," the former suggests that Caroline's overall (negative) demeanor can be explained, in part, from sexual frustration.[51] Indeed, the desires Caroline shares to "never get up, go to work, be polite" are regularly contextualized with fantasies of Nat King Cole and acknowledgments of her husband's absence.[52]

In other words, then, while one participant in Kushner's Mammy-dependent dyad occupies the literal role of child (in this case the employer/dependent and not the Mammy herself), sexual tension—or at a minimum, an unsatisfied sexual existence—operates on several political levels for *Caroline*'s anti-Mammy. In this purportedly and often self-consciously "progressive" musical, one of the two parties employs a *literally* infantilized subjectivity, a remarkable phenomenon when any sexual tensions between Mammy and charge are suggested or engaged. More than just deviating from the obliging, warm, and hypernurturing modes of black maternity of the past, Kushner's anti-Mammy performs a subtle warning of interracial eroticism that veers into the further taboo of adult-child sex.

Representing the Mammy: Beyond the Body, Beyond Gender

As Alfred Uhry's massively successful *Driving Miss Daisy*'s Hoke attests, biological women are not the exclusive agents of maternally coded labor to dependent whites. We might read Hoke as Mammy, for example, in light of the reality that biology and motherhood are not always historically concurrent within Black maternity. In terms of her (or his) white charges, for example, the Mammy as an archetype is conspicuously not connected to the biological process of giving birth or in any way physically specific (to the gestation and birth of her charge). Further, in the earliest form, a Mammy (a slave who was allowed to reside with or nearer to whites and was responsible for white children's care) was not considered a mother to her own biological children, procreating merely for the capital gain of her owner.[53] In this

context, we might consider a Mammy construct as removed from the physical restrictions of binaried gender.

Particularly with regard to the figure's characterization and his dramatic function to other characters in the play, the biologically male character in *Driving Miss Daisy* also engages the Mammy construct. Uhry's Hoke emerges as the prototypical desexualized man of color who works as servant or healer, consistently guiding his white employer through emotional crises as he performs a myriad of mother-like functions. Throughout the play Hoke completes numerous acts of Mammy-esque altruism toward his charge, often after the audience learns of Daisy's son Boolie's failure to perform the very same acts. In addition to solidifying the emotional bond of caretaker and charge for the spectator, Hoke's repeated acts of nurturance to his vulnerable dependent—among them feeding, scolding, and soothing—also underscore another component to the Mammy narrative: caretaking of a charge (who is also an employer/owner) in ways that the charge's sanguilineal family deem too bothersome or inconvenient. This occurs on a stage in which Hoke's own family is verbally referred to but never seen. What initially appears as a touching relationship between whites and their loyal caregivers is instead a venture defined by the parasitic rewards received by nurtured whites at the expense of the "mothering" worker of color. And as with Kushner's *Caroline*, the employer and source of potential oppression is coded as a qualified "other" her/himself. In Uhry's Atlanta Daisy and her married son Boolie are upper-middle-class Jews who reside in a Georgia community inconsistently tolerant of both its Black and its Jewish population.

The gender of the Mammy construct in Uhry's play becomes especially relevant, however, when considering the gender of the charge s/he cares for. Since in typical Mammy narratives the recipient of care is usually a child or in some way infantilized, when the dependent occupies the opposing biological gender, any threat of interracial (straight) sexuality is bypassed. Although I argue here that black men as well as women can both function as a Mammy figure, obviously adult women as Mammies outnumber men. This is not surprising considering centuries-old discourses of essentialized dangerous black male sexuality. But when the Mammy figure *is* male, and further, the charge is an adult white female, the threat of interracial sexuality would presumably exist as a dormant possibility, assuming a straight subjectivity on the part of both characters. In order to combat this so-called untoward subject matter, the play would need to provide an innocuous and altruistic subject in its adult Black male, a role that Uhry's Hoke performs consistently. It might also offer a conciliatorily infantilized white dependent, which Uhry's Daisy does intermittently.

Yet Hoke as Mammy does provide sporadic if telling challenges to this paradigm of black nurturance. Spectators experience a working-class subject

with a political savvy and ideological awareness and agency that contests the broader argument of ideological ignorance purported by, for example, Louis Althusser.[54] Hoke also performs various moments of assertiveness toward an employer/charge who herself is not a literal child and only occasionally childish. Yet, while the audience does witness two adults who are unmarried, presumably straight, and who share emotional intimacy, Hoke and Daisy's relationship never approaches even the remotely erotic. The platonic connection they share as two unmarried adults of similar age, varyingly resistant to infantilization, can be read as progressive in its evasion of miscegenation anxieties, even if it is represented in a sometimes sentimentalized or even maudlin tone. With *Daisy*'s Mammy-dependent relationship, any unease that is undercut, historically, by the caretaker's/Mammy's infantilization (a jovial and neutered black mother figure) is avoided.

Without a doubt, miscegenation anxieties—not to mention the various legislation attempting to regulate interracial sexual contact or reproduction—speak to broader, essentializing categorizations of black bodies as fundamentally different from white bodies. Wallace-Sanders shrewdly points out that "laws against intermarriage," along with general "taboos against respectable social mixing of the races," or even "the different legal sanction against rape...when committed against white or black women" all speak to the most basic assumptions white American culture has maintained about black corporeality.[55] Rereading the Mammy icon as an instrument that responds to and perhaps complicates miscegenation anxieties potentially repositions the legacy of this maternal construct in the American cultural imagination. The purportedly natural, *essential* (potentially dangerous) differences portended by the African American body (a sexualized form, to be sure, but also, always, a body that *could* potentially reproduce with whites and generate offspring that blur hierarchizing color lines) could ostensibly challenge established, hierarchizing binaries.

As numerous literary, drama, and cinema scholars point out, the Mammy figure has been romanticized in American culture as the primary nurturer of her(/his) owners and the owners' children. As Daisy's primary nurturer, Hoke performs many examples of Mammy-informed altruism, but perhaps the most selfless action he demonstrates toward the woman he is paid to care for (and certainly the one coded in the narrative as climactically "heartwarming") occurs during a frightening blizzard that leaves Daisy stranded in her large home, alone and with unknown resources and no help to speak of. Although her adult son Boolie finds the roads too difficult to negotiate and decides to wait until conditions are safer before checking in on his isolated, elderly mother, Hoke heroically and selflessly (and to Daisy's great surprise) checks in on his vulnerable charge, verifying that she is safe and has necessary provisions. Consequently surfacing as Daisy's primary and most

selfless caregiver, Hoke displays concern, but concern that importantly surpasses Daisy's own son—all to better serve the gruff-but-lovable old woman who, in addition to being his boss, is the recipient of his tutelage in humanity (before the play concludes, the former and now reformed racist Daisy will inform her African American employee that he is her "best friend").[56]

Despite the arguably saccharine tone that peppers much of Hoke's interactions with his employer and charge, however, Uhry's text presents a male Mammy who, in addition to possessing an un-Mammy-like political savvy along with the fortitude to frequently act on it, also avoids even the slightest intimation of erotic subtext. Hoke as Mammy serves, educates, and loves his charge/employer, but he escapes political triteness when we look through a lens specifically concerned with what if any sexual tension exists between white dependents and their black caretakers. Most obviously, with both protagonists of a similar chronological age, Hoke and Daisy do not fulfill the most easily met convention of avoiding interracial erotic subtexts—one subject a literal adult and one subject a literal child. We also know within the first few moments of the play that both are presently unmarried. Although Daisy and Hoke have adult children, thereby marking them as subjects who at least in the past have performed sexually, both have also survived the loss of a spouse and as widow/widower, *could* legitimately engage in a postmarital romantic relationship.

Although Daisy occasionally (although only rarely, and always uneasily) descends into a childlike role of dependent, Hoke importantly displays a maturity foreign to his infantilized, Bojangles-like predecessors. For example, when Hoke stops a car ride for a bathroom break, in a scene that reminds Daisy and the spectator/reader that he is after all a "grown man," with unequivocal frustration he asks his employer how does she think he feels "havin' to ax [her] when can [he] make water like [he] some damn dog?" His anger, significantly never intimidating, continues: "I ain' no dog and I ain' no chile and I ain' jes' a back of the neck you look at while you goin' wherever you want to go. I a man nearly seventy-two years old and I know when my bladder full."[57] The deployment of a verbally assertive and mature man—and further, within the discussion of a topic as private and potentially indelicate as expelling his urine—acutely reminds the audience and reader that these are two adults (one Black and one White) who are similar in age and more or less equal in life experience. The potential for even a minor instance of heterosexual romantic tension between the two, especially as they morph into the "best friends" they will be by the play's conclusion, would seem obvious. But the relationship remains invariably platonic, albeit sometimes unrealistically; the emotional connection they share (as two adults, both verbally resisting infantilization) might be read as more progressive as it evades engagement with miscegenation anxieties.

Any sexual-textual unease that is usually undercut by either subject's expression of childishness, sexual innocence, or even political immaturity does not become an issue.

Yet *Daisy*'s success in its avoidance of reactionary treatment to interracial sexual connection is perhaps undercut in the dramatic form Uhry employs to stage his story. The play's heavy reliance on realism, with the notable exception of a minimal set, poses a danger of quietly (or not) reinforcing any ideological missives at work in Uhry's frequently described "heartwarming" treatise on black-white relations in a complicated American south. The good feelings and optimism white spectators are encouraged to feel with the play's conclusion might easily lead to, at best, a compliant or quiescent self-congratulatory catharsis; at worst, this realism and the conclusion to which it leads might generate heartfelt confidence in the essential justice of the status quo, an argument that itself potentially relies on a unified and homogenously articulated subjectivity to make that point. Dorinne Kondo writes: "Realist representation minimizes contradiction. The conventional narrative structure introduces disruptions in the social order, and then through plot and character development—a development that elicits audience identification—the play or text arrives at a narrative closure that re-establishes order."[58] Expanding the arguments of Catherine Belsey and Jill Dolan, Kondo explains that realism "forecloses political possibilities and leaves codes of representation intact." While Dolan sees realism as "politically conservative and inadequate to the kind of materialist feminist theatrical practice she envisions as subversive," Belsey maintains that realism subverts progressive counternarratives to a conservative status quo. For both, however, a "text that problematizes the process of representation, foregrounding contradiction and disrupting easy identification" is key. As Kondo rightly suggests, a powerful mode to accomplish this objective is "through Brechtian alienation effects, calling attention to the theatricality of theatrical production: for example, having the actors address the audience 'out of their roles' or undercutting psychological realism" by any number of nonrealism-based techniques.[59] Unlike *Caroline*'s various engagements with alienation effects—or at minimum, its consistent interruptions of realism— Uhry's text does not use form to productively question the spectator's ideological assumptions. As Belsey suggests, "Classic realism, still the dominant popular mode,... performs the work of ideology, not only in its representation of a world of consistent subjects who are the origin of meaning, knowledge and action, but also in offering the reader, as the position from which the text is most readily intelligible, the position of subject as the origin both of understanding and of action in accordance with that understanding."[60] With a narrative trajectory that heavily implies the eventual, almost teleological political and emotional reconciliation of what can only be described

as a still contested American south, *Daisy*'s reliance on dramatic realism at minimum could potentially influence spectator apathy. At worst, this lulling linearity might act in compliance with a spectator's own participation in the hierarchies Uhry's text purports to critique.

STAGED BLACK MOTHERHOOD, STAGING BLACK AGENCY

Particularly when placed alongside Kushner's politically oriented *Caroline, or Change*, Cheryl West's *Jar the Floor* emerges as considerably lighter in tone as it investigates maternal performance amid four generations of African American women and the Jewish, one-breasted lesbian partner of one of them. While the play redefines reductive Mammy constructs rather than simply offering up, as Kushner potentially does, maternal subjects who fail at their post, West also arguably contends with the potential for staged-but-acceptable sexual tensions between black nurturers and white counterparts, a relationship that altogether bypasses the more untoward "anxieties" of Kushner's more intentionally political musical. Unlike the bulk of the critical reception garnered by *Caroline* and *Daisy*, the majority of *Jar*'s reviews do not significantly pick up any race-based threads of discussion in their mostly positive accounts of the play. Often referred to simply as "a play about a group of black women,"[61] or more favorably, a "hilarious" play in which "West emerges as a master playwright,"[62] or more specifically, a play about "women's struggles with their conspicuously absent menfolk and their ambivalent love for their own daughters,"[63] reviews rarely foray into the territory of black-white relations or the dramatic presentation of two marginalized women, a nurturing Black mother figure and a White, one-breasted lesbian and cancer patient who comfort each other amid their own individual chaos and marginalization. Indeed, analogous to West's public persona as a playwright, the play's critical reception and even its casting would seem to suggest for many a less-than-revolutionary production.

Collective mothering has obviously been a presence in African American communities since slavery.[64] This continuing tradition of shared motherwork, a tradition that emerges repeatedly in *Jar*, surfaces among West's all-woman cast as a feminized, intergenerational, mutually rewarding alternative to the less flexible and usually employee-dependent filial (vertical) organization presented *Caroline* and *Daisy*. The qualified class privilege and economic freedom that the tenure-earning Maydee maintains as an established academic and a homeowner, for example, mark her as an agent who need *not* rely on extended family networks for the professional care of her great-grandmother, the wheelchair-bound Madear. In other words, as is the case with *Daisy*'s Boolie and *Caroline*'s Stuart, Maydee, as well as her mother (Madear's daughter) Lola *can* afford outside care for family

dependents (the elderly mother/grandmother Madear), but they opt not to. West also reveals that Maydee's daughter Vennie, on her way to Madear's birthday celebration, is traveling leisurely with her lover Raisa, all suggesting that professional care of the variably coherent Madear is affordable if desired and further, that the shared care arrangement is voluntary. This communal and feminist caretaking arrangement is further underscored by the fact that Madear's only son does not participate in the care of his mother.

West's *Jar the Floor* features not one or two but three strong black mother characters, four if one includes the youngest, Vennie, as she performs, sporadically, the role of nurturer to her white lover Raisa. Particularly given that West's play is a comedy, less-than-revolutionary or even Tyler-Perry-inspired images of all-female narratives featuring cartoonishly "strong black women" mother characters are a reductive possibility—particularly in a play whereby several generations of black mother-daughter arrangements are characterized by emotional misunderstandings. Women-led family units, however, occupy a very real, inarguably *non*theatrical political and cultural value and West's play certainly engages this reality. Melinda Chateauvert explains the rhetorical and political value generated by "the presence of scholars, primarily black feminists [who] defen[d] the matrifocality of many African American families as a crucial survival mechanism and the result of economic necessity." And "while decrying the 'strong black woman' stereotype as racist and sexist" often makes sense, many of these same notions of black filiality can "send up the emotional appeal to motherhood and the call to solidarity."[65] West's all-woman cast is not only a viable, indeed potentially realistic, construct of family, it is one that casts a kind of emotional and financial agency for each of its characters. Not only are each of West's mother characters emotionally stalwart and financially successful, they achieve the latter in professions that evade the typical landscape of domestic labor that stubbornly haunts the Mammy archetype. K. Sue Jewell writes:

> Inherent in...cultural images of African American women is the belief that they have a proclivity for performing tasks of domesticity, not [only] in their own families, but working for others...Associated with this cultural image is a justification for the meager wages earned by African American women, and others, who work as domestics and in predominantly and historically female-dominated occupations. Therefore, it is believed that the subsistence wages received in these low-income-generating occupations are acceptable and augmented by the intrinsic satisfaction derived by women in these positions, and that they are unable to perform well in other occupations.[66]

Presenting her audience with Lola-as-entrepreneur and Maydee as (eventually) tenured college professor, West offers up matriarchs who deviate from previous models in several ways. Not only is Lola—a quasi-real-estate

mogul—financially independent and the mother of a professional, but the professional woman she raised, Maydee, holds a scholarly affiliation in both African American Studies and Political Science, marking both women as strong deviations from the poor, misinformed, passive maternal constructs that narratively precede them. To be sure, even Maydee's academic specialty casts her as a uniquely informed and ideologically aware subject.

Reductive representations of black maternity regularly conflate (un)official caregivers with an inherent wisdom (if not a noble-savage-inspired spiritual sagacity) in their dealings with the more privileged white dependents who look up to them. As Bogle contends in his discussion of Hattie McDaniel's iconic performance in *Gone with the Wind*, "Mammy becomes an all-seeing, all-hearing, all-knowing commentator and observer." In a nearly superhuman emotional intelligence when it comes to the needs and circumstances of her charge, "it is Mammy who knows...It is she who criticizes or advises, counsels or warns, protects or defends, but always understands"[67] This is a far cry from the confusion, at time humorous chaos, and often poignant miscommunication shared by multiple arrangements of mothers and dependents in *Jar*. In addition to Madear, her daughter Lola, her daughter Maydee, and her daughter Vennie regularly misunderstanding the motives and needs of each other, a certain kind of emotional, professional, and cultural shortsightedness (in all four women, at different times) speaks to a diversity in their lack of insight(s) that keeps them three-dimensional and anything but caricatures.

Tellingly, in one of the most emotionally laden interchanges between the elderly matriarch Madear and Vennie's white Jewish lover Raisa, neither assumes the all-knowing savant status that more typically defines mammy and charge. And between Raisa and Vennie, the text's interracial lovers, West creates a dyad of equals with neither woman occupying a position of emotional/spiritual sensei. Both provide a nurturing, quasi-maternal support to the other in their respective moments of need: Vennie receives counsel from Raisa as the former deals with family stress; Raisa garners support from Vennie as the latter shaves her head in solidarity with her lover who lost her hair due to chemotherapy.

While West briefly engages interracial and even maternal sexuality, she steadfastly refuses any reactionary response. In an early exchange between characters coded as the "uptight" Maydee and her sexually outspoken mother Lola, for example, the former (the presumed "uptight" character) instructs her mother that a lack of qualified male companionship, regardless of race, should simply be remedied with masturbation; Maydee continues, very matter-of-factly explaining to her mother the inherent value to masturbation, informing Lola: "It's safer, cleaner and more expedient."[68] In addition to presenting both women as sexual subjects (importantly, women who

are defined first and foremost throughout the play as "black mothers"), the character coded in the play as "uptight" ends up assuming the less predictable, sexually liberal attitude.

As an out lesbian and college dropout, Vennie (who at times performs caretaking to her lover Raisa) is the youngest of the four generations and is perhaps the strongest deviation from the Mammy. As we learn of Vennie's sexual preference for women before she even enters the stage, her queerness itself can be read as a potential-while-not-perfunctory refusal of motherhood. We also learn that she has had an earlier abortion and further, has no wish for children in the future. As the only white character, Vennie's lover Raisa would be a likely source for rhetorical apprehension or subtextual anxieties surrounding interracial sexuality. Yet West steadfastly presents any conflict surrounding Raisa's biological gender and race in overtly comic terms. Unlike *Daisy* and *Caroline*, no latent (or explicit) tensions surround the interracial relationship itself. Vennie and Raisa are constructed as two adults enjoying a mostly healthy (certainly the healthiest any of the play's characters have enjoyed), mutually rewarding sexual relationship while sharing an authentic intimacy. Potential unease regarding the crossing of racial boundaries becomes neutralized in comic exchanges meant to generate audience laughter *at* the frustrated or confused characters around the couple.

Most significantly, however, during a scene in which Raisa massages the matriarchal Madear's aching feet, the young white woman nurtures the black mother, grandmother, and great-grandmother by virtue of the wisdom Raisa's illness has newly afforded her, with sexual tension nonexistent. In this same scene, as Raisa removes her shirt and reveals the scar that has replaced her cancerous breast, Madear's touch augments the sincerity of the women's connection, fashioning the matriarch as both a source as well as recipient of wisdom and care. As Madear and Raisa open up to each other in words and a tone marked by a naked intimacy absent throughout the rest of the play, they comfort and validate each other's pain and challenges, but always as equals, and often in/concerning their roles *as mothers*. In one of her more coherent moments, Madear explains the fear and loneliness that is a staple of senility and its imposed emotional isolation, further adding some words about her discomfort toward the only mixed satisfaction she has achieved as a mother—a maternal ambivalence to which Raisa also confesses. As the two remain alone in the house after Raisa has wheeled Madear in from the cold, Raisa gets on her knees and begins massaging Madear's feet when the latter asks her, "You got a bad wound?" As Raisa tenderly but never condescendingly replies, "You wanna see? I'm warning you, it's not very pretty,"[69] the two women discuss the merits and unacknowledged limitations of a breast, motherhood, and life in general. While Madear and Raisa trade emotional and physical nurturance, earthy—if sometimes sentimentalized—life

lessons get bounced back and forth with neither woman holding a monopoly on insight by (the usually predictable) virtue of illness or race.[70] Both agents of economic privilege, neither the other's employee or employer, and further, both mothers, Raisa and Madear comfort, nurture, and provide "insight" to each other on terms that are coded as feminine, to be sure, but never exclusively (or merely) maternal.

As Karen Shimakawa writes in her discussion of the (significance of) literal physical presence of ethnic American performers on American stages,[71] the theatre "is always already densely populated with phantasms of [otherness] through and against which an [ethnic minority] performer must struggle to be seen."[72] These "ghosts," as Marvin Carlson[73] would term them, unavoidably inform the semiotic negotiations between spectator and performer. While the sometimes melodramatic suffering and selflessness of Hansberry's Lena Younger has plenty of company in the Mammy figures offered by playwrights of color and white playwrights alike, earlier (and progressively critical) examples exist as well. And in relief to these constructs, West's play emerges as noteworthy, to be sure. Hansberry's *Raisin in the Sun* and Wolfe's *Last Mama on the Couch Play* are more well-known "ghosts" that inform present-day Mammy performances, but Angelina Weld Grimké's less frequently researched *Rachel* also proves a significant juxtaposition to more contemporary attempts to complicate the Mammy. As the NAACP's direct response to D. W. Griffith's *Birth of a Nation*, Grimké's *Rachel* might be taken as, at best, a melodrama that featured lead African American characters to (occasionally) white audiences. *Rachel* also arguably reads as an apologetic and accommodating text working very hard to represent a Christian, white, "nonthreatening" African American household to the white women spectators that the play (explicitly) set out to reach.[74]

In her examination of African American women's drama's refusal of motherhood, including an analysis of *Rachel*, Joyce Meier maintains that abstinence, abortion, and infanticide have often functioned as "strategies of resistance," a kind of corporeal "refusal to participate in and help perpetuate a system that treated [black female] bodies and their children's bodies as property." Meier argues that these resistant maternal performances not only elucidate more fully "how historical oppression recurs in the present," but also "how the black woman's body continues to be the site of both domination and resistance."[75] In her discussion of *Rachel*, Meier posits that the play offers productive alternatives to the status quo of staged black motherhood for, among other reasons, its title character's conspicuous refusal of motherhood. She suggests that this rejection is a positive alternative performance because of (1) its active role in *resisting* the normative maternal construct white culture places on black women and (2) the specific *reason behind* Rachel's refusal—her (explicitly professed) unwillingness to bring another innocent African

American child into a violently racist world. Arguably, however, the agency embodied in Rachel's "refusal" of motherhood is undercut by her unofficial mothering of the quasi-adopted orphan Jimmy, as well as the more typical narratives describing the play's other two mother characters, two single women raising children on their own because of a (melodramatically performed) combination of economic strife, the violent loss of husbands at the hands of racist whites, and even suggested physical abuse. The more (stereo)typical tropes of anguished, solo black motherhood that Grimké's narrative invokes arguably, undercut any resistance sustained by Rachel's refusal of motherhood. In a consideration of *Rachel*'s influence on how we read West's more contemporary meditation on black maternity and social hierarchies, however, Vennie's lesbian sexuality and certainly, her assertions of her intended avoidance of motherhood engage what Meijer reads as a productive "refusal" of motherhood from the position of a black female character.

It cannot be argued, of course, that particularly in her role as an African American woman playwright, West's accomplishments and the continued staging of her work in a landscape still populated mostly by white, male practitioners, has (positive) repercussions that exceed the historically informed and presently situated semiotics of the stage. Wallace-Sanders points out that "[t]he false paradigms that portray Black women as both physically unattractive and sexually promiscuous, passive and aggressive, good caregivers to white children and bad mothers to their own children, have all been challenged by Black artists... and have resulted in a partial dismantling of these myths."[76] Contextualizing her analysis from broader arguments made by bell hooks and Patricia Morton, Wallace-Sanders writes: "Black artists have actively appropriated and exploited their own negative stereotypes in order to assert control over them." The very need for this (appropriated) "control"—the political necessity of rearticulating a previously reductive and marginalizing status quo—does not emerge in a vacuum, of course. Wallace-Sanders points out that "these myths" of black subjectivity, chief among them the Mammy, "serve to justify white fears and alleviate status anxieties by projecting what is feared onto others—a practice that both rationalizes and perpetuates oppression."[77] West's three-dimensional, non-sexually reactionary staging of black motherhood, in other words, speaks to an interrogation into the Mammy icon, but also engages/speaks back to the "justif[ed] white fears," and the ways those fears are projected on to the black maternal body.

* * *

As the quintessential image of the happy slave who enjoys working for white society, the Mammy is one of the best-known stereotypes of African American motherhood. Considered weaker and less threatening than men,

the Mammy could work much closer to white employers/owners than her male counterpart and as a consequence, a frequent paradigm of a "naturalized" ethnic maternity takes shape around her. In negotiation with this phenomenon lies the potential for worthwhile but less obvious insight into discourses of racially essentialized sexuality, particularly as those narratives emerge in support of and reaction to miscegenation anxieties. In her thorough examination of the mammy figure, McElya contends that the Mammy occupies a powerful role in US culture and politics in part because the construct gives fictional flesh and bones to a so-called black contentment that simultaneously allays white fears.[78] As the research of historian W. Fitzhugh Brundage points out, the icon of black maternity is at once both reassuring (to the whites whose fantasy of harmonious race relations she supports) and destructive.[79] The reassuring and smiling face, while charged with the care of white society's most vulnerable citizens—its children and elderly—obfuscates the pain and violence of racial oppression and violence. Bearing in mind McElya's argument, then, the threat of any race-based erotic "corruption" between Mammy and charge would seem especially crucial, as deviations from this benign portrait bode poorly for continued hegemony over caretakers of color. Although *Daisy, Jar,* and *Caroline* provide provocative models of politicized black nurturance as they appear alongside their "qualified" white dependents, analyses into these alternatives are incomplete without a deeper examination that reads against expectations and considers specifically what engagement these constructs have with paradigms of essentialized black sexuality—particularly as those reductive performances comment on cultural anxieties surrounding increased African American visibility and the increased "threat" of interracial sexual contact.

It is likely no accident, but also telling that some of the most damaging, if not always obvious foundations of oppression for African American women transpire at the earliest confluences of motherhood and race. The desexualized wet nurses of color in the American south who effectively "raised" and comingled with their white charges—in ways that exceeded even the intimacy between white child and (white) *non*nursing biological mother—serve as early, paradigmatic examples of who is and is not allowed entry into white/privileged filiation. Supposedly posing no sexual threat, the Mammy is allowed to raise her employer's/owner's child and perform maternal labor to which her own children are not legally entitled. But the so-called innocuous intimacy between wet nurse of color and white charge reveals much about hidden reservations concerning black-white sexual landscapes. Miscegenation anxieties are and were triggered to some degree in this wet nurse/infant relationship by virtue of the bodily fluid exchange between the two; an equally insidious "peril" emerges from what potentially happens when those white children grow up into sexual subjects. Historians such as Arthur Calhoun

posit that anxieties surrounding the unacceptable and "corrupting" phenomenon of miscegenation actually find their earliest sources in the logistics of the mammy/charge dyad;[80] Sally McMillen explains that historians such as Calhoun point to the presence of black wet nurses in whites' earliest lives/childhoods as an underlying *explanation for* "the southern gentlemen's alleged predilection for a black mistress."[81] Thus the Mammy portends as well—as a result of bodily fluid exchange in the most maternal of activities (nursing)—her potential *future* influence on the straight, white, male libido; this influence remains ominous by virtue of that very maternity.

Finally, in addition to looking at how the historical realities inform the staged politics of a play, or a play's production history, or even the Carlson-esque ghosts with which any play might be contextualized, an additional aspect of actual production merits value in any historiographical analysis. The actual number of seats filled for any production inarguably comments on a text's relevancy, political or otherwise. While compared to Kushner and Wolf, West-as-playwright enjoys significantly less political cachet in American theatre circles, *Jar* played and continues to play to fuller houses and more of them.[82] To be sure, due no doubt to its Brechtian forms of dramatic representation (talking appliances as major characters, minimalist set, operatic score) and the frequently angry tone of its protagonist and theme, *Caroline* proved problematic for audiences and many critics. As Wolf explains to *Variety*'s Robert Hoffler, in addition to Tesori's "difficult score" and the (challenging) narrative departures from more successful, easier-to-digest productions such as *The Producers* or *Spamalot, Caroline* proved problematic for many New York audiences and critics in part because they were "coming to see a show" that they were not sure was "supposed to be there" in the first place.[83] And while its reception improved outside of New York and during later stagings (e.g., in Minneapolis and Los Angeles), it remains true that *fewer people* have been exposed to Kushner's text compared to West's, the latter of which is, typical to her oeuvre, consistently commercially successful in predominantly black theatres in the United States.

It is valuable to consider Dorinne Kondo's exploration of ethnic American playwrights and performers on American stages and her position regarding "the question of audience reception": plays written and performed by people of color, whether "realist, non-realist, avant-garde, or some combination of strategies representation" can

> potentially effect...the empowering of those other [people of color]. The question of realist representation, then, must take into account not only narrative strategy, but also effect on actual audience members, mindful of an historical context in which there is a general subversiveness in simply being able to *see* progressive plays by and about people of color.[84]

Yet, while West's net commercial success with *Jar* eclipses that of *Caroline*, her name recognition and ability to get projects approved pales in comparison to the powerful political cachet afforded by Kushner/Wolf or the almost pop culture level familiarity of Uhry and *Daisy*. Although counternarratives of black nurturance from figures such as West are noteworthy and obviously valuable, her presence and the presence of playwrights like her is still rare on college syllabi and throughout mainstream established theatres across the United States. As Hermine Pinson recently asked Black Arts Movement poet Lorenzo Thomas in a discussion of black theatre in the United States, "Sure, everybody's going to do August Wilson. But is everybody going to do Cheryl West?"[85]

CHAPTER 4

QUEERING THE DOMESTIC DIASPORA, *ENDURING* BORDERLANDS: CHERRÍE MORAGA'S FAMILIA DE LA FRONTERA

In *UNMAKING MIMESIS*, ELIN DIAMOND SUBMITS THAT HYSTERIA "HAS become the trope par excellence for the ruination of truth-making," and that this undoing is "meaningful precisely as a disruption of traditional epistemological methods of seeing/knowing."[1] Throughout her analysis of the critical space occupied by mimesis, gender, and dramatic form, Diamond explores what she describes as "the most pressing questions in feminist theory" as that scholarship negotiates theatrical representation: Who is speaking? Who is listening? Whose body is in view? and finally, Whose is not?[2] Silent and silenced bodies emerge repeatedly as sites of political debate amid the gender-, race-, class-, and sexually based conflicts so pervasive in Cherríe Moraga's 1994 *Shadow of a Man*. In particular, the *maternal hysteric body*, as it varyingly sustains and dismantles the hegemonic architecture that facilitates it, becomes a site of suffering and resistance, but uniquely, queerly so. Within a cultural landscape unforgiving to anyone who occupies a nonnormative position, the trope of the maternal hysteric emerges for Moraga most obviously in the play's occasionally victimized matriarch Hortensia, but more significantly, I argue, through the character of her beleaguered husband, Manuel. As a self-hating gay man and cuckold who is not the biological father of the girl (and the play's protagonist) he raises as his own, Manuel becomes what I will describe as a queered maternal hysteric, a figure who

occupies a nonnormative position in his economic, ethnicized, and gender "failures," but further, one who is never defined by the corporeal delineations that typically define maternity.

The queered hysteric offers a construct of maternity disengaged from the gender-specific notions of motherhood that modern American drama regularly reinforces. I use the term "queer" in what I hope is a helpful shorthand to connote what Niall Richardson explains as a "potential to describe mismatches of sex, gender, and sexuality," a term drawing its "subversive potential from being in opposition with 'normal' rather than merely 'heterosexual.'"[3] In his essay arguing the gender dissidence and hysteria of extreme male bodybuilding, Richardson defines the (male, bodybuilding) hysteric and queered subject as one occupying a "gender dissident body which simultaneously affirms masculine and feminine characteristics"; this male hysteric produces a "body which offers a hemorrhaging of meaning."[4] In this sense I point to a *queered* maternal hysteric. If, as Michael Warner argues, "queer gets a critical edge by defining itself against the normal,"[5] then this queer, nonnormative understanding of hysterical maternity accomplishes what María Herrera-Sobek describes as a performative "decolonization process" that, at its best, can effectively "destroy those images imposed upon us by an outside world hostile to women and ethnic peoples 'different' from the so-called mainstream."[6] For the queer maternal hysteric, the so-called mainstream remains elusive; for this subject, in fact, "mainstream" is coded not just as white, straight, and middle-class, but indeed, *maternity* is organized according to identity rubrics based reductively on essentialized difference. The result for the queered maternal subject in Moraga's *Shadow*, then, is a hysterical mother figure who, using Richardson's terms, is defined by "mismatches and incoherencies" to the normative (binaried-gender-, race-informed) paradigms that place him/her as Other.

Amid conflations of hysteria, nonnormative sexuality, and alternative/ nonbiological paradigms of maternity, a telling testing ground exists for productive feminist subjectivities. In what follows, after unpacking my understanding of the sometimes contested concepts of *queer*, *maternal*, and *hysteria*, I explore the play while relying on multiple discourses of hysteria and the critical moves they allow; specifically, I consider perspectives offered by Freudian psychoanalysis, nineteenth-century literary production, and identity-based Borderland discourses, which together enable a useful purchase on Elin Diamond's suggestion as dramatic realism *as* hysteria. In exploring a queered maternal "performance," in other words, Moraga's Manuel offers radical, arguably bodiless alternatives to existing codes of identity and illuminates a uniquely, productively "mismatched" construct of nurturance, sexuality, and race.

Queer/Maternal/Hysteria: Stories Told by the Body

"Maternity" and "hysteria" reinforce and complicate each other in ways that are both semiotically rich and politically relevant. In an interview discussing his piece *My Queer Body*, performance artist and one of the original NEA Four Tim Miller explains his take on the body's ability to tell stories, suggesting that whether occurring vis-à-vis individual body parts or the plethora of physical phenomena gestated by the body (e.g., disease), there is a universe of "stories that come from the body."[7] "Stories told by the body" are germane to hysteria discourses as these "stories" position the body as a space that reveals (hidden) meaning and knowledge. For Freud and the nineteenth-century writers picking up his pathologized baton, hysterical bodies exist as a "counterpart to conscience—a moral response to an immoral situation"—in other words, a conflict perennially highlighted in "the relationship between hysteric and the various forms of censorship that are applied to the secret sexual domain" of their bodies.[8] No stronger example exists of the vessel portending its secret than the maternal body.

Beyond discursive links between motherhood and hysteria, we might consider motherhood's unique position within hysteria by nature of the maternal *body's* (at least temporary) inability to hide the secret of sexual knowledge. If the "hysteric expresses her yearning for erotic and intellectual freedom,"[9] the *biological* mother, in strikingly visible terms during gestation, testifies to sexual experience. Not far from the "testifying" (of sexual secrets) function explored in Freud's talking cure or even fictional nineteenth-century narratives of hystericized fallen women, the literally visible manifestations (truth/secret telling) of the mother's physiology *testify* to a sexual history/secret, and can code the maternal body as a potential site of resistance to the (sexual) laws of the father, the dominant/marginalizing ideologies that facilitate the "pathology" to begin with. Expanding this notion of maternal subjectivity (and its secrets) outside of biological gender, however, and looking at a biological male as a (queered) maternal subject, allows a productive unpacking of filiation, agency, and identity-based shame.

While a biological male character might seem an unlikely subject for maternal analysis, we might remember the useful repositioning of paradigms of biological gender (not to mention family and biology) within identity theory. In her memoir on queer motherhood, Moraga beckons a rupture between blood, gender, and parental identity: "There is no accounting for what finally makes a family...I remain awed by this mystery of how love and blood and home and history and desire coalesce and collide...I know bloody quantum does not determine parenthood any more than it determines culture."[10] But the queered maternal *hysteric* exceeds physical definitions. In her memoir on queer motherhood, Moraga underscores the

usefulness of maternal constructs divorced from paradigms of blood and gender. On queer parenting, she writes: "We cannot make babies with one another. Our blood doesn't mix into the creation of a third entity...Sure, we can co-adopt, we can co-parent...but blood mami and papi we aint."[11] Richard T. Rodríquez posits an understanding of family as a historical narrative that "reflects a process of systematic domination suppressing discrepant narratives"; indeed, we might "construe the family as both symbol and social category whose signification is not necessarily foreordained by blood, circumstance, and monologic notions such as 'History.'"[12] And as the play's "victim," Manuel repeatedly points to that much studied "historico-medical object whose unreadable symptoms derive...from the material and gender constraints of bourgeois life"[13]: the hysterical mother, but of the queerest sort. Within a feminized/domestic landscape, this queer figure exists as a powerful source of identity to her/his offspring; and as a biological male, the queer maternal hysteric achieves what Richardson terms the "subversive potential from [its] opposition with 'normal'" offered by valuable "mismatches of sex, gender, and sexuality,"[14]—productive for its ability to complicate and exceed binaried, reductive constructs conflating motherhood and biology.

Maternal constructs speak to gender, sex, and reproductive paradigms, obviously; but as my later discussion of Anzaldúa's Borderland theories posits, these constructs also incorporate race-based identities. The mismatching fluidity of the queer maternal hysteric underscores the imbricated nature of these hierarchized relationships. If, as Ellie Hernández suggests, "the lineages of queer confrontations are matriarchal...and not derivatives of a patriarchal...origin,"[15] then the critical nexus of memory, secrets, and maternal performance within the broader lens of hysteria might facilitate semiotic interventions into the politics of the personal body and body politic, alike. These interventions potentially remap an amorphous subjectivity in which the (pathologized) secrets and memories of the maternal hysteric oppose a domestic, dualistic ontology based in difference. Indeed, the discursive associations of domesticity, political agency, and the hysteric's secrets are many. Mary Pat Brady, for example, contends that "Moraga's dissection of the zones of complicity (the gendered and sexualized secrets) that structure the seemingly 'domestic'" exposes the ways in which the "revelation of memory's secrets holds out the possibility of wholesale transformation of the socio-spatial fabric of existence...[B]oth revolution and cooperation with domination lie within memory's reach."[16] Brady contends that a "shifting, embodied process indelibly and intangibly affected by desires and memories" exists throughout Moraga's work. Invoking what sounds like discourses of hysteria, she submits that for Moraga, "memory, desire, and the body cannot be disentangled from each other, they call and respond to one another, shaping one another's conditions of possibility." Repeatedly, the playwright

focus[es] on these subjects not as merely historical signs but because they are essential for surviving domination and exploitation: memory fuels resistance... [T]he political charge of memory and its connection to desire... repeatedly argues that dominating systems cannot force people to forget entirely that they are dominated. Somewhere memories live, rooted in bodies and spaces... signaling the terrains of power which Chicana/os navigate.[17]

In addressing the regularity with which Moraga engages a kind of *"looking backward,* being haunted," Brady contends, "This kind of remembering—for example... the marital/homoerotic anxiety exposed in *Shadow of a Man*—offers the latent possibility of either permanent paralysis or rejuvenation." To remember or reveal "haunting" secrets, pathologized memories, "may mean knocking out the hard-won crutches of survival, but it can also mean moving past festering secrets."[18] Memories, secrets, and disallowed subjectivities are ubiquitous to hysteria discourse, but considerations of male feminized hysteria, as it does/not engage maternal performance, remain elusive. If, as Caminero-Santangelo argues, "the madwoman has come to stand all but universally in feminist criticism for the elements of subversion and resistance in women's writing,"[19] what happens to this interpretive model when we take the (essential) notion of biological gender/femaleness out of the equation and consider, broadly, the "feminized body," or specifically, a feminized maternity?

The potential for a recuperative model of gender, reproduction, and even race exists, however, alongside the peril of critical essentialisms. Caminero-Santangelo explains that "while critical uses of the category of madness... have gone virtually unchallenged, the relationship between 'real-life' madness and social order has been the subject of substantial debate within feminist theoretical circles." In asking how analyses of hysteria avoid the "violent repressions" that potentially reside in "a search for the subversive madwoman in literature,"[20] she describes a "productive move in feminist literary criticism [that works to] trace the symbolic rejection of hopelessly disempowering solutions in... narratives of madness."[21] If the madwoman/hysteric can (ever) productively "suggest the dangers of complicity within an oppressive dominant culture," the more valuable endeavor to which the critic might aspire has more to do with locating what Caminero-Santangelo describes as "counter[ing] representation with representation";[22] rather than asserting the "premise that insanity is the final surrender to such discourses... because it is characterized by the (dis)ability to produce meaning,"[23] I suggest a hysteric who (queerly/productively) hemorrhages meaning vis-à-vis the political, identity-based border crossings s/he performs.

While most of Moraga's writing explores motherhood to some degree, a specific entailment of maternal *hysteria* becomes a meaningful site of

oppression and resistance in *Shadow* by virtue of Manuel's surreptitiously feminized presence.[24] Theoreticians, writers, and artists alike are "calling for a return to the discourses of hysteria as a means of negotiating masculine rationality."[25] As Rosie McLaren explains,

> [i]nstead of seeing hysteria as a gendered, prejudiced symptom of defective femininity, a specific female disorder, these critics, working with discourse theory and semiotics, regard hysteria as a specifically feminine protolanguage, a primitive or original language of the body which cannot be verbalized in every day forms of communication. Hysteria... is the result of *repressed bodily knowing which speaks out against the social construction of sexual roles and identities*.[26]

As Ender argues, "the figures of hysteria act as a vivid reminder of the fact that, for certain categories of subjects, *consciousness* remains secret, not because of a choice, but as an imposed condition;"[27] the role of the maternal hysteric might then be understood as a "category of subject" who inhabits a life of secrets as "imposed conditions" of a queered maternal identity. A glean of psychoanalytic discourses of hysteria (and connotations of hysteria as a typically gender- and sex-based pathology) illuminates the construct of the hysteric as I employ it here. Diane Herndl surmises:

> Psychoanalysis informs most of the discussions of hysteria, either as an example of the patriarchal discourse which hysteria resists or as a congenial and explanatory model for understanding oppression. Many feminists argue that psychoanalysis, itself a male-founded and male-dominated discourse, is not a suitable basis for feminist study, because it perpetuates sexual and psychological stereotypes which feminists seek to change. Other feminists argue that psychoanalysis, understood as a descriptive, not prescriptive discourse, helps to explain the workings of sexual power and sexual stereotyping.[28]

In the final section of his 1893 paper with Joseph Breuer, Freud argues that the paralysis, numbness, pain, or nervous coughing characteristic of hysteria are somatic results of nonanatomical constraints: "Hysteria behaves as though anatomy did not exist or as though it had no knowledge of it."[29] In her summary of Freud's analyses, Elizabeth Wilson describes "the transformation of psychic conflict into somatic symptoms" whereby incapacitated "organs, limbs, and nerves" are impaired "according to a symbolic or *cultural logic* rather than according to the dictates of anatomy."[30] This "disassociation of somatic symptoms from anatomical constraint"[31] is central to Freud's contention, but relevant also to an understanding of the maternal hysteric as a subject not tied to rubrics of biological gender/reproduction. If the hysteric's symptoms are independent from literal anatomical origin

while also associated with cultural, symbolic oppressions, we might consider how the hysteric manifests physical objections to oppressive race-, class-, gender- and sex-based hegemonies. Or, employing an overused but accurate shorthand, we might consider how the hysteric represents a resisting Other attempting to make her/himself (unconventionally) heard.

In the published analysis of her case history, Freud represents Dora as a protesting subject pushed back through an inner history of which she is largely unaware—pushed beyond an "outer shell of her own self interpretations." Dora surfaces as a hysterical subject who consistently attempts to avoid Freud's own effort to "reindoctrinate"[32] her toward more tolerable attitudes toward her place in the (patriarchal) law of the land. We might then read a modern-day hysteric as a marginalized (at best, pathologized) subject who is occasionally protesting, sometimes silenced, but never at ease with the superstructures framing his/her knowledge/awareness as intolerable.

QUEER STAGING IN FREUDIAN CONTEXTS

Some of *Shadow*'s material could be interpreted as loosely autobiographical, primarily through Moraga's protagonist Lupe, a twelve-year-old trying to reconcile her love for family and Catholicism with a nascent awareness of her own queerness while her family occupies various locations on the political continuum.[33] Wearing her "United Farm Workers" jacket, embracing La Raza, and shedding her virginity to avoid being defined by it, older sister Leticia performs an antiassimilationist militancy, while Aunt Rosario exercises practical rebellion. With children grown and gone, Rosario has a freer life and doesn't care if "something is wrong with her" because she left an unsatisfactory husband.[34] Rosario's qualified revolt contrasts the passivity of Lupe's mother Hortensia, a sometimes victim of physical abuse and permanent object of rancor for the angry, alcoholic, cuckolded Manuel. Although never physically on stage, Lupe's brother Rigo, described as "trying to get over" racially,[35] exerts heavy influence; Rigo's conduit to Anglo-accommodation begins with marriage to a racist white woman and culminates with enlistment during the Vietnam War. Finally, Manuel's Compadre Conrado, living a bourgeois, Anglo-centric success narrative that painfully eludes Manuel, occupies the role of Hortensia's one-time lover and Lupe's biological father (not to mention Manuel's true love and continued, secret obsession) and exerts formidable influence long before his brief appearance in the final Act.[36] With Conrado's climactic visit serving as a last-straw reminder of forbidden love, Manuel eventually accedes to the quasi-suicidal behavior he demonstrates throughout the play.

The Manuel-Conrado-Hortensia love triangle is the most obvious allusion to Manuel's maternal performance, hysteric or otherwise. As a result

of his de facto "shared parentage" of favorite child Lupe with his beloved Compadre, Manuel literally shares parenting in his role as cuckold, raising the genetic offspring of Hortensia and Conrado. But Manuel embodies a more telling maternity in the figurative, feminized role he "plays" in the sexual circumstances of Lupe's conception. In a scenario that he himself choreographs, Manuel's body assumes the role Hortensia would otherwise execute and as a result, performs for the audience/reader an essentially maternal body. Suggesting a queer, disallowed love for Conrado as well as his desire to act as feminized sexual "recipient" to Conrado during Lupe's conception, Manuel's (and the hysteric's prototypical) "troubled reminiscence" is confessed to a safe audience, a Susan Glaspell/*Trifles*-inspired caged canary:

> I look across the table and my compadre's there y me siento bien. All I gotta do is sit in my own skin in that chair. (*Pause*.) But he was leaving...I tried to make him stay. I asked him, "Do you want her, compa?" And he said, "Yes." So, I told him, "What's mine is yours, compadre. Take her." (*Pause*.) I floated into the room with him. In my mind, I was him. And then, I was her too. In my mind, I imagined their pleasure and I turned into nothing.
> Black out.[37]

More than any other moment in the play, here Manuel identifies a less-than-scientific, but symbolically possible sexual relationship with Conrado that could, nonnormatively, produce a child between the two men. In addition to acknowledging the objectification of Hortensia as a loanable thing, Manuel's offer of his *acceptable* sexual partner (Hortensia) to the man he loves, his unacceptable choice, enables sexual contact and reproduction with Conrado by proxy.

The incorporation of motherhood within notions of hysteria is significant here. To begin with, the hysteric must battle with her/his (non)ignorance of sexual knowledge; the *maternal* hysteric, by nature of his/her status as mother and consequently, sexual subject, is caught in a no-man's land of knowing/needing-to-not-know (or remembering, needing-to-not-remember; here Manuel battles with memories he both longs and feels shame for). As Ender's description of hysteria suggests, the "mother" visibly portends sexual enigma "reconceived in terms of knowledge"; the maternal body, like the hysteric's, surfaces as a "paroxysmic form taken by a guilty secret, revealed by bodily symptoms or exposed in the more spectacular scenes of hysteria." The maternal body "marks a knowledge that does not know itself."[38] Understanding Manuel as maternal hysteric enables a semiotic bypass of the compulsively, involuntarily revealing maternal body. And queerly so. In a mismatched notion of maternity that, using Richardson's terms, hemorrhages meaning, Manuel shares parenting with Lupe's biological father.

Because his "daughter" is the biological offspring of Conrado (and his objectified proxy, Hortensia), Manuel performs a quasi-maternal function. That he orchestrated this arrangement when he faces losing Conrado further implies the lover's/hysteric's desperation over a situation out-of-control and points to (sexual) knowledge intolerable to the conscious mind. While the sexual stories that the maternal body tells are more normally compulsory (and unambiguous) by virtue of the change in the maternal corporeal form, Manuel's explicitly and repeatedly tender "shared parenting" with Lupe's biological father performs a nonnormative reproductive relationship. Queer maternal hysteria results not just from Manuel's deviation from Chicano machismo and homophobia, but in the semiotic positioning he occupies as a queer/contested maternal body.

Troubled, pathologized reminiscence of Conrado in general and Lupe's conception in particular invoke obvious notions of Freudian hysteria, in terms of memory, to be sure, but also an (un)knowable knowledge and the promise of a (talking) cure held out by revelation/confession. Freud's Dora, for example, exhibits physical symptoms that metaphorically mimic psychic phenomena: both coughing and *loss of voice* explicitly point to Dora as silenced subject. Not unlike that which transpires for Moraga's often silent, brooding Manuel, Freud's paradigmatic hysteric suffers from what today we can see as a genuine and powerful same-sex attraction (for Frau K.) toward an individual whose reciprocated affections remain prohibitive. Discourses of Freudian hysteria as well as critical literary interventions abound with examples that harken to Manuel's disallowed same-sex attractions and the voicelessness that "speaks" to its pathology. In addition to Freud's Dora and the infamous "Anna O.," a frequently explored figure is Charlotte Perkins Gilman, by virtue of the latter's experience with the pathology of/as "sufferer" of hysteria, not to mention her unofficial treatise on hysteria, "The Yellow Wallpaper." In an essay that considers the relationship between hysteria and Gilman, Diane Price Herndl maintains that for Gilman, "hysteria can be understood as a woman's response to a system in which she is expected to remain silent, a system in which her subjectivity is continually denied, kept invisible." As a literary subject unable to make herself (or himself) seen/heard, the hysteric displays resistance in the only way s/he can, through a feminist "body language" of hysteria.[39] Or as Dianne Hunter argues, the "male-defined signifying system" leads the hysteric—marginalized by virtue of reductive sexual constructs—into a state whereby "the body signifies what social conditions make it impossible to state linguistically."[40] The hysteric emerges whereby a silenced, pathologized instability haunts the individual whose cultural norms forbid articulation of self.

In Freudian discourse, these forbidden articulations of self often move from specific references of "knowledge" to slightly different connotations

of "memory" or "reminiscence." As opposed to "knowledge," "memory"/"reminiscence" suggests the individual subject's *own* experience, a phenomenon lived by the individual in the first person and (with the exception of notions of group- or cultural-memory specific to trauma studies, for example) directly experiential. Regarding understandings of the "unknowable" and memory, what becomes irreconcilable for the hysteric is one's *own participation* in the unacceptable idea (not just external awareness of "its" existence). In Freud's case, for example, we get more than just a Dora who "ache[s] with anger at everyone near her" from a "failure to understand her true emotions"; Dora's failure is reported by her doctor as an individually generated "willful failure" to not remember.[41] Freud writes that "hysterics suffer mainly from reminiscences" and further, hysterical symptoms can be treated and removed "immediately and permanently" when the "event" is both remembered and articulated.[42] Freud's suggested remedy rings familiar with what the spectator imagines as Manuel's psychic salve. For the Freudian hysteric and the silenced gay Chicano, the talking cure (or at least, verbal expulsion of that which cannot be comfortably remembered) promises redemption; remedy is invested in (verbal) agency. Freud specifies what releases the hysteric from neuroses; in what will eventually be described as "the talking cure," he writes:

> In the further course of the treatment the patient supplies the facts which, though he had known them all along, had been kept back by him or had not occurred to her or his mind. The paramnesias prove untenable, and the gaps in his memory are filled in... Whereas the practical aim of the treatment is to remove all possible symptoms and to replace them by conscious thoughts, we may regard it as a second and theoretical aim to repair all the damages to the patients' memory. These two aims are coincident. When one is reached, so is the other.[43]

Making clear both "sexual secret" as instigation of and "talking cure" as remedy for hysteria, Freud's early analysis of Dora explains:

> If it is true that the causes of hysterical disorders are to be found in the intimacies of the patients' psycho-sexual life, and that hysterical symptoms are the expression of their most secret and repressed wishes, then the complete exposition of a case of hysteria is bound to involve the revelation of those intimacies and the betrayal of those secrets.[44]

For the hysteric, the talking cure is twofold: (1) the secret (sexual) desire and knowledge is articulated and freed from its repressed state, but significantly, (2) the (recuperated) memory becomes restored and conscious, a live-able and acceptable memory. These secrets and (un)knowingness, however, are

regularly, tellingly conflated with the maternal. And in this sense, Manuel as specifically *maternal* hysteric functions discursively.

For the Freudian hysteric, not unlike Manuel, "existence is reconceived in the *feminine* mode as hysterical suffering—to be is to suffer, in the body's pains and secret ecstasies, the slings and arrows of fortune. But, as Ender explains, "the hysteric subject... merely answers the nineteenth-century doctors' learned maxim, *pati natae*—born to suffer."[45] This suffering is deeply invested in maternity, and not just because hysteria's etymology recalls women's reproductive organs. Edward Jorden's seventeenth-century text on hysteria, for example, predates the eighteenth- and nineteenth-century "wandering womb" theories that Freud would later engage. Jorden argues the source of hysteria (also termed "Suffocation of the Mother") lies in an "un-seeded" vaginal cavity that lacks moisture and thus leads to physical pathology. Or as G. S. Rousseau points out, Jorden's theories eventually lead to the "medical" shorthand that sees hysteria described merely as "Jorden's theory of 'the mother'—itself a metonymy loaded with cultural significance at the turn of the seventeenth century."[46] Manuel as the performative, often melodramatic domestic sufferer, the subject who shares parenting with Conrado, offers more than a useful reimagining of maternal subjectivity, however; reductive binaries of identity and beingness that are based in difference might also be reconstituted. As the (pathologized, maternal) body deviates from dualistic ontologies based in corporeal difference, opportunities to reimagine subjectivity, if not beingness more generally, abound. Suzanne Bost writes: "Unlike other texts, bodies are never static. Once they fail to assume their familiar shapes, they become something else: a source of embarrassment, a medical problem, a theoretical provocation, or an emotional provocation";[47] regarding the pathologized body potential for meaning-making, Bost conflates (and theoretically prioritizes) bodily pain, suffering, and pathology with existential crises. In her discussion of Ana Castillo and Moraga, Bost suggests Chicana writers regularly explore motherhood as "an existential problem... but the problem is not contained within the body of the patients." Interrogations into the "corporeal upheaval" of motherhood raise questions "beyond conventional modes of sociopolitical inquiry to the degree that our experience of our own physical instability does not obey the laws of reason." She continues: "The body can metaphorically communicate non-corporeal ideas."[48] In understanding Manuel's suffering and sexual "engagement" with Conrado as the vehicle that both "produces" Lupe but also enables a productive queering of otherwise stable/Western constructs of la familia and being, the queer maternal hysteric rises above difference and crosses into a fluid, permissible borderland. In the queer/contested space of Lupe's conception, Manuel confesses that he "floated into the room" and in his own mind, "I was him. And then, I was her... and I turned

into nothing";⁴⁹ in this bodiless reproduction rubric, he engages borders that are mutable, if they exist at all. While I address Anzaldúa's border discourse later, a brief comment on the recuperative potential within her conception of La Frontera merits mention here, particularly in light of border crossings suggested by Manuel's "shared" parentage.

In her analyses of the pathological/restorative potential within Anzaldúa's borderland discourse, Bost highlights the former's use of Aztec culture as it "extends embodiment beyond 'Western' corporeal limitations [and] opens identity to continual restructuring'"; Anzaldúa "names the Coatlicue state in honor of the 'serpent-skirted' Aztec goddess of fertility and death. Coatlicue makes life from destruction, breaking down binary oppositions."⁵⁰ Bearing in mind the Aztec goddess's "link to fertility and life cycles," the Coatlicue state posits that "as psychological processes in which one engages with... the pain and destruction that we fear, *rebirthing* the self in the process"; and as a result, "[Anzaldúa] theorizes identity as an open-ended process."⁵¹ If, as Anzaldúa suggests, "every increment of consciousness, every step forward is a *travesía*, a crossing,"⁵² then Manuel's (destructive/painful) "crossing over of consciousness" or suffering-infused "knowing" suggests

> the ability of—and the need for—bodies to mutate in the process of life-making, like the serpent with which Coatlicue is associated. The *aching* body that falls apart in Coatlicue states feels pain as a materialization of *increased awareness* and *expanded embodiment*.⁵³

With an increased "awareness," an expansive embodiment that exceeds corporeality invested in difference, the queered maternal body invokes a painful knowing, a *travesía*-inspired consciousness that, as a result of its "increased awareness," mimics and gestates the Coatlicue state of (painful/pathologized/politically recuperative) rebirth.

Digressions from binaried notions of gender/reproduction become (queerly) productive in their alignment with Native/non-Western paradigms of creation and embodiment. Expounding on Moraga's (and other Chicana lesbian writers) interrogation of "bodily norms" and the "opening[s] of corporeal possibilities," these interrogations can comment on "the power of boundary-crossing."⁵⁴ As with Bost, Yvonne Yarbro-Bejarano suggests Moraga's invocations of Native American culture as source material in explorations of health, sickness, and reproduction enable "fragmentation" of the body to perform resistance vis-à-vis a removal of the body "from patriarchal/white/heterosexist norms and to reconstruct it 'from the blueprint' of her own desire."⁵⁵ Consider Moraga's retelling of the Quiché Maya story in *Heart of the Earth*. As she employs "indigenous cosmologies to conceive pain and dismemberment as part of larger creative processes," audiences/

readers conceive "Moraga's medical journal as a recovery of ancient corporeal sensibilities."[56] Throughout her memoir on queer motherhood—*Waiting in the Wings*—Moraga alludes to death and disease as much as nonsanguineal notions of family,[57] and invokes a nontraditional/queered maternity that is multiple and fragmented, while also informed by suffering, even pathology. *Wings*' maternal narrative not only avoids "reproduce[ing] conventional politics" but in nearly existential terms speaks to a "disavowal [of] the normative shape of motherhood"; the text productively complicates "the conventional affective responses associated with it, taking readers through a painful and nonteleological encounter with illness and death."[58] *Wings*' repositioning of the paradigmatic "birth story," itself typically conservative, for the centrality it assigns motherhood, is a narrative inclusive of pain and pathology, but repeatedly (and queerly) divorced from biology:

> The "queerness" of the motherhood whose portrait Moraga outlines...goes beyond the mother's lesbian sexuality (and the "queer" process of insemination involving two female lovers, one male friend, a mason jar, and a syringe) to "queer" understandings of birth, life, family, body, and medicine.[59]

Regarding the more obvious noncorporeal reproduction narrative that he choreographs between Hortensia and Conrado (or a less obvious rebirth-of-self, facilitated by his final confession), the shadow of Manuel's pathologized/queer maternity casts a mutable construct of motherhood specifically, and subjectivity generally.

LITERARY AND DRAMATIC BODIES REFUSING SILENCE

As the woman who at the end of Act I "hysterically falls" into the bath while murmuring gibberish, apologies, and screams, Hortensia easily conjures the nineteenth-century hysteric as she falls onto "Freud's well-padded couch... [on] which so many heroines of early realism collapse."[60] As a well-represented literary figure of gendered hysteria, the beaten and rejected "fallen woman," Hortensia performs mad ravings about drowning Lupe and a fanatical rebaptism with a metonymically rich douche to cleanse her soiled soul. Her correspondence to La Llorona—the "crying woman," or "insane woman" who opts for infanticide rather than have her children suffer poverty and her husband's indiscretions—also marks Hortensia as a strong candidate for maternal hysteria. But, as Lionel Cantú explains, Moraga's use of the mythopoetic figures of La Llorona (as well as La Malinche) actually works to "expose the contradictions of patriarchy" that often result in less obvious casualties: men.[61] Whether suffering a more figurative political silence or the contradictory "(non)speaking" performed by the psychic-somatic vernacular

of hysterical bodies, what Cantú describes as Moraga's "non-resilient victims, the male characters of the drama," surface in the queered maternal hysteria of Manuel, particularly, as I will argue here, in the ethnocentric context of his failed father-son relationship.[62] Manuel as queered pathologized/hysteric mother—emerging *specifically* from the Chicana feminism of Moraga—makes sense on grounds beyond the quasi-parentage he shares with Conrado, and nod as well to "pathologies" distinct from his Compadre. As he negotiates the growing reality of an assimilating, perhaps shame-ridden son, Manuel as maternal hysteric resituates the cultural and personal pathologies emerging from the congress of machismo, kinship models, and Chicano nationalism.

Unpacking the dialectic between filial sex-gender identity and ethnic subjectivity in his extrapolation of sociologist Alma M. Garcia's work, Rodríguez understands the "intersecting discourses of nationalism, family and machismo" as key to understanding how Chicana feminism of the 1960s and 1970s (dis)engages from/with the Chicano movement. If one assumes, as Rodríquez does, that "strands of Chicano cultural nationalism tethered to machismo promot[e] a family ideal...identifi[ed] as a safe haven in a heartless world," then within this "'nation' defined within the contours of domesticity," he suggests, "the archetypal Chicana would necessarily provide a feminine spirit of *maternal consolation* (in spite of her suffering) while ensuring the procreation, hence survival, of Chicano culture."[63] Literally, then, the mother figure holds the key to survival vis-à-vis biological reproduction. But cultural survival/reproduction is also at stake.

Manuel performs maternal function as coparent with Conrado, to be sure; but he also functions, socioculturally, as the agent (he deems) responsible for the continuation of Chicanismo in the household. Manuel's failure of this responsibility makes the role no less important. Rodríquez writes: "The threads that bind la familia (the family) with la raza (the people) [are] an often-taken-for-granted, naturalized site where cohesion presupposed not only the fixity of gender roles but by extension, a continuum between male authority and heterosexual presumption"—what Rodríquez describes as "heteropatriarchy," or the filial ideologies "adopted by heteronormative and patriarchal discourses." These ideologies construct domestic landscapes as "crucial sites for political struggle when informed by egalitarian possibility."[64] In other words, "patriarchy as a system dependent upon paternal governance and heterosexual presumption in relation to Chicano/a community formations"[65] highlights the imperative nature of "the father" in ethnonational consciousness. Failure yields trauma/shame that disturbs (the functioning of) la familia, but impairs (survival of) la raza, as well.

For example, when Manuel's demonstrative tenderness toward Rigo meets with the latter's disapproval (a powerful rejection given the importance of a

Chicano son, particularly firstborn), Rigo's displays an Anglo assimilation that will culminate, eventually, with enlistment in the Army to fight the "white man's war" in Vietnam. Rebuking Manuel's affection, Rigo complains, "No, Dad. *I'm a man now.* We shake hands."[66] Refusal to share a physical, Chicano mode of affection with Manuel becomes invested in a rubric that defines masculinity in rigid terms predicated on binaried (varyingly Anglo-informed) sexual difference, a gender- and race-based rubric Manuel fails. As an ethnonational-consciousness gatekeeper—an ineffective one— this queer/failed patriarch as hysterical mother figure facilitates a recasting of Chicano nationalism itself. Chicano nationalism, heterosexual reproduction, and patriarchy become imbricated in a machismo that, with the male body as host, is seen as an agent of ethnic pride and revolution. Bearing this in mind, casting (or queering) Manuel (the play's physiological male, the male body on the page and stage) as one who takes on a queered "loca"/ hysterical/maternal role to Lupe, ethnic pride is no longer a function of a domestically informed, nation-building machismo, which itself foregrounds the primacy of a unilateral notion of the Chicano male body. Indeed, a productive *re*construction of gender, Chicano corporeality, sex, and nation perform new/fluid meaning(s) in Moraga's queer maternal body.

Evolving from the Greek *hystera* (womb), hysteria evokes everything from "a mental disorder characterized by emotional outbursts"[67] and "an extreme degree of emotional instability and an intense craving for affection: an outbreak of wild emotionalism."[68] Julia Kristeva explains that such "wild emotionalism" should not be understood as the Freud-maligned *subjective narcissism,* but rather a self-reflective narcissism. For Kristeva, this "self-reflective narcissism" derives from the hysteric's anguish, stemming from "sublimating [one's] *otherness*"; the hysteric's condition can be traced to a "*love in the feminine*" sublimated "to *masculine rationality.*"[69] While Manuel's otherness is invested in a feminized love (for Compadre, for son) marginalized by the "masculine rationality" of Chicano machismo and later, Rigo's newer, "whiter" understanding of father-son relationships, Rigo's deviations from a masculinity Manuel aspires to pass on are conflated with (1) a denial of his father's Chicanismo and (2) repulsion toward Manuel's "emotionalism." Consider Ender's notion of hysteria based in a "division between consciousness and the unconscious, knowledge and ignorance, and also masculinity and femininity." From the perspective of a "nineteenth-century obsession with a gender-marked subjectivity," a portrait of hysteria emerges regularly in literary texts; the hysteric articulates a worst-case scenario of rational/emotional divisions crossed. "Emotionalism," if it exists, is feminized and in and of itself sustains notions of binaried difference. Whether or not it is always the result of alcohol, Manuel's constant state of high emotionalism performs a hysteria, but signifies also a feminized

subjectivity Rigo disdains, often in racially specific terms. Rigo's absence of sentiment (or filial/Chicano allegiance) in his failure to invite Aunt Rosario to his wedding, not to mention his *non*reaction to Manuel's own absence to the wedding, are sources of political failure to Manuel, as are Rigo's attachments to racist white in-laws. And the once expressive Rigo is now also *emotionally unavailable*:

> *Manuel*: We're not good enough for them, that's what they think! Y tú eres igual que Rigo.
> *Hortensia*: (*unbuckling his pants*): How you think Rigo's gointu feel without his padre there?
> *Manuel*: He's gonna feel nothing. Rigo's got no feelings no more.[70]

For Manuel Rigo's position within an either-or notion of gender, with emotions and feelings occupying a mutually exclusive feminized subjectivity, becomes obvious. The rejection of the (eventually pathologized) model espoused by the father is conflated with a betrayal and rejection surreptitiously supported by and supporting assimilation.

Amid anguish over Rigo's exodus (a moment in which Manuel-as-hysteric is "talking to [himself] como un loco," Manuel declares his son no longer has "huevos," adding that their removal is the result of the "gabachita" (Rigo's white wife) who "come along and squeeze the blood" out of them.[71] As with Freud's hysteric, somatic events manifest visibly as a result of inner turmoil (chest pains and increasing verbal incoherence) to reveal metaphorical truths implicated in emotional/psychological phenomena: a broken heart and painful confusion. Suffering anguish from a "gabachero" son who is "pussywhipped," and who does not think his Chicano family is "good enough" to socialize with,[72] Manuel's pathology bespeaks gendered as well as nationalism-based betrayal/shame. Manuel's failures and their manifestations of powerlessness make Anzaldúa's concept of el Choque a useful lens here. While Freudian, nineteenth-century literary and recent feminist interventions into hysteria provide explorations of psychic/cultural conflicts manifesting in somatic, "hysterical" events, discourses of La Frontera enable a productive unpacking of what Hernández calls "Anzaldúa's association of psychic unrest, writing, and the borderlands" that functions as a charge to "heal the wound caused by historical division, cultural misunderstanding, and the twin legacies of racism and sexism."[73]

As a queer Chicano who displays (at a minimum) consistent, often unwanted tendencies toward tenderness and unacceptable erotic-romantic love for his compadre, Manuel traverses the machismo and homophobia that haunt him and experiences daily ruptures of self (what Anzaldúa describes as un choque siempre) that leave him silenced. This cleavage of self occurs

amid the perceived emotional/political betrayal of a firstborn son as much as it does love for Conrado.

One of the earliest and more poignant indications of his tender, nonnormative inclinations occurs when Manuel bemoans the explicit rejection to paternal affection he now encounters from his firstborn son: "Rigo, hijo, I can't touch you no more. I have to tie my hands down to keep from reaching for you. Cuz it goes against my nature not to touch the face of my son."[74] The powerful urge toward "tenderness" is in his "nature," in his blood and bones; he exists divided from what his son's new culture permits. This divide and its imposed "silences" (regarding same-sex attractions as well as failures involving a son he can no longer communicate with) say much about the hysteric's need for articulation, whether literally (e.g., the "talking cure") or figuratively making one's voice heard.

Alluding to a pattern that echoes Herndl's description of Freudian-inspired hysteria as well as literary examples from, among others, Charlotte Perkins Gilman or Henry James,[75] Pierrette Hondagneu-Sotela and Michael Messner submit that as "marginalized and subordinated men," Chicanos "tend to overtly display exaggerated embodiments and verbalizations of masculinity that can be reads as a desire to express power over others *within a context of relative powerlessness*"; moreover, in an *attempt to reverse perceived cultural silence*, overt displays of "exaggerated masculinity" are performed "to assert a masculinity that must constantly be re-asserted for fear of losing one's identity."[76] Or as Anzaldúa explains, "tenderness, a sign of vulnerability, is so feared that it is showered on women with verbal abuse and blows. Men, even more than women, are fettered to gender roles...Only gay men have had the courage to expose themselves to the woman inside them and to challenge the current masculinity."[77] Challenging the current gender paradigms, whether for a gay Chicano in 1969 or a nineteenth-century woman under oppressive domesticity, silence becomes pervasive. Herndl describes silence and the hysterical subject in "The Yellow Wallpaper":

> The effects of the continual repression of her entry into the symbolic start to become apparent...She begins to cease functioning as a "speaking subject" in the world. Continually denied recognition as a subject, treated as a nonspeaker, as one whose representations are invalid...she comes to reject the effort of maintaining this "invalid subjectivity" and regresses into hysteria.[78]

In his analysis of political posters that cast the Chicano/a family as the primary subject matter in the Chicano movement's texts, Rodríguez expounds on the "father figure and his placement at the proscenium of the familia-raza performance." As critics such as Rodríguez, Tomás Almaguer, and Cesar A. González understand these visual texts—images that "symbolize the

patriarchal, male-centered privileging of the heterosexual, nuclear family in Chicano resistance against white racism"—these "widely circulated images for the Chicano movement" worked to "suppress sexual non-conformity" but assumed semiotic equivalent with Raza groups."[79] Indeed, at a time in which the Chicano movement saw some of its most impassioned, public activism, Armando Rendón's 1971 *Chicano Manifesto* declared: "The Chicano revolt is a manifestation of Mexican Americans exerting their manhood...against the Anglo society. Macho...can no longer relate merely to manhood but must relate to nationhood as well."[80] Importantly, as Rodríquez highlights in his extrapolation of Angie Chabram-Dernersesian's take on Rendón, by "identifying 'machismo' as the symbolic principle of the Chicano revolt and adopting machismo as the guideline for Chicano family life,"[81] figures such as Rendón "ground symbolic treatment of machismo in a specific male body," and by "equating macho with Chicano, a term generalized to embrace the nationalist objective: nationhood," then objectives such as "brotherhood, heterosexual procreation, and patriarchy are elements that inform this insistence on machismo to attain that nationalist objective."[82] Said another way (heterosexual) procreation and the macho patriarch work as discursively linked signs in the semiotics of Chicano nationalism; deviations from that norm suggest sex-gender paradigms that inform a multivalenced *travesía*, if not queer subjectivity.

As he unpacks the connections between Chicano/a filiation and political survival in his discussion of José Armas' work, Rodríguez argues: "'La Familia'...is not the kinship network one is born into but the one created out of political necessity...it makes clear the necessity of connecting political mobilization and consciousness with *procreation*." In addition to maternity/reproductivity, Rodríguez's statement alludes to the "procreative"[83] function of the patriarch as political progenitor, a "patient zero" who might set right race-based pathologies for future generations. In this regard, particularly with regard to Rigo, Manuel's hysteria performs what Ender describes as the prototypically hysterical "duplicitous" response "to the patriarchal law."[84]

Chicana/o identity itself exists in the borderland; it is neither exclusively Anglo nor Mexican and by definition, hybridized, a place of contradiction, a space of (sometimes intentional) incongruity and resistance. For the queered maternal hysteric, the Borderland/La Frontera—as both a real and imagined "space"—works as a revealing paradigm when applied to what Herrera-Sobek describes as "a multiplicity of experiential instances be they local or international or applied in a more expansive sense to psychosocial realms of human experience."[85] And in the form s/he inhabits according to Freud, as well as those consistently offered by nineteenth-century literature's fallen women mothers, the hysteric comes into prominence precisely because s/he is neither in nor out of ignorance of knowledge that, at best, generates

"discomfort" for the (not)knowing subject. Texts present her as guilty in that "she knows," while also "innocent since that knowledge remains a secret to herself";[86] the hysteric is a nebulous, often silenced form trying to relay: "I tell and don't tell you that I know and don't know what I can't and can tell."[87] But as a specifically *Chicano/a* figure whose body potentially reveals—in the context of a shadowed borderland/Frontera—a contested and nondefinable "space," the maternal hysteric is a queered beacon of dissidence who might contradict what Anzaldúa describes as a reductionist "masculine order casting its dual shadow."[88]

Hysteria in the Borderlands

Shadows and borderlands inform Manuel's subjectivity (as they do Anzaldúa's) in ways that often exceed gender and sexuality, engaging ideologies based in class as well as race, identity categories that inform the other(s) in myriad ways, to be sure. Insinuating shadows and borderlands of many kinds, Ender explains the hysteric "comes into prominence precisely because she is neither in nor out of ignorance," while "embod[ying] the contradictions and paradoxes" of social paradigms designed "to deny woman access."[89] As a suicidal alcoholic trapped in an irreconcilable borderland comprised of unforgiving sex/gender paradigms, Manuel personifies the "contradictions and paradoxes" of access-denying ideologies. But these paradigms also constitute rigid economies of ethnicity and class. "Being queer, and being of color," Anzaldúa writes: "I consider myself standing in the Borderlands (the actual crossroads or bridge)."[90] Manuel's (often tendentious) crossroads of (not)knowing and (not)speaking are informed by his own struggle with an awareness of queer desire, but his (need for) "not knowing" also incorporates class- and race-based marginalization, particularly, as I explore here, regarding Conrado's successes. This specific alchemy of oppressions that Conrado's success narrative reveals—and its engagement with (1) Indio-centric valorizations of the natural world and (2) critiques of free-market capitalism—make Anzaldúa's borderland discourse a revealing lens to employ.

In her analysis of the literal, geographical border spaces alongside the imagined borderlands of the "new mestiza healing consciousness," Anzaldúa points to a new understanding of a "marginal identity" that exists in a state of ambivalence and conflict. While the subject occupying different cultures is a potentially optimistic construct, a self who can rebelliously/willfully occupy the border, Anzaldúa also recognizes the voiceless, disparate "life in the shadows" of one trapped in two cultures, alien within both. La Frontera's "shadow" spaces parallel more than Moraga's title. A neither here-nor-there, queered-if-conflicted subjectivity, the shadow space of the borderland is the

bedrock of Manuel's universe. Anzaldúa contends "the struggle of flesh, a struggle of borders" is always also "an inner war." She continues: "The multiple, often opposing messages, [t]he coming together of two self-consistent but habitually incompatible frames of reference causes *un choque*, a cultural collision."[91] Manuel endures this collision/*un choque* beyond conflicts based in gendered/sexual mores, however. In addition to inhabiting a disallowed sexual landscape, he occupies the conflicted borderland of his own race and class. Conrado's economic success reflects a normative bourgeois subjectivity that relies on financial rewards from urban sprawl and exploitation of the land.

As Bost and others have pointed out, Anzaldúa, Castillo, and Moraga "adopt indigenous understandings of humanity, nature, the divine, and the relationship among all of these elements of the universe."[92] The non-Western/Indio-supported concept of interdependence/connectedness of the material *and* supernatural world clashes violently, como *el choque*, with the suburban sprawl-, capitalist-inspired model of Conrado's success (not to mention the military-informed model of masculinity of Manuel's assimilating son). The land (which Conrado's success narrative requires seizure of) works as metaphor for the people/pueblo/nation, as well. If, as Norma Alarcón points out, "displacement and dislocation are at the core of the invention of the Americas,"[93] then we might also see the dislocation—indeed, the permeable, shifting, and displacing connotations—of a frontera/borderland as a rhetorical congress of, on the one hand, a (definitively Chicana/o) hybridized/mestize subjectivity with a (natural) landscape that is constructed as equally permeable and shifting; both exist as a source of rhetorical and literal displacement. Borders are crossed, violated, and shifted, sometimes violently, pathologically so.

Coded as "American," Conrado's success deviates from less profit driven, Indio-Chicano relationships to the natural world; as a result, Manuel's (pathologized) discomfort with economic failure battles a self-hatred/awareness that conflates nation-based betrayal as well as sex/gender identity. Rodríguez suggests the battles of cultural survival fought by the macho and the patriarch regularly conflate class, ethnic, and gendered subjectivities with a nationalistic Chicanismo that pervades la familia. Anzaldúa maintains that "today's macho has his doubts about his ability to feed and protect his family."[94] Underscoring the mutually informative relationship between nationalism, filiation, and masculinity, she suggests there is required a "new masculinity and the new man needs a movement."[95] In his account of Anzaldúa's and Moraga's position on a rearticulation of Chicano masculinity necessary for cultural survival, one invested in nationalist subjectivity, Rodríquez summarizes Moraga's assertion that "the need to be a man, and the impact of that need on Chicano cultural nationalist sentiment, has...codified la familia as a sacred institution in which gender roles are

fixed in the name of tradition."⁹⁶ Nation- and sex-based subjectivities, in other words inform the other, to be sure, but also might exist to sustain/ dismantle the other in such a way as entirely new constructs of gender and family merge.

In an argument whose terms conjure both feminist and psychoanalytic understandings of hysteria, Anzaldúa writes of La Frontera: "Every increment of consciousness...is a *travesía*, a crossing...But if I escape conscious awareness, I escape 'knowing,' I won't be moving. Knowledge makes me more aware, it makes me more conscious." She later explains, referring to the "discomfort" of a *non*static consciousness (the potential to move away from machismo): "Today's macho...is an adaptation to oppression and poverty and low self-esteem. It is the result of hierarchical male dominance...It overlays a deep sense of racial shame";⁹⁷ as a queered maternal subject, Manuel's border crossings encompass physical, interpersonal, but also *political* and *economic* margins, regularly in flux, often crossed over. As Hernández maintains in her analyses of Anzaldúa, there is a "transformation of the borderlands from a space in which she is caught among conflicting loyalties and overlapping oppressions into a space in which she remaps and revises her cultural identity."⁹⁸ Far from a paralyzing quicksand of multiple oppressions, then, Anzaldúa's La Frontera might also exist as mutable and agency-producing amid multiple oppressions—a recuperative potential lost on Manuel.

Conrado epitomizes a (celebrated) machismo that contrasts Moraga's feminized, economically challenged hysteric. When Hortensia describes the image Conrado cuts then and now, she describes a "warrior, un gallo. His plumas bien planchadas." In addition to the gendered, phallic, implications of the warrior/peacock boasting plumes, Conrado contrasts Manuel in class-specific ways; far from the chronically poor, foul-smelling failure, Conrado's shadow casts a potent machismo with "shoes shined, the crease in his pantalones sharp likes swords...y tan perfumado, you could smell him before you saw him." Describing Manuel, Hortensia explains, "I've never felt that with [him]."⁹⁹ And her (continued) attraction is no secret to her husband. Confronting "contradictions and paradoxes which deny accessibility," Manuel is denied (all that Conrado represents) on multiple fronts, all while struggling to remain unaware of myriad inaccessibilities. With Hortensia functioning as universal scapegoat to all that eludes him, efforts to retard-if-not-eliminate (self) knowledge continue.

The hysteric's barely circumvented "innocence of mind" takes on new meaning when we learn of Manuel's longing for the simpler (sexually innocuous) days of his youth. Haunted by a corruption of *natural spaces* as much as his own psychosexual borderlands, hysteria becomes invested in an idealized, precapitalistic, and ecologically if not sexually pure past. In detailed,

poetic reminiscences of the bucolic, uncomplicated lifestyle of his adolescence, a past predating Conrado's Anglo-informed success, Manuel recounts naked communal showers following arduous day laboring that pose no threat to Chicano machismo—a blissfully ignorant, if still eroticized version of the "good old days." The past's psychosexual innocence—afforded by the hysteric's displaced awareness—is colored by rhetorical investments in pristine natural landscapes that contradict the urban, developed, and profit-driven sprawl surrounding him in Los Angeles. And as he *consciously* consents to the party line of straight masculinity and urban sprawl capitalism that constitutes Conrado's (Anglo-centric) prosperity, we're reminded of a revealing "dirtiness" that still haunts Manuel; here recollections of earlier days in Arizona with Conrado and his "primos" nod to one of the more obvious sexually infused descriptions of the past, conflating an idyllic history with an uncorrupted natural landscape:

> Suddenly the lighting flashed and the whole desert lit up and you could see the mountain with the camel back clear as noontime. Then, crack! The thunder came and it started raining cats and dogs. In minutes the water soaked up all the dust of the road and it smelled real clean. Then right there in the open back of the troque, we tore off our clothes and took our showers in the rain (*Another swig.*) Sometimes, you know, you want to be a boy like that again. The rain was better then, it cleaned something.[100]

The erotic undertones to the utopian communal shower are complimented here in a description of what it was like "then"; the past is associated with a physically/sensorially rich life of a boy unconcerned (unaware) of restrictive economic hierarchies that await in his future and that will deem him a failure. Here a body-mind gap subsumes more than just a conflict informed by disallowed sexuality; caught between the shame-filled present and memories of a pastoral/idyllic past, he suffers a hysteric's "abyss" whereby the present offers mental anguish, and the past entails the acute and blissful physical sensations of the smell of wet dust on pavement, a dramatic "crack!" of thunder, and the feeling of cold rain on naked skin. Yet the idyllic past also incorporates a more pure, if not sacred, notion, a universe based in sensation and nature.

In her exploration of corporate and state-sponsored violations of natural spaces for economic and political gain in the American southwest, particularly within locations associated with Latino history, and culture, Mary Pat Brady writes, "Places are processes" rather than "static locales."[101] In this sense, Conrado's financial success hints at what Brady describes as a "neo-Marxist critique of capital's spatial appetite." Gentrification, segregation, and development violate and deplete the rural (perhaps sacred) existence of natural spaces, to be sure. But these movements against (natural) space(s)—coded

as Western, Anglo, masculinized, and aggressive—are often quite literally enabled by equally aggressive/violating actions toward poor, ethnically marginalized/Chicano labor whose economic and political oppression sustains the enterprise. Brady notes that in Moraga's effort to "redefine entirely the concepts of body and land," the playwright explores how "the micropractices, the little tactics of patriarchy and homophobia... ensure these systems' longevity" in ways that involve "their control of the landscape."[102]

In Brady's explanation of how geographical spaces identified as Chicano (by virtue of both population as well as original inhabitants and cultures prior to Western/US colonization) have transformed into state- and corporate-managed economies, she points to Douglas, Arizona (the same state Conrado make his fortune in) as one example; the systematic seizure and privatization of land and points out how the (native, originally Indian) natural landscape as well as inhabitants become victimized by colonial, corporate, and police-supported aggressors.[103] She writes that the "capitalization and abstraction [of the] frontera meant that as a space it could be understood as isotropic," it was "emptied of meaning."[104] The "shift from the differentiated spaced conceptualized by Apaches, Yaquis, and Mexicanos the conquered and closed fronteras—a shift from the lived and sacred to the measured and homogenized" eventually "resulted in space's abstraction into geometric homogeneities" (e.g., the cookie-cutter developments in which Conrado likely installs underground pools). Exploring Henri Lefebvre's argument that land's/space's abstraction is a process that "require[s] the neglect and even repression of other sensual knowledges of space, including those derived from auditory, tactile, and olfactory capacities,"[105] Brady's analysis easily conjures Manuel's overtly sensual description of the "crack!" of "lightening flash[ing]"[106] that explodes with clean rain that soaks up the dirt soiling him, while he and his campesinos disrobe under the downpour. In his analysis of José Armas' understanding of land and natural spaces, Rodríguez's suggests Armas poses "an appeal to 'Mother Earth'"; Rodríguez sees Armas's suggestion of a "Lat Tierra Sangrada" as a sacred land in which "the roots of the Familia drops its seeds and grows, expands and takes nourishment from the tierra and the plant of life the Familia." While Rodríguez expands this notion of land as sacred,[107] the analysis is significantly invested in discourses of maternal reproduction, further implicating Manuel's *dis*engagement with a nation-based appreciation for la tierra sangreda, whether through fetishization of Conrado's model of wealth or his own (dis)placement in Los Angeles after a rural Arizona youth.

Correlations between geographic/literal space and psychological space within studies of La Frontera are revealing. Theorists such as Anzaldúa, Lefebvre, Alarcón, Doreen Massey, and Homi Bhabha have looked at the confluence of meaning produced by spatial and psychological borderlands.

Antonieta Oliver Rotger writes: "In the writings of Chicanas, space has become a fundamental component in the definition of cultural and political identity"; often these texts can be "read as political, ethnographic and aesthetic documents, which show the different (gender, race, class, national, sexual) power relations shaping the 'real' space inhabited by Mexican-Americans." Rotger maintains that these notions of space include, among other locations, the home, the workplace, the barrio, and important for my argument, "the body."[108] Within this paradigm of space that includes notions of "the physical body" (as space, per se) we might find a productive rubric of what Rotger describes as those "places *traversed* by a *multiplicity of simultaneous social codes,* which make them *contradictory* and always dependent on other spaces."[109] Multiple, queered crossings, and conflicts, indeed. Recall Judith Butler's contention that no interpretable body can exist without the simultaneous presence of a cultural system that inscribes and reifies that body.[110] When we read the body of the queered maternal hysteric as a border space coded with an absence of "timeless truth, essence or authenticity," this space is more than just a setting "for the representation of customs and conflicts"; this space (the body) is a "changing presence that shape[s] and [is] shaped by social relations."[111]

If we expand Rotger's model and consider the maternal hysteric as it occupies a mismatched locus of gender, ethnicity, reproduction, and sexuality, the body queered maternal hysteric posits a space (Frontera) occupied by a subject who "desire[s] to go beyond established... barriers that reinforce social differences and power relations grounded upon race, class, sexual, gender and national status." If Chicana texts "inherently" allude to space as invocation of borderlands, then there also exists "a wish to address [in this borderland] a multiplicity of communal struggles and predicament without privileging one over the other."[112] Without a doubt, Moraga's and Anzaldúa's conceptualization of (contested) space and La Frontera frequently nods to a queered Aztlán—a quasi-utopian, Indio-centric construct of pyschosexual and literal "space" in which borders are celebrated for their fluidity.[113] Expounding on Anzaldúa's queer Aztlán within *Borderlands/La Frontera,* Hernández suggests that rather than "losing its emphasis on the values of home and family so sacred to early Chicana/o movement activists...[it] enlarges its own definition to address the issues of global migration, transnational capital, and shifting identity, insisting always on the fluidity and impermeability of categorizations and definitions... It is a vision of Aztlán inclusive of linguistic, cultural, and spiritual border crossers."[114] And in her analysis of the processes "capitalizing and abstracting la Frontera," Brady contends Chicana literature "offers an important theoretics of space"; these texts have repeatedly "contested the terms of capitalist spatial formation... especially the use of space to naturalize violent racial, gender, sexual, and class ideologies."[115] She surmises,

If the production of space is a highly social process, then it is a process that has an effect on the formation of subjectivity, identity, sociality, and physicality in myriad ways. Taking the performativity of space seriously also means understanding that categories such as gender, race, and sexuality are not only discursively constructed but spatially enacted and created.[116]

Nodding to Anzaldúa's discursively formed, identity-laden notions of la Frontera, Brady's contention of space (e.g., the natural/geographic spaces of Arizona which exist, for Conrado, as a landscape vulnerable to a violent/ capitalist/conquering) points to the natural landscape, to be sure, but also nods to *Manuel* as a contested body/space.[117] The hierarchies that organize Conrado's dominance are invested in his relationship (and conquering/disconnect) with the space of the natural world. Not unlike Anzaldúa's borderland, the (colonized/contested) spaces Manuel suffers in and through mark him as outsider (and Anzaldúa's potential for a celebrated fluidity remains elusive).

If, as Herrera-Sobek posits, "ethnonational consciousness" delineates a state whereby one is "aware of [her or his] specific ethnicity within the boundaries of a nation (in this case the United States)," it follows that ethnonational consciousness connotes the duality of existence experienced by the always already outsider status definitive to Chicano/a subjectivity. Neither completely "Mexican" nor unequivocally "American," Chicano existence is simultaneously inside and outside. Manuel's ethnonational consciousness embodies a push-pull beyond just the hysteric's "gender confusion." Describing Conrado's quasi-racialized economic/Western success—a model that eludes him—Manuel tells Lupe:

> When my compadre Conrado was a little boy, he usetu shine shoes for a living. He was never ashamed of it because, like he said, it was about making a buck any way you could... You don't know him, Lupita. But my compadre is an American success story. He usetu live here... near us. But then he went back to Arizona to make it big.[118]

Conrado is "getting rich" by "pouring cement holes in the ground" and making swimming pools for the Arizona bourgeoisie,[119] economic privilege invested in destruction of the natural world and likely reliant on poor Latino labor. Internal conflicts based specifically in ethnicity are key in terms of Manuel's boundary crossings here. Extrapolating from Timothy Brennan's "The National Longing for Form" (1990), Hernández explains:

> Nationalism is a trope anchored in two main nations: belonging and bordering. The patriarchal imagining of a nation is done when the subject who belongs defines himself in contrast to another outside of the borders

imposed... The "other" in national discourse may refer to those groups outside national borders and/or to those within its borders but outside of the hegemony controlling that nation's discursive practices. One facet of the efforts to transform these hegemonic and normative traces of nation building resides in the confrontations that create queer spaces.[120]

The queer spaces Manuel inhabits, however, are informed by self-/culturally imposed silences and pathologized margins. In the best sense, borderland consciousness *boasts* marginality, a usefully inside/outside status as a foundation of a (redefined) resistant state. When we consider the correlative meanings between notions of *body* and/as a *space*, as with Massey's analyses of space as a social construction, we might consider her contention of space (or "body as space") as that which transgresses time, but also serves as the foundation and vessel for collective memory and experience.[121] For notions of the maternal body as well as "the hysterical body," especially telling here is Massey's contention of space/"body" as *a product of* social/cultural constraints and Massey's contention of space/"the body" as a site of memory. Massey's hysteric, queered or not, must live with, is arguably *pathologized* as a result of her/his memories and experience. Moraga's Manuel, the queered hysteric whose maternal status is not limited by corporeality, inhabits a physical space "socially produced" but also haunted, even pathologized, by memories and experience.

Beyond specific plot- and character-level engagements with "reproduction," and shameful memories/knowledge, *Shadow*'s specific aesthetic form also evokes truth-telling and hysteria. To begin with, many of Chicano Theatre's recurring themes and conflicts revive ideas and motifs that predate the tradition by decades, if not centuries. In addition to expressionistic devices, agitprop premises, and domestic conflicts that result from societal oppression, Chicano performance frequently invokes notions (and valorization) of community, as well as a hybridized subject who occupies a quasi-nation based borderland/"Frontera." As I argue earlier, this hybridized subjectivity lends itself to broader discourses of La Frontera in ways that implicate the gendered and race-based landscapes of hysteria. But this fractured, multiple "beingness," as it does/not emerge *specifically* from a linear realism, also comments on broader epistemologies, ways of "knowing" that themselves engage gender-, class-, sex-, and race-related notions of hysteria. In other words, as a dramatic text emerging from a broader tradition of Chicano/a performance, *Shadow's* complicated relationship with the truth-telling function of dramatic realism comments on hysteria's potential (as both discourse and narrative/dramatic construct) to productively interrogate the teleological trajectories inherent to this linear/Western form that relies on catharsis, often espousing universalisms.

REALISM'S PATHOLOGY

Shadow represents one of Moraga's most significant forays into dramatic realism. Among the material realities occurring during the play's action (a working-class Chicano family inhabiting 1969 Los Angeles), the Chicano movement is germane for the broader role it serves in spawning Moraga's initial politicization as a lesbian Chicana, but is also an important moment that engenders the dramatic/political interventions of Luis Valdez's El Téatro Campesino. This civil rights movement and theatrical tradition is not always divorced from the misogyny and machismo against which Moraga's oeuvre works, but is also a movement that regularly invokes nonrealistic dramaturgy.[122]

Valdez and his contemporaries are relevant here, in particular, for their disengagements with realism. Jorge Huerta points to the late 1970s and what he terms the "*Zoot Suit* phenomenon" as a starting point for the Chicano theatre movement, while also noting other activist-oriented practitioners/*teatristas* were staging politically motivated performances before "Zoot Suit fever,"[123] practitioners/performers who deviated from realism and focused on consciousness raising. Heralded under the national coalition of teatros *TENAZ* (El Teatro Nacional de Aztlán) in 1971, individual groups such as Teatro M.E.Ch.A., Teatro Justicia, and Teatro de la Esperanza were active years before *Zoot Suit*'s 1979 Broadway premier. Alongside Teatros across the United States in the 1960s and early 1970s, poet, novelist, editor, and playwright Estella Portillo-Trambley emerged as an establishing force of Chicano dramaturgy.[124] Predating Portillo-Trambley and Valdez much further, the forces shaping modern Chicana/o performance traditions can be seen going back centuries, with implications of non-Western/Indio performance invoking pre-Columbian traditions. The stylized, Vaudeville-like "Actos" that TENAZ's Teatros utilized (or in Valdez's case, made famous) typically engage mitos/myths, themes, and musical undertones traceable to Indo-Hispano and Mexican sources dating to the 1500s.[125] Specific subject matter also repeats in the tradition, only to become complicated throughout Moraga's oeuvre (e.g., the sexually aberrant and/or fallen woman bringing destruction vis-à-vis cultural and moral punishment).[126]

But it is Moraga's (and the tradition's) relationship with dramatic realism that I want to focus on here. Arguably indebted to the actos of the political teatristas who precede her, Moraga often eschews the lulling catharsis of dramatic realism; this persistent resistance to linear realism is invested, certainly, in the more expressionistic traditions of Indo-Chicano performance. But divergences from realism also find import in what some consider politically dangerous "intellectual lulling" that deters spectators' critical engagement—analyses that realism/catharsis preclude. As in Brechtian alienation,

preventing the release of catharsis/escapism forces spectator awareness of the (meta)performance at work and the ideologies surreptitiously espoused by the text. Chicano theatre's stylized, nonrealistic dramaturgy shares political objectives with Brechtian expressionism in both prevention of catharsis and the use of performance for political/critical engagement (if not indoctrination). Huerta points out that the teatros of the 1970s

> were more intent on bringing about social justice than following any traditional rules of aesthetic theory. Metaphorically, at least, they wanted to light fires of social justice wherever there were Mexicans and Chicana/os being oppressed. In other words, the message was much more important than the medium. The Teatro Campesino's actos became the standard model for these young troupes because the acto form is easily emulated and adaptable to any socio-political motive or situation. Anyone with a cause can collectively create an acto, but the cause is essential.[127]

Huerta continues:

> This was a theatre movement based on the need to make a difference in the community, not through Art but through Action...Early teatristas...were unabashed in their disdain for traditional theatrical practice and purposes...these dedicated individuals, who called themselves 'cultural workers,' were eager to challenge the status quo any way they could.[128]

With the potential to sustain an oppressive status quo, any engagement with realism might raise questions about a work's political efficacy; when the (potentially regressive) form also explores *subject matter* associated with social hierarchies (domesticity, restrictive gender paradigms, essentialized racial subjectivity), the stakes are higher.

The constructs of and politics embedded in maternity are ubiquitous to Moraga's career. With frequently invoked mythopoetic of figures such as La Llorona, and La Virgen de Guadalupe, to name just a few, maternal issues are also central to Chicano literature and culture. A glean of nineteenth-century *literary* discourses of the maternal hysteric (and frequent doppelganger, the Fallen Woman) generates insight into the construct from a variety of genres and styles, including less-than-realistic staged melodramas, domestic fiction, and—especially relevant to my analysis here—a new and developing dramatic "realism" offered by playwrights such as Bernard Shaw, Arthur Wing Pinero, and Henrik Ibsen. A figure emerging from a nineteenth-century obsession with gender-marked subjectivity, this frequently maternal (often, a mother-gone-bad) hysteric finds recurrent documentation in medical and literary discourse, as well as actual literary articulations of the "Fallen Woman."[129] Deviating from a Victorian Cult of True Womanhood,

the nineteenth-century Fallen Woman/hysteric possesses a clandestine past/ secret to be discovered and solved. Employing what Elin Diamond describes as a particularly "Ibsenite realism" (a realism Moraga engages in *Shadow*), nineteenth-century dramatic stages conflated hysteria, inflexible gender mores, and the "sexual secrets" aggregated by both.[130] In her exploration of what she describes as the definitive hysteria of late nineteenth-century dramatic realism, Diamond notes that late Victorian critics increasingly hypothesized a "literature of hysteria" in tandem with a new "doleful" dramatic realism, a realism that increasingly positioned itself alongside the new realism of Ibsen.[131] (That Moraga so frequently finds critical comparison with Arthur Miller, and Miller, in his own domestic realism, often earns similar critical association with Ibsen seems no coincidence.)[132]

Diamond writes: "Semiotically, discursively, the hysteric has always been a fallen woman."[133] Emerging like a maternal phoenix from the ashes of melodrama, the fallen woman evokes a feminine construct that resists/ fails the role of domestic nurturer. That failure can emerge from pursuing unsanctioned romance, career/public life, or merely resisting domesticity. Whether considering ancient, etiological sources of hysteria (Greek physicians termed any disease of the female womb *hystera*) or eighteenth- and nineteenth-century physicians who believed that menses and pregnancy "produced a deficiency of blood" leading to hysteria (not to mention the Victorian medical melodrama, which frequently posits the morally inadequate mother as fallen woman/hysteric), ideologies surrounding hysteria associate themselves with maternity/reproduction regularly.[134] Diamond's positioning of realism, hysteria, and Ibsen is telling.[135] We might consider many genre-specific traditions within realism as a late nineteenth-century form: "Ibsenite realism" affords a revealing purchase on an increasing focus on family, as well as character conflict focused on an internal rather than external agon (e.g., spousal infidelity replaces military threats to the crown; anguish from oppressive cultural norms "internally" haunts a protagonist in lieu of a mustachioed melodramatic villain). But it is Diamond's association of "Ibsenite realism" to hysteria that becomes especially significant with regard to Moraga. Maternal fallen women emerging *from* popular melodrama and moving *into* the new realism surface as discursive subjects who, in conjunction with a new positivist science of psychoanalysis, exist as problems to be solved. In the (new) dramatic form especially suited to a problematized-but-decipherable subject (the fallen woman hysteric with a sex-related secret), the culturally confused hysteric finds a frequent stomping ground on a stage characterized by its ability to "realistically" address the internal, psychological, and cultural tensions of its time. Diamond explains: "For Ibsen and his English imitators...the conventionalized fallen woman became more than automatic sinner. Her *social position*, her

desires, her *confusion, most of all her secret sexual past,* were a...problem or enigma that has to be solved."[136] In their role as, what Diamond terms "English Ibsenites," Pinero and Henry Arthur Jones submit figures whose sexual secrets conflict directly with the paradigms of maternity articulated in Victorian Cult of True Womanhood, a repressive domesticity based in class-, gender-, sex-, and even nation-based ideologies. In this vein, Moraga's Manuel—conflicted by means of sociopolitical position, desire, and secret sexual past (if not present)—has a long narrative line of predecessors.

Amid this Ibsenite realism, "the new therapy and the new theater depend on exploring and exposing the woman with a past."[137] Notions of realism invested in a subject who possesses a shameful/hidden "truth" become especially relevant to Moraga's own "fallen (wo)man" hysteric, one revealed in (primarily) realistic form. While the truth of Manuel's sexual donation of Hortensia is nothing to boast of, even more shameful is Manuel's own truth— which will be "solved" by play's end—a sexual past defined by romantic love for Conrado. "Realism," Diamond explains, "is more than an interpretation of reality passing as reality; it produces 'reality' by positioning its spectator to recognize and verify its truths: this escritoire, this spirit lamp affirms the typicality, the universality of this and all late Victorian bourgeois drawing rooms."[138] For the drawing rooms and their imparted, "naturalized" ideologies, secrets (and the subjects who bear them) are coded as problems to be solved, pathologies to be cured. Or, as Diamond explains, in "the Ibsenite drama of the 1890s...secrets will be told and debated, although the taint of female degeneracy will never be expunged. The crime...will simply be displaced and 'internalized' as a pathology like bisexuality or the [hysterical] state."[139]

Moraga, however, queers the "typicality" and "universality" of bourgeois drawing rooms on two fronts. While the sexual secret of a maternal, perhaps "fallen" character is presented as secret-to-be-solved (this gender/sex identity reversal a kind of queering in and of itself), the play's final, celebratory moment *delighting* in Lupe's own same-sex attraction (for Frankie Pacheco, the girl whose name Lupe will take as a confirmation moniker) also queers the existing, if not retrograde "typicality," that is otherwise universalized in dramatic realism's drawing room. Further, unlike much of Moraga's work, in matters of form *Shadow* resides in close proximity to the realism that bequeaths Ibsen's (and Pinero's and Shaw's) fallen women. Consider in this context Diamond's contention of Ibsenite realism *as* hysteria, an hermeneutics vested in, among other things, the form's tradition of surreptitiously "operating in concern with ideology."[140] Diamond contends that as a kind of "dramatic form that legitimized itself through its ability to know, to respect, to reflect the truth," this new cathartic dramaturgy increasingly "establish[ed] its truth by reading the enigma of hysterical symptoms."[141] In

its habit of presenting a hidden/conflicted truth waiting for discovery/revelation, the new realism, like the hysteric, moves toward relief/dénouement by means of the discovery/expunging of (sexual) secret histories.

Diamond points out, the "Brechtian-feminist performer 'alienates her/his own gendered...history, when that body is 'historicized,' spectators are invited to move through and beyond imaginary [constructed, culturally based, artificial] identifications."[142] What this means for the spectator is that, unlike the more expressionistic or Brechtian traditions of Moraga's other works (indeed, interruptions into realism that are more typical of Chicano/a drama), *Shadow* does *not* repeatedly interrupt the spectator's cathartic experience; like the hysteric's body, the play (according to Diamond's contention of realism as hysteria) portends conflicted and furtive representations to be explored and deciphered.[143]

* * *

Isolating maternity from strictly corporeal conditions, the critically queer endeavor of casting Manuel as maternal hysteric relieves the mother figure from restrictive tenets conflating gender and anatomy. As a self-hating, self-denying gay man and cuckold, this figure must deal with his (increasingly rebuked) propensity toward nurturing tenderness, particularly toward his offspring and his unacceptable erotic love toward his financially successful Compadre. Imbricated within a Freudian-inspired/"sexual secret" paradigm of hysteria, Manuel surfaces as queered maternal hysteric as he nods as well to the fallen woman, the "bad mother" archetype of nineteenth-century literary discourse. In Ender's analysis of hysteria in George Sand and George Eliot, she writes: "Gender is...represented at the very core of that *Seelensleben* (life of the soul) that is the object of the quest, the ultimate enigma of the scene of hysteria." The war over the hysteric's soul," she continues, "inevitably raises questions of property and appropriation."[144] For Manuel, as with Dora, questions of "property and appropriation" point to the paradigms of gender (and race) that find both subjects relatively powerless. As McLaren reminds us, hysterical women have "for centuries...been labeled hysterical whenever they exhibited signs of anger, rage, frustration and despair."[145] Expanding assessment beyond gender and incorporating race-based border crossings can offer value into an understanding of hysteria as a kind of psychic-corporeal resistance to oppressive external law, but one that does not merely reside in the female body, but rather the feminized/Otherized body. Distinguishing this form as a frequently "occupied," sometimes physical site of (contested) hegemonic rule, we might usefully also consider the male form, a queer maternal presence whose pathology belies a body speaking, or rather an occupied body who refuses to be silenced.

Conclusion

Nurturing Performance, Raising Questions

On August 19, 2012, US representative for the state of Missouri Todd Akin declared his nearly infamous "legitimate rape" sound bite. In the context of a series of questions about the acceptability of abortion in various scenarios of conception (including when a mother's life is in danger), St. Louis reporter Charles Jaco asked Akin: "[W]hat about in the case of rape? Should it be legal or not?" Akin replied: "It seems to be, first of all, from what I understand from doctors, it's really rare. If it's a legitimate rape, the female body has ways to try to shut the whole thing down."[1] The list of why Akin's remarks are everything from inaccurate to offensive is too long to mention. But what seems particularly relevant in this statement—a point of view supported by more than one US politician at the state and federal level, it was soon revealed—is an underlying endorsement of the relationship between women's bodies, the act of conception, and culturally specific moral paradigms governing reproduction.[2]

Later that day when Akin released another statement explaining, "I believe deeply in the protection of all life, and I do not believe that harming another innocent victim is the right course of action,"[3] he revealed another (widely shared) assumption underlying his earlier remarks about the so-called biological logic of women as child-makers. In anthropomorphizing a hypothetical fetus as "another victim" he and many prolife advocates equate the female body with, in the most extreme case, a single-cell fertilized zygote. As reproductive rights advocates have long pointed out, this placement of the fetus on equal standing with the woman (or rape victim) whose egg is fertilized ascribes a (sometimes mythical) human subjectivity (and importance) to what in its earliest stages is a collection of cells a few millimeters

in size. Equally significant, however, is the diminished subjectivity (and importance) of the woman—the potential mother—who experiences the conception. The value and rights of the product of conception are elevated while, simultaneously, female subjectivity is reduced to anything from incubator to latent storehouse of shame. In addition to the obvious potential within this ideology for far-reaching gender-based disenfranchisement and human rights abuses (and not just in the developing world), we might also consider how it mimics, perhaps reinforces, other identity binaries that involve an interdependent coalition of maternity, class, and race.

While the discourse from Akin and his cohorts does not consistently mention "motherhood" in explicit terms, the clear indication of a woman's *natural*, physical ability to regulate when she does/not produce offspring unavoidably assigns a biologically based intelligence to her reproductive organs and along with this logic, casts those reproductive organs as the most important thing about her. The consequent implication of this rhetoric is that—despite an assumed *biological logic*—when the results do not turn out "optimally," some moral shortcoming on the part of the pregnant woman must be responsible. This purported corporeal intelligence functions along with ideologies that themselves hinge upon essentialist notions of female subjectivity, binaried gender constructs, and a host of other socially conservative beliefs that frequently invoke narratives of race and class for the mother subject.

In *Unmaking Mimesis* Elin Diamond incisively explains

> [G]ender... refers to the words, gestures, appearances, ideas and behavior that dominant culture understands as indices of feminine or masculine identity. When spectators "see" gender they are seeing (and reproducing) the cultural signs of gender and by implication, the gender ideology of a culture. Gender in fact provides a perfect illustration of ideology at work since "feminine" or "masculine" behavior usually appears to be natural—and thus fixed and unalterable—extension of biological sex.[4]

Invoking Judith Butler's contention of the corporeal narratives that occur in the body as text, Diamond continues: "The 'body' is itself a construction; that is 'bodies'... come into being in and through the mark of gender," and as a result, "this rigorously antifoundationalist argument insists on the fictionality—yet the persistence—of gender taxonomies and the critical role of performance."[5] If one expands Diamond's contention to include race-based taxonomies within this "critical role of performance," the interdependence of these two categories of identity makes a compelling case for scholarship that considers literal/staged performance within the discursive practices that sustain social hierarchies. But what stands to be gained in going a step further, toward analyses that integrate as well nation-based subjectivities? The

perilous landscape of gender, maternity, and (dis)enfranchisement alluded to in positions such as Akins' implicate and are implicated by the contested battlefield of reproductive rights, certainly. But these reductive discourses also engage an often unstable, specifically *American* narrative of maternity. While the arguments offered by figures like Akin and the responses that they evoke reveal the conditional liaison of morality, conception, and motherhood, they also reveal how those affiliations sustain and complicate national subjectivities.

The preceding chapters focused on ideologies that are based in race and class and that, while in congress with normalized rubrics of motherhood, situate particular individuals in power while marginalizing others. The plays I explored signify an assignation of blame/shame or valorization of the individual based on how s/he corresponds to particular rubrics of maternal identity and behavior. Indeed, the maternal body itself—with its unique ability to engage, refuse, or merely complicate corporeal changes vis-à-vis reproduction or paradigms of nurturance (to name a few)—exists as a powerful tool in complicating nation-specific narratives of being. In this last chapter I explore in a bit more detail how those identities and behaviors become invested in notions of Americanness. If, as Shannon Sheen posits, one of "the primary conception[s] of race...is of a process through which certain groups are either equated with or excluded from national citizenship,"[6] how might performances of maternity that resist the status quo reimagine a specifically national subjectivity, one that exceeds the maternal?

While this volume has limited its inquiry to staged representations of motherhood and the maternal, here I gently push against the restrictions of analyses constituted in dramatic performance and literature and consider also a handful of cultural "texts" outside the domain of theatrical performance. To be sure, the widely disseminated thoughts of a conservative American politician are but one example of the ways that reproductive ideologies get mapped onto women's bodies and are imbricated within culturally specific moral systems. If inquiry exceeds the scope of a discipline already preoccupied with "acting out identity," what remains to be discovered with regard to, for example, the naturalized paradigms of family, gender, and professional ambition in the performance of workplace labor? How are these constructs imbedded in the ways that geopolitical identity is conceived? How does the changing scientific and political landscape of contraception and reproduction technologies comment on feminism, autonomy, and class privilege? What opportunities are afforded by unpacking the relationship between social hierarchies and maternal performance when broader cultural phenomena are considered?

Finally, while the book in toto considers Anglo-, Latino-, Asian-, and African American constructs of motherhood, this final section restricts its

focus to the narratives and ideologies that engage specifically Latino- and African American motherhood. In addition to brevity and focus, this tighter lens will, I hope, facilitate a richer and more nuanced analysis while at the same time resist the puerile conception of critical race studies that places its subjects along a reductive, binaried axis of black and white.

* * *

Simultaneously Mexican and American by definition, Chicana subjectivity unavoidably occupies a border culture that requires constant negotiation of affiliation and loyalty; a cultural (and sometimes political) allegiance to Mexico as "homeland" (even for American-born Chicanas) can dramatically conflict with ideological affiliations to an Anglo-centric American world that is also home. Progressively repositioning Chicana identity outside of theatres but very visibly in the press and the material political world, the Mothers of East Los Angeles (MELA) provides a provocative instance of the recasting of Chicano maternity—a recasting that emerges specifically from the "confines" of the mother role and its negotiation with Americanness.

In the early 1980s, a group of Chicana mothers protesting the construction of a state penitentiary in their East Los Angeles neighborhood created MELA. With a membership that has ranged from 200 to 400, these long-time Los Angeles residents did eventually achieve hard-won success in preventing the creation of the proposed state prison, but also went on to (and continue to) achieve impressive changes in policy and local government, all from a collectivity defined first and foremost by maternal status.[7] As Mary Pardo writes, for this group of Mexican-American mothers, a growing "process of activism...transformed previously 'invisible' women, making them not only visible, but the center of public attention." Furthermore, while in theory and "[f]rom a conventional perspective, political activism assumes a kind of gender neutrality," in practice, historically, in American culture "men are the expected key actors."[8] Under early, initial guidance from a local priest, Father John Moretta, however, MELA's leadership eventually became mother-led. Significantly, it was/is their employment of a very public identification as mothers that generates an activist edge. Pardo explains: "These women have defied stereotypes...and used ethnic, gender, and class identity," not as something to succeed *despite* of, but rather "as an impetus, a strength, a vehicle for political activism."[9]

For example, MELA's website notes that in their initial protests, "the [mothers] would always wear scarves on their heads as a sign of peace, dignity and respect for their community."[10] The scarves—not unlike those worn by the Argentinean "Madres de la Playas," a collective of mothers who wear white headscarves while protesting for information regarding their

"disappeared" children taken during Argentina's "dirty war"—visually unify for spectators a group of American mothers as one coalesced political force. The scarves function also as a kind of costume for the (new) performance of (politicized, Chicana) maternity that the California mothers themselves have self-consciously constructed. With regard to their earlier protests over the prison, MELA's website proudly declares: "Never in the history of the State of California had Latina mothers united to confront a Governor."[11] This new and reimagined Mexican-American motherhood, significantly a self-generated construct, offered an alternative to the martyred and/or disenfranchised Chicana, a passive subject who might live next to a new state prison or toxic waste treatment plant but remain unable to do anything about it. As American subjects, the Chicano-American mothers of MELA refuse the victimization and passivity generated by an ideology of Marianismo—a gendered belief system invested deeply in Latin American culture and understands a Chicana's primary value and importance in terms of her sexual and maternal status.

The alternative, enfranchised maternal performance that MELA constructs, while certainly a productive complication to the "virgin/compulsory-mother versus whore" binary that constitutes Marianismo, does still rely in part on culturally based essentialisms based in maternal sacrifice and selflessness. In reference to MELA's activism focusing heavily on environmental justice, for example, the *Los Angeles Times* asserts: "They are mothers who have coalesced around something of immediate importance to them, *the safety of their families and children.*"[12] Or, as the homepage of MELA's splinter group "The Mothers of East Los Angeles Santa Isabel" proudly declares, the women are "not economically rich—but culturally wealthy, not politically powerful—but socially conscious, not mainstream educated—but armed with the knowledge, commitment and determination *that only a mother can possess.*"[13]

More specifically negotiating (if not complicating) their status as hybridized American mothers, MELA's members assume a collectivity that mirrors activism rubrics more frequently practiced outside US borders. Pardo explains that these American mothers who are also Chicanas successfully "transform 'traditional' networks and resources based on family and culture into political assets to defend the quality of urban life."[14] Reconstructing a new kind of (American) Chicana maternity, these mothers tellingly take a cue from existing, successful models of political organization *outside* the country they call home. As Pardo points out, "Far from unique, these patterns of activism are repeated in Latin America and elsewhere."[15]

Further evidence of a newly situated, newly defined Chicana motherhood occupying American culture/politics emerges from MELA's practical reemployment of the Catholic Church, whose support proved integral to

MELA's early successes. In addition to the ideology of Machismo, perhaps the most significant cultural reinforcement to the patriarchy that marginalizes Chicanas, is a conservative Chicano Catholicism, one that relies on and reinforces the sexual (mother/whore) binaries informing essentialized maternity. Yet, not far from the liberation theology espoused by Moraga herself (as seen in, for example, *Shadow*'s Letitia's reappropriation of the Mary Magdalene figure in her reimagining of a shame-free sexuality), MELA also employs and repurposes Catholicism to help secure a progressive political agenda. In reference to Catholicism's role in MELA's successes, Pardo again points out the ways that the organization's tactics and tenor mirror activism not necessarily based in the United States:

> Religion, commonly viewed as a conservative force, is intertwined with politics. Often, women speak of their communities and their activism as extensions of their family and household responsibility. [This] central role of women in grass-roots struggles around quality of life in the Third World... challenges conventional assumptions about the powerlessness of women and static definitions of culture and tradition.[16]

The culture and tradition of Chicano family life, invested so deeply in a Catholic-informed self-sacrificing, essentialized maternity, is rearticulated by MELA in such a way that religion, like motherhood itself, becomes not an albatross but a motivating factor in justice-oriented campaigns aimed at protecting children, families, and frequently, the natural world.

In *Shadow of a Man*'s second act, when oldest daughter Leticia informs her mother that she voluntarily "sacrificed" her virginity the previous night, she says she did it because she was "tired of carrying it around, that weight of being a woman... walking around with that special secret, that valuable commodity." In what might be read as an explicit negation of conservative Catholic and Chicano sex-gender ideologies that would otherwise invest her entire worth in her sexual status, she tells her mother: "I wanted it to be worthless, mamá. Don't you see? Not for me to be worthless, but to know that my worth had nothing to do with it." And when a supremely heartbroken Hortensia asks her daughter, "You protect yourself, hija?" Lettie acknowledges that she did indeed use birth control.[17] With the outspoken, unapologetically sexually active Letitia the play suggests a Chicana whose politicized consciousness is informed by a (new) ethnically based agency. For example, among other things Letitia openly supports the United Farm Workers and praises la Raza; she focuses on an increased Chicano presence at ivy-league schools; and she resents what she sees as her brother's shame-based assimilation as evidenced by, among other things, his marriage to a white woman and naming his son "Sean." Alongside this resistant Chicana politics,

however, is a progressive engagement with a shame-free, nonreproductive sexuality affiliated more closely with an Anglo-American gender ideologies of 1969. Understood another way, as a newly conceived national subject, this reimagined, empowered American woman—a subject whose ethnicity is established by both her Mexicanness *and* her Americanness—Letitia is not defined exclusively by her engagement with racially informed political resistance. With her openly declared use of birth control (an unsanctioned practice according to her family's Catholicism, of course), Letitia's *performed* refusal of motherhood explicitly incorporates a rejection of (multiple) externally imposed hierarchies. These hierarchies are powerfully imbricated in conservative Chicano gender paradigms: systems of behavior and identity profoundly invested in premarriage virginity and postmarriage motherhood, and systems of behavior and identity that in 1969 are not shared (or at minimum, as deeply felt) in Anglo culture, comparatively.[18]

The one source of (any) power a Chicana can hope to secure in *Shadow*'s culture is in her role as mother, and in particular a mother of sons. As the tortured matriarch Hortensia proudly lectures Letitia, "That's one thing, you know, the men can never take from us. The birth of son. Somos las creadoras." (We are the creators.) Obviously this essentialist notion of Chicana subjectivity and motherhood (and its positioning of maternity as a Chicana's raison d'être) rhetorically equates Chicana maternity with god-like agency. And when Letitia ponders, "Who knows? May I won't have kids," her mother quickly retorts, "Then you should have been born a man."[19] As opposed to the Anglo-American woman who, in 1969, would have started to question her worth and potential for contribution beyond mere reproduction, Hortensia's standpoint assigns complete and total value in maternal identity. This is also a powerful contrast to Hortensia's thoughts on the minimal importance of fatherhood. While "what comes out of [Hortensia] is [her] own flesh and blood!" by contrast the father (a mere sperm donor) is simply "the one who puts the food on the table, nomás."[20] By engaging, premeditatedly, in premarital sex, openly and without apology, Letitia denounces the virgin/mother-whore binary that haunts her own mother and other Chicanas. But by (equally premeditatedly, publicly) refusing motherhood in her use of birth control, her rearticulation of a Mexican-American subjectivity is defined in large part by her (non) engagement with conservative Chicano sexual ideologies that incorporate compulsive motherhood.[21] In other words, as a newly (self-)defined ethnic-American subject, Leticia moves toward a more open, at minimum a more flexible, sexual/maternal subjectivity that is politically progressive, to be sure, but one that also resituates a Mexican-American gender construct that is not defined exclusively in the Chicano culture that would place her on the margins.

Unpacking the ways that essentialist black subjectivity negotiates—among other things—national identity, Carol Henderson explains that "the material for sociopolitical scripts of race, gender, and sexuality" exists throughout the American cultural imagination and places African American women "in linguistic and social fetters."²² Moreover, these "fetters" function "to the extent that the sexual and gendered implications of such interplays...unveil the social industry built on the erotic and spiritual vulnerability of these same black female subjects."²³ In the social industry of American culture, a plethora of reductive stereotypes defining African American women persistently converge in images of (struggling) African American *single* motherhood—frequently single mothers who are economically disadvantaged. When juxtaposed against the absence of hardships or similar stereotypes in representations of white mothers (single or not), a powerful semiotics of racially informed American maternity emerges. For example, in her exploration of white American employers' assumptions (and consequent actions regarding) Black women in the US labor market, Ivy Kennelly's research suggests that African American women workers are overwhelmingly and automatically perceived as mothers and unmarried, particularly when those women are from working-class backgrounds.²⁴ Kennelly's study reveals that US employers artificially assign these employees (who may or may not actually be single mothers) a host of unattractive qualities. White employers presume that these workers are unreliable and/or unqualified, insufficiently prepared for the labor market, lacking in motivation (lazy), prone to tardiness and absenteeism (particularly as their children's lone caretaker), and likely to participate in high turnover. Furthermore, according to the majority of employers surveyed, "Most of these women...were just one step from being...welfare mother[s]."²⁵ Because employers maintain the power to hire, pay, promote, and, of course, fire these women, in the American labor market the black single-mother moniker—whether actual or imagined—becomes a maternal construct with material repercussions. And while these assumptions "regarding [workers'] race and gender, as well as their sexuality, age, religion, class, and ability" were indeed "less overt than in previous decades," as Kennelly points out, they nevertheless stubbornly "prevail and are arguably even more dangerous than outright slander because they are hidden."²⁶

Kennelly's findings on American employers' essentializing of African American maternity—namely the "welfare mother"—also resonate in public policy and the rhetoric of US politicians. For example, while many employers in Kennelly's study perceived "the bad Black mother" as economically disadvantaged, single, and often absent from the home (due to long work hours), these employers also understood this "poor mothering " (and consequent neglect) as a legitimate factor in African American children's

academic performance.²⁷ This offensive narrative of black American motherhood is famously demonstrated in the then assistant secretary of labor Patrick Moynihan's 1965 report: "The Negro Family: The Case for National Action," typically referred to as "The Moynihan Report."²⁸ Among other things, the highly contested and problematic document suggests that African American filiation is steeped in a "tangle of pathology," and further, this pathology is principally culpable in the "deterioration of the Negro family...and community."²⁹ More than anything, the report concludes, it is the "matriarchal structure" within the African American community that weakens the authority of African American men, so many of whom are absent from their families and consequently their responsibilities.³⁰ Micki McElya notes the "study appealed to many with its suggestion that racial inequality and economic dislocation persisted, despite the passage of federal civil rights legislation, because of deep-seated problems within black families rather than in the wider society."³¹ As James Patterson makes clear, Moynihan's unambiguous censure of "female-headed families [that] were at a 'distinct disadvantage' in U.S. society" assigns blame in no uncertain terms to mothers with preschool-aged children who are "working outside of their homes." More than just participating in the feminization of poverty, Patterson writes, "by highlighting increasing welfare rolls, [Moynihan] left an impression that lower-class black women having babies out of wedlock were irresponsible" and thus continued to solidify the narrative that Kennelly's research also reveals: a portrait of black maternity characterized as "oversexed welfare cheats and malingerers."³²

As one of the first public, officially sanctioned examples of blaming the victim, the Moynihan Report suggests that the responsibility for any economic, social, even moral shortcomings in black communities (including, for example, an increased welfare state in urban areas, the education gap, and increased numbers of incarcerated African Americans) resides in a broken family structure; the fault for *that*, the report suggests, lies heavily in the hands of a particular construct of American (race-based) motherhood, one that is dangerously emasculating. Doris Witt suggests that with romanticized "traits such as 'strength' and 'power,'" the Moynihan Report places these characteristics that are "historically...attributed to African American women in the context of an indictment of Black matriarchy"; ³³ what in other frameworks or more nuanced imageries could be constructed as positive are used instead to reductively shape a construct of American motherhood in which a racially informed domesticity is ultimately culpable.

As a maternal performance unique to American culture, along with the mammy the African American single-mother construct (and often, a conflation of both) stubbornly haunts American drama as well as broader American culture and politics. While the majority of staged offerings still

rely to varying degrees on incarnations of these roles, African American women playwrights of the 1970s, and recent works from playwrights such as Cheryl West, to name a few, continue to make inroads into three-dimensional offerings of black maternity that are not defined exclusively (or at all) in an unmarried and/or economically disadvantaged status. If, as Patricia Hill Collins suggests, "the mammy image was designed to mask [the] economic exploitation of social class,"[34] then what commentary is offered by the maternal construct that bypasses mammy-dom? Rather than camouflaging the "economic exploitation" of those Americans who do *not* benefit from a specifically American subjectivity that is invested in free market bourgeois individualism, might alternative (more three-dimensional) narratives of ethnic-American motherhood offer critique, particularly in their articulation of filiation based not in individualism but in multigenerational, community-oriented kinship?

In her analysis of Alice Childress's *Mojo* (1970) and Aishah Rahman's *Unfinished Women Cry in No Man's Land While a Bird Dies in a Gilded Cage*, Joyce Meier writes that while both plays "emphasize the economic vulnerability of the single black mother," they simultaneously explore uniquely race-based maternal agency via mother characters who voluntarily place their children up for adoption as opposed to keeping them and bringing them up in poverty.[35] The trajectory of *Mojo*'s Irene, for example, incorporates many of the material hardships that other African American single-mother characters negotiate. But in the politically conscious year of 1970, it could be argued, a year in which American culture and politics saw a strengthening black consciousness inside theatres (via the Black Arts Movement) and outside theatres (via an increasingly politically organized and active Black Nationalism), the black American single-mother character is also extremely aware of the unjust material circumstances that make her offspring's future a potentially dark one, not to mention the social structures that are responsible. Rather than what might be represented with a long suffering mammy, *her* pain and eventual sacrifice are contextualized with (and conspicuously performed among) an explicit critique of race- and class-based hierarchies that define American life for its maternal characters. Along with Irene's unambiguous "celebration of blackness,"[36] it is this ideological awareness that casts Childress's protagonist as a more productive representation of an empowered, nonassimilationist mother character that deviates from her mammy predecessors, even if she is unmarried.

Similar to her discussion of Childress, Meier's analysis of Rahman argues that the latter offers a performance of black maternity that, while unmarried and contextualized within a broader scope of racism and poverty, productively "challenges both racism and sexism."[37] In addition to the play featuring white and Latina single-mother characters alongside African American,

it models an American single motherhood of color that is (1) not exclusively defined as African American, but also (2) reveals maternal subjects whose narratives perform an "analysis of class difference."[38] This un-Mammy-like political consciousness—one that incorporates (and addresses/performs a critique of) racial as well as economic marginalization endemic to American culture and even domestic policies—is mirrored in nearly all of West's characters in *Jar the Floor*. Although West's African American mother characters are all single, they are all acutely aware of the socioeconomic systems that participate-if-not-enable the status quo. Considering, for example, Lola's successful entrepreneurship or Maydee's eventual tenure achievement, West's unmarried mothers are neither unaware of nor victimized by class-based hierarchies; and while unmarried, West's African American mother characters are financially comfortable. Finally, *Jar*'s black American mothers varyingly perform an un-Mammy-like unapologetic and shame-free sexuality (including the elderly Madear), but without ever engaging in an exoticized (or even fetishized) Jezebel stereotype. As the play's lone African American character who is not a mother, Vennie is unmarried, but as an out lesbian who in various ways verbally confirms her refusal of biological motherhood, she avoids a reductive construct of single maternity but also reinscribes black motherhood in the nurturing role she plays to her lover who deals with cancer.

Two-dimensional portraits of black maternity couched in singleness and financial hardships were and still are more common in what mainstream American media offers. In television, for example, typical Mammies are featured in programs such as *Gimme a Break*, *That's My Momma*, and *What's Happening*, to name a few. These offerings also provide a portrait of black American motherhood (whether literal or figurative) as a single enterprise.[39] Particularly throughout the 1970s and 1980s, black maternity is represented as a distinctly "American" motherhood defined as much by ethnicity as poverty and unmarried status.[40] Although K. Sue Jewell suggests that *The Cosby Show* "represents a first in television for introducing and maintaining positive imagery of African American women without any of the traditional negative images that were portrayed in previous television,"[41] some critics point to 20th Century Fox's *Julia* as the initial groundbreaker. Running from 1968 to 1971, the program's eponymous lead is an African American mother character who broke political ground more than a decade before Phylicia Rashad's Clair. Tellingly, however, singer and actor Diahann Carroll's Julia was defined explicitly as a single mother. And the (single Black mother) character's engagement with a specifically American subjectivity—particularly in relation to the realities taking place outside of television, theatre, and film—are particularly revealing.

When Julia first aired on NBC on September 17, 1968, it was the first American network television program to feature an African American

woman protagonist.⁴² In addition to a motherhood foregrounded in its single status, Julia is a performance of American maternity that, while performatively ethnic (many episodes deal with racism as a plot point), is never militant or threatening—particularly juxtaposed against the US foreign and domestic policies that were debated and contested by African Americans at the time the program aired. For example, with the extremely likeable, widowed single mother, audiences are explicitly reminded over the course of three seasons that Julia very patriotically lost her Army captain husband in Vietnam. Critical assessment of *Julia* is mixed; for some the show was positive for featuring a female lead who was an ethnic minority, an educated professional, a loving and responsible mother, and a mother character who had a/any romantic life. Others see it as a compromise (or conciliatory watering down) of increasing political consciousness among African Americans occurring in the late 1960s and early 1970s. Analogous to what my previous chapters have suggested regarding American drama, Christine Acham sees the patterns of black representation on American television as a reflection of the "social, political, and industry factors" that generate the representational "shift[s] from invisibility" to what she terms the "hyperblackness" of the 1960s and 1970s. Acham posits, "[*Julia*] is topical, as the viewer is aware of black political activists"; racism is presented regularly as an unavoidable fact of life, but, too frequently, the program "does not explore structural or institutional racism, choosing instead to center [racism] on an individual [thereby] reduc[ing] the problems of racism to just the few." Said another way, as a single mother, Julia's specific way of engaging racial hierarchies and political marginalization "works to code [her] as the 'safe Negro.'" ⁴³ As an unmarried black mother Julia "simply wants to provide her child with the best an integrated [America] can offer."⁴⁴

This arguable affinity for integration, this "safe Negro" representation in what some contend is a groundbreaking cultural text, is unavoidably undercut via its (non)engagement with the American historical context from which it emerges. By 1968, the Black Arts Movement and Black Nationalism (and among both, the organized activities of the Black Panthers) were on the cultural radar and for Julia's white audience members, this is a potentially "threatening" presence to be narratively avoided. Indeed, as Acham astutely points out, *Julia* occurs at a time in US race relations that increasingly revealed African Americans' growing disinterest, if not refusal, of earlier integrationist policies within the US civil rights movement.⁴⁵ As American drama from playwrights such as Ed Bullins and Amiri Baraka mirrored an apathy if not hostility for integration, so too did the collective activities of many Americans of color increasingly angry at the rate of so-called progress. *Julia*'s endearing, palliative single mother deviates from this position considerably.

CONCLUSION

If we consider historical moments as varied as Chicago's 1916 Marjorie Delbridge case, the US Supreme Court's decision in 1967's *Loving v. Virginia*, or even the (successful) emergence of primetime television's first professional single black mother character, twentieth-century American culture has proffered unavoidably politicized interpretations of African American subjectivity as that subjectivity negotiates specifically *American* culture, *American* identity. Analyses of a distinct historical moment such as the sweeping diaspora of African Americans during the first wave of the Great Migration—as the Delbridge case suggests—reveals how the century's first three decades witnessed (white) public sentiment reacting to the increased "threat" of black-white relations, and in the process articulated a black subjectivity marked as American Other. In the case of Marjorie Delbridge and her black mother, the maternal role explicitly absorbs these anxieties; these anxieties surround blacks and whites intermingling, to be sure, but these tensions are also correlative to the Great Migration, a massive influx of "less appealing" immigrant populations in US cities, American involvement in a world war, and eventually a massive national economic depression.

In the years leading up to and witnessing 1967's landmark case on the marriage of Mildred and Richard Loving, the domestic is again the linchpin of American legislation and policies that seem to be reacting to and against growing "threats" of African American visibility and enfranchisement and African American subjectivities that de-emphasized the latter term. In the years leading up to the 1967 decision, American media (and in many cases, federal law enforcement such as the FBI) externally cast politicized black Americans as less American/foreigners; but *internally* as well, many (as in the case of more politicized black nationalists) identified self-consciously and publicly as less American/more African.[46] It is no accident that *Loving*'s lower court and eventual US Supreme Court decisions correspond, roughly, to an increasing pan-Africanism within the United States, the emergence of a more organized Black Nationalism and the Black Arts Movement, and, of course, any number of race riots across US cities. It also seems no accident that in this racially charged historical moment, public and legislative attention focuses so explicitly on matters based in the domestic (and sexual) sphere of African American life.

Yet these same years correspond to the eventual commercial success of American television's first African American woman character in a lead role. Not accidentally, in many episodes, Carroll's performance of innocuous American motherhood incorporates her ethnicity, but race is never the most significant part of her identity. With a mother figure who never gets angry and poses no threat to the white characters who surround her, from 1968 to 1971 *Julia* offered white audiences a maternal analgesic in relation

to, for example, a figure such as Angela Davis who in 1970 was placed by FBI director J. Edgar Hoover on the FBI's Ten Most Wanted Fugitive List.

And, of course, when Carroll's version of black American motherhood appeared in American living rooms from 1968 to 1971, she represented a less politicized feminine presence, but tellingly, the construct was also explicitly coded as unmarried. In the years 1968 through 1970, as many American households witnessed what some feared might be a war against a middle-class status quo—indeed, a bourgeois-supported patriotism—this articulation of a benign but "flawed"/single ethnic-American mother emerges. For potentially anxious white audiences, this less threatening alternative functions as "more American" than the Panafricanist, communist-based alternatives in the Black Panthers. Indeed, harkening back to her Mammy predecessors this innocuous unmarried mother is steeped in a kind of hyperdomesticity by virtue of the fact that even her profession as nurse involves the support and caretaking of others.

* * *

Overtly politicized discourses of conception, reproduction, and choices regarding motherhood comprised an inarguably consequential (and for some deciding) factor in the American presidential election of 2012. The potential for American women to be marginalized in gender- and also class-specific issues generated more than provocative talking points. For a large bloc of voters—according to some, a faction that made the difference for winner Barack Obama in key swing states—the positions on reproduction and motherhood held by many in the losing party made what would ordinarily be morally based issues (regarding motherhood and reproduction) into class-based issues. In particular, a promise to end publically funded birth control heavily influenced white working-class women and mothers, a group that tends to vote conservatively in several key swing states; for this bloc of voters, a formerly social issue became an economic one.

Positions that explicitly engage issues of domesticity were ubiquitous to both national and state-level campaigns. For example, in her analysis of 2012 voting patterns in the US presidential election, *New York Times* columnist Maureen Dowd argued that "the more [political conservatives] tried to force chastity belts on women," the more American women "burned to prove that, knitted together, they could give the dead-enders of white male domination the boot."[47] In the same paragraph, after significant page space devoted to threats on women's reproductive rights, Dowd also alludes to the culture war's contestations over immigration reform, social welfare programs, and gay rights issues, while also arguing that Barack Obama's challenger

Romney was still running in an illusory country where husbands told wives how to vote, and the wives who worked had better get home in time to cook dinner. But in the real country, many wives were urging husbands not to vote for a Brylcreemed boss out of a '50s boardroom whose party was helping to revive a 50-year-old debate over contraception.[48]

What seems especially relevant here is the way that Dowd's commentary reveals the ease with which contemporary American culture partners broader political debate with issues concerning women's (non)reproduction, and further, how this association finds focus on women's bodies and the maternal status it occupies (or doesn't). Myriad achievements, failures, and disputed domestic and international issues were fair game in the 2012 presidential election; and some of these issues were actually explored to some extent. But issues regarding women's reproduction and the essentializing paradigms of maternity espoused by those on the far right emerged as one of the most visible factors in awarding Barack Obama a second presidential term.[49] Within the American culture wars that characterize the twenty-first century's first decade, an increasing interest in and attacks on women's reproductive rights suggest that a new construct of American motherhood—one based in conservative perspectives on domesticity and women's primary role *as* mother—is gaining traction with more than just extremists. It may also be a typical backswing of the social sexual pendulum that, for some, was too far left. Regardless of the reasons, however, the prominent place a woman's uterus occupied on the American political stage reveals a nearly obsessive focus on matters of reproduction, maternal identity, and a woman's (dis)engagement with motherhood. That specific notions of race- and class-specific maternal ideologies (not to mention specific populations) also affected a possibly deciding influence on very real political outcomes seems no accident. As both the theatrical stage and the sociopolitical stage engage identity-based hierarchies under the broader umbrella of maternity, everyday acts of "the mother" become a powerful semiotic and material platform for sustaining or resisting the status quo.

To borrow from Susan Bennett's discussion of the challenges facing women's theatre and current historiography, feminist theatre practitioners and critics might work toward what Bennett imagines as the potential of an "infinity" kind of criticism of theatre history; Bennett sees the "task [of historiography] as one that must draw emphatically not on notions of 'truth' or 'fact,' but on what history most fears: imagination."[50] In this sense, then, while contemplating a hermeneutics that transpires on and beyond the stage, the preceding chapters attempt to go so far as to "imaginatively reconceive,"[51] as Bennett describes, the theatrical and textual event as it occurs/ed for the reader and spectator while also incorporating the literary and

material conditions of production, including the sociohistoric moments from which the plays emerge. In this analysis I suggest that in modern American drama the role of the mother offers a unique testing ground for alternative, potentially progressive ways of being. That the essentializing epistemologies that project race-, class-, sex-, and gender-based hierarchies onto maternity occasionally do so regardless of the biological gender of the mother character enables, at the same time, a "reimagining" of the semiotics of motherhood. Within narratives of domesticity, as well in public life, maternal performance can work to assemble or raze the epistemological (often Western) architecture that is typically, falsely constructed as fact. (Indeed, this is perhaps best demonstrated by an analysis that involves aesthetic as well as political contexts.) Particularly when approached with a critical lens that includes actual productions, dramaturgy, and material history, drama and performance can participate in an exciting and productive dialectic between text and performance, realities on stage and off.

As maternal "performance" emerges in this context, it both reacts to and informs narratives of (1) "failed masculinity" and flawed patriarchs unable to protect their families and themselves from race- and class-based hegemonies; (2) participation in/resistance to eugenics-informed discourses of reproduction; (3) agents supporting or challenging conservative sexual ideologies that exist in reaction to (unsettling) political progress and miscegenation anxieties; and (4) politicized maternal subjects who maintain unique (even physical, reproductive) powers to engage assimilation and the cultural anxieties that accompany it. Indeed, maternal performance can represent everything from a loosening grip on racial identity and embodied shame, on the one hand, to a political action that consolidates ethnic subjectivity and pride on the other. But whether biologically male or female, as the figure responsible for the moral and practical shaping (not to mention, occasionally, literal existence) of future generations, the mother role hosts/absorbs and rearticulates cultural responses that speak to matters of great consequence. As a centrally contentious, portentous site of being whose influence exceeds the private landscape of domesticity, the mother role can be latent scapegoat or potential liberator for agents seeking ethnic survival, class mobility, personal redemption, or merely change.

Notes

Introduction If It's Not One Thing, It's Your Mother? Race, Sex, Class, and *Essential* Maternity

1. Ayelet Waldman, "Truly, Madly, Guiltily," *New York Times,* March 27, 2005, accessed August 1, 2011, http://www.nytimes.com/2005/03/27/fashion/27love.html. The *New York Times* essay was written for the HarperCollins anthology *Because I Said So: 33 Mothers Write about Children, Sex, Men, Aging, Faith, Race and Themselves* (2005). Waldman's most recent published exploration on motherhood and popular culture is Doubleday's *Bad Mother: A Chronicle of Maternal Crimes, Minor Calamities, and Occasional Moments of Grace* (2009).
2. Ibid.
3. Ibid.
4. I address my use of the term "American" later in this Introduction.
5. Waldman, "Truly." This comparative itinerary of whose death could and could not be endured appears in the article's infamous "God forbid" section. As Waldman worked out the "God forbid" game that, she argues, all mothers play out in their head, she explains that God forbid her children should perish before her, she could imagine a future happiness—contrary to the same God forbid scenario featuring her husband's death.
6. Bridget Kinsella, "The Bad Mommy: Ayelet Waldman Take the Heat and Keeps on Writing," *Publishers Weekly,* January 2, 2006, 26. Among Waldman's "favorite" responders was a Winfrey audience member who, upon the former's initial entrance to the set, stood up and screamed, "Let me at her!" (Waldman Homepage, accessed August 1, 2011, http://ayeletwaldman.com/books/bad.html.)
7. Carol Memmott, "Maternal Ambivalence is Ayelet Waldman's Baby," *USA Today,* February 24, 2006.
8. Henry Bial and Scott Magelssen, eds., introduction to *Theater Historiography: Critical Interventions* (Ann Arbor: University of Michigan Press, 2010), 4–5. With this, Bial and Magelssen provide early summary of Alan Sikes' historiography in the latter's "Sodomitical Politics: The 1737 Licensing Act and the Vision of the Golden Rump."

9. Bottoms' conceptual use of a "braid of efficacy versus effeminacy" arises out of Richard Schechner's analysis in the latter's *Performance Theory*, which posits theatre and performance as two opposing poles of a continuum.
10. Stephen J. Bottoms, "The Efficacy/Effeminacy Braid: Unpicking the Performance Studies/Theatre Studies Dichotomy," *Theatre Topics* 13, no. 2 (2003): 173.
11. Ibid., 174.
12. Bial and Magelssen, introduction, 3.
13. Using Schechner's work with the *TDR* as his primary but not exclusive example, Bottoms' argument points to the extensive linguistic and conceptual history of "theatre and theatricality" connoting effeminacy, (male) homosexuality, and sterility, while the more culturally "subversive" "performance and performativity" implying effectuality, potency, and virility.
14. Bottoms, "The Efficacy/Effeminacy Braid," 173.
15. Ibid., 181.
16. Ibid., 184.
17. Ibid., 185.
18. Stephen Watt, *Postmodern/Drama: Reading the Contemporary Stage* (Ann Arbor: University of Michigan Press, 1998), 3.
19. Ric Knowles, *Reading the Material Theatre* (Cambridge: Cambridge University Press, 2004), i.
20. Catheine Schuler, "The Gender of Russian Serf Theatre and Performance," in *Women, Theatre and Performance: New Histories, New Historiographies*, ed. Maggie Barbara Gale and Vivien Gardner (Manchester: Manchester University Press, 2001), 216. Here Schuler unpacks her own methodology supporting her exploration of women performers in Russian serf theatre.
21. See S. E. Wilmer's *Writing and Rewriting National Theatre Histories* (Iowa City: University of Iowa Press, 2004), 19–22.
22. See, specifically, Wilmer, "On Writing National Theatre Histories," in *Writing and Rewriting National Theatre Histories*, 23.
23. See Ann E. Kaplan's *Motherhood and Representation: The Mother in Popular Culture and Melodrama* (London: Routledge, 1992).
24. See, for example, Baz Kershaw's *The Radical in Performance: From Brecht to Baudrillard* (London: Routledge, 1999).
25. David Savran, "Queer Theater and the Disarticulation of Identity," in *The Queerest Art: Essays on Lesbian and Gay Theater*, ed. Alisa Solomon and Framji Minwalla (New York: New York University Press, 2002), 152–167.
26. This sentiment is admittedly only an early portion of Savran's analysis in his "Queer Theater and the Disarticulation of Identity," an essay that evolves into a more far-reaching argument, relying on what Pierre Bourdieu designates as the "dominated position" of the "literary and artistic field" (Savran, "Queer Theater," 154–157).
27. Ibid., 155.
28. Jill Dolan, *Geographies of Learning: Theory and Practice, Activism and Performance* (Middletown: Wesleyan University Press, 2001), 52–54.

29. David Savran, *Communists, Cowboys, and Queers: The Politics of Masculinity in the Work of Arthur Miller and Tennessee Williams* (Minneapolis: University of Minnesota Press, 1992), x.
30. C. W. E. Bigsby, *Modern American Drama 1945–2000* (Cambridge: Cambridge University Press, 2000), 1.
31. Minna Caulfield, "The Family and Cultures of Resistance," *Socialist Revolution* 20 (1975): 81.

1 NEW WOMAN (RE)PRODUCTION IN RACHEL CROTHERS' ALTERNATIVE MATERNITIES

1. Ric Knowles, *Reading the Material Theatre* (Cambridge: Cambridge University Press, 2004), i.
2. Sharon Friedman, "Feminism as Theme in Twentieth Century American Women's Drama," *American Studies* 25 (Spring 1987): 69.
3. A consistent trope within Victorian narratives and imagery, the "Fallen Woman" most commonly (though not always) emerged in the form of an adulterous wife. On the American stage, English-born Olga Nethersole is probably the most famous embodiment of the *fin de siècle* Fallen Woman. Along with her portrayal of Paula in Arthur Wing Pinero's *The Second Mrs. Tanqueray*, Nethersole's performance of Sapho in Clyde Fitch's adaptation of the Alphonse Daudet novel of the same name title titillated huge American audiences while shocking and provoking conservative critics. Joy Harriman Reilly, "A Forgotten 'Fallen Woman': Olga Nethersole's Sapho," in *When They Weren't Doing Shakespeare: Essays on Nineteenth-Century British and American Theatre*, ed. Judith L. Fisher and Stephen Watt (Athens: University of Georgia Press, 1989), 106–107.
4. Lois Rudnick, "The New Woman," in *1915, The Cultural Moment: The New Politics, the New Woman, the New Psychology, the New Art, and the New Theatre in America*, ed. Adele Heller and Lois Rudnick (New Brunswick: Rutgers University Press, 1991), 69. While the Progressive Era in the United States is understood by some as the period beginning in the 1890s and lasting through the 1920s, others consider the term delineated by the narrower time frame of 1900–1913, or even 1917. Throughout this chapter I utilize the term to imply roughly 1900 through 1915.
5. Rhetoric of women's moral superiority worked integrally with factions that argued for (and often gained success with) temperance platforms, women's suffrage, and even reproductive control. To quote one of the many examples, influential women's advocate, educator, and suffragist Frances Willard worked tirelessly in her work with temperance reform; one of the founders of the Women's Christian Temperance Union, she served as its national president from 1879 to 1898. Willard is a provocative example, as she is also regularly identified as a lesbian and an activist who invoked (platonic) woman-to-woman love as a bulwark of social reform. See Eric Burns' *The Spirits of America: A Social History of Alcohol*.

6. Judith L. Stephens, "Gender Ideology and Dramatic Convention in Progressive Era Plays, 1890–1920," in *Performing Feminisms: Feminist Critical Theory and Theatre*, ed. Sue-Ellen Case (Baltimore: Johns Hopkins University Press, 1990), 284.
7. Ibid.; my italics.
8. Motherhood and domesticity was more than just the locus of gender equality debates; off the stage it was regularly offered as the *reason* for more progressive social and legislative actions. Reformers such as Carrie Chapman Catt, Florence Kelly, Jane Addams, Lillian Wald, and Anna Howard Shaw supported an agenda for that increased sociopolitical freedoms for women with rhetoric that advocated extending women's moral advantage (over men) from the domestic sphere to the public. Stephens notes, "Charlotte Perkins Gilman asked women not to limit their nurturing ability to a nuclear family but to assume their full duty as 'mothers of the world.'" Ibid., 285.
9. Elaine Showalter, *A Literature of Their Own: British Women Novelists from Brontë to Lessing* (Princeton: Princeton University Press, 1993), 12.
10. Jill Bergman, "'Natural' Divisions/National Divisions: Whiteness and the American New Woman in the General Federation of Women's Clubs," in *New Woman Hybridities: Femininity, Feminism and International Consumer Culture, 1880–1930*, ed. Ann Heilmann and Margaret Beetham (London: Routledge, 2004), 229.
11. Ibid.
12. Anna Stubblefield, "'Beyond the Pale': Tainted Whiteness, Cognitive Disability, and Eugenic Sterilization." *Hypatia* 22, no. 2 (2007): 164.
13. Charles B. Davenport, *Heredity in Relation to Eugenics* (New York: H. Hold, 1911), 207, quoted in Matthew Frye Jacobson, *Barbarian Virtues: The United States Encounters Foreign Peoples at Home and Abroad, 1876–1917* (New York: Hill and Wang, 2000), 157.
14. Bergman, "'Natural' Divisions/National Divisions," 227.
15. Ibid.
16. Angelique Richardson discusses how issues of feminism, "national efficiency," and eugenics existed as political partners: "In the wake of the new biology, concern over the future of women was converging with concern over national fitness." And while the escalating attention and texts devoted to the study of "the Woman Question and the issue of national efficiency" may have made "curious bedfellows," they were nonetheless regularly "thrown increasingly together at this time of social and sexual instability." Angelique Richardson, "The Birth of National Hygiene and Efficiency: Women and Eugenics in Britain and American 1865–1915," in *New Woman Hybridities*, 241.
17. Martha H. Patterson, *Beyond the Gibson Girl: Reimagining the American New Woman 1895–1915* (Urbana: University of Illinois Press, 2008), 2–3. In Britain, the term and political discussions surrounding the New Woman appear earlier than in the United States. However, reform activities and progress on both sides of the Atlantic corresponded and at times directly

related to each other. In Britain, momentum was marked most visibly by the nearly annual delivery of Suffrage Bills to parliament throughout the last three decades of the century. Richardson, "The Birth of National Hygiene and Efficiency," 242–243.
18. Patterson, *Beyond the Gibson Girl*, 2.
19. Although many of these "first generation" New Women "wove the traditional ways of their mothers into the heart of their brave new world," a smaller, but substantial minority refused to marry and instead opted for "long-term relationships with other women in communities where women predominated." Rudnick, "The New Woman," 71.
20. Ibid.
21. By and large, the term New Woman came to signify white, middle-class women and not their poorer and/or nonwhite sisters; however, thousands of women in the American North and American South were also involved in the national Black Women's Club Movement, a faction primarily devoted to social welfare causes and increased education of African Americans. Black American women also played a significant role in the suffrage movement of this era. Ibid., 23. See also "The New Negro: Explorations in Identity and Social Consciousness, 1910–1922" in Rudnick's and Heller's *1915, The Cultural Moment*.
22. The variations within and multiple agendas espoused by the different factions the Progressive Era's New Woman are exemplified by the Greenwich Village hub of social reform and activism known as the Heterodoxy Club. Meeting for over twenty years, this consciousness-raising group boasted political affiliations ranging from Republican to Socialist; individuals favoring sexual monogamy, versus lesbianism, versus free love; feminist capitalists as well as Marxists-socialists; and members who worked as writers, social theorists, philanthropists, and political activists. Ibid., 72–74; Christine Stansell, *American Moderns: Bohemian New York and the Creation of a New Century* (New York: Henry Holt, 2000), 67, 89–90.
23. Among the many women who were, in essence, the first generation of American women *choosing* not to marry, women in the year 1900 made up the majority of all high school graduates and for the first time, 80 percent of colleges, universities, and professional schools in the United States admitted women students. Rudnick, "The New Woman," 70, 75.
24. Among others, Max Eastman, Emma Goldman, Floyd Dell, John Reed, and Louise Bryant were more visible Greenwich Village forces arguing more "radical" platforms, many of which were debated on the pages of *The Masses*.
25. Patterson, *Beyond the Gibson Girl*, 5.
26. Ibid., 4. The Gibson Girl is a provocative construct and one that, according to some critics, exists as distinct from the Progressive Era New Woman. Trina Robbins suggests the Gibson Girl was to some degree a conservative figure. See "The Day of the Girl: Nell Brinkley and the New Woman," in *New Woman Hybridities*.

27. One notable exception can be found in Edna Pontellier's cocktail scene in Kate Chopin's 1899 *The Awakening*. This negative association of alcohol with increased freedoms for women is figured more strongly in the subsequent flapper construct of the 1920s, following Prohibition in 1919. See Patterson, *The Gibson Girl*, 6, 73.
28. Glenda Riley, *Inventing the American Woman: A Perspective on Women's History 1865 to the Present*. (Arlington Heights: Harlan Davidson, 1986), 53. In actuality the low birthrate trend, most pronounced among white, middle-class women in urban areas, was largely due to "growing concerns for child welfare, desires for more autonomy, aspirations for a middle-class lifestyle, and increased information about birth control, the latter in defiance of Comstock laws." David M. Kennedy, *Birth Control in America: The Career of Margaret Sanger* (New Haven: Yale University Press, 1973), 45–46.
29. Patterson, *Beyond the Gibson Girl*, 6–7.
30. Herbert Spencer, *The Principles of Biology* (London: William and Norgate, 1899), 512–513.While the logic of Spencer's explanation is laughable, the actual data for birth trends does suggest a positive correlation between higher education in women and smaller numbers of offspring; in 1910, when birthrates were at an all-time low, 40 percent of all college-age Americans attending college were women. Riley, *Inventing the American Woman*, 47.
31. Patterson, *Beyond the Gibson Girl*, 6–7.
32. , *Inventing the American Woman*, 54–55.
33. Deborah S. Kolb, "The Rise and Fall of the New Woman in American Drama," *Educational Theatre Journal* 27 (May 1975): 149. As a realist playwright interrogating New Woman constructs and themes, Crothers already stood in solid company, as all sides of the Atlantic offered compelling New Women characters. Among two of the most famous productions, Ibsen's *A Doll's House* (1879) as well as Shaw's *Mrs. Warren's Profession* (1894) had already been staged, although critical debate exists regarding the degree to which both present New Women. Regarding Shaw, for example, Jill Davis writes that *Mrs. Warren's Profession* deploys a "deeply ambiguous" articulation of New Womanhood. Jill Davis, "The New Woman and the New Life," in *The New Woman and Her Sisters: Feminism and Theatre, 1850–1914*, ed. Viv Gardner and Susan Rutherford (New York: Harvester Wheatsheaf, 1992), 30. While Mrs. Warren (as prostitute) could be considered more akin to the Fallen Women trope, Vivie Warren more or less parodies the New Woman identity—as did frequent parodies surfacing in West End dramas of the same period. Ibid., 22–23. While the scope of this book is relegated to specifically American drama, a thorough examination of British drama and the New Woman character can be found in Viv Gardner's and Susan Rutherford's *The New Woman and Her Sisters*.
34. Friedman, "Feminism as Theme, 72.
35. For detailed information on Crothers' individual productions and their (often profitable) runs, see Lindroth and Lindroth's *Rachel Crothers: A Research and*

Production Sourcebook (Westport: Greenwood Press, 1995) or Engle's *New Women Dramatists in America, 1890–1920* (New York: Palgrave Macmillan, 2007).
36. Judith Barlow, *Plays by American Woman: 1900–1930* (New York: Applause Theatre and Cinema Books, 2000), xiv.
37. In addition to Glaspell's success with *Trifles* (1916), progressive activist Gale's Pulitzer Prize–winning play *Miss Lulu Bett* (from her popular 1920 novella of the same title) explores the specifically gender- and class-based hardships and indignities endured by an unmarried thirty-four-year-old (Lulu Bett) who lives in unpaid servitude with her sister and brother-in-law; and as the author of over forty plays from 1919 through 1944, Akins' stage adaptation of Edith Wharton's *The Old Maid* garnered her the Pulitzer in 1935.
38. Cynthia Sutherland, "American Women Playwrights as Mediators of the 'Woman Problem,'" *Modern Drama* 21 (1978): 319.
39. Ibid., 324.
40. Ibid., 324–325.
41. Ibid., 330.
42. Addams' Hull House, modeled after earlier work done at London's Toynbee Hall starting in 1884, housed and aided impoverished immigrants in Chicago and inspired numerous examples throughout other urban areas. Addams' and Hull House's efforts also extended to labor rights and organized relief for striking. Despite being a consistent, effective voice for the poor and the political left, however, Addams' sentiments concerning feminism are a strong example of the inconsistencies in the "progressive" mindset. In 1915, for example, she told an interviewer for the *Ladies Home Journal* that she was "taken aback at the modern young woman—at the things she talks about and at her free and easy ways." Jane Addams, quoted in *The Rise of the New Woman: The Women's Movement in America, 1875–1930*, ed. Jean V. Matthews (Chicago: Ivan R. Dee, 2003), 116.
43. Sutherland, "American Women Playwrights, 320.
44. One of the most repeated themes within the negative criticism Crothers' work receives from feminists is the playwright's inability to provide final alternatives or "solutions" to the domestic issues she foregrounds; as in *He and She*, the frustrated wife and mother figure often finds resolution to the domestic conflict only by returning (sometimes even happily) to her domestic role, albeit *after* engaging and productively drawing attention to the imbalance of power the status quo demands.
45. Ibid., 322.
46. Rachel Crothers quoted in Irving I. Abramson, "The Career of Rachel Crothers in the American Theater" (PhD dissertation, University of Chicago, 1956), 216.
47. Alexander Wollcott, "Rachel Crothers, Herself," *New York Times*, February 13, 1920, http://query.nytimes.com/mem/archive-free/pdf?res=9E06E1DE 103BEE32A25750C1A9649C946195D6CF.

48. Charlotte Canning, *Feminist Theaters in the U.S.A.: Staging Women's Experience* (New York: Routledge, 1996), 114.
49. In their production sourcebook Collette and James Lindroth argue that in looking at the period from the turn of the century through the late 1930s (when Crothers' final play *Susan and God* was successfully produced at the Plymouth Theatre), the playwright's career fell into roughly three decade-long phases: the first two decades of the twentieth century present Crothers' most politically explicit material, with *He and She* and *A Man's World* chief among them, followed by lighter fare with less controversy and more comedy during the 1920s and throughout most of the 1930s. (Lindroth and Lindroth, *Rachel Crothers*.)
50. Abramson, "The Career of Rachel Crothers," 193.
51. Ibid.
52. Actress and celebrity Olga Nethersole enjoyed significant commercial success, often in sexually provocative roles, during many of the same years Crothers' early work emerged. While Nethersole, like Crothers, often assumed a leadership role in the creative process and management of her productions, (unlike Crothers) she did not compose the productions she oversaw; also, Nethersole's oeuvre was marked by decisively salacious and melodramatic protagonists (i.e., Fallen Women), and the length of her career falls significantly shorter than Crothers' near forty years. See Harriman Reilly, "A Forgotten 'Fallen Woman,'" 106–122.
53. Canning, *Feminist Theatres*, 112–113; my italics.
54. Ibid., 11.
55. Lois C. Gottlieb, *Rachel Crothers* (Boston: Twayne, 1979).
56. Stanhope-Wheatcroft provided Crothers both initial training as well as her first professional job. Her first produced work, which also appeared before New York audiences in conjunction with Stanhope-Wheatcroft, started with 1899's *Criss-Cross, Elizabeth* and *Mrs. John Hobbs*—all one-act plays that were staged at the Madison Square Theatre in New York City.
57. Engle, *New Woman Dramatists*, 9.
58. Canning, *Feminist Theatres*, 112.
59. Indeed, Crothers helped designate the term "discussion play," and *A Man's World* and *He and She* were marketed as such.
60. Christopher Herr notes the Theater Guild (as an outgrowth of the Washington Square Players) and the Group Theater were the hub of experimentation and progressive political content for American drama in the 1920s and 1930s. As products of the Little Theatre movement of the 1910s and 1920s, they embraced experimentation in playwriting, direction, and performance, and existed as the "aesthetic counterpart to the progressivist movement in politics." Christopher Herr, *Clifford Odets and American Political Theatre* (Westport: Praeger, 2003), 16.
61. Malcolm Goldstein, *The Political Stage: American Drama and the Theater of the Great Depression* (New York: Oxford University Press, 1974), 125–126.
62. Ibid.

63. Cheryl Black, *The Women of Provincetown, 1915–1922* (Tuscaloosa: University of Alabama Press, 2002), 93.
64. Ibid., 93–94.
65. Ibid., 94–95.
66. Gottlieb, *Rachel Crothers*, 18–19.
67. Black, *The Women of Provincetown*, 95.
68. *Myself Bettina* ran for thirty-two performances at New York's Daly's Theater. Gottlieb, *Rachel Crothers*, 33.
69. Black, *The Women of Provincetown*, 95.
70. Brenda R. Weber, "'Were Not These Words Conceived in Her Mind?' Gender/Sex and Metaphors of Maternity at the Fin De Siècle," *Feminist Studies* 32, no. 3 (2006): 549.
71. Ibid., 550.
72. Ibid., 551.
73. Lindroth and Lindroth, *Rachel Crothers*, 6.
74. Goldstein, *The Political Stage*, 122.
75. Lindroth and Lindroth, *Rachel Crothers*, 9.
76. Ibid., 3–6.
77. After additional tours in 1917 and 1919, the play was staged on Broadway at the Little Theatre on February 12, 1920.
78. Sutherland, "American Women Playwrights," 325.
79. Friedman, "Feminism as Theme," 74. In addition to Glaspell's and Crothers' more well-known examinations of "truth" as a larger dramatic theme, Zoe Akins, Clare Kummer, Lulu Vollmer, and Zona Gale also interrogated the concept of "truth" on stage during a time of "intense feminist activity," and specifically from the New Woman's point of view. Ibid.
80. Rachel Crothers, *He and She* (Boston: Walter H. Baker, 1911), 31.
81. A New Woman in her own right, Dr. Marie Depew Crothers' professional career began the same year of her daughter Rachel's birth. Coming from a prosperous family of merchants and Whig organizers, Dr. Depew Crothers also enjoyed the social cachet of her father's close relationship with President Lincoln. Gottlieb, *Rachel Crothers*, 15.
82. Sutherland, "American Women Playwrights, 321.
83. Gottlieb, *Rachel Crothers*, 55–56.
84. Sutherland, "American Women Playwrights, 321.
85. Crothers, *He and She*, 11.
86. Ibid, 12.
87. Ibid., 13.
88. Ibid.
89. Ibid., 14.
90. Ibid., 16.
91. Ibid., 33–34.
92. Ibid., 40.
93. Ibid., 38.
94. Ibid., 49.

95. The official publication date, and the version of the text used here, is 1915, published by Richard G. Badger, Boston. First staged at the Comedy Theatre in New York, February 8, 1910, the play was produced by Crothers and the Shuberts and directed by Crothers; this first production ran in New York for seventy-one performances. Outside of New York, the play was also generally well received. See Barlow, *Plays by American Women* or Engle, *New Women Dramatists*.
96. Keith Newlin, *American Plays of the New Woman* (New York: Rowan and Littlefield/Ivan R. Dee, 2000), 2.
97. Arthur Hobson Quinn, *A History of the American Drama from the Civil War to the Present Day* (New York: Irvington, 1936), 56. A respected and influential critic, Quinn praised Crothers' work in general, suggesting that she was the exception to the unfortunate and "usually romantic or farcical comedies" that characterized most of New York theatre during the Progressive Era. Ibid., 50. Further, as Engle points out, "Quinn has not remained alone in both his disparagement of Progressive era plays and his shunning of all women playwrights other than Crothers." Engle, *New Woman Dramatists*, 8.
98. Stephens, "Gender Ideology and Dramatic Convention, 288.
99. Jacobson, *Barbarian Virtues*, 154. See also Galton's "Hereditary Talent and Character."
100. Stubblefield, "'Beyond the Pale,'" 164.
101. See, for example, Richardson, *Love and Eugenics in the Late Nineteenth-Century*.
102. Among economically privileged white women who personified the New Woman, real-world "Frank Ware" types were not rare, and their relationship to eugenics is noteworthy. Heilmann writes that the first female presidential candidate, Virginia Woodhull, was an ardent supporter of eugenics, as was feminist Sybil Neville-Rolf, who in 1907 founded the Eugenics Society (presently the Galton Institute). And in her agreement with Richardson's reading of Charlotte Perkins Gilman, Heilmann writes that Gilman's utopian fiction of "makes for uncomfortable reading." Heilmann and Beetham, introduction to *New Woman Hybridities*, 11. Anna Steese Richardson, in her role as the National Chairman of the Department of Hygiene and the Congress of Mothers and Parent-Teachers Association, worked tirelessly as a children's advocate, suffragist, and writer, using her work to further a campaign for controlled reproductive patterns among women, "[u]sing the *Women's Home Companion* as a national soapbox." Daniel E. Bender, "Perils of Degeneration: Reform, the Savage Immigrant, and the Survival of the Unfit," *Journal of Social History* 42, no. 1 (2008), 2.
103. Angelique Richardson, *Love and Eugenics in the Late Nineteenth Century: Rational Reproduction and the New Woman* (London: Oxford University Press, 2003), 3–5. Here Richardson discusses specifically New Woman writer and women's rights advocate Sarah Grand and her texts *Ideala* (1883) and *The Heavenly Twins* (1893).

104. Review, *A Man's World*, "The Drama," *Nation*, February 10, 1910.
105. Lindroth and Lindroth, *Rachel Crothers*, 5.
106. Frank's work originating in London echoes her real-world contemporaries; Bender notes that progressive social reformers "like so many other Americans dedicated to the value of social science... were proud of their historic ties to England." Bender, "Perils of Degeneration," 9. Christine Stansell posits that the United States was the preeminent source constructing New Woman identity and ideology. Stansell, *American Moderns*, 232; Richardson sees the evolvement as a transatlantic enterprise: "Developments in Britain and the United States that were crucial to the birth of the New Woman were parallel and interlinked." Richardson, "The Birth of National Hygiene," 242.
107. Rachel Crothers, *A Man's World* (Boston: Richard G. Badger, 1915), 35.
108. For further discussion of the drawing room/salon as a patriarchal site see Patricia Schroeder's "Realism and Feminism in the Progressive Era."
109. The text stops short of explicitly revealing Frank's wealth or its source (indeed, in the play's first act she references working toward an income that will help her "get rich for [her] Kiddie"); however, her philanthropic work in London and the United States, as well several remarks she makes to her more penurious housemates, such as "You lucky dogs, to be so poor that you don't have to work!" strongly suggest a financially comfortable single woman. Crothers, *A Man's World*, 18.
110. Patricia Schroeder, "Realism and Feminism in the Progressive Era," *The Cambridge Companion to American Women Playwrights*, ed. Brenda Murphy (Cambridge: Cambridge University Press, 1999), 38–39.
111. Weber, "Were Not These Words," 548.
112. Ibid., 549.
113. Stubblefield points out that the primary targets of eugenics policies were individuals engaging in so-called moral depravity, which was unofficially equated with unacceptable sexual practice. This designation applied primarily to women who were sexually promiscuous and/or living in poverty. Stubblefield, "'Beyond the Pale,'" 163–164.
114. While there is certainly no evidence that Frank harbors racist ideologies, the potential for class- and race-based hierarchies in Progressive Era activists' logic is inarguable. Within the eugenics movement, those socially and economically privileged whites who feared birthrate patterns indeed saw decreased rates among what were termed "pure whites" and increasing birth rates among "tainted whites." This along with anxieties regarding reproduction between whites and tainted whites – the latter regularly defined as such due to poverty—manifested in fears of the latter "displacing" but also "replacing" whites as "heirs of the great republic." See Stubblefield, "'Beyond the Pale',″ 163; Jacobson, *Barbarian Virtues*, 162.
115. Bender, "Perils of Degeneration," 5; my italics.
116. Ibid., 6. The rhetorical and political links between (1) discourses of reproduction and national hygiene and efficiency movements and (2) the increasingly vocal population of women reformers and activists were many. In her

unpacking of Angelique Richardson's study of how feminist demands for political and educational reform were obstructed by the medical establishment, Heilmann suggests that by (reductively) "defining women through their reproductive organs, white middle-class feminists adapted scientific discourses for social purity purposes, countering hegemonic claims with the argument that the real problem was men's polluted and contagious bodies, not women's aspirations"; moreover, "biologized models of sexual behavior held great appeal for many feminists because they established women as the morally superior sex and authorized feminist eugenicist interventions for the purposes of racial regeneration." Heilmann and Beetham, introduction to *New Woman Hybridities*, 11.
117. Crothers, *A Man's World*, 35.
118. Richardson, *Love and Eugenics*, 2.
119. Stubblefield, "Beyond the Pale," 162. Stubblefield's study explores the social threat posed by "'off-white' ethnicities, poverty, and gendered conceptions of a lack of moral character" was mapped on to populations conveniently labeled "feebleminded." Approximately 60,000 Americans received this diagnostic label and as a result "underwent sterilization at state institutions in the name of eugenics," and tellingly, "sixty percent of those sterilized were women, and a large majority of those sterilized were white and poor" (ibid.).
120. Ibid., 163.
121. Within the eugenics movement, those socially and economically privileged whites who feared birthrate patterns indeed saw decreases among "pure whites" and increases among "tainted whites" (increases that also paralleled an escalation in "undesirable" immigration). This manifested in fears of the latter "displacing" but also "replacing" whites as "heirs of the great republic." Stubblefield, "'Beyond the Pale,'" 163; see also Jacobson, *Barbarian Virtues*, 162.
122. Galton's early treatise eventually morphed into his 1869 book *Hereditary Genius*.
123. Francis Galton, *Inquiries into Human Faculty and Its Development* (London: Macmillan, 1883), 337; my italics.
124. Crothers, *A Man's World*, 110.
125. Ibid., 111.
126. Bergman, "'Natural' Divisions/National Divisions," 227–228. Here Bergman continues Nira Yuval-Davis' and Floya Anthias' exploration of the New Woman's role in American nationalism. Yuval-Davis and Anthias surmise that as a "touted agent of progress," the New Woman was constructed as a domestic agent in service to empire; as gender-specific icons of the Progressive Era, these figures "serve[d] as 'symbolic signifiers of national difference' and as 'reproducers of the boundaries of national groups' (through restrictions on sexual or marital relations)." Nina Yuval-Davis and Floya Anthias (eds.), *Woman-Nation-State* (New York: St. Martin's Press, 1989), 7; Bergman, "'Natural' Divisions/National Divisions," 227–228.

127. Pamela M. Fletcher, "The Fallen Woman and the New Woman: *The Prodigal Daughter*," *Narrating Modernity: The British Problem Picture, 1895–1914* (Aldershot: Ashgate, 2003), 69; my italics.
128. Ibid.
129. Crothers, *A Man's World*, 104.
130. Richardson, "The Birth of National Hygiene," 242.
131. Ibid., 245.
132. Ibid.
133. Among Progressive Era reformers, "Social purity groups began to distribute prescriptive literature on morals and child-rearing. Borrowing from, and transforming, the language of Darwinian sexual selection [and] reinvesting women with the agency of selection on the grounds that they alone were sufficiently race aware to make responsible sexual choices" (ibid., 241).
134. Ibid., 245.
135. Eliza Lynn Linton, quoted in Richardson, "The Birth of National Hygiene," 241; my italics.
136. Here I refer to Sharon Friedman's discussion of Susan Glaspell. See note 34.
137. Crothers, *He and She*, 9.
138. Ibid., 125.

2 Ethnic Anxieties, Postwar Angst, and Maternal Bodies in Philip Kan Gotanda's *The Wash*

1. The American Breeders Association—not unlike its contemporary organizations, John Harvey Kellogg's Race Betterment Foundation and the Galton Society—dedicated its focus to "the presumed hereditary differences between human races," and worked to "populariz[e] the themes of selected breeding of superior stock, the biological threat of 'inferior types,' and the need for recording and controlling human heredity." Steve Selden, "Eugenics Popularization," *Image Archive on the American Eugenics Movement, Dolan DNA Learning Center*, accessed October 12, 2012, http://www.eugenicsarchive.org/html/eugenics/ essay6text.html,
2. I employ the term "race" here to connote both a social construct and material component of identity that inflects meaning and influences the circumstances of daily life. Notwithstanding the term's myriad "uncertainties and contradictions," as Michael Omi and Howard Winant shrewdly describe, "race" might be understood as a concept that "continues to play a fundamental role in structuring and representing the social world" and as such, a productive "race theory" might work both to "avoid both the utopian framework which sees race as an illusion we can somehow 'get beyond,' and also essentialist formulation which sees race as something objective and fixed, a biological datum." Michael Omi and Howard Winant, *Racial Formation in the United States: From the 1960s to the 1990s* (New York: Routledge, 1994), 55. Particularly relevant for my analyses in this chapter, I rely on Shannon

Sheen's conceptualization of the "geometry of race." If race has been invoked historically "as a way to measure," Sheen explains, in "thinking of it as a form of geometry, race becomes a means to organize international power, global space, and the bodies within it...a process through which certain groups are either equated with or excluded from national citizenship." Shannon Sheen, *Racial Geometries of the Black Atlantic, Asian Pacific and American Theatre* (New York: Palgrave Macmillan, 2010), 5.

3. Eiichiro Azuma, *Between Two Empires: Race, History, and Transnationalism in Japanese America* (Oxford: Oxford University Press, 2005), 192.

4. Regarding my use of the term "Asian American," in no way does this book mean to suggest a monolithic Asian, Asian American, or even Nisei experience. As Asian American studies scholars have long pointed out, the culture and historiography of multiple and distinct Asian ethnicities is often more vulnerable to a theoretical universalism than other marginalized ethnicities (i.e., equating individual ethnicities such as Japanese, Chinese, and Korean under one homogenized rubric). Particularly given the tendency of Asian American culture to be subsumed or invisibilized within race-based economies defined in black-white binaries, any exploration of Asian American performance would be well served to remember, as Wendy Ho submits, "Asia and Asian American culture are much more heterogeneous, more fluid than phallocentric, monolithic, binary divisions would suggest." Wendy Ho, *In Her Mother's House: The Politics of Asian American Mother-Daughter Writing* (Oxford: Rowman & Littlefield, 1999), 235. Or, as Lisa Lowe reminds, "As with other diasporas in the United States, the Asian immigrant collectivity is unstable and changeable, with its cohesion complicated by intergenerationality, by various degrees of identification and relation to a 'homeland' and by different extents of assimilation to and distinction from 'majority' culture in the United States." Lisa Lowe, "Heterogeneity, Hybridity, Multiplicity: Marking Asian American Differences," *Diaspora* 1, no. 1, (1991): 27.

5. Nisei denotes second generation Japanese American, while Issei and Sansei represent, respectively, first generation and third generation.

6. Philip Kan Gotanda, interview by Robert Ito, *Words Matter: Conversations with Asian American Writers*, ed. King-Kok Cheung (Honolulu: University of Hawaii Press, 2000), 175. In this section of the interview, Gotanda addresses explicitly *Fish Head Soup*, his 1991 play in which a yet another disturbed Nisei patriarch deals with internment trauma of the past while also negotiating present anxieties, not the least of which is being an unfaithful wife.

7. Teresa Williams-León and Cynthia Nakashima, "Reconfiguring Race, Rearticulating Ethnicity," in *The Sum of Our Parts: Mixed Heritage Asian Americans*, ed. Teresa Williams-Leon and Cynthia L. Nakashima (New York: Oxford University Press, 2001), 8.

8. Caroline Chung Simpson, *An Absent Presence: Japanese Americans in Postwar American Culture, 1945–1960* (Durham: Duke University Press, 2001), 115–116.

9. Ibid.

10. Ibid.
11. Homi K. Bhabha, "Of Mimicry and Man: The Ambivalence of Colonial Discourse," in *The Location of Culture* (London: Routledge, 1997), 86. This ambivalence occurs within and emerges from that "area between mimicry and mockery," in which the Other performs "instances of colonial imitation." These imitations generate "a discursive process by which the excess or slippage produced by the *ambivalence* of mimicry (almost the same, *but not quite*) does not merely 'rupture' the discourse, but becomes transformed into an uncertainty." This "uncertainty," moreover, "fixes the colonial subject as a 'partial' presence itself." As such, the close-but-not-quite-the-same enterprise for the Japanese American mother simultaneously liberates and censures in terms of a gendered agency always inflected by race.
12. Simpson, *An Absent Presence*, 125–126. Simpson notes that a small number of Japanese American "mothers" also participated in the HMP.
13. Evelyn Nakano Glenn, *Issei, Nisei, War Bride: Three Generations of Japanese American Women in Domestic Service* (Philadelphia: Temple University Press, 1986), 193.
14. Traise Yamamoto, *Masking Selves, Making Subjects: Japanese American Women, Identity, and the Body* (Berkeley: University of California Press, 1991), 150.
15. Philip Kan Gotanda, *The Wash, Fish Head Soup and Other Plays* (Seattle: University of Washington Press, 1995), 142. The kite and kite flying as a paternally invested, highly emotional symbol is particularly relevant as an *ethnically* coded touchstone. Beloved in many Asian cultures, kiting dates back to the Chinese Han Dynasty (206 BC–AD 220) and reached Japan by Buddhist monks in the seventh century. Because in Japanese culture kites are also a gift occasionally given to new parents as a congratulatory totem for the birth of a firstborn *son* (Wilson), Nobu's eventual gift of the kite to Timothy would further solidify the racially informed, tradition and multigenerational resonance kiting holds for Nobu and Judy's child.
16. Ibid., 166.
17. Ibid., 158.
18. Ibid.
19. Ibid., 185.
20. Ho, *In Her Mother's House*, 68. Indeed, David Yoo writes that the "threat" posed *specifically* "by the influx of Japanese immigrants prompted legislators in 1905 to expand section 60 of the California Civil Code to make marriage between Whites and 'Mongolians' unlawful." David K. Yoo, *Growing Up Nisei: Race, Generation, and Culture among Japanese Americans of California, 1924–49* (Urbana: University of Illinois Press, 2000), 78. Immigration restrictions were often one of the most useful policy-level weapons to guard against interracial relationships and reproduction. For example, in addition to criminals, "insane persons," beggars, illiterate adults, homosexuals, and "feeble-minded persons," the Immigration Act of 1917 banned new immigration of those originating from the "Asiatic Barred Zone," an area that

included nearly all of Asia and the Pacific Islands. Even during sporadic relaxation of immigration restrictions, clauses and conditions often existed that worked to disinhibit interracial relationships; 1907s Gentlemen's Agreement, for example, relaxed naturalization limitations, but only for women, children, and parents who already had family members (typically men) already in the United States. When Congress passed the McCarran-Walter act in 1952, while Asian immigrants were endowed with the right to apply for citizenship, preferences for family member clauses existed, not to mention limiting quotas established for individual countries (e.g., 185 for Japan, 105 for China, 100 each for "Asia-Pacific Triangle" countries) (3, 174).
21. Azuma, *Between Two Empires*, 191.
22. Yen Le Espiritu, "Possibilities of a Multiracial Asian America," in *The Sum of Our Parts: Mixed Heritage Asian Americans*, ed. Teresa Williams-Leon and Cynthia L. Nakashima (New York: Oxford University Press, 2001), 26.
23. Yoo, *Growing Up Nisei*, 78.
24. Paul R. Spickard, *Japanese Americans: The Formation and Transformations of an Ethnic Group* (New York: Simon and Schuster Macmillan, 1996), 146.
25. Karen Shimakawa, *National Abjection: The Asian American Body Onstage* (Durham: Duke University Press, 2002), 7.
26. David Palumbo-Liu, *Asian/American: Historical Crossings of a Racial Frontier* (Stanford: Stanford University Press, 1999), 24.
27. Yamamoto, *Masking Selves, Making Subjects*, 62.
28. Ibid., 63. A conflation (or cultural-political alignment) of Asian Americanness with Whiteness against the relief of African American and even Latino identity and culture manifests quite specifically in marriage-related prejudices and miscegenation anxieties. Spickard notes that "while "[i]ntermarriage contributed to the declining sense of community in the Sansei generation," if/when intermarriage took place, "there was a decided Nisei preference that their children choose White or other Asian mates over African Americans or Latinos." Spickard, *Japanese Americans*, 147.
29. Yamamoto, *Masking Selves, Making Subjects*, 63–64; my italics. Yamamoto continues this discussion in her analysis of the so-called model minority status of Asian Americans in the race-based hierarchies of US culture: "Since Asian Americans supposedly are not 'dark,' they are therefore closer to white than other groups whose bodies read as 'brown' or 'black' [and] Asian Americans are further ideologically invisibilized as 'model minorities' or 'honorary whites.'... [T]his hierarchy of pigmentation has resulted in an invisibility whose potency is in direct relationship to their placement near the 'white' end of the color scale," in which a "white by analogy" racial economy dictates privilege and worth.
30. Ibid., 3.
31. Elena Tajima Creef, *Imaging Japanese America: The Visual Construction of Citizenship, Nation, and the Body* (New York: New York University Press, 2004), 173.

32. Ibid., 174.
33. Ibid. Houston is particularly relevant subject matter for Creef's analysis, as the playwright and poet is herself a daughter of a World War II Japanese war bride and an African-American GI Father.
34. This "productive" potential is not without its limitations. For example, in her discussion of Houston's essay "On Being Mixed Japanese in Modern Times" and her poem "Amerasian Girl" (1985), Creef points to the former's suggestion of the multiracial body as a text "reconfigured as an alien in the nation and dispossessed of racial identity and citizenship." The ethnically mixed body can work as a "multiply marked" text in addition to/instead of existing as a romanticized marker of multiculturalism. She posits that it also "problematically exists outside of simple visual categories of racial and national representation, while speaking to the problematic conception of where and how one can safely retreat to a place called 'home.'" The dilemma, she explains, lies in the multiracial body's "suspen[sion] between racist configuration of identity... stripped of any possibility of belonging to the nation (Creef, *Imaging Japanese America*, 177). Judy's maternal agency—sourced as it is in her position as the mother of a biracial Yonsei son whose own ethnic subjectivity involves a hybridized flux of home, identity, and nation—also becomes complicated by that "suspension," a semiotic deferral that could offer a reductive semiotics just as easily as more progressive alternatives in reading the Asian American body.
35. Gotanda, *The Wash*, 160.
36. Spickard, *Japanese Americans*, 70–71.
37. Gotanda, *The Wash*, 182–183.
38. Jeanne Wakatsuki Houston and James D. Houston, *Farewell to Manzanar* (New York: Ember, 2012), 24.
39. Yamamoto, *Masking Selves, Making Subjects*, 147; my italics.
40. Ibid., 165.
41. Ibid., 143.
42. Gotanda, *The Wash*, 141.
43. It was not merely embarrassment in front of other Japanese Americans at stake for so-called bad behavior; preoccupation with public opinion also came from the added responsibility of making sure one's racial group maintained honor in front of the unfriendly perspective of white Americans. In his explanation of the Japanese ideology of "on" or "duty," specifically the duty to avoid generating family shame, Spickard writes: "The emphasis was on shame and dependency, on obligation and responsibility"; and one had to make sure to never "do anything to sully the family name, cause the neighbors to gossip, or bring Japanese people under criticism from non-Japanese Americans." Spickard, *Japanese Americans*, 71.
44. Since the "median age of Nisei at the outbreak of World War II was... seventeen," and only 20 percent of the Nisei married before the war, the second generation and their parents thought about dating and marriage issues frequently as they considered an uncertain future. Yoo, *Growing Up Nisei*, 78.

In his analyses of the strong presence and influence of Japanese American newspapers such as San Francisco's *Nichibei Shimbum*, the *Shin Sekai*, and Los Angeles' *Rafu Shimpo*, Yoo notes that consistent page space was devoted to directives on romantic exigencies of Japanese American women: "The subject of dating and marriage... raised concerns about gender, most often expressed in the examination of women's roles. These pieces "illustrated ethnic community expectations of *women as keepers of the culture*" (Yoo, *Growing Up Nisei*, 79; my italics), while discussion of what did/not make a suitable partner revealed how the institution itself involved "the hopes and fears about the future of Japanese Americans" (86; my italics).

45. Gotanda, *The Wash*, 174.
46. Ibid., 179.
47. In his explanation of the complicated Issei/Nisei power shifts preceding and during internment, Spickard writes of the years 1930–1945: "With generations diverging in language and worldview, shared cultures stood at perhaps only about the midpoint on the continuum." He adds, however, that "the breakup of cultural uniformity was not complete [and t]he generations still held many aspects of culture in common." Spickard, *Japanese Americans*, 132.
48. See Azuma, *Between Two Empires*, 133, 192.
49. Ibid., 190.
50. In his discussion of Seattle Nisei woman disowned by her parents after her marriage to a non-Japanese man, Azuma explains that prewar Nisei, "especially females, were not allowed to encounter other groups are free individuals but only as *a racialized people whose utmost responsibility was to their compatriots and the collective future.*" Azuma, *Between Two Empires*, 192; my italics. In the years preceding as well as during internment, fears and hostility toward marriage outside of the Japanese American community were sometimes so strong—from both Issei and Nisei—that several instances were marred by acts of violence, including homicide and suicide. Yoo writes: "The ethnic community stressed endogamy as a means of preserving racial and cultural boundaries... In advocating racial solidarity, English-language sections of the immigrant press aligned themselves with prevailing mores against interracial relationships in the ethnic community and society at large." Yoo, *Growing Up Nisei*, 86, 68–90.
51. Issei parents such as Masi's would have been deeply influenced in this paradigm of family (over individual) responsibility. Generally, "Issei did everything they could to raise their children as good Japanese," and typically "replicated Japanese families of the Meiji (1868–1912) and Taisho (1912–1926) eras," with the result being a filial model "based on the 'ie,' or household"; all those who lived under one roof, often three generations and extended kin, were considered one unit. Spickard writes: the "ie was the basic unit of society," and further, was understood as "an economic entity," sharing not just work and land, but also business, and profits. The ie was also a "unit of political and religious organization—the *entire household*

was responsible for the misbehavior of any individual." Spickard, *Japanese Americans*, 68–69; my italics.
52. Ibid., 71
53. Gotanda, *The Wash*, 185.
54. Ibid., 146.
55. While in the play's conclusion Masi does attempt to reassure a (recently gun-toting, possibly suicidal) Nobu that she actually never engaged in anything untoward with Chester in the camp, it is never clear whether or not she is being truthful. Further complicating any assessment of her veracity in this tense moment, she immediately follows this "reassurance" by leaving Nobu in the living room to go get Sadao, her lover who is sleeping in the next room.
56. Gotanda, *The Wash*, 155.
57. With its precursor, the 100th Infantry Battalion, the 442nd Infantry Regimental Combat Team of the US Army (known as the "Go For Broke" regiment) is known for, among other things, earning the most decorations of any unit in the entire history of the US military, based on length of service and its size. The mostly Nisei servicemen were not allowed to serve in the pacific theatre, as issues of allegiance were thought to pose too much of a threat, but the unit saw 225 days of combat and intense fighting in Italy and France; in the end seventy men died in combat. US policy at the time dictated that Japanese American men were not involved in the draft, again for reasons involving suspicion of national loyalty, but volunteering was allowed and many of Nisei saw enlistment as an opportunity to prove their Americanness and perform a kind of patriotism they could not while interned. As a result, many of the 442nd had family members living in internment camps while serving abroad. Yoo, *Growing Up Nisei*, 104–106.
58. In his role with the special White House political intelligence network established by FDR in 1941, journalist and former State Department official John Franklin Carter visited Hawaii and several Western states in fall 1941 to assess the loyalty of Japanese Americans. Carter's reports determined that Japanese Americans were "overwhelmingly loyal," and as Agent Curtis B. Munson reported, Nisei in particular were "90–98 percent loyal" and "pitifully anxious to demonstrate their patriotism." Greg Robinson, *After Camp: Portraits of Midcentury Japanese American Life and Politics* (Berkeley: University of California Press, 2012), 21.
59. Paul R. Spickard, "The Nisei Assume Power: The Japanese Citizens League, 1941–1942," *Pacific Historical Review* 52, no. 2 (1983): 148.
60. Shimakawa, *National Abjection*, 11. Assimilation and even cooperation was a particularly complicated matter in terms of the dueling costs/benefits of "separateness." In the period following internment, sources as diverse as the War Relocation Authority, FDR, First Lady Eleanor Roosevelt, a handful of liberal groups, the War Department, and *many Japanese Americans*, all agreed on the merits of and worked collectively toward assimilation, something that was understood as a valuable course of economic and political

action. These groups—including Nisei—felt that "by retarding assimilation...the *prewar* ghettoization of Japanese Americans in 'Little Tokyos' had helped inspire the hostility that led to evacuation." In the years leading up to and following internment, in other words, a cultural/literal isolation from white America was thought to actually feed the fire of white suspicion and distrust. Robinson explains: "Despite their continuing conflicts over the justice of removal and the morality of the government's operation of the camps," these varied groups at times actually facilitated assimilation and dispersal. Robinson, *After Camp*, 73, 85–86.

61. Gotanda, *The Wash*, 185–186; my italics.
62. Ibid., 178,
63. Ibid., 180.
64. Ibid., 180–181.
65. Regarding Nobu's lost prosperity, as a "retired produce man" (Gotanda, *The Wash*, 133) Nobu's past class identity is admittedly not one of poverty; nevertheless, the financial promise that awaited him before and (as the bank scene alludes to) immediately after internment remains painfully unfulfilled, a failure arguably felt more acutely in the finality of retirement.
66. Gotanda, *The Wash*, 160.
67. Ibid., 182–183.
68. Ibid., 183.
69. Ibid., 178.
70. Ibid.
71. Gordon H. Chang, *Asian Americans and Politics: Perspectives, Experiences, Prospects* (Stanford: Stanford University Press, 2001), 223.
72. Philip Kan Gotanda, interview by Robert Ito, 183.
73. Spickard goes so far as to suggest that "Nisei were distinguishable (from their Issei parents) because they aspired more explicitly to adopt a *middle-class American* life style." Spickard, "The Nisei Assume Power," 150–151; my italics.
74. Gotanda, *The Wash*, 194; italics in original.
75. Ibid., 194–195; italics in original.
76. Ibid., 194–195; my italics. Gotanda's *Fish Head Soup* engages a similar dynamic. As the play's traumatized (indeed, mentally questionable) patriarch, Togo "Papa" Iwasaki is a Nisei interment survivor who also finds cause and potential remedy in a maternal landscape. Among other stress factors (including his youngest son's race-based shame and attempts to racially pass), Papa is arguably cognizant of "Mama" Iwasaki's ongoing infidelity (with an Orientalizing white business man). Like *The Wash*'s Nobu, Papa frequently refers explicitly to his wife as "Mama" in times of intense desperation. Further, suggestions of a maternally-based salve for Papa's ethnic- and gender-based anxieties are not exclusive to biological females; as the performatively maternal eldest son Victor exists as a repeated source of refuge to Papa, often while *literally* feeding and bathing his infantilized father.
77. Ibid., 194.

78. Ibid., 165.
79. Ibid., 163.
80. Perhaps no accident, the "morning after" waffle scene in which Sadao performs a maternally coded sustenance is also a scene in which Masi begins to get a bit more comfortable with unchartered gender territory. As one of the earlier moments Masi voices explicit resistance to Nobu, she curtly instructs Marsha to tell her father that he needs to be more organized in setting out his soiled laundry before she picks it up.
81. Gotanda, *The Wash*, 148–149.
82. Ibid., 149.
83. Ibid., 165; italics in original.
84. The details of the support group session and the complete lack of self-consciousness with which Sadao shares them dramatically contrast several ethnically coded ideologies that Sadao would have been exposed to by prewar Issei parents. Among the Japanese values Issei parents passed on to their children, enryo, a kind of "modesty on a level that seems extreme to many non-Japanese," was "practiced by everyone toward everyone else. As part of what Harry Kitano calls the 'enryo syndrome,' every Nisei child heard hazukashi—'*people will laugh at you*'—and found it a powerful incentive to be more modest." In addition to enryo, Nisei children also learned gaman, or perseverance; according to gaman, "No matter how great the obstacles...how obnoxious the taunts of enemies, one must face one's responsibilities with *stoic lack of affect*. One should not show anger, fear, or other emotions. Spickard, *Japanese Americans*, 72; my italics.
85. Gotanda, *The Wash*, 146; my italics.
86. Spickard, *Japanese Americans*, 134.
87. David Mura, Michi Weglyn, and Edison Uno quoted in Spickard, *Japanese Americans*, 134. In studying the "psychological costs" paid for by a people enduring theft, dispossession, and incarceration at the hands of their own country, many researchers point out that among later generations, "the Nisei typically said little or nothing about their concentration camp experiences." Spickard, *Japanese Americans,* 130. Manzanar survivor Jeanne Wakatsuki Houston recounts that her imprisonment in Manzanar "filled [her] with shame for being a person guilty of something enormous enough to deserve that kind of treatment...[A]s I sought for ways to live agreeably in Anglo-American society, my memories of Manzanar...lived far below the surface...Even among my brothers and sisters, we seldom discussed the internment." Houston, *Farewell to Manzanar,* 185. Survivors' accounts regularly allude to the combination of shame and even self-loathing; or Amy Iwasaki Mass writes, there existed in the Nisei generation "the unspoken assumption that there was something wrong with us because we were Japanese." Amy Iwasaki Mass, "Socio-Psychological Effects of the Concentration Camp Experience on Japanese Americans," *Bridge* (Winter 1978): 62.
88. Yoo, *Growing Up Nisei*, 4–5; my italics.

89. Henry Yu, *Thinking Orientals: Migration, Contact, and Exoticism in Modern America* (New York: Oxford University Press, 2001, 118.
90. Frank Miyamoto, quoted in Henry Yu, *Thinking Orientals*, 118–119.
91. Josephine Lee, *Performing Asian American: Race and Ethnicity on the American Stage* (Philadelphia: Temple University Press, 1997), 6.
92. Homi K. Bhabha, "The Other Question: Stereotype, Discrimination, and the Discourse of Colonialism," *The Location of Culture* (London: Routledge, 1997), 66.
93. Lisa Lowe, *Immigrant Acts: On Asian American Cultural Politics* (Durham: Duke University Press, 1996), 26; my italics.
94. Dorinne Kondo, *About Face: Performing Race in Fashion and Theater* (New York: Routledge, 1997), 205.
95. Ibid., 7.
96. Una Chadhuri, "The Future of the Hyphen: Interculturalism, Textuality, and the Difference Within," in *Interculturalism and Performance*, ed. Bonnie Marranca and Gautam Dasgupta (New York: Performing Arts Journal, 2001), 202.
97. Lee, *Performing Asian American*, 3. It bears mention that generalizing these and other Asian American playwrights in terms of national original, stylistic choice, and performance modes, political agenda, or broad content would be inaccurate (if not offensive). As Josephine Lee submits, "To place [Asian American] playwrights...into a grouping designated by national original, ethnicity, or race is to imply that they participate in a common project: the consideration of identity as it is linked both to social representation and to artistic presentation" (4).
98. Kondo, *About Face*, 7.

3 RACE AND THE *DOMESTIC* THREAT: SEXING THE MAMMY IN TONY KUSHNER, ALFRED UHRY, AND CHERYL WEST

1. Susanna A. Bösch, *Sturdy Black Bridges on the American Stage: The Portrayal of Black Motherhood in Selected Plays by Contemporary African American Women Playwrights* (New York: Peter Lang, 1996), 16.
2. See Elise Lemire's *"Miscegenation": Making Race in America* (Philadelphia: University of Pennsylvania Press, 2009). Lemire's research suggests that three major "waves" of black-white miscegenation anxiety have plagued American culture, starting in 1802 with the first published reports that Thomas Jefferson was having sex with one of his slaves (Sally Hemmings); the second occurring in the 1830s, following the first widespread organization of abolitionists; and the third occurring in response to "threats" posed by Lincoln's signing of the Emancipation Proclamation.
3. *Loving v. Virginia*, 1967.
4. As Lemire explains, some sources situated Blacks as "near relatives of primates and thus a separate species from Whites so that inter-racial sex...could be declared against the biological laws of Nature." *"Miscegenation,"* 3.

5. Ibid., 1. Obviously, Black Americans and White Americans are not the exclusive agents of racially based fears of miscegenation, and the United States is not the originator of discourses regarding sexually essentialized subjects. Early European settlers to the Americas, for example, are just one group who disseminated cautionary portrayals of forbidden heterosexual liaisons between native American Indian men and Anglo women. See Wickstrom's "The Politics of Forbidden Liaisons: Civilization, Miscegenation, and Other Perversions," *Frontiers: A Journal of Women's Studies* 26, no. 3 (2005): 168–198.
6. Patricia Hill Collins, *Black Feminist Thought: Knowledge, Consciousness, and the Politics of Empowerment* (New York: Routledge, 2000), 72.
7. Judith Williams, "Uncle Tom's Women," in *African American Performance and Theatre History: A Critical Reader*, ed. H. Elam, Jr., and D. Krasner (New York: Oxford University Press, 2001), 20.
8. A note on this chapter's use of "sexuality" or "sexual contact" as terms describing physical-sexual connections between blacks and whites. The broad concept of (and material activities that contribute to) its meaning might (inaccurately) suggest voluntary, pleasurable participation from the standpoint of its participants. With specific regard to interracial sexual contact (and the miscegenation anxieties that frequently accompany it), as Hortense Spillers incisively suggests, "We could go so far as to entertain the very real possibility that 'sexuality,' as a term of implied relationship and desire, is dubiously appropriate, manageable, or accurate to any of the familial arrangements under a system of enslavement." Although Spillers discusses here sexual contact between white owners and female slaves, the less acute (but still often legislated) interracial sexual contact postslavery is still nevertheless politically hierarchical and informed by imbalances of social power, not to mention influenced by cultural taboos that typically objectify African American women. Regarding the black (sexual) body's relationship to motherhood in particular, Spillers contends that "under th[e] arrangements" of this never politically neutral sexual schema, "the customary lexis of sexuality, including 'reproduction,' [and] 'motherhood'... are thrown into unrelieved crisis." "Mama's Baby, Papa's Maybe: An American Grammar Book," *Diacritics* 17, no. 2 (1987): 76.
9. "'Extraordinarily Convenient Neighbors': African American Characters in White-Authored Post-Atomic Novels," *Journal of Modern Literature* 30, no. 4 (2007): 124.
10. Collins, *Black Feminist Thought*, 74; my italics.
11. Catherine Clinton, *The Plantation Mistress: Woman's World in the Old South* (New York: Pantheon, 1982), 201–202.
12. See Kimberly Wallace-Sanders' *Mammy: A Century of Race, Gender, and Southern Memory* (Ann Arbor: University of Michigan Press, 2008).
13. While staged adaptations of Stowe's *Uncle Tom's Cabin* were a mainstay of nineteenth-century American melodrama, often incorporating actors in black face and minstrelsy, productions continued to be staged into the

early twentieth century and even saw an animated filmed version from the Disney Corporation in 1933 with *Mickey's Mellerdramer*. See Eric Lott, *Love and Theft: Blackface Minstrelsy and the American Working Class*.
14. Lisa Anderson, *Mammies No More: The Changing Image of Black Women on Stage and Screen* (New York: Rowman and Littlefield, 1997), 5–7.
15. Carol Henderson, "Guest Editor's Introduction: The Bodies of Black Folk: The Flesh Manifested in Words, Pictures, and Sound," *MELUS* 35, no. 4 (2010): 5–6.
16. Wallace-Sanders, *Mammy*, 2–3.
17. Ibid., 16. Tucker is himself an intriguing figure; married three times he made a living as a Professor of Moral Philosophy at the University of Virginia (a position he occupied at Thomas Jefferson's request), a science fiction writer, the first author of a complete history of the United States, and a lawyer who also served three terms in the US House of Representatives.
18. Wallace-Sanders, *Mammy*, 17.
19. Ibid.
20. Among them, the Nat Turner Rebellion in 1831, the abolition of slavery in the British Empire in 1834, the publication of Frederick Douglass' autobiography in 1845, the publication of *Uncle Tom's Cabin* in 1852, the election of Lincoln in 1960, and eventual declaration of war in 1961.
21. Micki McElya, *Clinging to Mammy: The Faithful Slave in Twentieth-Century America* (Cambridge, MA: Harvard University Press, 2007), 74–75.
22. McElya, *Clinging to Mammy*, 75–76; my italics.
23. Ibid., 74.
24. The landmark civil rights case involving the illegal marriage of African American Mildred and her white husband Richard Loving was decided unanimously in the US Supreme Court in 1967, finding Virginia's "Racial Integrity Act of 1924" (which outlawed miscegenation) unconstitutional and a violation of the Fourteenth Amendment's Due Process and Equal Protection Clauses. The decision was significant as well for its official overturning of 1883's *Pace v. Alabama*, in which the US Supreme Court upheld the Alabama Supreme Court conviction of an interracial Alabama couple for participating in interracial sex, at that time a felony. Despite *Loving v. Virginia*'s 1967 decision, many states retained (unenforceable) antimiscegenation statutes until 2000. See Kevin Noble Maillard and Rose Cuison Villazor, eds., *Loving v. Virginia in a Post-racial World: Rethinking Race, Sex, and Marriage* (Cambridge: Cambridge University Press, 2012).
25. See Anderson, *Mammies No More*; McElya, *Clinging to Mammy*, or Wallace-Sanders, *Mammy*.
26. While employing heavy (critical) allusion to Hansberry's *A Raisin in the Sun* and that play's matriarch Lena Younger, the icon of the Mammy is bitingly satirized in *The Last Mama on the Couch Play*, one of eleven vignettes in Wolfe's *The Colored Museum* (1991). In his critique of Hansberry's Walter Lee Younger and his mother Lena, Wolfe's character "Mama" is described as an innocuous woman who "speaks in a slow manner" and is first seen by the

spectator "sitting on a couch reading a large, oversized Bible." Wolfe repeatedly satirizes the hypernurturance and Christian-informed martyrdom of his protagonist toward her son, "Walter-Lee-Beau Willie." And because *The Colored Museum* relies consistently on expressionistic staging techniques, this play from *Caroline's* original director and one of its producers also critiques the linearity and realism of American drama as those concepts converge in Hansberry's original. George C. Wolfe, *The Colored Museum: Two by George C. Wolfe* (Garden City: Fireside Theatre), 35.
27. Meryle Secrest, *Stephen Sondheim* (New York: Knopf, 1994), 195.
28. Scott McMillin, *The Musical as Drama: A Study of the Principles and Conventions behind Musical Shows from Kern to Sondheim* (Princeton: Princeton University Press, 2006), 4.
29. Among several scholars who have recently begun paying attention to the American musical as a dramatic and politically meaningful form, McMillin writes that "among other serious practitioners of the musical who wanted to elevate the cultural status of the form," George and Ira Gershwin and Dubose Heyward "made the most notable gesture in this direction by writing the Broadway opera *Porgy and Bess*" in 1935. It is telling that this particular musical text, based on Heyward's novel and play *Porgy*, and a text that attempts to critically "elevate" the genre, deals explicitly with the politics of race, class, and gender (in the fictitious *Catfish Row*). McMillin, *The Musical as Drama*, 5.
30. Ibid., 199.
31. Ibid.
32. Tony Kushner, *Caroline, or Change* (New York: Theatre Communications Group, 2004), 21.
33. Admittedly, in a later version of Hansberry's *Raisin* as well as the 1961 film directed by Daniel Petrie, a sometimes politically aware Lena does complicate the selfless model who puts her charge's needs in front of her own biological family; her tendency toward a sexually neutered and selfless martyrdom remains unchallenged, however.
34. Kushner, *Caroline, or Change*, 14–16.
35. Ibid., 11–13.
36. Ibid., 12.
37. Ibid., 14.
38. Ibid., 14–15.
39. Ibid.
40. Ibid., 17–18.
41. Simone's song is a "first person rendition...in reaction to the unbridled racism and white supremacy of the civil rights era" and individually explores four iconic caricatures of black female subjectivity: Aunt Sarah, Siffronia, Sweet Thang, and Peaches (respectively the Mammy, Tragic Mulatto, Jezebel, and Sapphire) (Debra Powell-Wright, "Four Women, for Women: Black Women—All Grown Up," in *Imagining the Black Female Body: Reconciling Image in Print and Visual Culture*, ed. Carol E. Henderson [New York: Palgrave Macmillan, 2010], 109).

42. Ibid., 111–112.
43. The Mammy's typically large form, contributing to a culturally coded nonsexual status, is deeply embedded in twentieth-century cultural production and exceeds American stages. In Donald Bogle's exploration of the semiotics of the black female body and the Mammy, he explains that actor Louise Beavers, best known for her paradigmatic Mammy performance in John Stahl's 1934 *Imitation of Life*, was "forced to replicate the stereotypical bodily boundaries of 'mammy' and regularly went on 'force-feed diets, compelling herself to eat beyond her normal appetite." Although Beavers weighed two hundred pounds at the time of filming, she was instructed to gain weight and engaged in "a steady battle...to stay overweight." When during filming Beavers started to lose weight, she was "padded to look more like a full bosomed domestic who was capable of carrying the world on her shoulders." Donald Bogle, *Toms, Coons, Mulattoes, Mammies, and Bucks: An Interpretive History of Blacks in American Films* (New York: Continuum, 2001), 63.
44. One of the earliest and easily one of the most troubling "staged" black female bodies—one that offered one of the earlier, infamous conflations of the black female body with an essentialized eroticism—was South African Sarah Baartman, a Khoikhoi woman who was labeled as the "Hottentot Venus." Upon arrival in London in 1810, she was put on display in freak shows and as a medical oddity because of her distinctive body parts, including large breasts and projecting buttocks. In England and then France, Baartman was caged, put on display, and after her death, French naturalist Georges Cuvier preserved her skeleton, brain, and genitalia in a jar, all presented in Paris for public display as so-called scientific evidence of African women as the missing link between human being and animals. Carol Henderson, *Imagining the Black Female Body: Reconciling Image in Print and Visual Culture* (New York: Palgrave Macmillan, 2010), 4. Not coincidentally, Baartman is the inspiration in Suzan-Lori Parks' engagement with, among other things, the staged black female body in her 1996 *Venus*.
45. Kimberly Wallace-Sanders, *Skin Deep, Spirit Strong: The Black Female Body in American Culture* (Ann Arbor: University of Michigan Press, 2010), 144.
46. Kushner, *Caroline, or Change*, 41–45.
47. Aaron C. Thomas, "Engaging an Icon: *Caroline, or Change* and the Politics of Representation," *Studies in Musical Theatre* 4, no. 2 (2010): 201.
48. Ibid.
49. Ibid., 204–205.
50. Bogle, *Toms, Coons, Mulattoes, Mammies, and Bucks*, 9.
51. Kushner, *Caroline, or Change*, 30–33.
52. Ibid., 46–47.
53. Although playing out tensions between the Mammy as a devoted nurturer of white children against her life as slave mother of her own offspring occasionally became a powerful rhetorical trope in abolitionist discourse, the

constructs themselves still heavily rely on essentialized subjectivities of motherhood and race. Wallace-Sanders, *Mammy*, 30.
54. In "Ideology and Ideological State Apparatuses: Notes Toward an Investigation," Althusser explores the concept of ideology as, among other things, an source of repression—one that is unavoidable, inescapable, and that exists outside of the subject's consciousness.
55. Wallace-Sanders, *Skin Deep*, 223.
56. Alfred Uhry, *Driving Miss Daisy* (New York: Dramatists Play Service, 1987), 36.
57. Ibid., 26.
58. Dorinne Kondo, *About Face: Performing Race in Fashion and Theater* (New York: Routledge, 1997), 199.
59. Ibid., 200.
60. Catherine Belsey, *Critical Practice* (London: Routledge, 1980), 67.
61. Misha Berson, "Theater Preview," *Seattle Times*, September 22, 2000.
62. David Patrick Stearns, "*Jar the Floor* Shows Heart While Shaking Expectations," *USA Today*, August 19, 1999.
63. Arlene McKanic, "Five Women Jar Audience to the Floor," *New York Amsterdam News*, August 19, 1999.
64. While the de facto responsibility of childcare was communally organized for women slaves who raised slave children, in much of the white imagination this was not considered motherwork in the strictest sense. As Wallace-Sanders explains in her discussion of earlier work on black maternity by, among others, Hortense Spillers and Angela Davis, American slaves who gave birth were not considered mothers at all. According to binding legislative directive, slaves' offspring could be sold at any time and at any age because their identity was tantamount to livestock or other live assets of the slave-owner. Wallace-Sanders, *Mammy*, 112.
65. Melinda Chateauvert, "Framing Sexual Citizenship: Reconsidering the Discourse on African American Families," *Journal of African American History* 93, no. 2 (2008): 207.
66. K. Sue Jewell, *From Mammy to Miss America and Beyond: Cultural Images and the Shaping of U.S. Social Policy* (London: Routledge, 1993), 21–22.
67. Bogle, *Toms, Coons, Mulattoes, Mammies, and Bucks*, 88–89.
68. West, *Jar the Floor*, 15.
69. Ibid., 38.
70. Ibid., 37–38.
71. In this discussions Shimakawa considers specifically the staged presence of Asian American actors.
72. Karen Shimakawa, *National Abjection: The Asian American Body Onstage* (Durham: Duke University Press, 2002), 17. Here Shimakawa expands earlier analysis from scholars such as James Moy, Dave Williams, and Robert Lee.
73. See Carlson, *The Haunted Stage*.
74. After the egregiously offensive representations of African Americans (in particular African American men) in Griffith's film, not to mention the

film's success and its endorsement from figures such as then President Theodore Roosevelt, W. E. B. Dubois, and the NAACP commissioned Grimké to offer a counternarrative of African American identity and African American family life, more specifically. Grimké and the NAACP actually felt that white Christian women were the most likely to sustain preconceived and racist beliefs invariably represented in Griffith's film; but they also believed that these same women were the group most likely to be swayed by a melodramatic narrative that focused on the Christianity, hardships, and unerring devotion of (African American) mothers. The play reads today, for some, as an apologetic and accommodating narrative pleading an innocuous notion of African American subjectivity to the white audiences who feared them. (For example, the play's almost syrupy tone, strong use of melodrama, sometimes flowery dialogue and genteel dialect, and even the canonical European Christian artwork Grimké text describes for the set are all a far cry from the self-consciously expressed, celebrated black culture of later playwrights such as August Wilson, George C. Wolf, or Suzan-Lori Parks.) For a deeper exploration of the theatrical and political history of Grimké's *Rachel*, see James V. Hatch's "Angelina Grimke," in *Black Theatre USA: Forty-Five Plays by Black Americans 1948–1974*, or Kathy A. Perkins' Introduction to *Black Female Playwrights: An Anthology of Plays before 1950*.

75. Joyce Meier, "The Refusal of Motherhood in African American Women's Theater," *MELUS* 25, nos. 3–4 (2000): 117. Among other plays, Meier's analysis considers Angelina Grimké's *Rachel*, Georgia Johnson's *Safe*, Alice Childress' *Mojo*, and Shirley Graham's *It's Morning*.
76. Wallace-Sanders, *Skin Deep*, 132.
77. Ibid., 132–133.
78. See McElya, *Clinging to Mammy*.
79. For more a more thorough context on Brundage's broader argument, see Fitzhugh Brundage, *The Southern Past: A Clash of Race and Memory* (Cambridge, MA: Harard University Press, 2008).
80. See Arthur Calhoun,
81. Sally McMillen, "Mothers' Sacred Duty: Breast-feeding Patterns among Middle- and Upper-Class Women in the Antebellum South," *Journal of Southern History* 51, no. 3 (1985): 333.
82. In 1989 *Jar the Floor* did play to (mostly) positive reviews off Broadway, but before its August 11, 1989, debut at New York's Second Stage Theatre, it found (and continues to find) enthusiastic audiences in regional theatres and theatres that play to predominantly African American audiences.
83. Robert Hoffler, "Big 'Change' in Tuners: West Coast Embraces Serious Shows, Gotham Goes for Fluff," *Variety*, January 31, 2005, 62.
84. Kondo, *About Face*, 205; my italics. Here Kondo's analysis addresses specifically Asian American theatre practitioners and spectators.
85. Hermine Pinson, "An Interview with Lorenzo Thomas," *Callaloo* 22, no. 2 (1999): 288.

4 Queering the Domestic Diaspora, *Enduring Borderlands*: Cherríe Moraga's Familia de la Frontera

1. Elin Diamond, *Unmaking Mimesis: Essays on Feminism and Theater* (London: Routledge, 1997), 5.
2. Ibid., ii.
3. Niall Richardson, "The Queer Activity of Extreme Male Bodybuilding: Gender Dissidence, Auto-Eroticism and Hysteria." *Social Semiotics* 14, no. 1 (2004): 49–50.
4. Ibid., 49.
5. Michael Warner, introduction to *Fear of a Queer Planet: Queer Politics and Social Theory*, ed. Michael Warner (Minneapolis: University of Minnesota Press, 1993), xxvi.
6. María Herrera-Sobek, introduction to *Chicana Literary and Artistic Expressions: Culture and Society in Dialogue*, ed. María Herrera-Sobek (Santa Barbara: Center for Chicano Studies Series, 2000), 14–15.
7. Lizbeth Goodman, "Bodies and Stages: An interview with Tim Miller." *Critical Quarterly* 36, no. 1 (1994): 64.
8. Evelyne Ender, *Sexing the Mind: Nineteenth-Century Fictions of Hysteria* (Ithaca: Cornell University Press, 1995), 15.
9. Ibid., 13.
10. Cherríe L. Moraga, *Waiting in the Wings* (Ann Arbor: Firebrand Books, 1998), 125.
11. Ibid., 15.
12. Richard T. Rodríquez, *Next of Kin: The Family in Chicano/a Cultural Politics* (Durham: Duke University Press, 2002), 3.
13. Diamond, *Unmaking Mimesis*, 5.
14. Ibid.
15. Ellie D. Hernández, *Postnationalism in Chicana/o Literature and Culture* (Austin: University of Texas Press, 2009), 163.
16. Mary Pat Brady, *Extinct Lands, Temporal Geographies: Chicana Literature and the Urgency of Space* (Durham: Duke University Press, 2002), 139.
17. Ibid., 138–139.
18. Ibid., 159.
19. Marta Caminero-Santangelo, *The Madwoman Can't Speak: Or Why Insanity Is Not Subversive* (Ithaca: Cornell University Press, 1998), 1.
20. Ibid., 3.
21. Ibid., 4.
22. Ibid., 11.
23. Ibid.
24. Indeed, consider Moraga's description of Manuel as the figure who occasionally "talks to himself "como un loco" (49) alongside Rodríguez's explanation that the feminized version of the Spanish word for "crazy," "*loca*," is the same "term used by Latino/a queers to refer to someone *as* queer." Moraga, *Shadow of a Man*, 49; Rodríquez, *Next of Kin*, 175.

25. Rosie McLaren, "The Discourses of Hysteria: Menopause, Art and the Body." *Hecate* 25, no. 2 (1999): 106–107.
26. Ibid., 107; my italics.
27. Ender, *Sexing the Mind,* 19; my italics.
28. Diane Price Herndl, "The Writing Cure: Charlotte Perkins Gilman, Anna O., and 'Hysterical' Writing." *National Woman's Studies Association Journal* 1, no. 1 (1988): 55.
29. Sigmund Freud, "Some Points for a Comparative Study of Organic and Hysterical Motor Paralyses." *Standard Edition* 1 (1893): 169.
30. Elizabeth Wilson, "Gut Feminism." *differences: A Journal of Feminist Cultural Studies* 15, no. 3 (2004): 68; my italics.
31. Ibid.
32. Phillip Rieff, introduction to *Dora: An Analysis of a Case of Hysteria*, by Sigmund Freud (New York: Macmillan, 1963), ix–x.
33. The two-act drama started out as a staged reading in New York City, developed through INTAR's 1985 Hispanic Playwrights-in-Residence program, with María Irene Fornes directing. The play was subsequently performed as staged readings at the Los Angeles Theatre Center's New Works Festival (1989), and the American Conservatory Theatre's Playroom (1989), and a 1989 version of the play was produced at the South Coast Repertory's Hispanic Playwright's Festival. In 1990 the play made its professional debut in its final, published form at the San Francisco Eureka Theatre as part of the Brava! For Women in the Arts program.
34. Moraga, *Shadow of a Man*, 63–64.
35. Ibid., 56.
36. As Moraga explains, "Compadre" implies best friend/brother or, "the relationship of a godfather to the parents of his godchild," whereby the two men share "a very special bond, akin to that of blood ties, sometimes stronger." Moraga, *Shadow of a Man*, 41.
37. Ibid., 71.
38. Ender, *Sexing the Mind*, 14.
39. Price Herndl, "The Writing Cure," 53–54.
40. Dianne Hunter, "Hysteria, Psychoanalysis, and Feminism: The Case of Ana O," *Feminist Studies* 9 (1983): 485. Feminist women writers such as Gilman are not the only source of fictional discourse to engage hysteria. A plethora of feminized "nonspeakers" and "invalidated invalids" pervade nineteenth-century fiction. In his 1857 account of Emma Bovary as literary hysteric, Charles Baudelaire writes that Flaubert's heroine "embodies with the force of an icon" the "outward bodily inscription of an inner state, which neither the outer voice of the narrative nor its inner voice can retrieve"; for Baudelaire and Flaubert, hysteria "defines an existential predicament...symptomatic of a time that was held in awe in front of a [the] hystericized body." Charles Baudelaire quoted in Ender, *Sexing the Mind*, 4. Similarly, Henry James points to Eliot's *Daniel Deronda* as a novel that "tells a story of hysteria": "The universe forcing itself with a slow, inexorable pressure into a

narrow, complacent, and yet after all extremely sensitive mind, and making it ache in the process." Henry James, *The Wings of the Dove* (Oxford: Oxford University Press, 1984), 990. For James, Eliot's hysteric, Gwendolyn Harleth is in fact suffering from a "demise of the mind" that eventually translates into "the melodrama of hysteria." To be sure, conflations of hysteria and Melodrama (and latter's frequent, often maternal, agent, the Fallen Woman) seems no accident here.
41. Rieff, introduction, xii.
42. Sigmund Freud, *Dora: An Analysis of a Case of Hysteria*, trans. Phillip Rieff (New York: Macmillan, 1963), 7–10.
43. Ibid., 11.
44. Ibid., 2.
45. Ender, *Sexing the Mind*, 4.
46. G. S. Rousseau, "'A Strange Pathology': Hysteria in the Early Modern World, 1500–1800," in *Hysteria Beyond Freud*. ed. Sander L. Gilman, G. S. Rousseau, Helen King, Roy Porter, and Elaine Showalter (Berkeley: University of California Press, 1993), 119.
47. Suzanne Bost, *Encarnación: Illness and Body Politics in Chicana Feminist Literature* (New York: Fordham University Press, 2010), 1.
48. Ibid., 2–3.
49. Moraga, *Shadow of a Man*, 71.
50. Bost, *Encarnación*, 94.
51. Ibid., 95; my italics.
52. Gloria Anzaldúa, *Borderlands/La Frontera: The New Mestiza* (San Francisco: aunt lute books, 1987), 48.
53. Bost, *Encarnación*, 95; my italics.
54. Ibid., 114–115.
55. Bost, *Encarnación*, 116–117; Yvonne Yarbro-Bejarano, *The Wounded Heart: Writing on Cherríe Moraga* (Austin: University of Texas Press, 2001), 7–10.
56. Bost, *Encarnación*, 118.
57. In her memoir on queer motherhood, Moraga argues a kinship network that includes, among others, Paul Monette, Audre Lorde, and César Chávez.
58. Bost, *Encarnación*, 118–119.
59. Ibid., 120.
60. Diamond, *Unmaking Mimesis*, 7.
61. Lionel Cantú, "Mythopoetic Chicana in Moraga's *Shadow of a Man*," in *Chicana Literary and Artistic Expressions: Culture and Society in Dialogue*, ed. María Herrera-Sobek (Santa Barbara: Center for Chicano Studies Series, 2000), 118.
62. Taking a cue from Rodríquez, "Chicanismo" is used here to indicate the growing ethnic identification and collective politicization occurring in and around the late 1960s and early 1970s, particularly in the US southwest.
63. Rodríguez, *Next of Kin*, 1–2; my italics.
64. Ibid.
65. Ibid., 19.

66. Moraga, *Shadow of a Man*, 46; my italics.
67. William T. McLeod, *The New Collins Dictionary and Thesaurus* (London: Collins, 1987), 491.
68. Hilary Robinson, "Border Crossing," in *New Feminist Art Criticism*, ed. K. Deepwell (New York: Manchester University Press, 1995), 19.
69. Julia Kristeva, "Narcissus: The New Insanity," in *Tales of Love* (New York: Columbia University Press, 1987), 112–113; my italics.
70. Moraga, *Shadow of a Man*, 50.
71. Ibid., 49.
72. Ibid., 50.
73. Anzaldúa, *Borderlands/La Frontera*, 180.
74. Moraga, *Shadow of a Man*, 49.
75. While not the ethnically informed model of el choque, nineteenth-century literary hysterics suffer mind-body chasms with equally telling results. Describing Henry James' Milly Theale as a "late avatar of the hysteric," Peter Brooks sees *Wings of the Dove*'s protagonist as suffering from "an aching female mind" imbricated with bodily symptoms. Milly-as-hysteric embodies the "gap" or "abyss" that separates body and mind. Peter Brooks, introduction to *The Wings of the Dove*, by Henry James (Oxford: Oxford University Press, 1984), xxi. In this way, then, hysteria affords useful purchase on the "body" and "mind" chasm informing the painful gulf between the (physically gendered) body and (intolerably queer) mind experienced by Manuel.
76. Pierrette Hondagneu-Sotelo and Michael A. Messner, "Gender Displays and Men's Power: The 'New Man' and the Mexican Immigrant Man," in *Theorizing Masculinities*, ed. Harry Brod and Michael Kaufman (Thousand Oaks: Sage, 1994), 214; my italics.
77. Anzaldúa, *Borderlands/La Frontera*, 85.
78. Herndl, "The Writing Cure," 71.
79. Rodríguez, *Next of Kin*, 98; 32–33.
80. Armando Rendón, *Chicano Manifesto* (Berkeley: Ollin and Associates, 1996), 95.
81. Angie Chabram-Dernersesian, "I Throw Punches for My Race, but I Don't Want to Be a Man: Writing Us—Chica-nos (Girl, Us/Chicanas—into the Movement Script)," *Cultural Studies*, ed. Lawrence Grosberg, Cary Nelson, and Paula Treichler (New York: Routledge, 1992), 83.
82. Rodríguez, *Next of Kin*, 45.
83. Ibid., 26; my italics.
84. Ender, *Sexing the Mind*, 17.
85. Herrera-Sobek, introduction, 15.
86. Ender, *Sexing the Mind*, 16.
87. Lynda Swinger, *Daughters, Fathers, and the Novel: The Sentimental Romance of Heterosexuality* (Madison: University of Wisconsin Press, 1991), 122.
88. Anzaldúa, *Borderlands/La Frontera*, 49.
89. Ender, *Sexing the Mind*, 16.

90. Anzaldúa, *Borderlands/La Frontera*, 172.
91. Ibid., 78.
92. Bost, *Encarnación*, 66.
93. Norma Alarcón, "Tropology of Hunger: The 'Miseducation' of Richard Rodriguez," in *The Ethnic Canon: Histories, Institutions, and Interventions*, ed. David Palumbo-Liu (Minneapolis: University of Minnesota Press, 1995), 15.
94. Rodríguez, *Next of Kin*, 83.
95. Anzaldúa, *Borderlands/La Frontera*, 84.
96. Rodríquez, *Next of Kin*, 54.
97. Anzaldúa, *Borderlands/La Frontera*, 83.
98. Hernández, *Postnationalism in Chicana/o Literature and Culture*, 180.
99. Moraga, *Shadow of a Man*, 63–64.
100. Ibid., 55.
101. Pat Brady, *Extinct Lands, Temporal Geographies*, 12.
102. Ibid., 10–12.
103. As Brady explains, seized originally by the Phelps Dodge Copper Company (claiming the land as a "depot town" during conflicts surrounding the Mexican Revolution and the presence of US corporate capital in Mexico), Douglas first fell victim to Phelps Dodge but eventually becomes acquired by local government (and police, followed by the DEA and INS) only to find itself in the current position as a major player in the border patrol and narcotics industries of the prison industrial complex. Originally a landmass of and for the Indian people who inhabited it, the violated space of this new Frontera is managed/occupied by the corporate and police state (including the DEA and INS).
104. Brady, *Extinct Lands, Temporal Geographies*, 3.
105. Ibid., 4.
106. Moraga, *Shadow of a Man*, 55.
107. Rodríguez, *Next of Kin*, 26–27. Rodríguez also points to Rodolfo "Corky" Gonzales' seminal poem "I am Joaquín, which "speaks to the urbanization processes that divide the Chicano family and community in relation to…colonization of the United States through mass culture and assimilation" (30). Gonzales notes, "Nationalism becomes la familia. Nationalism comes first out of the family" (425).
108. Antonieta Oliver Rotger, "Places of Contradiction and Resistance: The Borderland as Real and Imagined Spaces in Chicana Writing," in *Chicana Literary and Artistic Expressions: Culture and Society in Dialogue*. ed. María Herrera-Sobek (Santa Barbara: Center for Chicano Studies Series, 2000), 44–45.
109. Ibid., 45; my italics. Moraga joins many theorists who correspondingly investigate notions of "space," "place," and "the body." In "Queer Aztlán," she condemns the mistreatment of the earth alongside human subjects: "Land is more than the rocks and trees…For immigrants and gay men, land is the physical mass called our bodies Throughout *las Américas*, all these

'lands' remain under occupation by an Anglo-centric, patriarchal, imperialist United States" (173).
110. Judith Butler, *Gender Trouble: Feminism and the Subversion of Identity* (London: Routledge, 1999), 146.
111. Rotger, "Places of Contradiction and Resistance," 44–45.
112. Ibid.
113. As a sociopolitical construct, Aztlán itself does not escape matriarchal underpinnings. Brady writes: "As a number of contemporary literary critics have observed, Aztlán collects a series of critiques, utopian longings, and postures that enable a multi-sited Chicano nationalist resistance to dominant labor and symbolic relations... That complex political resistance requires an organizing mythology solidly grounded in a mythic understanding of the '*dark womb-heart of the earth.*'" Brady, *Extinct Lands, Temporal Geographies*, 144; my italics.
114. Hernández, *Postnationalism in Chicana/o Literature and Culture*, 181.
115. Brady, *Extinct Lands, Temporal Geographies*, 6.
116. Ibid, 8.
117. For example, Yarbro-Bejarano and Brady both highlight Anzaldúa's "Crossers y otros atravesados" as a compelling example of the discursive links between border crossing, queerness, and a semiotically rich, always fluid Frontera (slang for "queer," conflating the atravesados and "crossers" in the poem suggests an obvious congress between queerness and border crossing, but also posits "the interplay between movement and pleasure" and the ways in which "sexuality and desire may be referenced with a spatial shorthand." See Brady, *Extinct Lands, Temporal Geographies*, 84–85.
118. Moraga, *Shadow of a Man*, 69.
119. Ibid., 55.
120. Hernández, *Postnationalism in Chicana/o Literature and Culture*, 163
121. Doreen Massey, *Space, Place and Gender* (Minneapolis: University of Minnesota Press, 1994), 135.
122. More than one occasion could be understood as unofficial commencement of Chicana/o theatrical tradition. Here I consider the 1979 production of Valdez's *Zoot Suit* to represent an inauguration of what is often termed "Chicana/o Theatre." (Not coincidentally, this period marshals a twenty-year-long period marked by publications from Chicanas reacting against the misogynistic undertones of Chicano culture and earlier theatre.) While Valdez as point of naissance is arguable, I take my cue from Huerta, who designates Valdez as "the father of Chicano Theatre," and "the undisputed leader of the Chicano Theatre Movement." Jorge Huerta, *Chicano Drama: Performance, Society, Myth* (Cambridge: Cambridge University Press, 2000), 6; 3.
123. Ibid., 1–5.
124. Ibid., 20–26.
125. Ibid., 9. As a non-Western dramaturgical form, nonrealistic "Actos" are "characterized as brief, collectively created sketches based on a commedia

dell-arte model of slapstick, exaggeration, stereotypes and allegories poking satiric jabs at any given enemy or issue" (Huerta, *Chicano Drama*, 3).
126. These styles and themes can be traced as far back as Indo-Hispano performance histories. Eleven years following the Aztec empire's collapse, in the first Spanish drama staged in what would eventually become Mexico, natives mounted *Adan y Eva* in 1532, a quasi-Genesis narrative exploring the sexual misconduct of a fallen woman and arguable "mother" to the human race that morphed into what Huerta describes as one of the many "legac[ies] of the indigenous peoples and their mestizo descendants to this day." Huerta points out how the "Aztec mother goddess, Tonantzin, was supplanted by the Virgin Mary/Guadalupe." Huerta, *Chicano Drama: Performance, Society, Myth*, 16–17.
127. Ibid., 3.
128. Ibid., 4.
129. In *The Second Mrs. Tanqueray* (1893), Pinero offered Paula Tanqueray, a maternal hysteric/fallen woman who, as Nina Auerbach submits, performs the same "histrionics" over social "trespasses" that earlier spectators observed in another paradigmatic maternal fallen woman, *East Lynne's* Isabel Vane. Nina Auerbach, introduction to *The Cambridge Companion to Victorian and Edwardian Theatre*. ed. Kerry Powell (Cambridge: Cambridge University Press, 2003), 12. In *The Notorious Mrs. Ebbsmith* two years later, Pinero's Agnes Ebbsmith (although only a figurative maternal figure) nods to this archetype.
130. In his 1895 medical text *Degeneration*, Max Nordau includes a chapter on hysteria, which contains a section explicitly subtitled "Ibsenism." Diamond, *Unmaking Mimesis*, 3.
131. Ibid. Among others, Diamond points to critic H. E. M. Stutfield who, in his 1896 assessment of Ibsen's *Little Eyolf*, surmises this new "neurotic school" of playwright is a "literary mosquito, probing greater depths of agonized human nature than anybody else"; the "needless self-torture" of the writer, he argues, parallels the same misery transpiring in the enthusiastic spectators ("women") who are consuming the form enthusiastically.
132. See Catherine Wiley's "Cherríe Moraga's Radical Revision of *Death of a Salesman*," *American Drama* 11 (2002): 32–46.
133. Diamond, *Unmaking Mimesis*, 8.
134. Ibid.
135. Reacting against its (literary and staged) stylized predecessor, melodrama, dramatic realism echoed many changes taking place offstage within the new literary realism. Believable/recognizable dialogue, three-dimensional characterization, and most importantly, credible/recognizable conflicts within plot deviated from the stock characters, unbelievable-yet-predictable plots, and often over-the-top characterization and dialogue of melodrama. But in addition to readers/spectators experiencing a new recognition of themselves on the stage/page (as opposed to the stock characters and/or socially elite populating plot-driven melodramas), the character studies within dramatic

realism also employ *dramaturgical* interventions unavailable to the purely literary, including set design, costume choices, lighting, even music. See, for example, Emile Zola's *Naturalism in the Theatre* (1878), a key text that extrapolates the components of and celebrates the values within the new dramatic/"Ibsenite" realism.
136. Diamond, *Unmaking Mimesis*, 18; my italics.
137. Ibid., 15.
138. Ibid., 4.
139. Ibid., 13.
140. Ibid., 4.
141. Ibid., 6.
142. Ibid., xiv.
143. Another Moraga play uniquely invested in realism, 1996's *Watsonville: Some Place Not Here* also invokes the figure of the maternal hysteric/fallen woman; *Watsonville's* maternal hysteric also engages pathologized internal conflicts surrounding political, racial, and (to a lesser extent) sexual ideologies alongside irreconcilable memories and increasing insanity that often manifests in somatic symptoms.
144. Ender, *Sexing the Mind*, 21.
145. McLaren, "The Discourses of Hysteria," 107.

Conclusion Nurturing Performance, Raising Questions

1. Lori Moore, "Rep. Todd Akin: The Statement and the Reaction," *New York Times*, August 20, 2012. Accessed December 1, 2012, http://www.nytimes.com/2012/08/21/us/politics/rep-todd-akin-legitimate-rape-statement-and-reaction.html?_r=0.. The adjective "legitimate" would seem to suggest that a number of reported rapes are either false or "illegitimate."
2. Shortly after Akin's remarks, several political pundits, journalists, and cultural critics pointed out the connection between Akin's offensive remarks and the public, often violent, punishments endured by many women in the developing world after experiencing rape and the consequent "shame" their rape brought their families.
3. Moore, "Rep. Todd Akin."
4. Elin Diamond, *Unmaking Mimesis: Essays on Feminism and Theater* (London: Routledge, 1997), 45–46.
5. Ibid., 46.
6. Shannon Sheen, *Racial Geometries of the Black Atlantic, Asian Pacific and American Theatre* (New York: Palgrave Macmillan, 2010), 5.
7. "Mothers of East Los Angeles," accessed November 12, 2012, http://www.mothersofeastla.com/. MELA's targets (and accomplishments) exceed its initial work with the proposed state prison: among their fights (and victories) are the prevention of a toxic waste incinerator proposed for Vernon, California; stopping plans for a treatment plant for hazardous waste in

Huntington Park, California; and the completion of a residential development in Los Angeles County as well as a Home Ownership Center—both aimed at providing assistance to low-income families.
8. Mary Pardo, "Mexican American Women Grassroots Community Activists: 'Mothers of East L.A,'" *Frontiers: A Journal of Women Studies* 11, no. 1 (March 1990): 3.
9. Ibid., 6.
10. "Mothers of East Los Angeles."
11. Ibid.
12. Louis Sahagun, "The Mothers of East L.A. Transform Themselves and Their Neighborhood," *Los Angeles Times*, August 13, 1989, accessed November 15, 2012, http://articles.latimes.com/1989-08-13/local/me-816_1_east-los-angeles; my italics.
13. "Mothers of East Los Angeles St. Santa Isabel," accessed November 16, 2012, http://clnet.ucla.edu/community/intercambios/melasi/; my italics.
14. Pardo, "Mexican American Women," 1.
15. Ibid.
16. Ibid.
17. Cherríe Moraga, *Shadow of a Man*, in *Heroes and Saints and Other Plays: Giving Up the Ghost, Shadow of a Man, Heroes and Saints* (Albuquerque: West End Press, 1994), 78.
18. In Anglo American culture, sex and gender norms from the 1950s through the early 1970s experienced a markedly different political tone regarding reproductive rights compared to more traditional attitudes still defining Chicano culture. For example, nineteen years before *Shadow* is set, Margaret Sanger underwrote the scientific research that went into the establishment of the birth control pill in 1950; ten years later saw the release of Enovid, the first incarnation of the pill released in America; in 1965, in the *Griswold v. Connecticut* case, the US Supreme Court ruled birth control's availability to married women as constitutional; in *Baird v. Eisenstadt*, the same court issued a 1972 decision that made birth control legal to all US citizens, whether married or not. "A Brief History of Birth Control," accessed November 20, 2012, http://www.ourbodiesourselves.org/book/companion.asp?id=18&compID=53.
19. Moraga, *Shadow of a Man*, 61.
20. Ibid., 77.
21. Whether or not this can be considered outright assimilation to Anglo (sexual) mores depends on how progressive/conservative one considers sex-gender norms to be for middle-class white American women in 1969.
22. Carol E. Henderson, introduction to *Imagining the Black Female Body: Reconciling Image in Print and Visual Culture*, ed. Carol E. Henderson (New York: Palgrave Macmillan, 2010), 4.
23. Ibid.
24. Ivy Kennelly, "'That Single-Mother Element': How White Employers Typify Black Women," *Gender and Society* 13, no. 2 (April 1999): 168–192.

25. Ibid., 182.
26. Ibid., 169–170.
27. Ibid., 183–185.
28. In addition to his other high-profile positions, Moynihan would eventually be elected to the US Senate in 1976, representing the state of New York and reelected three times, serving until 1994.
29. Daniel Patrick Moynihan, "The Negro Family: The Case For National Action," Office of Policy Planning and Research United States Department of Labor, March 1965, accessed December 2, 2012, http://www.dol.gov/oasam/programs/history/webid-meynihan.htm. Hortense Spillers addresses the patronizing and paternalistic rhetoric of The Moynihan Report in "Mama's Baby, Papa's Maybe: An American Grammar Book" (1987).
30. Ibid.
31. Micki McElya, *Clinging to Mammy: The Faithful Slave in Twentieth-Century America* (Cambridge, MA: Harvard University Press, 2007), 256.
32. James T. Patterson, *Freedom Is Not Enough: The Moynihan Report and America's Struggle over Black Family Life From LBJ to Obama* (New York: Perseus, 2010), 60.
33. Doris Witt, "What (N)ever Happened to Aunt Jemima: Eating Disorders, Fetal Rights, and the Black Female Appetite in Contemporary American Culture," in *Skin Deep, Spirit Strong: The Black Female Body in American Culture* ed. Kimberly Wallace-Sanders (Ann Arbor: University of Michigan Press, 2002), 244.
34. Patricia Hill Collins, *Black Feminist Thought: Knowledge, Consciousness, and the Politics of Empowerment* (New York: Routledge, 2000), 74.
35. Joyce Meier, "The Refusal of Motherhood in African American Women's Theater," *MELUS* 25, nos. 3–4, Revising Traditions Double Issue (2000): 131.
36. Ibid., 132.
37. Ibid.
38. Ibid.
39. Norman Lear's *Good Times* and *The Jeffersons* offered American audiences nonsingle black mothers with their characters Florida and Louise ("Weezie"), respectively. But in the former, Florida emerges as the "strong black matriarch," and further, while her character is married in the beginning of the series, she is eventually widowed and even when still married, she is plagued (indeed *defined*) by economic hardships. With Louise Jefferson American audiences did see an upper-middle-class black mother character who was also married, but any productive representation the sitcom may have offered was undercut by its protagonist's (George Jefferson) "clowning," a consistent buffoonery rivaling minstrelsy.
40. A prominent exception was the explosively popular *The Cosby Show*. Sometimes the subject of heated contention with regard to its representational/political value, the Carsey-Werner sitcom aired from 1984 to 1992 and featured the Huxtables, an African American family headed by

longtime married parents. Happily married lawyer Clair and ob/gyn Cliff live in a pricey Brooklyn brownstone while raising five children, many of whom are either in college or college-bound. Many factors made *The Cosby Show* anomalous to representations of African American domesticity on American television. Under no circumstances a cartoonish mammy or emasculating matriarch (some of which were on the air at the same time), Clair is notable for the character's profession, an invariable poise, but also, significantly, she is a black American mother happily married to the father of her children (indeed, the couple's healthy romantic life is a staple of the episodes' storylines).

41. K. Sue Jewell, *From Mammy to Miss America and Beyond: Cultural Images and the Shaping of U.S. Social Policy* (London: Routledge, 1992), 189.
42. The year in American media and American racial politics is significant also for the first televised interracial kiss, shared by William Shatner's Captain Kirk and Nichelle Nichols' Lieutenant Uhura on the program *Star Trek*. "TV Guide," accessed December 1, 2012, http://www.tvguide.com/news/shattered-tv-taboos-1005496.aspx.
43. Christine Acham, *Revolution Televised: Prime Time and the Struggle for Black Power* (Minneapolis: University of Minnesota Press, 2005), 121–122. Indeed, in 1968 Diahann Carroll herself described the arguably "safe" program and protagonist this way: "At the moment we're presenting the white Negro. And he has very little Negroness." Joanne Morreale and Aniko Bodroghkozy, *Critiquing the Sitcom* (Syracuse: Syracuse University Press, 2003), 138.
44. Acham, *Revolution Televised*, 121–122.
45. Ibid., 123. Acham cites as just one example a 1966 Howard University incident indicating the growing impatience with/disinterest in integration. Sometimes referred to as the Black Harvard, Howard's 1966 homecoming queen, Robin Gregory, characterized her winning campaign as one invested in black pride and "wore a natural, or an Afro, in contrast to previous homecoming queens, who were judged on their ability to imitate white standards of beauty"—what Acham refers to as "one of the cultural pitfalls of integration."
46. For example, during the 1968 Summer Olympics, African American Olympic athletes Tommie Smith and John Carlos performed the Black Power (raised fist) salute on the winner's podium as they received their gold and bronze medal, respectively; in 1966, Mohammed Ali made headlines with his politically based, public refusal of inscription in the Vietnam War.
47. Maureen Dowd, "Romney Is President," *New York Times*, November 12, 2012, accessed December 1, 2012, http://www.nytimes.com/2012/11/11/opinion/sunday/dowd-romney-is-president.html?src=me&ref=general.
48. Ibid.
49. According to the Gallup poll, the presidential election of 2012 saw the largest gender gap in their history, dating back to 1952. Successfully reelected Obama won the vote of single women by a margin of 36 percentage points

and won "the two-party vote among female voters...by 12 points, 56% to 44%, over Republican challenger Mitt Romney" (the latter "won among men by an eight-point margin, 54% to 46%"). Jeffrey M. Jones, "Gender Gap in 2012 Vote Is Largest in Gallop's History," "Gallop Poll," November 9, 2012, accessed December 1, 2012, http://www.gallup.com/poll/election.aspx.
50. Susan Bennett, *Theatre Audiences: A Theory of Production and Reception* (New York: Routledge, 1997), 51.
51. Ibid.

BIBLIOGRAPHY

Abramson, Irving I. "The Career of Rachel Crothers in the American Theater." PhD diss., University of Chicago, 1956.
Acham, Christine. *Revolution Televised: Prime Time and the Struggle for Black Power.* Minneapolis: University of Minnesota Press, 2005.
Alarcón, Norma. "Tropology of Hunger: The 'Miseducation' of Richard Rodriguez." In *The Ethnic Canon: Histories, Institutions, and Interventions*, edited by David Palumbo-Liu, 140–152. Minneapolis: University of Minnesota Press, 1995.
Anderson, Lisa M. *Mammies No More: The Changing Image of Black Women on Stage and Screen.* New York: Rowman and Littlefield, 1997.
Anzaldúa, Gloria. *Borderlands/La Frontera: The New Mestiza.* San Francisco: aunt lute books, 1987.
Auerbach, Nina. Introduction to *The Cambridge Companion to Victorian and Edwardian Theatre*, edited by Kerry Powell, 3–16. Cambridge: Cambridge University Press, 2003.
Azuma, Eiichiro. *Between Two Empires: Race, History, and Transnationalism in Japanese America.* Oxford: Oxford University Press, 2005.
Bankey, Ruth. "La Donna é Mobile: Constructing the Irrational Woman." *Gender, Place and Culture* 8, no. 1 (2001): 37–54.
Barlow, Judith E. *Plays by American Woman: 1900–1930.* New York: Applause Theatre and Cinema Books, 2000.
Barnes, Clive. "The Stage; New York Notebook." *New York Post*, September 2, 1999: 7.
Belsey, Catherine. *Critical Practice.* London: Routledge, 1980.
Bender, Daniel E. "Perils of Degeneration: Reform, the Savage Immigrant, and the Survival of the Unfit." *Journal of Social History* 42, no. 1 (2008): 5–29.
Bennett, Susan. *Theatre Audiences: A Theory of Production and Reception.* New York: Routledge, 1997.
Bergman, Jill. "'Natural' Divisions/National Divisions: Whiteness and the American New Woman in the General Federation of Women's Clubs." In *New Woman Hybridities: Femininity, Feminism and International Consumer Culture, 1880–1930*, edited by Ann Heilmann and Margaret Beetham, 223–239. London: Routledge, 2004.
Berson, Misha. "Theater Preview." *Seattle Times*, September 22, 2000: I32.
Bhabha, Homi K. "Of Mimicry and Man: The Ambivalence of Colonial Discourse." In *The Location of Culture*, 85–92. London: Routledge, 1997.

Bhabha, Homi K. "The Other Question: Stereotype, Discrimination, and the Discourse of Colonialism." In *The Location of Culture*, 66–84. London: Routledge, 1997.

Bial, Henry and Scott Magelssen. Introduction to *Theater Historiography: Critical Interventions*, edited by Henry Bial and Scott Magelssen, 1–8. Ann Arbor: University of Michigan Press, 2010.

Bigsby, C. W. E. *Modern American Drama 1945–2000*. Cambridge: Cambridge University Press, 2000.

Black, Cheryl. *The Women of Provincetown, 1915–1922*. Tuscaloosa: University of Alabama Press, 2002.

Bogle, Donald. *Toms, Coons, Mulattoes, Mammies, and Bucks: An Interpretive History of Blacks in American Films*. New York: Continuum, 2001.

Bordo, Susan and Leslie Heywood. *Unbearable Weight: Feminism, Western Culture and the Body*. Berkeley: University of California Press, 1993.

Bösch, Susanna A. *"Sturdy Black Bridges" on the American Stage: The Portrayal of Black Motherhood in Selected Plays by Contemporary African American Women Playwrights*, edited by Richard Martin and Rüdiger Schreyer. Frankfurt: Peter Lang, 1996.

Bost, Suzanne. *Encarnación: Illness and Body Politics in Chicana Feminist Literature*. New York: Fordham University Press, 2010.

Bottoms, Stephen J. "The Efficacy/Effeminacy Braid: Unpicking the Performance Studies/Theatre Studies Dichotomy." *Theatre Topics* 13, no. 2 (2003): 173–188.

Brady, Mary Pat. *Extinct Lands, Temporal Geographies: Chicana Literature and the Urgency of Space*. Durham: Duke University Press, 2002.

"A Brief History of Birth Control." http://www.ourbodiesourselves.org/book/companion.asp?id=18&compID=53.

Brooks, Peter. Introduction to *The Wings of the Dove*, by Henry James, xvii–xxiii. Oxford: Oxford University Press, 1984.

Brunt, Rosaline and Caroline Rowan. Introduction to *Feminism, Culture and Politics*, edited by Rosaline Brunt and Caroline Rowan, 11–36. London: Lawrence and Wishart, 1982.

Butler, Judith. *Gender Trouble: Feminism and the Subversion of Identity*. London: Routledge, 1999.

Caminero-Santangelo, Marta. *The Madwoman Can't Speak: Or Why Insanity Is Not Subversive*. Ithaca: Cornell University Press, 1998.

Canning, Charlotte. *Feminist Theaters in the U.S.A.: Staging Women's Experience*. New York: Routledge, 1996.

Cantú, Lionel. "Mythopoetic Chicana in Moraga's *Shadow of a Man*." In *Chicana Literary and Artistic Expressions: Culture and Society in Dialogue*, edited by María Herrera-Sobek, 111–121. Santa Barbara: Center for Chicano Studies Series, 2000.

Caulfield, Minna Davis. "The Family and Cultures of Resistance." *Socialist Revolution* 20 (1975): 67–85.

Chabram-Dernersesian, Angie. "I Throw Punches for My Race, but I Don't Want to Be a Man: Writing Us—Chica-nos (Girl, Us)/Chicanas—into the Movement Script." In *Cultural Studies*, edited by Lawrence Grosberg, Cary Nelson, and Paula Treichler, 81–95. New York: Routledge, 1992.

Chadhuri, Una. "The Future of the Hyphen: Interculturalism, Textuality, and the Difference Within." In *Interculturalism and Performance*, edited by Bonnie Marranca and Gautam Dasgupta, 197–207. New York: Performing Arts Journal, 2001.

Chang, Gordon H. *Asian Americans and Politics: Perspectives, Experiences, Prospects.* Stanford: Stanford University Press, 2001.

Chateauvert, Melinda. "Framing Sexual Citizenship: Reconsidering the Discourse on African American Families." *Journal of African American History* 93, no. 2 (2008) 198–222.

Clinton, Catherine. *The Plantation Mistress: Woman's World in the Old South.* New York: Pantheon, 1982.

Collins, Patricia Hill. *Black Feminist Thought: Knowledge, Consciousness, and the Politics of Empowerment.* New York: Routledge, 2000.

Creef, Elena Tajima. *Imaging Japanese America: The Visual Construction of Citizenship, Nation, and the Body.* New York: New York University Press, 2004.

Crothers, Rachel. *He and She.* Boston: Walter H. Baker, 1911.

———. *A Man's World.* Boston: Richard G. Badger, 1915.

Davis, Jill. "The New Woman and the New Life." In *The New Woman and Her Sisters: Feminism and Theatre, 1850–1914,* edited by Vivien Gardner and Susan Rutherford, 17–36. New York: Harvester Wheatsheaf, 1992.

de Lauretis, Teresa. "The Technology of Gender." In *Technologies of Gender: Essays on Theory, Film, and Fiction,* 1–30. Bloomington: Indiana University Press, 1987.

D'Emilio, John and Estelle B. Freedman. *"Intimate Matters": A History of Sexuality in America.* Chicago: University of Chicago Press 1997.

Diamond, Elin. *Unmaking Mimesis: Essays on Feminism and Theater.* London: Routledge, 1997.

Dolan, Jill. *Geographies of Learning: Theory and Practice, Activism and Performance.* Middletown: Wesleyan University Press, 2001.

Dowd, Maureen. "Romney Is President." *New York Times*, November 12, 2012. http://www.nytimes.com/2012/11/11/opinion/sunday/dowd-romney-is-president.html?src=me&ref=general.

"The Drama" (Review, *A Man's World*). *Nation*, February 10, 1910.

Ender, Evelyne. *Sexing the Mind: Nineteenth-Century Fictions of Hysteria.* Ithaca: Cornell University Press, 1995.

Engle, Sherry D. *New Women Dramatists in America, 1890–1920.* New York: Palgrave Macmillan, 2007.

Espiritu, Yen Le. "Possibilities of a Multiracial Asian America." In *The Sum of Our Parts: Mixed Heritage Asian Americans,* edited by Teresa Williams-Leon and Cynthia L. Nakashima, 25–33. New York: Oxford University Press, 2001.

Fletcher, Pamela M. "The Fallen Woman and the New Woman: The Prodigal Daughter." In *Narrating Modernity: The British Problem Picture, 1895–1914,* 69–76. Aldershot: Ashgate, 2003.

Foertsch, Jacqueline. "'Extraordinarily Convenient Neighbors': African American Characters in White-Authored Post-atomic Novels." *Journal of Modern Literature* 30, no. 4 (2007) 122–138.

Freud, Sigmund. "Fragment of an Analysis of a Case of Hysteria [Dora] 1905." In *Dora: An Analysis of a Case of Hysteria*, translated by Phillip Rieff, 1–112. New York: Macmillan, 1993.

———. "Some Points for a Comparative Study of Organic and Hysterical Motor Paralyses." *Standard Edition* 1 (1893): 160–172.

Friedan, Betty. *The Feminine Mystique*. New York: W. W. Norton, 1997.

Friedman, Sharon. "Feminism as Theme in Twentieth Century American Women's Drama." *American Studies* 25 (1987): 69–89.

Galton, Francis. *Inquiries into Human Faculty and Its Development*. London: Macmillan, 1883.

Gilbert, Helen and Joanne Tompkins. *Post-colonial Drama: Theory, Practice, Politics*. London: Routledge, 1996.

Glenn, Evelyn Nakano. *Issei, Nisei, War Bride: Three Generations of Japanese American Women in Domestic Service*. Philadelphia: Temple University Press, 1986.

———. "Social Constructions of Mothering." In *Mothering: Ideology, Experience, Agency*, edited by Evelyn Nakano Glenn, 1–29. New York: Routledge, 1994.

———. *Unequal Freedom: How Race and Gender Shaped American Citizenship and Labor*. Cambridge, MA: Harvard University Press, 2004

Goldstein, Malcolm. *The Political Stage: American Drama and the Theater of the Great Depression*. New York: Oxford University Press, 1974.

Gonzales, Rodolfo "Corky." "Chicano Nationalism: The Key to Unity for La Raza." In *Chicano: The Evolution of a People*, edited by Renato Rosaldo, 420–435. Minneapolis: Winston Press, 1973.

Goodman, Lizbeth. "Bodies and Stages: An Interview with Tim Miller." *Critical Quarterly* 36, no. 1 (1994): 63–73.

Gotanda, Philip K. *Fish Head Soup*, in *Fish Head Soup and Other Plays*. 1–67. Seattle: University of Washington Press, 1995.

———. Interview by Robert Ito. In *Words Matter: Conversations with Asian American Writers*, edited by King-Kok Cheung, 173–185. Honolulu: University of Hawaii Press, 2000.

———. *The Wash*, in *Fish Head Soup and Other Plays*. 131–198. Seattle: University of Washington Press 1995.

Gottlieb, Lois C. *Rachel Crothers*. Boston: Twayne, 1979.

Heilmann, Ann and Margaret Beetham. Introduction to *New Woman Hybridities: Femininity, Feminism, and International Consumer Culture, 1880–1930*, edited by Ann Heilmann and Margaret Beetham, 1–14. London: Routledge, 2004.

Henderson, Carole E. "Guest Editor's Introduction: The Bodies of Black Folk: The Flesh Manifested in Words, Pictures, and Sound." *MELUS* 35, no. 4 (2010) 5–13.

———. Introduction to *Imagining the Black Female Body: Reconciling Image in Print and Visual Culture*, 1–19. New York: Palgrave Macmillan, 2010.

Hernández, Ellie D. *Postnationalism in Chicana/o Literature and Culture*. Austin: University of Texas Press, 2009.

Herndl, Diane Price. "The Writing Cure: Charlotte Perkins Gilman, Anna O., and 'Hysterical' Writing." *National Woman's Studies Association Journal* 1, no.1 (1988): 53–74.

Herr, Christopher. *Clifford Odets and American Political Theatre*. Westport: Praeger, 2003.

Herrera-Sobek, María. Introduction to *Chicana Literary and Artistic Expressions: Culture and Society in Dialogue*, edited by María Herrera-Sobek, 13–19. Santa Barbara: Center for Chicano Studies Series, 2000.

Ho, Wendy. *In Her Mother's House: The Politics of Asian American Mother-Daughter Writing*. Oxford: Rowman & Littlefield, 1999.

Hoffler, Robert. "Big 'Change' in Tuners: West Coast Embraces Serious Shows, Gotham Goes for Fluff." *Variety* 391, no. 11 (January 31, 2005): 62–63.

Hondagneu-Sotelo, Pierrette and Michael A. Messner. "Gender Displays and Men's Power: The 'New Man' and the Mexican Immigrant Man." In *Theorizing Masculinities*, edited by Harry Brod and Michael Kaufman, 200–218. Thousand Oaks: Sage, 1994.

Horowitz, Daniel. *Betty Friedan and the Making of "The Feminine Mystique": The American Left, the Cold War and Liberal Feminism*. Amherst: University of Massachusetts Press, 1998.

Houston, Jeanne Wakatsuki and James D. Houston. *Farewell to Manzanar*. New York: Ember, 2012.

Huerta, Jorge. *Chicano Drama: Performance, Society, Myth*. Cambridge: Cambridge University Press, 2000.

Hunter, Dianne. "Hysteria, Psychoanalysis, and Feminism: The Case of Ana O." *Feminist Studies* 9 (Fall 1983): 464–488.

Jaco, Charles. "Full Interview with Todd Akin." *Jaco Report*. Fox. August 19, 2012. http://fox2now.com/2012/08/19/the-jaco-report-august-19–2012/.

Jacobson, Matthew Frye. *Barbarian Virtues: The United States Encounters Foreign Peoples at Home and Abroad, 1876–1917*. New York: Hill and Wang, 2000.

Jewell, K. Sue. *From Mammy to Miss America and Beyond: Cultural Images and the Shaping of U.S. Social Policy*. London: Routledge, 1992.

Jones, Jeffrey M. "Gender Gap in 2012 Vote Is Largest in Gallop's History." Gallop Poll. November 9, 2012. http://www.gallup.com/poll/election.aspx.

Kaplan, E. Ann. *Motherhood and Representation: The Mother in Popular Culture and Melodrama*. London: Routledge, 1992.

Kennedy, David M. *Birth Control in America: The Career of Margaret Sanger*. New Haven: Yale University Press, 1973.

Kennelly, Ivy. "'That Single-Mother Element': How White Employers Typify Black Women." *Gender and Society* 13, no. 2 (1999): 168–192.

Kinsella, Bridget. "The Bad Mommy: Ayelet Waldman Take the Heat and Keeps on Writing." *Publishers Weekly*. Features. January 2, 2006: 26.

Knowles, Ric. *Reading the Material Theatre*. Cambridge: Cambridge University Press, 2004.

Kolb, Deborah S. "The Rise and Fall of the New Woman in American Drama." *Educational Theatre Journal* 27 (1975): 149.

Kondo, Dorinne. *About Face: Performing Race in Fashion and Theater*. New York: Routledge, 1997.

Kristeva, Julia. "Narcissus: The New Insanity." In *Tales of Love*, 112–113. New York: Columbia University Press, 1987.

Kushner, Tony. *Caroline, or Change.* New York: Theatre Communications, 2004.
Lee, Josephine. *Performing Asian American: Race and Ethnicity on the American Stage.* Philadelphia: Temple University Press, 1997.
Lemire, Elise. *"Miscegenation": Making Race in America.* Philadelphia: University of Pennsylvania Press, 2009.
Lindroth, Colette and James Lindroth. *Rachel Crothers: A Research and Production Sourcebook.* Westport: Greenwood Press, 1995.
Lorde, Audre. *Sister Outsider: Essays and Speeches.* Berkeley: Crossing Press, 1984.
Lowe, Lisa. "Heterogeneity, Hybridity, Multiplicity: Marking Asian American Differences." *Diaspora* 1, no. 1 (1991): 24–44.
———. *Immigrant Acts: On Asian American Cultural Politics.* Durham: Duke University Press, 1996.
Mantle, Burns. *The Best Plays of 1936–1937.* New York: Dodd, Mead, 1937.
Mass, Amy Iwasaki. "Socio-Psychological Effects of the Concentration Camp Experience on Japanese Americans." *Bridge* (1978): 61–63.
Massey, Doreen. *Space, Place and Gender.* Minneapolis: University of Minnesota Press, 1994.
Matthews, Jean V. *The Rise of the New Woman: The Women's Movement in America, 1875–1930.* Chicago: Ivan R. Dee, 2004.
McElya, Micki. *Clinging to Mammy: The Faithful Slave in Twentieth-Century America.* Cambridge, MA: Harvard University Press, 2007.
McKanic, Arlene. "Five Women Jar Audience to the Floor." *New York Amsterdam News*, August 19, 1999.
McLaren, Rosie. "The Discourses of Hysteria: Menopause, Art and the Body." *Hecate* 25, no. 2 (1999): 107–129.
McLeod, William T. *The New Collins Dictionary and Thesaurus.* London: Collins, 1987, 491.
McMillen, Sally. "Mothers' Sacred Duty: Breast-feeding Patterns among Middle- and Upper-Class Women in the Antebellum South." *Journal of Southern History* 51, no. 3 (1985): 333–356.
McMillin, Scott. *The Musical as Drama: A Study of the Principles and Conventions behind Musical Shows from Kern to Sondheim.* Princeton: Princeton University Press, 2006.
Meier, Joyce. "The Refusal of Motherhood in African American Women's Theater." *MELUS* 25, nos. 3–4, Revising Traditions Double Issue (2000): 117–139.
Memmott, Carol. "Maternal Ambivalence Is Ayelet Waldman's Baby." *USA Today*, February 24, 2006. 10E.
Moore, Lori. "Rep. Todd Akin: The Statement and the Reaction." *New York Times*, August 20, 2012. http://www.nytimes.com/2012/08/21/us/politics/rep-todd-akin-legitimate-rape-statement-and-reaction.html?_r=0.
Moraga, Cherríe L. "Queer Aztlán: the Re-formation of Chicano Tribe." In *The Last Generation*, 145–174. Boston: South End Press, 1993.
———. *Shadow of a Man.* In *Heroes and Saints and Other Plays: Giving Up the Ghost, Shadow of a Man, Heroes and Saints,* 37–84. Albuquerque: West End Press, 1994.
———. *Waiting in the Wings.* Ann Arbor: Firebrand Books, 1998.

Morreale, Joanne and Aniko Bodroghkozy. *Critiquing the Sitcom*. Syracuse: Syracuse University Press, 2003.
"Mothers of East Los Angeles." http://www.mothersofeastla.com/.
"Mothers of East Los Angeles Santa Isabel." http://clnet.ucla.edu/community/intercambios/melasi/.
Moynihan, Daniel Patrick. "The Negro Family: The Case For National Action." Office of Policy Planning and Research United States Department of Labor. March 1965. http://www.dol.gov/oasam/programs/history/webid-meynihan.htm
Newlin, Keith. *American Plays of the New Woman*. New York: Rowan and Littlefield /Ivan R. Dee, 2000.
Omi, Michael and Howard Winant. *Racial Formation in the United States: From the 1960s to the 1990s*. New York: Routledge, 1994.
Palumbo-Liu, David. *Asian/American: Historical Crossings of a Racial Frontier*. Stanford: Stanford University Press, 1999.
Pardo, Mary. "Mexican American Women Grassroots Community Activists: 'Mothers of East L.A.'" *Frontiers: A Journal of Women Studies* 11, no. 1 (1990): 1–7.
Patterson, James T. *Freedom Is Not Enough: The Moynihan Report and America's Struggle over Black Family Life From LBJ to Obama*. New York: Perseus, 2010.
Patterson, Martha H. *Beyond the Gibson Girl: Reimagining the American New Woman 1895–1915*. Urbana: University of Illinois Press, 2008.
Pinson, Hermine. "An Interview with Lorenzo Thomas." *Callaloo* 22, no. 2 (1999). 287–304.
Plant, Rebecca Jo. *Mom: The Transformation of Motherhood in Modern America*. Chicago: University of Chicago Press, 2010.
Powell-Wright, Debra A. "Four Women, for Women: Black Women—All Grown Up." In *Imagining the Black Female Body: Reconciling Image in Print and Visual Culture*, edited by Carol E. Henderson, 109–120. New York: Palgrave Macmillan.
Quinn, Arthur Hobson. *A History of the American Drama from the Civil War to the Present Day*. New York: Irvington, 1936.
Reilly, Joy Harriman. "A Forgotten 'Fallen Woman': Olga Nethersole's Sapho." In *When They Weren't Doing Shakespeare: Essays on Nineteenth-Century British and American Theatre*, edited by Judith L. Fisher and Stephen Watt, 106–122. Athens: University of Georgia Press, 1989.
Rendón, Armando. *Chicano Manifesto*. Berkeley: Ollin and Associates, 1996.
Richardson, Angelique. "The Birth of National Hygiene and Efficiency: Women and Eugenics in Britain and American 1865–1915." In *New Woman Hybridities: Femininity, Feminism and International Consumer Culture, 1880–1930*, edited by Ann Heilmann and Margaret Beetham, 240–262. London: Routledge, 2004.
———. *Love and Eugenics in the Late Nineteenth Century: Rational Reproduction and the New Woman*. London: Oxford University Press, 2003.
Richardson, Niall. "The Queer Activity of Extreme Male Bodybuilding: Gender Dissidence, Auto-Eroticism and Hysteria." *Social Semiotics* 14, no. 1 (2004): 49–65.

Rieff, Phillip. Introduction to *Dora: An Analysis of a Case of Hysteria*, by Sigmund Freud, translated by Phillip Rieff, xii–xix. New York: Macmillan, 1963.

Riley, Glenda. *Inventing the American Woman: A Perspective on Women's History 1865 to the Present*. Arlington Heights, IL: Harlan Davidson, 1986.

Robinson, Greg. *After Camp: Portraits of Midcentury Japanese American Life and Politics*. Berkeley: University of California Press, 2012.

Robinson, Hilary. "Border Crossing." In *New Feminist Art Criticism*, edited by Katy Deepwell, 16–24. New York: Manchester University Press, 1995.

Rodríquez, Richard T. *Next of Kin: The Family in Chicano/a Cultural Politics*. Durham: Duke University Press, 2002.

Rotger, Antonieta Oliver. "Places of Contradiction and Resistance: The Borderland as Real and Imagined Spaces in Chicana Writing." In *Chicana Literary and Artistic Expressions: Culture and Society in Dialogue*, edited by María Herrera-Sobek, 41–75. Santa Barbara: Center for Chicano Studies Series, 2000.

Rousseau, G. S. "'A Strange Pathology': Hysteria in the Early Modern World, 1500–1800." In *Hysteria Beyond Freud,* edited by Sander L. Gilman, Helen King, Roy Porter, G. S. Rousseau, and Elaine Showalter, 91–186. Berkeley: University of California Press, 1993.

Rudnick, Lois. "The New Woman." In *1915, The Cultural Moment: The New Politics, the New Woman, the New Psychology, the New Art, and the New Theatre in America*, edited by Adele Heller and Lois Rudnick, 69–81. New Brunswick: Rutgers University Press, 1991.

Sahagun, Louis. "The Mothers of East L.A. Transform Themselves and Their Neighborhood." *Los Angeles Times*, August 13, 1989. http://articles.latimes.com/1989-08-13/local/me-816_1_east-los-angeles.

Savran, David. *Communists, Cowboys, and Queers: The Politics of Masculinity in the Work of Arthur Miller and Tennessee Williams*. Minneapolis: University of Minnesota Press 1992.

———. *A Queer Sort of Materialism: Recontextualizing American Theater*. Ann Arbor: University of Michigan Press, 2003.

———. "Queer Theater and the Disarticulation of Identity." In *The Queerest Art: Essays on Lesbian and Gay Theater*, edited by Alisa Solomon and Framji Minwalla, 152–167. New York: New York University Press, 2002.

Schroeder, Patricia R. "Realism and Feminism in the Progressive Era." In *The Cambridge Companion to American Women Playwrights*, edited by Brenda Murphy, 31–46. Cambridge: Cambridge University Press, 1999.

Schuler, Catherine. "The Gender of Russian Serf Theatre and Performance." In *Women, Theatre and Performance: New Histories, New Historiographies,* edited by Maggie Barbara Gale and Viv Gardner, 216–235. Manchester University Press, 2001.

Secrest, Meryle. *Stephen Sondheim*. New York: Knopf, 1994.

Selden, Steve. "Eugenics Popularization." *Image Archive on the American Eugenics Movement*. http://www.eugenicsarchive.org/html/eugenics/essay6text.html

Sheen, Shannon. *Racial Geometries of the Black Atlantic, Asian Pacific and American Theatre*. New York: Palgrave Macmillan, 2010.

Shimakawa, Karen. *National Abjection: The Asian American Body Onstage*. Durham: Duke University Press, 2002.

Showalter, Elaine. *A Literature of Their Own: British Women Novelists from Brontë to Lessing*. Princeton: Princeton University Press, 1993.

Simpson, Caroline Chung. *An Absent Presence: Japanese Americans in Postwar American Culture, 1945–1960*. Durham: Duke University Press, 2001.

Spencer, Herbert. *The Principles of Biology*. London: William and Norgate, 1899.

Spickard, Paul R. "The Nisei Assume Power: The Japanese Citizens League, 1941–1942." *Pacific Historical Review* 52, no. 2 (1983): 147–174.

———. *Japanese Americans: The Formation and Transformations of an Ethnic Group*. New York: Simon and Schuster Macmillan, 1996.

Spillers, Hortense. "Mama's Baby, Papa's Maybe: An American Grammar Book." *Diacritics* 17, no. 2 (1987): 64–81.

Stack, Carol B. and Linda M. Burton. "Kinscripts: Reflections on Family, Generation, and Culture." In *Mothering: Ideology, Experience, Agency*, edited by Evelyn Nakano Glenn, 33–44. New York: Routledge, 1994.

Stansell, Christine. *American Moderns: Bohemian New York and the Creation of a New Century*. New York: Henry Holt, 2000.

Starr Jordan, David. Statement to Congressional Committee. "Hearings Before the Committee on Immigration." U.S. Senate, 68th Congress, First Session, March 1924: 60.

Stearns, David Patrick. "*Jar the Floor* Shows Heart While Shaking Expectations." *USA Today*, August 19, 1999.

Stephens, Judith L. "Gender Ideology and Dramatic Convention in Progressive Era Plays, 1890–1920." In *Performing Feminisms: Feminist Critical Theory and Theatre*, edited by Sue-Ellen Case, 283–293. Baltimore: Johns Hopkins University Press, 1990.

Strong, Edward K. *The Second-Generation Japanese Problem*. London: Oxford University Press, 1934.

Stubblefield, Anna. "'Beyond the Pale': Tainted Whiteness, Cognitive Disability, and Eugenic Sterilization." *Hypatia* 22, no. 2 (2007): 162–181.

Sutherland, Cynthia. "American Women Playwrights as Mediators of the 'Woman Problem.'" *Modern Drama* 21 (1978): 319–336.

Takaki, Ronald. *Strangers from a Different Shore: A History of Asian Americans*. Boston: Back Bay, 1998.

Thomas, Aaron C. "Engaging an Icon: *Caroline, or Change* and the Politics of Representation." *Studies in Musical Theatre* 4, no. 2 (2010): 199–210.

Thurer, Shari L. *The Myths of Motherhood: How Culture Reinvents the Good Mother*. Boston: Houghton Mifflin, 1994.

Uhry, Alfred. *Driving Miss Daisy*. New York: Dramatists Play Service, 1987.

Ussher, Jane. *The Psychology of the Female Body*. London: Routledge, 1989.

Waldman, Ayelet. http://ayeletwaldman.com/books/bad.html. Accessed August 1, 2011.

———. "Truly, Madly, Guiltily." *New York Times*, August 1, 2011. http://www.nytimes.com/2005/03/27/fashion/27love.html.

Wallace-Sanders, Kimberly. Introduction to *Skin Deep, Spirit Strong: The Black Female Body in American Culture*, edited by Kimberly Wallace-Sanders, 1–12. Ann Arbor: University of Michigan Press, 2002.

———. *Mammy: A Century of Race, Gender, and Southern Memory*. Ann Arbor: University of Michigan Press, 2008.

Warner, Michael. Introduction to *Fear of a Queer Planet: Queer Politics and Social Theory*, edited by Michael Warner, i–xxx. Minneapolis: University of Minnesota Press, 1993.

Watt, Stephen. *Postmodern/Drama: Reading the Contemporary Stage*. Ann Arbor: University of Michigan Press 1998.

Weber, Brenda R. "'Were Not These Words Conceived in Her Mind?' Gender/Sex and Metaphors of Maternity at the Fin De Siècle." *Feminist Studies* 32, no. 3 (2006): 547–572.

West, Cheryl L. *Jar the Floor*. New York: Dramatists Play Service, 2002.

Wickstrom, Stefanie. "The Politics of Forbidden Liaisons: Civilization, Miscegenation, and Other Perversions." *Frontiers: A Journal of Women's Studies* 26, no. 3 (2005): 168–198.

Williams, Judith. "Uncle Tom's Women." In *African American Performance and Theatre History: A Critical Reader*, edited by H. Elam, Jr., and D. Krasner, 19–39. New York: Oxford University Press, 2001.

Williams-León, Teresa and Cynthia L. Nakashima. "Reconfiguring Race, Rearticulating Ethnicity." In *The Sum of Our Parts: Mixed Heritage Asian Americans*, edited by Teresa Williams-Leon and Cynthia L. Nakashima, 3–10. New York: Oxford University Press, 2001.

Wilmer, S. E. "On Writing National Theatre Histories." In *Writing and Rewriting National Theatre Histories*, 17–28. Iowa City: University of Iowa Press, 2004.

Wilson, Elizabeth A. "Gut Feminism." *differences: A Journal of Feminist Cultural Studies* 15, no. 3 (2004): 66–94.

Wilson, Kay. "The History of Kites in Japan and Other Parts of the World." *North Texas Institute for Educators of the Visual Arts*. http://art.unt.edu/ntieva/download/teaching/Curr_resources/mutli_culture/Japan/Other/History_Kites_Japan_Other_Parts_World.pdf.

Witt, Doris. "What (N)ever Happened to Aunt Jemima: Eating Disorders, Fetal Rights, and the Black Female Appetite in Contemporary American Culture." In *Skin Deep, Spirit Strong: The Black Female Body in American Culture*," edited by Kimberly Wallace-Sanders, 239–262. Ann Arbor: University of Michigan Press, 2002.

Wolfe, George C. *The Colored Museum. Two by George C. Wolfe*. Garden City: Fireside Theatre, 1991, 1–64.

Wollcott, Alexander. "The Play." *New York Times*, February 13, 1920. http://query.nytimes.com/mem/archive-free/pdf?res=9E06E1DE103BEE32A25750C1A9649C946195D6CF.

Yamamoto, Traise. *Masking Selves, Making Subjects: Japanese American Women, Identity, and the Body*. Berkeley: University of California Press, 1991.

Yarbro-Bejarano, Yvonne. *The Wounded Heart: Writing on Cherríe Moraga*. Austin: University of Texas Press, 2001.

Yoo, David K. *Growing Up Nisei: Race, Generation, and Culture Among Japanese Americans of California, 1924–49*. Urbana: University of Illinois Press, 2000.

Yu, Henry. *Thinking Orientals: Migration, Contact, and Exoticism in Modern America*. New York: Oxford University Press, 2001.

Yuval-Davis, Nina and Floya Anthias. *Woman-Nation-State*. New York: St. Martin's Press, 1989.

Zwinger, Lynda Marie. *Daughters, Fathers, and the Novel: The Sentimental Romance of Heterosexuality*. Madison: University of Wisconsin Press, 1991.

INDEX

442nd Regimental Combat Team, 73, 187

abolition (of slavery), 97, 190
 abolitionist discourse, 194
 in British Empire, 192
 and women, 26
Acham, Christine, 164, 207
Adan Eva, 203
Addams, Jane, 22, 27, 172, 175
 see also Hull House
adoption
 and African American maternal performance, 162
 in Crothers, 44, 49, 88
Aiken, George, 96
Akin, Todd, 153–5, 204, 213
Akins, Zoe, 26–7, 175, 177
Alarcón, Norma, 140, 143, 201
alcohol
 and associations with women's sexual freedom, 174
 and *Shadow of a Man* (Moraga), 127, 135, 139
 see also temperance
alienation effect, 100–1, 110, 147–8
 see also Bertolt Brecht
Almaguer, Tomás, 137
Althusser, Louis, 108, 195
American Breeders Association, 53, 181
American imperialism, 21
American Theater Wing Allied Relief Fund, 34
Anderson, Lisa, 96, 192
androgyny, 41

Anthias, Floya, 180
Anzaldúa, Gloria, 13, 124, 132, 136–7, 139–45, 199, 202
Aoiki, Brenda Wong, 90
 see also *La Frontera*
Armas, Jose, 138, 143
assimilation, 4, 12, 22–3, 53–63, 66, 74–80, 87, 127–36, 158, 162, 168, 182, 187–8, 201, 205
atomic bomb, see Hiroshima
Auerbach, Nina, 203
Awakening, The (Chopin), 174
Azuma, Eiichiro, 54, 61, 69, 186

Barlow, Judith, 26, 178
Baudelaire, Charles, 198
Belasco, David, 32
Belsey, Catherine, 110
Belmont Theatre, 27
Bennett, Susan, 167
Bergman, Jill, 21, 48, 180
Bhabha, Homi, 55, 89, 143, 183
Bial, Henry, 4–5, 169
birth control, 23, 158–9, 166, 174, 205
 see also reproductive rights
Black, Cheryl, 31
Black Arts Movement, 99, 119, 162, 164–5
Black Nationalism, 162, 164–5
Black Panthers, 164, 166
Black Women's Club Movement, 173
Bogle, Donald, 105, 113, 194
Bösch, Susanna A., 4, 93
Bost, Suzanne, 131–2, 140
Bottom, Stephen, 5–6, 170

Index

Bovary, Emma (Flaubert), 198
Boyce, Neith, 22
Brady, Mary Pat, 124–5, 142–5, 201, 202
Brava! For Women in the Arts Program, 198
Brecht, Bertolt, 88, 100–1, 103, 110, 118, 147–8, 151
 see also alienation effect
Breuer, Joseph, 126
 see also Sigmund Freud
Brooks, Peter, 200
Brundage, W. Fitzhugh, 117, 196
Brunt, Rosaline, 30

Calhoun, Arthur, 117–8
Caminero-Santangelo, Marta, 125
Canning, Charlotte, 28–31
Cantú, Lionel, 133–4
Carlson, Marvin, 7, 115, 118
Carroll, Diahann, 163, 165–6, 207
 see also *Julia*
Carter, John Franklin, 186
Case, Sue-Ellen, 11
catharsis, 11, 88, 100, 110, 146–8
Catt, Carrie Chapman, 27, 172
Caulfield, Minna, 15
Chabon, Michael, 1, 3
Chabram-Dernersesian, Angie, 138
Chad, Harrison, 102
Chadhuri, Una, 90
Chang, Gordon H., 79
Charles, Michael Ray, 96
Chateauvert, Melinda, 112
César Chávez, 199
Chicana feminism, 131–2, 134, 144, 156–8
Chicanismo, 134–5, 140, 199
 see also Chicano movement, machismo
Chicano movement, 134–5, 137–8, 147
 see also Chicano nationalism, Chicanismo
Chicano nationalism, 202
 see also Chicano movement
Chicano theatre and performance, 146–8, 202–3
Chin, Frank, 90

Chong, Ping, 90
Chopin, Kate, 18, 174
civil rights
 legislation, 98, 161, 164, 192
 movement, 11, 98, 147, 164
Clinton, Catherine, 96
Cohan, George M., 32
Cole, Nat King, 103, 106
Collins, Patricia Hill, 94–5, 162
Colored Museum, The (Wolfe), 100, 192–3
 see also George Wolfe
Comedy Theatre, the, 178
Comstock laws, 174
Connor, "Bull", 101
Cooley, Winnifred Harper, 23
Cosby Show, The (television program), 163, 206–7
Creef, Elena Tajima, 64, 185
Crothers, Dr. Marie Depew, 36, 177
Crothers, Rachel, 11–12, 17–51, 88, 174–80
cult of true womanhood, 95, 148, 150
Cuvier, George, 194

Daniel Deronda (Eliot)
 and hysteria, 198
Darwin, Charles, 42–3, 181
Davenport, Charles, 21
David Starr Jordan, 53
Davis, Jill, 174
Death of a Salesman (Miller), 9
Delbridge, Marjorie, 98–9, 165
Diamond, Elin, 121–2, 149–51, 154, 203
Dijkstra, Bram, 45
Dodge, Mabel, 22, 201
Doll's House, A (Ibsen), 9, 174
 see also Henrik Ibsen
Dolan, Jill, 10–11, 110
Dowd, Maureen, 166–7

Egerton, George, 43
El Teatro Nacional de Aztlán, *see* TENAZ
Eliot, George, 151, 198
Ender, Evelyne, 197

Engle, Sherry, 30, 178
enryo syndrome, Japanese social construct of, 189
epic theatre, *see* Bertolt Brecht
Espiritu, Yen Le, 184
estrangement effect, *see* alienation effect
eugenics, 4, 12, 21, 42–3, 46–50, 62, 168, 172, 178–81
 see also American Breeders Association
Eureka Theatre (San Francisco), 198

fallen woman, 18, 41–9, 123, 133, 138–51, 171–6, 199, 203–4
Federal Theater Project, 34
feminist theatre, 18, 25–31, 110, 167
Fish Head Soup (Gotanda), 79–80, 83, 87, 182, 188
Fiske, Minne Maddern, 33
Flapper, the, 174
Flaubert, Gustave, *see* Emma Bovary
Fletcher, Pamela, 49
Foertsch, Jacqueline, 95
Fornes, María Irene, 198
Freud, Sigmund, 122–3, 126–38
 see also hysteria
Friedman, Sharon, 18, 25, 35

Gale, Zona, 26–7, 44, 175, 177
Galton, Francis, 42, 47, 180
 see also eugenics
Galton Institute, the, 178
Galton Society, the, 181
gaman, Japanese social construct of, 189
Garcia, Alma M., 134
Gentlemen's Agreement (immigration policy), 184
Gershwin, George and Ira, 193
Gibson Girl, 23, 172–3
Gilman, Charlotte Perkins, 18, 22, 33, 129, 137, 178, 198
Glasgow, Ellen, 24
Glaspell, Susan, 18, 25–31, 128, 175, 177, 181
Glenn, Evelyn Nakano, 1, 8–9, 56
Goldman, Emma, 27, 173
Goldstein, Malcolm, 31

González, Cesar A., 137
Good Times (television program), 206
Goodman, Lizbeth, 197
Gotanda, Philip Kan, 12–13, 54–91, 182–9
Gottlieb, Lois, 25, 30, 33, 37
Grand, Sarah, 43, 178
Great Depression, 7, 11, 23, 26, 31, 34, 165
Great Migration, 98–9, 165
Griffith, D. W., 115, 195, 196
Grimké, Angelina Weld, 18, 115–6, 196
gynocentrism, 12, 20, 37, 44

Hagedorn, Jessica, 90
Hansberry, Lorraine, 102, 115, 192–3
Harper, Frances Ellens Watkins, 18
Heilmann, 178, 180
Hellman, Lillian, 25, 30, 96
Hemmings, Sally, 190
Henderson, Carole E., 96–7, 160, 193, 194
Hernández, Ellie, 124, 136, 141, 144–6
Herndl, Diane Price, 126, 129, 137
Herr, Christopher, 121, 176
Herrera-Sobek, María, 122, 138, 145
Heterodoxy Club, 173
Hiroshima, 55
Hiroshima Maidens Project (HMP), 55, 183
historiography
 of Asian American culture, 182
 of theatre, 7–8, 167, 169
History of North American Theatre, The, 8
Ho, Wendy, 60, 182
Hoffler, Robert, 118
homophobia, 129, 136, 143
 see also machismo
Hondagneu-Sotela, Pierette, 137
hooks, bell, 116
Hopkins, Pauline, 23
Houston, Jeanne Wakatsuki, 66, 189
Houston, Valina Hasu, 64, 90, 185
Huerta, Jorge, 147–8, 202, 203
Hull House, 27, 175
 see also Jane Addams

Hunter, Dianne, 129, 198
Hwang, David Henry, 12, 90
hysteria, 13–14, 121–46, 148–51, 198–200, 203–4

Ibsen, Henrik, 9, 27, 33, 148–50, 174, 203, 204
Ibsenite realism, 149–50, 204
see also Henrik Ibsen; realism
ie, Japanese social model of, 186
immigrants, Japanese, 53–4, 60, 62, 70, 79–80, 86, 182–4, 186
see also Issei, Nisei, Sansei, Yonsei
Immigration Act of 1917, 183
INTAR
Hispanic Playwrights-in-Residence program, 198
intermarriage, 67, 69, 108, 184, 192
see also miscegenation
internment camps, US, 13, 54–6, 59–61, 67–77, 84–8, 182–9
inter-racial marriage
see intermarriage
inter-racial sex
see miscegenation
Issei, 61, 63–4, 67–70, 182, 186, 188–9
Ito, Robert, 54, 79, 182

Jackson, Camilla, 98–9
James, Henry, 137, 198–200
Japanese American Citizens League, 74
Jefferson, Thomas, 190, 192
Jeffersons, The (television program), 206
Jewell, K. Sue, 112, 163
Jim Crow
construct, 94
-era Mammy construct, 103
Jorden, Edward, 131
Julia (television program), 163–5
see also Diahann Carroll

Kaplan, E. Ann, 9
Kellog, John Harvey, 181
Kelly, Florence, 172
Kennelly, Ivy, 160–1

Kim, Elaine, 89
kites
as gendered activity in Japanese culture, 57–8, 183
Kneubuhl, Victoria Nalani, 90
Knowles, Ric, 7, 17
Komporaly, Jozefina, 3
Kondo, Dorinne, 90–1, 110, 118, 196
Kristeva, Julia
and subjective narcissism versus self-reflective narcissism, 135
Kummer, Clare, 177
Kuruvilla, Sunil, 90
Kushner, Tony, 11, 13, 94–5, 99–107, 111, 118–9

Ladies Home Journal, 175
La Frontera, 13, 132, 136, 138–46, 201–2
see also Anzaldúa, Gloria
La Llorona, 133, 148
Last Mama on the Couch Play (Wolfe), 115, 192–3
see also George Wolfe
Lauretis, Teresa de, 11
Lear, Norman, 206
Lee, Josephine, 89, 190
Lefebvre, Henri, 143
Lemire, Elise, 94, 190
Lilith Theatre (San Francisco), 31
Lindroth, Colette and James, 25, 33, 174, 176
Little Theatres, 31
Chicago, 26
New York, 26, 35, 177
Little Theatre Movement, 26, 176
little Tokyos, ghettoization of Japanese Americans and, 188
Loman, Linda, 9
Londrés, Felicia, see *History of North American Theatre, The*
Lorde, Audre, 104, 199
Los Angeles Theatre Center
New Works Festival, 198
Loving v. Virginia, 99, 165, 192
Lowe, Lisa, 89, 182

machismo, 129, 134–8, 141–2, 147, 158
 see also Chicanismo
Macmillan's Magazine, 47
Magelssen, Scott, 4–5, 169
Manhattan Theatre Club, 82
Manzanar, 66, 189
Mark Taper Forum, 82
Mary Magdalene, 158
Marxism, 10, 25
Massey, Doreen, 143, 146
McCarran-Walter act (1952), 184
 also known as "The Immigration and Nationality Act"
McCullers, Carson, 102
McElya, Micki, 98, 117, 161
McLaren, Rosie, 126, 151
McMillen, Sally, 118
McMillin, Scott, 100–1, 193
Meier, Joyce, 115, 162, 196
Member of the Wedding, The (McCullers), 102
Messner, Michael A., 137
mestize consciousness, subjectivity, 139–40, 203
Miller, Arthur, 9, 149
Miller, Tim, 123
Miss Lulu Bett (Gale), 26–7, 44, 175
minstrelsy, 94, 100, 191–2, 206
miscegenation, 4, 13, 53, 60–2, 94–8, 108–9, 117–8, 168, 184, 190–2
 see also intermarriage
Miyamoto, Frank, 86
Miyamoto, Nobuko, 90
Monette, Paul, 199
Moraga, Cherríe, 13, 121–51, 158, 197–9, 201, 204
Morton, Patricia, 116
Mothers of East Los Angeles (MELA), 156–8, 204
Moynihan, Daniel Patrick, 161, 206
Mrs. Warren's Profession (Shaw), 174
Mura, David, 85, 189

NAACP, 115, 196
Nakashima, Cynthia, 54

Native American
 culture as source material, 132
 and miscegenation, 191
 and motherhood, 8
 Performance traditions, theatre, 8
Nethersole, Olga, 33, 171, 176
Neville-Rolf, Sybil, 178
New Woman construct, 12, 18–25, 33–5, 38, 41–51, 172–4, 177–80
Newlin, Keith, 41
Nichibei Shimbum, 186
Nisei, 54–9, 61, 63–4, 67–75, 77–9, 82–9, 182–9
Nordau, Max, 203

Omi, Michael, 181
Ong, Han, 90

Pace v. Alabama, 192
Palumbo-Liu, David, 62
Pardo, Mary, 156–8
Patterson, James, 161
Patterson, Martha, 21–2, 174
pedophilia, staged allusions of, 102–3
Performance Studies, 5–6, 103
Phillips, Henry Albert, 29
Pinero, Arthur Wing, 148, 150, 171, 203
Pinkins, Tanya, 103
Pinson, Hermine, 119
Playwright's Theatre, 28
Portillo-Trambley, Estella, 147
Powell-Wright, Debra, 103, 193
Progressive Era, 12, 18–20, 30, 42, 44, 171, 173, 178–81
Provincetown Players, 26–8, 31–3, 50

Quinn, Arthur Hobson, 41, 178

Race Betterment Foundation, 181
Rafu Shimpo, 186
Raisin in the Sun, A, see Lorraine Hansberry
realism, 12, 33, 35, 88–90, 100, 110–11, 122, 133, 146–51, 193, 203–4
 see also Ibsenite realism
Reinelt, Janelle, 11

Rendón, Armando
 and *The Chicano Manifesto*, 138
relocation camps
 see internment camps
reproductive rights, 48, 50, 61, 153,
 155, 166–7, 171, 205
 see also birth control
Richardson, Angelique, 21, 43, 49–50,
 172–3, 178–80
Richardson, Anna Stease, 178
Richardson, Niall, 122, 124, 128
Robins, Margaret Dreier, 17
Robinson, Greg, 187–8
Rodman, Henrietta, 26
Rodríquez, Richard T., 124, 134,
 137–40, 143, 197, 199, 201
Roosevelt, Eleanor, 187
Roosevelt, Theodore, 196
Rotger, Antonieta Oliver, 144
Rousseau, G. S., 131
Rousseau, Jean-Jacques
 and *Emile, or on Education*, 9
Rowan, Caroline, 30
Rudnick, Lois, 18, 22, 173

Saar, Betye, 96
Sakamoto, Edward, 90
Sand, George, 151
Sanger, Margaret, 43, 205
Sansei, 57–61, 65–6, 78, 182, 184
Savran, David, 10, 170
Schechner, Richard
 and theatre studies versus
 performance, 170 studies
Schroeder, Patricia, 45, 179
Schuler, Catherine, 7, 170
Second Mrs. Tanqueray, The (Pinero),
 171, 203
second-wave feminism, second-wave
 writers, 11, 25, 28–31
Selden, Steve, 181
Settlement Workers, 22
sexual selection, language of, 181
 see also eugenics
Shaw, Anna Howard, 172
Shaw, George Bernard, 148, 150, 174

Shaw, Mary, 33
Sheen, Shannon, 155, 181–2
Shimakawa, Karen, 62, 74, 115, 187, 195
Simone, Nina, 193
Shin Sekai, 69, 186
Showalter, Elaine, 20
Sikes, Alan, 169
Simone, Nina, 103, 193
Simpson, Caroline Chung, 55, 183
Son, Diana, 90
South Coast Repertory's Hispanic
 Playwright's Festival, 198
Spencer, Herbert, 24, 174
Spickard, Paul R., 61, 64, 70, 74, 85,
 184–9
Stansell, Christine, 173, 179
Stage Relief Fund, 34
Stage Women's War Relief, 34
Stanhope-Wheatcroft School, 30, 33, 176
Stephens, Judith L., 19–20, 42, 172
Stubblefield, Anna, 21, 47, 179–80
suffrage, women's, 22, 25–6, 171, 173
Sutherland, Cynthia, 25–7, 37–8

Takei, George, 82
Téatro Campesino, El, 147–8
television, African Americans
 appearing in, 163–5, 206–7
temperance, 171
 see also alcohol
TENAZ, 147
Tesori, Jeanine, 103, 118
The Group Theater, 31, 176
The Theater Guild, 31, 176
The Theater Union, 31
Thomas, Aaron C., 104
Thomas, Lorenzo, 119
Toy Theatre (Boston), 26
Thurer, Shari L., 9
Trifles, 128, 175
True Woman, 24, 33, 45, 95, 148–50
Tucker, George, 97, 192

Uhry, Alfred, 13, 88, 94, 99–111, 119
Uno, Edison, 85, 189
U.S. Civil War, 98

U.S. Senate, 53, 206, 217
U.S. Supreme Court, 94, 99, 165, 192, 205

Valdez, Luis, 147, 202
Valley of Shenandoah, The, 97
Verfremdungseffekt, *see* alienation effect
Victorian
 discourses of hysteria, 148–9, 203
 gender paradigms, 18–19, 45, 95, 148, 150, 171
Virgen de Guadalupe, 148, 203
Virgin Mary, 203
Vollmer, Lulu, 177

Wald, Lillian, 172
Waldman, Ayelet, 1–3, 169
Wallace-Sanders, Kimberly, 97–8, 104, 108, 116, 194–5
War Relocation Authority, 186–7
Warner, Michael, 122
Washington, Margaret Murray, 23
Washington Square Players, 26, 176
Watt, Stephen, 6, 171
Wattermeier, Daniel, see *History of North American Theatre, The*
Weber, Brenda R., 34, 45
Weglyn, Michi, 85, 189
West, Cheryl, 13, 88, 94, 99, 111–19, 162–3
Wharf Theatre, 28
Wharton, Edith, 23, 175
Willard, Francis, 171
Williams-León, Teresa, 54

Williams, Judith, 94
Wilmer, S. E., 18
Wilson, Elizabeth, 126
Winant, Howard, 91, 181
Winer, Lucy, 28
Winfrey, Oprah, 2, 169
Wisconsin Equal Rights Law, 27
Witt, Doris, 161
Wolfe, George, 100, 102, 115, 192–3
Wollcott, Alexander, 28
Woodhull, Virginia, 178
women's clubs, 17, 21, 23, 43, 99, 171
 see also Black Women's Club Movement
women's emancipation, 22, 49
Woman's Peace Party, 27
Woman's Peace Union, 27
Women's Trade Union League, 17
World War
 first, 23, 34–5, 165
 second, 11, 185

xenophobia, 73, 78–80

Yamamoto, Traise, 56, 62–4, 66, 184
Yarbro-Bejarano, Yvonne, 132, 202
Yonsei, 60, 63, 65, 80, 185
Yoo, David K., 61, 85, 183, 185–7
Younger, Lena, 102, 115, 192–3
 (Lorraine Hansberry's)
Yu, Henry, 86
Yuval-Davis, Nina, 180

Zola, Emile, 204
Zoot Suit, *see* Luis Valdez

GPSR Compliance
The European Union's (EU) General Product Safety Regulation (GPSR) is a set of rules that requires consumer products to be safe and our obligations to ensure this.

If you have any concerns about our products, you can contact us on

ProductSafety@springernature.com

In case Publisher is established outside the EU, the EU authorized representative is:

Springer Nature Customer Service Center GmbH
Europaplatz 3
69115 Heidelberg, Germany

www.ingramcontent.com/pod-product-compliance
Lightning Source LLC
LaVergne TN
LVHW051913060526
838200LV00004B/118